© Ben McKee

EDMUND DE WAAL is one of the world's leading ceramic artists, and his porcelain is held in many major museum collections. His bestselling memoir, *The Hare with Amber Eyes*, has been published in thirty languages and won the Costa Biography Award and the Royal Society of Literature Ondaatje Prize. It was shortlisted for the Duff Cooper Prize, the Jewish Quarterly-Wingate Prize, the PEN/Ackerley Prize and the Southbank Sky Arts Award for Literature, and longlisted for the Orwell Prize and BBC Samuel Johnson Prize. De Waal lives in London with his family.

Also by Edmund de Waal *The Hare with Amber Eyes*

Additional Praise for *The White Road*

"It is rare for someone to write as well as Edmund de Waal, all the more since it's his secondary vocation.... *The White Road* is the story of how objects, through the accumulation of intent, labor, and the patina of history, accrue a sense of self." —*The Seattle Times*

"*The White Road* is filled with marvelous examples of storytelling, and de Waal has a gift for inhabiting his characters. Also, the historical material is interleaved with stories from de Waal's own life as a ceramicist, which adds an extra and very welcome dimension to the tale." —*The Boston Globe*

"At once meditation, memoir, and travelogue as well as history, *The White Road* is one of those unclassifiable books that simply astounds with the author's infectious love of his subject.... De Waal's prose is both elegant and powerful.... Despite covering so many places, so many historical periods, and so many themes, de Waal's beautiful narrative voice and his love for his subject manage to shape this book into an almost seamlessly formed whole. Which leaves me with my one resentment regarding *The White Road*: it's damned unfair that such a distinguished artist should also be such a great writer." —*The Christian Science Monitor*

"De Waal reveals the depths and permutations of his life-shaping fascination with porcelain.... [He] brings a historian's ardor for detail and a poet's gifts for close observation and radiant distillation to this exquisite chronicle of his extensive porcelain investigations.... De Waal's passionately and elegantly elucidated story of porcelain, laced with memoir and travelogue, serves as a portal into the madness and transcendence of our covetous obsession with beauty." —*Booklist* (starred review)

"A winning hybrid: a rueful family memoir, a shimmering meditation on loss and the reverberating significance of cherished objects, and a vividly episodic history of nineteenth- and twentieth-century Europe." —*The Atlantic*

"*The Hare with Amber Eyes* belongs on the same shelf with Vladimir Nabokov's *Speak, Memory*, André Aciman's *Out of Egypt*, and Sybille Bedford's *A Legacy*. All four are wistful cantos of mutability, depictions of how even the lofty, beautiful, and fabulously wealthy can crack and shatter as easily as Fabergé glass or Meissen porcelain—or, sometimes, be as tough and enduring as netsuke, those little Japanese figurines carved out of ivory or boxwood." —*The Washington Post Book World*

"*The Hare with Amber Eyes* unexpectedly combines a micro-craft form with macro history to great effect." —Julian Barnes

"In this rich and chastened family memoir, de Waal questions his project even as he glowingly carries it out. . . . He writes in vivid detail of how the fortunes were used to establish the Ephrussis' lavish lives and high positions in Paris and Vienna society. And, as Jews, of their vulnerability. . . . To question your art is a supreme art; and de Waal's questioning is one more reason for the reader to find his pilgrimage, beyond doubt, warranted." —*The Boston Globe*

"I was moved and excited by Edmund de Waal's *The Hare with Amber Eyes*." —A. S. Byatt

The White Road

Edmund de Waal

Journey into an Obsession

Picador Farrar, Straus and Giroux New York

For Sue, always

picadorusa.com • picadorbookroom.tumblr.com
twitter.com/picadorusa • facebook.com/picadorusa

Picador® is a U.S. registered trademark and is used by Macmillan Publishing Group, LLC, under license from Pan Books Limited.

For book club information, please visit facebook.com/picadorbookclub or e-mail marketing@picadorusa.com.

Designed by John Morgan

The Library of Congress has cataloged the Farrar, Straus and Giroux edition as follows:

De Waal, Edmund, author.
 The white road : journey into an obsession / Edmund de Waal. — First American edition.
 p. cm.
 Includes bibliographical references.
 ISBN 978-0-374-28926-3 (hardcover)
 ISBN 978-0-374-70909-9 (e-book)
 1. Porcelain—History. 2. De Waal, Edmund—Travel. I. Title.

NK4370.D45 2015
738.209—dc23 2015022207

Picador Paperback ISBN 978-1-250-09732-3

Our books may be purchased in bulk for promotional, educational, or business use. Please contact your local bookseller or the Macmillan Corporate and Premium Sales Department at 1-800-221-7945, extension 5442, or by e-mail at MacmillanSpecialMarkets@macmillan.com.

Originally published in Great Britain by Chatto & Windus

First published in the United States by Farrar, Straus and Giroux

First Picador Edition: November 2016

10 9 8 7 6 5 4 3 2 1

What is this thing of whiteness?

Herman Melville, *Moby-Dick*

Contents

Prologue

Jingdezhen – Venice – Dublin

I'm in China. I'm trying to cross a road in Jingdezhen in Jiangxi Province, the city of porcelain, the fabled Ur where it all starts; kiln chimneys burning all night, the city 'like one furnace with many vent holes of flame', factories for the imperial household, the place in the fold of the mountains where my compass points. This is the place where emperors sent emissaries with orders for impossibly deep porcelain basins for carp for a palace, stem cups for rituals, tens of thousands of bowls for their households. It is the place of merchants with orders for platters for feasts for Timurind princes, for dishes for ablutions for sheikhs, for dinner services for queens. It is the city of secrets, a millennium of skills, fifty generations of digging and cleaning and mixing white earth, making and knowing porcelain, full of workshops, potters, glazers and decorators, merchants, hustlers and spies.

It is eleven at night and humid and the city is neon and traffic like

Manhattan and a light summer rain is falling and I'm not completely sure which way my lodgings are.

I've written them down as *Next to Porcelain Factory #2* and I thought I could pronounce this in Mandarin, but I'm met with busy incomprehension, and a man is trying to sell me turtles, jaws bound in twine. I don't want his turtles, but he knows I do.

It feels absurd to be this far from home. There is televised mah-jong at high volume in the parlours with their glitter balls like a 1970s disco. The noodle shops are still full. A child is crying, holding her father's finger as they walk along. Everyone has an umbrella but me. A barrow of porcelain models of cats is wheeled past under a plastic tarp, scooters weaving round it. Ridiculously someone is playing *Tosca* very loudly. I know one person in the whole city.

I haven't got a map. I do have my stapled photocopy of the letters of Père d'Entrecolles, a French Jesuit priest who lived here 300 years ago and who wrote vivid descriptions of how porcelain was made. I've brought them because I thought he could be my guide. At this moment this seems a slightly affected move, and not clever at all.

Pages from Père d'Entrecolles' letters on Chinese porcelain, 1722

I'm sure I'm going to die crossing this road.

But I know why I'm here, so that even if I'm not sure which way to go, I'll go confidently. It is really quite simple, a pilgrimage of sorts – a chance to walk up the mountain where the white earth comes from. In a few years I am turning fifty. I've been making white pots for a good forty years, porcelain for twenty-five. I have a plan to get to three places where porcelain was invented, or reinvented, three white hills in China and Germany and England. Each of them matters to me. I have known of them for decades from pots and books and stories but I have never visited. I need to get to these places, need to see how porcelain looks under different skies, how white changes with the weather. Other things in the world are white but, for me, porcelain comes first.

This journey is a paying of dues to those that have gone before.

ii

A paying of dues sounds appallingly pious but it isn't.

It is a lived truth, a bit declamatory, but a truth none the less. If you make things out of porcelain clay, you exist in the present moment. My porcelain comes from Limoges in the Limousin region of France, halfway down on the West. It comes in twenty-kilo plastic bags, each bag with two ten-kilo sausages of perfectly blended porcelain clay, the colour of full-fat milk, with a bloom of green mould. I unwrap one and thump it down on to my wedging bench, pull the twisted wire through a third of the way along, pick up the lump and push it into the bench, raising it and pushing it down in a circular motion, like kneading dough. It gets softer as I do this. I slow down and the clay becomes a sphere.

My wheel is American and silent and low to the ground, jammed up against the wall in the middle of the slightly chaotic studio. I look at the white brick wall. There are too many people in this small space, two full-time and two part-time assistants to help with glazing and

firing and logistics and the deluge of mail from my last book. There is too much noise from the neighbours. I need another studio. Things are going well. I have just been invited to show in New York and I have a dream of walking through an expansive gallery, full of light, walking far away from a piece of my work, turning around and seeing it with new eyes, alone, seeing it as if for the first time. Here I stretch my long arms and touch packing crates. I can get fifteen feet away. On a good day.

Everyone is being as quiet as they can but, damn it, the concrete floor is noisy. There is an argument outside. I need to make time to be nice to estate agents again as getting a studio is difficult in London. All those useful bits of space where people used to make things or mend them round the backs of house are being developed for apartments. I need to talk to the accountant.

I sit at my wheel.

And I throw the ball of clay into the centre, wet my hands and I am making a jar now and pulling the clay up with the knuckle of my right hand on the outside, three fingers of my left tensed inside to support, as the walls grow taller and the volume changes like an exhalation, something being said. I'm in this moment while also being elsewhere. Altogether elsewhere. Because the clay is the present tense and a historical present. I'm here in Tulse Hill, just off the South Circular road in South London, in my studio behind a row of chicken takeaways and a betting shop, sandwiched between some upholsterers and a kitchen-joinery workshop, and as I make this jar I'm in China. Porcelain is China. Porcelain is the journey to China.

It is the same when picking up this Chinese porcelain bowl from the twelfth century. The bowl was made in Jingdezhen, thrown then moulded with a flower in a deep well, unglazed rim, green-grey with a slightly pooled glaze, *some issues* as the dealers would say, chips, marks, scuffs. It happens in the present tense and it is, itself, a continuous present of active, dynamic movements, judgements and decisions. It doesn't feel in the past, and it feels wrong to force it into one just to

obey a critical orthodoxy. This bowl was made by someone I didn't know, in conditions that I can only imagine, for functions that I may have got wrong.

But the act of reimagining it by picking it up is an act of remaking.

This can happen because porcelain is so plastic. Pinch a walnut-sized piece between thumb and forefingers until it is as thin as paper, until the whorls of your fingers emerge. Keep pinching. It feels endless. You feel it will get thinner and thinner until it is as thin as gold leaf and lifts into the air. And it feels clean. Your hands feel cleaner after you have used it. It feels white. By which I mean it is full of anticipation, of possibility. It is a material that records every movement of thinking, every change of thought.

What defines you?

You are by the sea at the turn of the tide. The sand is washed clean. You make the first mark in the white sand, that first contact of foot on the crust of sand, not knowing how deep and how definite your step will be. You hesitate over the white paper like Bellini's scribe with his brush. Eighty hairs from the tail of an otter ends in a breath, a single hair steady in the still air. You are ready to start. The hesitation of a kiss on the nape of the neck like a lover.

I pull the twisted metal wire under my finished jar, dry my fingers on my apron and pick it up from the wheel, place it with brief satisfaction on a board to my right. Reach for another ball of clay and begin again.

It is white, returning to white.

iii

This moment, this pause, holds a kind of grandeur.

Porcelain has been made for 1,000 years, traded for 1,000 years. And it has been in Europe for 800 of these. You can trace a few shards earlier. These broken fragments of Chinese pot gleam provocatively alongside

the heavy earthenware pitchers they were found with and no one can work out how they got to this Kentish cemetery, this Urbino hillside. There are scatterings of porcelain across medieval Europe in inventories of Jean, duc de Berry, a couple of popes, the will of Piero de' Medici with his *una coppa di porcellana*, a cup of porcelain.

You see a glimpse of white in a list of presents given on an embassy from one princeling to another: a stallion, a jar of porcelain, a tapestry with golden thread. It is so precious, goes the story in medieval Florence, that a porcelain cup prevents poison from working. A beautiful celadon-green bowl is deeply encased in silver and disappears into a chalice. A wine jar is mounted and becomes a ewer for a banquet. You can even see a glimpse in a Florentine altarpiece; one of the kings kneeling stiffly before the Christ child seems to be offering him myrrh in a Chinese porcelain jar, and this homage seems about right for a substance so scant and so arcane, for an object that has come such a long way from the East.

Porcelain is a synonym for far away. Marco Polo came back from Cathay in 1291 with his silks and brocades, the dried head and feet of a musk deer and his stories, a *Divisament dou monde*, his Description of the World.

The stories of Marco Polo are iridescent. Every element glistens and glitters as strangely as lapis lazuli, throwing off shadows and reflections. They are digressive, repetitive, rushed, rehearsed. 'In this city Kublai Khan built a huge palace of marble and other ornamental stones. Its halls and chambers are all gilded, and the whole building is marvellously embellished and richly adorned.' Everything is different, marvellously, richly so. Tents are lined with ermine and sable.

Numbers in Marco Polo are either vast – 5,000 gerfalcons, 2,000 mastiffs, 5,000 astrologers and soothsayers in the city of Khan-balik. Or singular. A great lion that prostrates himself with every appearance of great humility before the khan. A huge pear that weighs ten pounds.

And colours are drama. Palaces are decorated with dragons and birds and horsemen and various breeds of beasts and scenes of battle. The

roof is all ablaze with scarlet and green and blue and yellow and all the colours that are so brilliantly varnished. There is a feast, recounts Marco Polo breathlessly, for the New Year in February:

> and this is how it is observed by the Great Khan and all his subjects. According to custom they all array themselves in white, both male and female, as far as their means allow. And this they do because they regard white costumes as auspicious and benign, and they don it at the New Year so that throughout the year they may enjoy prosperity and happiness. On this day all the rulers, and all the provinces and regions and realms where men hold land or lordship under his sway, bring him costly gifts of gold and silver and pearls and precious stones and abundance of fine white cloth . . . The barons and knights and all the people make gifts to one another of white things . . . I can assure you for a fact that on this day the Great Khan receives gifts of more than 100,000 white horses.

Marco Polo reaches 'a city called Tinju'. Here,

> they make bowls of porcelain, large and small, of incomparable beauty. They are made nowhere else except in this city, and from here they are exported all over the world. In the city itself they are so plentiful and cheap that for a Venetian groat you might buy three bowls of such beauty that nothing lovelier could be imagined. These dishes are made of a crumbly earth or clay which is dug as though from a mine and stacked in huge mounds and then left for thirty or forty years exposed to wind, rain, and sun. By this time the earth is so refined that dishes made of it are of an azure tint with a very brilliant sheen. You must understand that when a man makes a mound of this earth he does so for his children; the time of maturing is so long that he cannot hope to draw any profit from it himself or to put it to use, but the son who succeeds him will repay the fruit.

This is the first mention of porcelain in the West.

It describes porcelain as a material that is beautiful beyond comparison, that is complex to create, that these vessels are innumerable. Porcelain demands attention and dedication. And Marco Polo shrugs, 'What need to make a long story out of it?'

And 'Let us now change the subject.'

He came back with a small grey-green jar made from this hard, clear white clay unlike anything seen before. And it is in Venice that object and name come together and start this long history of desire for porcelain. The name of this grandest of commodities, this white gold, the cause of the bankruptcy of princes, of *Porzellankrankheit* – porcelain sickness – comes from eye-stretching Venetian slang, the vulgar wolf-whistle after a pretty girl. *Porcellani*, or little pigs, is the nickname for cowrie shells, which feel as smooth as porcelain. Cowrie shells lead, obviously, to Venetian lads, to a vulva. Hence the echoing shout.

iv

Marco Polo can change the subject but I can't. Knowing that this jar is somewhere in the Basilica di San Marco in Venice, it is imperative that I go and find it.

I start out straightforwardly: 'I'm an English writer and potter and I'm trying to find . . .', but letters and emails disappear into nothing. I escalate. 'The papal nuncio recommended that I contact you . . .' Still nothing. A phone rings on a mahogany desk. Perpetual lunch, I assume sourly. Or, a second bottle of wine, or a holiday celebrating some Republican martyr.

I borrow Matthew, my middle child, and decide to chance it.

We get to the far left corner of the basilica, the knots and eddies of tourists, handbag salesmen scanning for police, and through the glass doors of the patriarchate where I make my pitch to a monsignor who is charmed and delighted and suggests tonight, when everything is

closed? There are, he stretches and sighs, in a pantomime of weariness, far far too many foreigners in the basilica in the day.

Always take a child, if possible, to Italy.

And as they are closing up we are taken by the man with the key along a marble corridor in the patriarchate past endless portraits of cardinals and into the shadows, the rolling swell of the marble pavements of the basilica with its dull glimmerings, the red flare of the sanctuary lamps, into the treasury.

It is small and high-vaulted. Rock crystal and chalcedony, agates, an Egyptian porphyry urn, a Persian turquoise bowl held in a golden vice; all materials that hold light. Chalices. A reliquary of the True Cross with gems set emphatically as a child's kisses. This is Byzantium, this treasury, Christ ascendant, conquering, one object after another from somewhere far away transfigured through Venetian skill.

And my jar is there, at the back of a cabinet between a pair of incense holders and a mosaic icon of Christ. It is five inches tall, I guess, far less than a hand span, a frieze of foliage, four small loops below the neck to hold a lid, five indentations for thumb and fingers. An object for a hand's memory. I can't pick it up. The clay looks grey and rough and a bit raggedy where it has been trimmed roughly. It has come a very, very long way.

We peer it at it for ten minutes until the man with the key starts tapping his foot. The treasury is locked up. The basilica is empty.

It is a start. Matthew is pleased I'm pleased and we go and celebrate at Florians in the piazza with hot chocolate and macaroons.

v

Any obsession with porcelain echoes as much as any Venetian alleyway.

What is it? It is 'made of a certain juice which coalesces underground and is brought from the East', wrote an Italian astrologer in the

mid-sixteenth century. Another writer asserted that 'eggshells and the shells of umbilical fish are pounded into dust which is then mingled with water and shaped into vases. These are then hidden underground. A hundred years later they are dug up, being considered finished, are put up for sale.'

There is agreement on the strangeness of porcelain, that it is subject to alchemical change, rebirth. John Donne movingly writes in his 'Elegy on the Lady Markham', of her transformation in the earth, that when you lose something precious to sight, something rarer and more beautiful can be created: 'As men of China, after an age's stay, / Do take up porcelain, where they buried clay'.

So how do you make it? How do you make it before anyone else makes it? How can you have a single piece? How can you have it all, surround yourself with it? Can you ever get to the place it comes from, the source of this river of white?

Porcelain is the Arcanum. It is a mystery. For 500 years no one in the West knew how porcelain is made. The word Arcanum, a jumble of Latin consonants, is pleasingly close to Arcady, Arcadia. There must be some kinship, I feel, between the first secret of white porcelain, and the promise of fulfilled desire, a kind of Arcadia.

vi

White is also my story. From my very first pot.

I was five. My father went on Thursdays to an evening class at the local art college to make pots, taking my two older brothers with him. You could do screen printing on to T-shirts or paint scumbly canvases. You could go up to life drawing, a lady in front of a draped red velvet curtain with a plant in a brass container, or you could go down to the basement and make pots. And I wanted to go down the stairs. There was a break after an hour and you were allowed a glass of Ribena and a chocolate biscuit.

It was dusty. Dust settles around clay. Someone was pinching a very small bowl out of white clay, cradling it in her hand and turning it round rhythmically.

I sat at the electric wheel with a large ball of brown clay. I wore a red plastic apron. The wheel was very big. It had an on and off switch and a foot pedal for speed that you depressed and was hard to push.

And next week my pot is there, hard and grey and dulled, smaller. You can dip it, says my teacher, into one of a dozen glaze buckets to make it sing in different colours and you can paint on to it in every colour. What are you going to decorate it with? She smiles. What does this pot need? I push my pot into the white glaze, as thick as batter.

And the following week I take home my white bowl, three waves of clay as fat as fingers, a scooped inside with a whorl of marks and heavy, but a bowl and white and mine: my attempt to bring something into focus. The first pot of tens of thousands of pots, forty-plus years of sitting, slightly hunched with a moving wheel and a moving piece of clay trying to still a small part of the world, make an inside space.

I was seventeen when I touched porcelain clay for the first time. All through my schoolboy years I had made pots every afternoon with a potter whose workshop was part of the school. Geoffrey was in his sixties, had fought in the war, was damaged by his past. He smoked untipped Capstan cigarettes, quoted Auden poems. His tea was deep brown like the clay we used. He made pots for use. They had to be cheap enough to drop, he'd say, beautiful enough to keep for ever. I'd left school early to start a two-year apprenticeship with him, and I spent a summer in Japan with different potters, trailing around the famous kilns where folk craft wares were made, the traditional villages where wood-fired tea bowls and jars were still being made. These pots were what I aspired to make — alive to texture and chance, good in the hands, robust and focussed on use. And on one humid afternoon in Arita, a porcelain town far down at the end of Japan, I sat and watched a National Living Treasure paint a few square centimetres of a vase with a brocade pattern in red and gold. It looked tight, breathless with expensive exactitude.

His studio was silent. His apprentice was silent. His wife opened the paper screen with a sound like a sigh, bringing tea in porcelain cups and white bean-curd cakes.

But I was given a small piece of the clay and worked it in my hand until all the moisture had gone and it crumbled.

vii

I am a potter, I say, when asked what I do. I write books, too, but it is porcelain — white bowls — that I claim as my own when challenged by the dramatic Syrian poet sitting on my right at a lunch.

Do you know, she says straight back, that when I got married in Damascus in the early 1970s, I was given a porcelain dish this big — she sweeps her hands wide — that *my* mother had been given by *her* mother. Pink porcelain. And I was given a pair of gazelles. They tucked their legs up under them on the sofas like hunting dogs. We all love porcelain in Damascus. The politician's wife on my left wants to cut in on Damascus — there is depressing news — but I need to know more about this pinkness. I've never heard about pink porcelain, it sounds unlikely.

But the marriage gift bit sounds right, ceremonial, particular, freighted. Porcelain has always been given away. Or stored and then brought out on special occasions to be handled with that slight tremble of care that hovers around anxiety.

And Damascus is intriguing as it is on the way from Yemen to Istanbul, or could be on the way if you wanted it to be and I remember, somehow, that a Yemeni sheikh collected Chinese porcelain in the twelfth century. The greatest collection ever, brought together to celebrate the circumcision of his son. There are supposed to be porcelain shards in the dunes near Sana'a. We talk about how to get to Yemen, about her grandmother's porcelain dishes and where they came from. We are still talking porcelain as the plates are cleared.

When I come back to the studio from this lunch I write up the conversation. And I put down another place, Damascus, on my list of places I have to visit. I have my three white hills in China, Germany and England and when I can't sleep I run through my list trying to make patterns out of the names, shifting them into clusters of places where white earth was found, where porcelain was made or reinvented, where the great collections were made or lost, where the ships dock and unload, the caravanserai stop. I connect Jingdezhen with Dublin, St Petersburg with Carolina, Plymouth and the forests of Saxony.

Go from the purest white in Dresden to the creamiest white in Stoke-on-Trent. Follow a line. Follow an idea. Follow a story. Follow a rhythm: there are meant to be unopened cases of imperial porcelain in a Shanghai museum, left on the quayside when Chiang Kai-shek sailed for Taiwan in 1947. And cases of Chinese porcelain still packed up after 500 years in a cellar of the Topkapi Palace in Istanbul. I could go there and work my way across to Iznik where they made white pots in imitation of unattainable porcelains, delicate jars with tulips, carnations and roses bending slightly in a breeze.

I'm making small porcelain dishes today, a few inches across, to stack together in rhythmical groups. I could follow this simple image of repetition. There was a monastery in Tibet, travelling with my girlfriend Sue over twenty-five years ago, before we married, where there were stacks of Sung Dynasty porcelain bowls low down behind chicken wire in cupboards in a long hall. I can remember the sounds — a dog, laughter — and I can see the coils of incense rising into the impossible clarity of the air. I can remember the massed porcelain, the feeling of casual, untidy plenitude.

Or it could be a journey through singular, spectacular beauty. There is meant to be another piece of Marco Polo's porcelain in Venice in some ducal palazzo somewhere, if I can face it.

Or I could journey through shards.

Porcelain warrants a journey, I think. An Arab traveller who was in China in the ninth century wrote that 'There is in China a very fine

clay with which they make vases which are as transparent as glass; water is seen through them. These vases are made of clay.' It is light when most things are heavy. It rings clear when you tap it. You can see the sunlight shine through. It is in the category of materials that turn objects into something else. It is alchemy.

Porcelain starts elsewhere, takes you elsewhere. Who could not be obsessed?

viii

Obsession builds. As I'm starting a journey, these first porcelains to arrive in Europe from China hold a claim on me. They are beginnings, after all. I return from Venice and Marco Polo and I realise that I need to see the Fonthill vase. It is the most irreproachably aristocratic, double-barrelled porcelain object in Europe: its proper name is the Gaignières-Fonthill vase.

Watercolour of the Gaignières-Fonthill vase, 1713

If you want provenance it is here: a Chinese vase from the early four-teenth century augmented with medieval silver heraldic mounts that has been in the collections of Louis the Great of Hungary, the king of Naples, the duc de Berry, then the dauphin of France in his rooms at Versailles, and then a great antiquarian collector until the French Revolution, when it was bought by the English author and collector William Beckford, who kept it in his strange cabinets of curiosities in his ersatz Gothic palace at Fonthill. And then his finances collapsed and it was sold, sold again and disappeared from view.

It is now in a Dublin barracks, an acre of grey tarmac and grey stone walls like cliffs. This is where the British garrisoned for a hundred years, drilling regiments, thousands of stamping feet echoing off the sheer faces of the building. It is now the National Museum of Ireland, Decorative Arts and History.

I go in November and the museum is spectacularly empty. I'm taken up to the office of the Keeper of Decorative Arts — proper piles of books on the floor — where it is lying in bubble wrap in an orange crate. We put on white gloves and the vase is lifted out.

It is a flummery of ideas. It is decorated with flowers and foliage under a pale grey-green glaze, and your eye might travel across it as you see *Old* and *Chinese* and *Jar*. It is all those, but it is also *New*, a trying-out, a conversation in a workshop, an attempt to create an extra depth to a porcelain vessel.

And it's a complicated new shape, too. To handle it, scrape a layer away — a few millimetres — to make a slight recess, damp the clay, and then press with affection the sprays of leaves and the daisies, and clean up the small scrapings and indentations, without knocking it, without it all collapsing, folding into your hands, is very hard.

I hold it. And it becomes clear that the trails of minute porcelain balls that sway and swag their way round the vase are just wrong. They were meant to add texture to the proportions, clarify and define the transition between neck and shoulder, but they do that bad fashion shtick of calling attention to an unexpected part, so that this fulsome curve is more of a bulge. And one trail has given up and slipped like a hem, untucked. And it has been lifted too warm from the saggar — the container of rough clay

that protects porcelain from the smoke and flames of the kiln during the firing – as the kiln was unpacked and so the base has cracked. There are many complexities to working with porcelain. Any discrepancy in thickness can lead to fractures, as it cools from 1,300 degrees Celsius – the white heat of the firing – down to 300 degrees, when it's safe to handle. You can get away with unevenness with other kinds of clay, but it is chancy with porcelain. Your errors, your slapdash decisions, are revealed.

Where you run your finger over the foot ring, the thickness of this vase is astray. But for whoever made this it was good enough.

I love these moments when you feel the decision. This was to smudge a piece of wet clay over an incipient crack and press down and move on. *Good enough* is not a term in art history, I think, as I slowly shift the vase round in my hands from daisies to camellias to daisies, but *Good enough* should be there. I hold the Gaignières-Fonthill vase and think of the Silk Road from China and the kingdom of Naples and the duc de Berry – the poor young dauphin trying to impress his unimpressible father – then Beckford collecting his treasures like a Medici in a damp valley in Wiltshire. The silver mounts have gone leaving very small drilled holes to show where they were attached 600 years ago.

I've taken off the Michael Jackson white gloves and sit with it in my hands. This is a moment of some danger. I could follow *this*, I think.

It is a lure.

Following *this* means a journey into connoisseurship, pedigree, a history of collections, and good God, I'm not doing that again. My last book followed an inherited collection of netsuke, small Japanese carvings, across five generations of my family: I know what collecting and inheritance entails. Before I came here to Dublin to pay homage I read the strange Gothic novel of Beckford and looked up in the sales catalogue to find where this beautiful thing stood amongst his treasures, and I can see how I could lose myself in his fantasy, mired in sultans and concubines and gerfalcons and all that sort of embroidered and gilded stuff. I can see unspooling time in archives, thinking about ownership. It would become a story of rich people and their porcelain.

This jar offers something different.

I'm late for the taxi to the airport, lunchless, high, and I run with the generous Keeper of Old and Strange Objects through the museum. She needs to show me a final thing before departure.

It is Buddha. He is reclining on an elbow, long fingers, bare feet, golden robes like eddies of water. Warm white marble. Stolen by Colonel Sir Charles Fitzgerald on a punitive military expedition to Burma and sent to join the Fonthill vase in 1891 to the museum in Dublin, where they sat near each other in *Asia, Antiquities*.

He is 'taking it easy with hand under his cheek' says Bloom in *Ulysses*. Molly recalls him breathing 'with his hand on his nose like that Indian god he took me to show one wet Sunday in the museum in Kildare Street, all yellow in a pinafore, lying on his side on his hand with his ten toes sticking out'.

I count Buddha's toes, then taxi, airport, home, wondering if Bloom or Molly or Joyce noticed the white vase in the case opposite in the echoey, mahogany-cased, imperially pillaged museum in Kildare Street on a wet afternoon.

Who could not be obsessed by porcelain? I write in my notebook.

And then after this foolish rhetorical question I write: *most people.* And then I add *James Joyce.*

ix

It's not that I like all porcelain.

If you look at the cases of eighteenth-century porcelain in any museum, a shelf of palely loitering Vincennes, two of Sèvres, a bit of Bow, they seem irredeemably precious. Not only can you not work out what most of this stuff was for – a trembleuse, a chocolatier, a girandole – but there is a mismatch between the amount of work that has gone into it and the result. The thimble-small cup and saucer with a

view of Potsdam, courtiers, gilding, was pointless then and looks like they did it because they could.

And because they can, they do. Dinner services for kings and queens and princelings aren't in themselves interesting. There is an awful lot of it out there and I don't want to get lost in the scholarship around small kilns of the eighteenth century.

I have a bowl, eight-sided, lobed and pinched, ten inches across and four high, with a sort of raised basketwork pattern, and a flat gilded rim. It is from Meissen, around the 1780s and it sits primly on a high foot, as if expecting to be the centre of a table and hence the centre of attention. There are panels on the outside with pears, apples, plums and cherries, and on the inside is a bouquet of fruit, redcurrants and strawberries and gooseberries and half a pear.

It is valuable. Its insipidity is total.

I'm not sure if its horridness is that everything is just so plump and sweet and high-summerish. You can taste nothing, no bite, no acidity, just sugariness waiting for the phlump of *Schlagsahne*, that coating of cream. You can feel the boredom in the fruit painter; berry, berry, berry.

Actually as I force myself to look at it, it is precisely the coming together of late summer in the 1970s – holidays as a teenager, boredom, small cottage, brothers, endless plums, blackberries, compulsive rereadings of bad novels – that makes me realise this is passive-aggressive porcelain.

I feel certain this is a new category of porcelain. I start a list.

x

A good list helps. And proper note taking, too, with full citations of where I've found references or quotations, seen a piece of porcelain that offers a lead for the journey. I have learnt from the research for my last book and this time I know how to do it. I have none of that stupid knock-it-off-in-six months bravado. I will not digress. I will plan this pilgrimage.

Pilgrimage is a complex word for me. I grew up near cathedrals and my childhood was full of pilgrims. We lived in a deanery, a vast house next to a cathedral. It was a house built and rebuilt over 600 years with grand rooms with panelling and portraits of deans. I had a room on the top corridor alongside my three brothers. The house gave up here with a lumber room, *No War but Class War* on our bathroom door, a table-tennis table, steps up to another tower where we smoked with school friends, plotted our lives.

My parents were proud of their open door. The Pope came. Princess Diana came. People came for meals, for weeks, for months. One American monk stopped wandering for a summer and stayed as a hermit for several years, using a room at the top of the spiral staircase in the tower, cleaning the house in the early hours in exchange for bed and board, and praying in our oratory.

I think my childhood was quite odd, choppy with priests, Gestalt therapists, actors, potters, abbesses, writers, the lost, the homeless and family-hungry, God-damaged, pilgrims.

Pilgrims don't know what to do when they finally reach the end. We were the end. They go on and on about their *journey*. They share. This is a risk I add to my list, another list.

I've read *Moby-Dick*. So I know the dangers of white. I think I know the dangers of an obsession with white, the pull towards something so pure, so total in its immersive possibility that you are transfigured, changed, feel you can start again.

And there is the issue of time. I have a family. I have a proper life making porcelain. The diary is already full, but I can always write at night.

I have my ground rules for this journey to my three white hills. All I have to do is find my lodgings next to Porcelain Factory #2. I dodge the scooters and taxis and set off towards the south.

I have to be up at six for my first hillside.

Part one

Jingdezhen

Chapter one

i

It looks as if it has been busy for hours. It is six a.m. and stalls are up,
watermelons arranged in pyramids, the bicycle-repair man sitting next
to his kit. The roads are eddying with bicycles and knots of people.
The carp seller with a polystyrene crate on the back of his scooter
cuts in front of us, turns and swears extravagantly. We are going north
out of the dusty city towards the hills, past alleyways squeezed
between great high brick walls, factories with open windows, rubbish.
The day is grey and promises deep, grey heat.

The car turns off the new highway on to the old road and off the old
road on to the old track rising between two farmer's houses. Each is
three storeys high, gabled. The one on the left has a portico held up by
gilded Corinthian columns.

When did farmers get rich in China?

The rice is young in the paddy fields. We bump up and stop outside
another farm, a modern house, half built, half stucco over thin
Chinese brick, old barns, set amongst trees. A wrecked car sits on

breeze blocks. We are a few hundred feet up in the lee of a hill, bamboo stretching up to a ridge, a mountain beyond that, fields half-heartedly cultivated below us. There is a small lake, a muddy declivity ringed with reeds.

A woman comes to the doorway and shouts at us and it is explained by my guide, through shouting, that I'm an archaeologist, a scholar, legitimate.

And under the tyres of our car amongst the weeds are broken saggars, brown and black, rough thrown clay vessels with high raised ridges, five, six inches across. And shards, pale crescents of porcelain in the red earth. I pick up the first and it is the base of a twelfth-century wine cup, a fine tapering stem holding a jagged bowl, a thumb's breadth across. It is impossibly thin. And not white at all, but a very light washed-out blue celadon, with a network of brown crackles across it where hundreds of years of this soil has stained it.

This is my grail moment and I'm holding it reverently and they are laughing at me with my ridiculous epiphany, for on and up is a hillside of shards, a tumbling landscape of brokenness, a lexicon of all the ways that pots can go wrong. It is not a spoil heap, careless but discrete, it is a whole landscape of porcelain.

Saggar containing a porcelain shard, Jingdezhen, 2012

I stoop and pick up a shard, and this one is too thin at the base and has sagged and twisted like an art-nouveau girl. And this beautiful straw-coloured shard is cracked through an air bubble that has blown in the firing. And this concatenation of clay is three saggars compressing three white bowls, a firing that has gone too high, too fast, too long, leaving this bit of fierce geology.

And God knows what happened here. There is a patch of broken bowls, the colour of green olives amongst high nettles, a sort of crime scene.

The summer rain has made the earth so friable that each step opens up a rim of a jar, a foot ring, the centre of a deep celadon bowl decorated by a running comb, a sketch of a peony, held in eddies of glaze.

I hold this shard, run my index finger over the pattern; to make this you need to feel when the clay is as soft as leather so that there is a bite between comb and bowl. Too soft and it snags and furs. Too hard and it skates. Or the bowl breaks. It is all this exactitude and all this excess in one place that collapses time for me. I know this bowl I think, it took a minute on the wheel, perhaps less, was dry for trimming within a few hours on a morning like this. It would be one of dozens on a board, passed on into the hands of the decorator and finished by noon.

We are swishing our way through the undergrowth with sticks because of snakes and I toss the shards back into the hillside in a moment of exultant connectedness and have to try and find my bit of twelfth-century wine cup ten minutes later to check on its weight. But this is beyond checking. The scale of this stretches me.

This place is one of hundreds in these hills, not a major kiln site, unimportant for art history, not documented, known to the farmers who would have to deal with the waste, the shards they have to shovel away to clear the field for beans, and known more latterly with the odd chancer braving the old woman in the farmhouse and digging and sifting for treasures to sell on in the Monday market in the city, twelve miles away.

Eight hundred years ago there would have been a couple of dozen potters here on this hillside, clagged with mud in winter, beset with horseflies on a midsummer morning like this, snakes in every season. The kilns are long gone, the bricks reused for a shed or pigsty, broken up for foundations or weathered back to the earth, but these slopes would have been useful to build into, and the bamboo and these long flat grasses would have been cut for packing finished pots to carry down to the river, to the boats to take them to the city.

And the wares that went wrong would have been thrown over a shoulder from the kiln mouth at opening, collecting season by season amongst the stones and the shifting earth in the spring rains. So many thousands and thousands of pots that haven't worked, each saggar that cracks needing to be made again, each stack of tea bowls that warp another few hours of effort to bank, another part of a day lost. The potters here would have been paid by finished pots, piecework, not wages. 'Pots cover every inch of space before the door', writes a poet 1,000 years ago, 'But there's not a single tile on the roof / Whereas the mansions of those who wouldn't touch clay / Bear tiles overlapping tightly like the scales of a fish.'

This answers my question of how you make a living when things go so wrong, so often. You work even harder. You make more, and then some more.

iii

If I look south from here across the valley floor I can just make out the river, several hundred feet wide as it passes through the city, flowing from the north towards the Yangtze. Tributaries join it, snaking their way down from the hills. Behind me, thirty miles away, are the hills that make up Kao-ling mountain and there are mountains ringing every direction. The forests are a dense black-green smudge. I can see the highway but the only sounds are of the breeze in the bamboos and the crickets in the tall grasses.

I've been looking at all the maps. There are Chinese ones from the seventeenth century, schematic ones that show the arrangement of houses and kilns and rivers. There are the Jesuits maps from a century later, the first dogged attempts to make the country explicable to the West, and then the strangely anaemic maps in the books of the archaeology of the region – variant names hopefully pinned to the hills and rivers.

A favourite is from 1937, when Mr A. D. Brankston, a young Englishman, climbed these hills and sketched a map with a scale of 'about three miles to an inch', small wobbly bowls for kiln sites. There are great gaps in his maps due to rumours of banditry. He makes this landscape look like Hampshire.

But nothing has prepared me for this. It is a beautiful puzzle of a landscape. Stretching before me is earth and forests and water and villages. And somehow people and happenstance, and trade and taste combined here to make this the centre of porcelain for the world.

I've got a plan. I want to get up to the mountain and follow the old route that the raw materials for porcelain took back to the city.

Map of Jingdezhen from the *Tao Lu*, 1815

Chapter two

i

As a boy I dug red clay from the stream bank, took out the bits of root and twig, thumped the sticky earth into a rough ball, stuck my thumb into the centre and pinched out a crude red pot, staining my hands. I fired it in a bonfire, not a high enough temperature to make it of any use, but high enough to make a vessel of sorts. It broke in my hands. It was porous. With more skill and a basic kiln to fire it above 1,000 degrees Celsius I could have made this red clay into earthenware, the first kind of pottery. And with a glaze I could have made it hold liquids.

The second clay I used as a schoolboy was grey, and more fine-grained. I made stoneware, a kind of pottery that is fired to a higher temperature than the rough earthenware clays, around 1,200 degrees Celsius. This stoneware was a slate grey colour when it came out of the kiln, a calm, slightly dulled hue that worked with the mossy hues of the glazes I used. These mugs and bowls rang when you tapped them. They were not translucent. They were emphatic pots.

The third type of clay is porcelain. It is far smoother than the other two. And it needs to be fired to the ridiculous temperatures above 1,300 degrees Celsius to achieve the whiteness, the hardness and the translucency, the beautiful resonance when you gently tap the rim of a bowl, that constitute proper porcelain. And this is where it gets intriguing. You cannot put a spade into the ground and dig up white porcelain clay, soft and clean and ready, however wonderful this idea might be.

ii

Porcelain is made of two kinds of mineral.

The first element is *petunse* or what is known as porcelain stone. In the vivid imagery used here in Jingdezhen it provides the flesh of the porcelain. It gives translucency and supplies the hardness of the body. The second element is *kaolin* or porcelain clay and it is the bones. It gives plasticity. Together petunse and kaolin fuse at great heat to create a form of glass that is vitrified: at a molecular level the spaces are filled up with glass, making the vessel non-porous.

'Everything that belongs to China-ware', writes Père d'Entrecolles with authority, 'is reduced to that which enters into the composition, and that which is preparatory thereto.' He goes on to tell an emblematic story:

> It is from kaolin that porcelain draws its strength, just like tendons in the body. Thus it is that a soft earth gives strength to petunse which is the harder rock. A rich merchant told me that several years ago some Europeans purchased some petunse, which they took back to their own country in order to make some porcelain, but not having any kaolin, their efforts failed . . . Upon which the Chinese merchant told me, laughing, 'They wanted to have a body in which the flesh would be supported without bones.'

This story is a terrific signpost for the journey. You have to understand the dual nature of this composition necessary to create a smooth, plastic clay body that can withstand the firing in the kiln. Both of these stones have to be purified and then mixed in the right proportions to get the plasticity that allows you to work, and the strength that allows you to fire. Increase one element and the clay becomes difficult to throw or mould, increase the other and your wares will deform at the high temperatures needed to fire porcelain. But change the quantities minutely and you can develop variant porcelain bodies to use in different parts of your kiln. For instance vessels made from a porcelain body that is half petunse and half kaolin can be placed in the very hottest parts of the kiln, lower-kaolin bodies in the cooler. These changes are not worked out by mineralogists or chemists but by potters adjusting one batch of clay to create a special run of objects, working out why these stem cups have warped, or responding to a hike in prices from the clay merchant.

If you alter the quality of the materials you are employing you can make everything from imperial wares to the teacup you might use at the stall by the side of the road.

And though it *is* possible to make porcelain out of petunse with small additions of other materials, the great tradition of translucent white wares comes out of this amalgamation, made here in Jingdezhen 1,000 years ago by potters working things out for themselves.

iii

Petunse is not difficult to find around here and old mine workings from the Sung Dynasty have been excavated close to the city itself. No great expertise is needed to mine the stone. It is sometimes hard and sometimes the texture of stale bread and it comes in myriad grades of fineness, but the very, very best was 'white and sweated slightly and did not cause disappointment to those who made porcelain out of it'.

Everyone seems to agree that if you split the highest-quality petunse, it has black markings like *lu-chiao tshai*, the deerhorn plant that is growing under my feet here on the hillside. It has speckles of mica.

Kaolin is white, and it too is sprinkled with mica that glitters. It is harder to find. The very best was designated for imperial use and deemed 'official' with heavy punishments for offenders who tried to work with it. It has 'blue-black seams and spots like grains of sugar, as translucent as white jade and with gold spots like stars' writes an official in the Ming Dynasty of the faint traces of quartz and mica that would need to be washed out, high on its lyrical qualities.

After they were exhausted, these special mines were sealed to prevent any commoner misusing the scraps. Over time the mines gave out, or came too close to old ancestral burial grounds and had to cease production, and these places were then elegised as being particular, special, and lost.

Kaolin takes its name from the mountain I am trying to get to – Kao-ling, or High Ridge.

Speculation and gossip about this mountain turn up in an eighteenth-century compendium called the *Tao Shu*, full of history, jostling along with surmise and anecdote. It records the families that worked the mountain, the grading of clay according to its mine, and the dodgy renamings of their material that goes on around these workings. The impression is of endless feudings and complaints. 'We may be sure', says the chronicler, 'that they fake the four characters stamped on the kaolin bricks.'

Père d'Entrecolles adds, with some weariness, that there 'wouldn't be anything more to add about this work if the Chinese were not accustomed to adulterating their merchandise'.

> But, from a people who roll little grains of paste in pepper powder to cover them, and sell them with real peppercorns, there is no protection from the sale of petunse without it being diluted with some waste material. That is why it is necessary to purify it again . . . before putting it into porcelain.

I realise how amateur Western obsessions are in comparison with the energy of classification here on this mountain, in this city. There are hundreds of lists tabulating the quality of petunse and kaolin – *official old*, *superior old*, *middling old*, *sweepings*. There are the poetic names of particular seams or special mines. There are records going back through the centuries on how to find these materials, cleanse them, ship them, buy them and sell them. And then how to compound them to make porcelain itself.

But as I read the chronicles warning me of 'errors and confusions', I realise that all statements about porcelain are subject to dispute and toxic refutation. Scholars from the Sung Dynasty onwards argue on the identity, value and meaning of these wares, a 1,000-year literature of claim and counterclaim continued to the present day, swirling around the idea of purity.

iv

We are finally on the road towards the mountain, climbing switchback up a narrow valley following a stream, when we stop the car. The sound is extraordinary, a rhythmical thumping, just off a regular beat, loud enough to hear from the village road.

I scramble down towards it. The sheds are low and open, the broken-backed roofs held on timber supports, forked trunks at perverse angles. I duck under the ragged straw thatch straight into a beam that gives me stars. I sit down heavily. There is no one here. There are red dragonflies that come in low over the water, tracing patterns through and out and gone.

v

The shed must be fifty feet long, two dozen wide, the floor compacted earth with the three holes where the hammers are piling down, thrown back into the air and then down again. It is mesmeric.

Water is diverted from the tumbling stream, rushes into a sluice and then on to a waterwheel that powers these trip hammers. It is technology that hasn't changed in hundreds of years, pragmatic and mendable. The *Tao Lu* tells me it is seasonal and that in spring with rushing water these kinds of sheds would have more hammers and that they would pound the petunse finer, that when there is less force in midsummer the stone is grainier. This makes today a slow time of year.

You have a heap of porcelain stone but you need fine, pure powder in a form that can be both easily weighed and transported. To prepare the petunse you need to break the rock that you have quarried into smaller pieces, until they are no bigger than a quail's egg. To my left is a mound of broken stone four feet high. These fragments can then be placed in a mortar – no more than a hole a couple of feet deep – into which pounds a hammer.

Outside there are the pits in which the slurry of white powdered stone and water is poured and vigorously stirred with paddles. This is where, say my 200-year-old notes, 'after allowing it to stand for a few moments, there will be a kind of cream on top with a depth of four to five fingers'. Open a little sluice gate and let it flow away into the next tank, leaving the rough residue, and repeat until you have a thick, white sludge. This is then left to dry outside in shallow pits until the sheen of the surface dulls and fissures appear and it is then dug out and put on beds of bricks to dry further until it can be cut with a kind of fine-bladed adze into bricks, stamped with a name and stacked.

To my right are stacks of the prepared bricks drying on racks and a pile of them against a wall. I pick one up and it looks dusted by icing sugar, like a lebkuchen, its insides speckled with silver, yellow and green, something dense and sweet.

Petunse means little white brick in Chinese. These are shorter and fatter than a European house brick. They weigh just over two kilos each.

I heft one, put it back, and then pick it up again. I scribble an apologetic message – *sorry I stole your brick* – and place it with five yuan and struggle back up to the road.

Chapter three

Mount Kao-ling

i

The road keeps climbing. There are unexpected, ramshackle houses with a couple of paddy fields cut into the hillside, a pile of tyres by the door. It is poor here. The trees change and there is the first liquidambar amongst the pines and bamboo. There are fast cold streams that look like they have come straight out of ink paintings. We stop near a bridge over a waterfall and walk down a track towards some of the workings. It is overgrown, deeply shaded by the high trees.

Round a corner there is a cleft in the rock surface. There is a little spoil outside, a weathered heap of rock, like a half-hearted badger sett, scrappy with ferns and moss. The air coming from the mine is very, very cold.

The opening is just wide enough to clamber in, five feet high. I duck in, pause to allow my eyes to accustom themselves. The mine runs twenty feet back and then peters out in a rockfall. I run my hands over the surfaces. There is a sheen of damp. The walls are great cuts of white streaked with green. Some rock must have come down recently as

there is cleaner, whiter rubble underfoot. I pick up a piece and it crumbles in my fingers. There is the glimmer of silver.

This is it, kaolin, my beginning. My guide calls, asking me if I'm alright in there.

These mines are now deserted. Once there would have been tunnels criss-crossing under this mountain, workers cutting into these soft white lodes, baskets of kaolin passed upwards and outwards towards the hillsides to be carried down. All mining is scary, but I wonder what it is like to feel this softness deeper underground, the give of porcelain clay in your hands.

In 1583, the eleventh year of the reign of the emperor Wanli, the director of the imperial factory Chang Huai-mei reported that the hillsides were so latticed that obtaining kaolin was almost *impossible* and that expensive extra labour was needed, that the whole business was *impossible*. You can hear his exasperation.

But at this moment I don't give a fig for emperors. This is Mount Kao-ling, my First White Hill. My hands are pale, almost white from the dust.

ii

To walk down this mountain is seven miles, longer by the forest track that follows the stream. As we come down from Mount Kao-ling we come to the river and a small town. Here the water is shallow and treacherous. It shifts its course, small banks appearing and disappearing day by day.

Three water buffalo lie on a bank unmoving in the afternoon heat. There are swallows and a self-important clutch of ducks that launch themselves out into the eddies as we pass. Two elderly women are beating clothes kneeling on the stone shelf that runs by the riverbank. A man is rolling black melon seeds between finger and thumb, up to his mouth, crack and spit. A boy is gutting a fish. It is completely silent

apart from the crack of teeth on seeds and the burble of the river; the first time I have heard silence in China.

This was the dock where the kaolin clay from the mountain was loaded on to long bamboo rafts and steered down the river. The village feels derelict. There is mud in the alleyway and mosaicked across some of the floors of the open houses where families are eating rice, tattered posters of Mao presiding. The river has just flooded again and the damp hangs in the air. I ask when the dock was last used. A hundred years ago the mines closed and it has been in decline ever since. This alley was the main street with shopfronts that began at five feet to serve all the horsemen that came through. There were inns and teahouses for traders to do deals, but these have all gone.

What is left is a run of sheds where kaolin was cleaned. No mortars are needed to pound the clay. It needs much less work to cleanse than petunse as 'nature has done the greatest part of the work'. But it too must be crumbled into water, and mixed into a thin white slurry. This allows any sediment to be skimmed off, and through a similar process to that of petunse the liquid kaolin becomes cleaner and cleaner and can then be dried and made into white bricks. This would have happened here.

From this jetty it is three dozen miles downstream to the city. It takes a day and a half after the spring rains, twice as long if you have to do the work with oars in the summer. The river used to be full of work, the artery along which flowed people and materials. Kiln bricks were made and fired on its banks and poled down on rafts, 'a never-ending line' of boats loaded with petunse and kaolin would come down from the hills. Père d'Entrecolles wrote of the congestion of 'up to three rows of boats, one behind the other' in Jingdezhen.

On the opposite side of the river across from the city were the tombs. And here where the boats docked was a hamlet with yet more potteries and kilns. 'All the riverbank by the ferry entrance is full of pottery — men unloading the raw clay boats and loading the finished porcelain

boats', writes the chronicler of the *Tao Lu*, of the noise and commotion.

And where you unloaded your petunse or your kaolin the banks of the river were piles of debris. If you looked at your feet you would see that this embankment was made up of centuries of broken saggars, the debris of hundreds of kilns crunching densely below you. When these banks were swept away periodically by winter floods, they would be replaced by new shards.

If you looked at the walls of the houses scrambling along the riverbank you would see that they, too, were made up of discarded porcelain, saggars, kiln bricks and tiles.

If you looked into the river you would see glimpses of broken porcelain twenty feet below you.

Porcelain shards on the riverbank, Jingdezhen, 1920

Here in this city, the purest objects in the world are made. It is a city of skills and knowledge, of industrial sophistication beyond anything attempted elsewhere.

There are twenty-three distinct categories to the creation of porcelain listed in the records: six categories of decorator, three of specialists in packing kilns, three for firing kilns, mould-makers, carpenters for crates, basketmakers, ash-men for cleaning away the residue after a kiln-firing, compounders for clay and grinders for oxides, experts in how to place pots inside saggars, others to place them inside a kiln, men who can balance a board of stacked cups over each shoulder and navigate a rainy street, full of people. And there are the dealers and merchants and scholars, officials and accountants, label writers, door-keepers, guards for the imperial porcelain factory.

This is the visible part of the city, tallied by the officials. There are a 'mass of poor families . . . many young workers and weaker people . . . the blind and the crippled who spend their lives grinding pigments' writes Père d'Entrecolles. On the margins are all those who are drawn to a city where work spills out from workshops into the streets, where there is a chance of rice after a day of sweeping or carrying or scraping bricks clean until your hands are raw. Here are those with burns from the kilns, the men breathless from years of the white dust of kaolin, the kids hoping to be taken on as apprentices.

In 1712, my Jesuit father estimated a population of 18,000 families, possibly 100,000 people making a living from porcelain: 'It is said that there are more than a million souls here, who consume each day more than 10,000 loads of rice, and more than a thousand pigs.' Walking through this densely packed city with its narrow streets was like being in the middle of a carnival, he wrote in his letters, picking an image that the other Jesuit fathers would understand. Carnival is noise, and chaos, and it is a little scary.

It works as an image; Jingdezhen is also a city of chancers.

There is a small island in the middle of the river called Huang, the place where small hucksters spread out their stalls, 'a large open space, in fact, and a market at the water's edge . . . entirely occupied by stalls selling porcelain. Here the whole countryside can come and go freely to buy odds and ends no matter whether they are sets or single pieces.'

Here there are peddlers with baskets who buy up odd vessels and hurry to the island, 'they are known as "Island basket carriers"'. There are also:

> certain fellows in the Town, energetic hands at rubbing or patching porcelain vessels. They go from establishment to establishment . . . making offers for their odd pieces and collecting them. Those with *mao-ts'ao* – excrescences – they rub down and those with deficiencies they patch up. The colloquial name for them is 'the shops that smooth the edges . . . Excessively bright porcelain pieces all have a hidden defect which has not yet caused their collapse. They are bought cheap . . . and strengthened with plaster. If they are dipped in hot water they break: they can only hold dry cold things. The popular name for them is 'goods that have crossed the river'.

It is too hot in summer and so cold in winter that the porcelain clay freezes and is useless. There are sudden and horrific fires when kilns go awry and destroy the densely packed houses in streets that are too narrow, 'only a short time ago there was a fire that burned eight hundred homes'. And, 'one hears on all sides the cries of porters trying to make a passage'. How you make your way through this city is complicated.

iv

It is eight in the evening when we get back from the hills, cross the river – encased in sheets of concrete – and stop in a packed restaurant and order beer. I've got my white brick and my lump of kaolin from

the mountain and I put them both on the table and feel like a drug dealer.

I'm ridiculously happy to have been inside my white hill.

I get out my notebook to do some planning for the coming ten days. And I wander through the possibilities of trying to find some of the people whose skills make porcelain happen. My compass spins. I'm *finally* in the place where I can see how they use cobalt. I want to see how a kiln is unpacked. And as I've struggled for twenty-five years to make huge porcelain vessels it would be good to see how it should be done. And I want to find some really white pots to take home. Ten days feels scant.

My driver and guide disagree about where I should go and who I should see, and the waitress and the man at the bar join in noisily, happily, and the owner tells me about his brother who makes porcelain figures of the Buddha and someone from next door is summoned with a Ming Dynasty bowl with a beautiful peony which is for sale, limpid in blue, excessively bright. And there is more beer.

Chapter four

making and decorating and glazing and firing

i

Imagine coming down into Jingdezhen from the mountains, a city set out on a grid of streets, a swerve of river. You would have seen smoke and flame. A writer in 1576 described his approach: 'I once travelled there as assistant administration commissioner and the noise of tens of thousands of pestles thundering in the ground and the heavens alight with the glare from the fires kept me awake all night.'

The place has been called 'the town of year-round thunder and lightning'.

There is a tradition of writing poems when you take up a position or leave it: in Chinese literature there are innumerable melancholic verses about leaving your family, almost all of which are about wrapping your cloak more tightly about you as you contemplate your new life. 'I come to fulfil the royal command to take charge of the potteries. A forest of fire can be seen all round like a railing', wrote Chu Yüan-cho, pottery superintendent in the late fifteenth century in his

'Lines on mounting the skyward-gazing pavilion and scanning the flames of the potteries from the ice-bound hall':

> The red gates nearby connect a thousand peaks. The vermilion watchtowers afar rise from ten thousand streets. The dawn rising spreads a gay brocade about the rosy city. The sun springing to life soars in auspicious brilliance over a sea of purple. Within the four bounds all is blazing prosperity from dawn to eve. Who knows the emperor's officers stands here in the cold alone?

I'm nursing some horrible coffee. I have a headache this morning. The planning meeting in the restaurant last night went on and on. I didn't buy the bowl. And though I've still got my kaolin I must have left my brick of petunse in the bar.

There is no smoke here, the wood kilns were supplanted with coal and now there are mostly gas and electric kilns. The city is grey and wet. Yesterday's exhilaration in the hills has also been supplanted. I have no idea of how to find what I am looking for. My list of questions and possibilities veers urgently from the mundane to the metaphysical. To the unreadable.

Who do I ask? Or, as an earlier official wrote plangently, 'Alas, I have to remain here for three years. How come I do not have a heart of iron? Just staying here my hair will go grey early.'

ii

I'm staying near the Sculpture Factory. There is a sort of hostel, clean and spartan, with a shared kitchen with notices about washing-up in most languages, and there are workshops which foreign artists can use. It is cheerful and noisy, and people show you pictures of their ceramics over coffee and tell you their plans and their discoveries. There is an Australian who came to a lecture I did fifteen years ago who catches me up with the pottery scene in Perth. It is

very collegiate, which is rather hard work first thing. I think I'm slightly too old for collegiate, or out of practice, or just in need of proper coffee.

The Sculpture Factory has gone, closed down, privatised under Deng Xiaoping in 1986, leaving its name to a sprawling twenty acres of city compound, with gates at the east and western sides. It is a warren of workshops of the mould-makers, throwers, sculptors, gilders, decorators and kiln men, interwoven with alleyways choked with detritus.

There are a couple of four-storey factories from the 1960s, but most of the buildings are single-storey, brick with small windows, without glass for better ventilation. There is no apparent logic that I can find of who is where. The factories making Guanyins – the goddess of mercy – and small figures of Buddha, and the couple of women making wine cups and the family who specialise in porcelain cats are all tumbled together. Then there is a yard of teapot makers.

One man has made good and his studio is freshly painted and empty. Others look derelict but are busy. How can you tell what is going on?

There are private kilns scattered through the site, but the communal kilns are lower down, past the workshops. They are well marshalled as there is a complex traffic of work in and out, with names scribbled on blackboards near the entrance to keep track. You book a kiln or a few shelves for a particular day and have to be there at the correct time or lose your slot.

By seven this morning there was a young woman sitting on a stool outside a cupboard-sized space, rolling very thin ropes of porcelain. Another nearby was creating petals the size of a baby's thumbnail and lining them up on boards. The potters round the corner damp them slightly and press them on to vases in baroque, effusive tendrils. Someone is making them into water lilies, stranding them in small bowls and glazing them in bright, bright colours. They look really cheap.

I double back. The flowers are the same as those on the Gaignières-Fonthill vase. She smiles and nods and I pick up one of the bowls and

she could have made the daisies on that precious, freighted, faraway vase locked up in its scholarship in the museum in Dublin.

And, actually, as I look more carefully at the flowers she has made today, I prefer hers.

The packers have a small yard too, piled with straw and wood for packing cases. Carriers weave along, pushing their two-wheeled barrows of unglazed Buddhas, swan-necked vases and stacked bowls from one workshop to another. This is a profession, a good one, easing a cargo over the cobbles, shifting round corners. Making and decorating and glazing and firing are all separated and so need this careful transition from place to place. Each state they are moved in has a different vulnerability, a different potential for damage.

I want to find someone to make porcelain tiles for me. I have an idea for an exhibition that I'm curating for the Fitzwilliam Museum in Cambridge. I want to place old vessels from Jingdezhen on new tiles, three or four feet long. It could be beautiful – a sort of river of white

Woodcut from the *Tao Lu* showing the preparation of porcelain moulds, 1815

through the empty galleries – and be suitably interrogative, question what is old and what is new, which is my brief from the museum. I've seen porcelain panels of this scale with washy landscapes painted on them, poems tumbling down one side, but I want mine plain. I keep asking and am getting nowhere.

iii

Jingdezhen is vast and I'm in the wrong bit.

I finally get a lead. The factory I need is in a far part of town. It is over the rail tracks, guarded by two huge tutelary heaps of broken plaster moulds, ten feet across, and up an incline the other side. The train line is a kind of public space, a track and short cut, a place to play ball. It is also a useful place to dry your plaster moulds. There are three steam-hauled trains a day, forty or fifty trucks long and slow and chest-stretchingly loud. Loud enough for you to have time to yell to get the kids away and to move your washing or your moulds from the line. By the tracks is a run of single-storey buildings where they are angle-grinding steel tools for the turners. The mould-makers in fine white plaster dust are here too. And the slip-makers in white clay dust.

A clutch of kids are playing a hopping game on the edge of the road. You close your eyes and have to catch the others on one leg.

A boy is selling songbirds, five baskets on his back. They look like thrushes.

There is an open door, a room with a table and five chairs. Porcelain panels lean against the wall, some decorated, some plain and ready to buy. Out the back is a covered shed, open to a courtyard, with stacks of wooden boards six feet high, barrels of porcelain and sacks of kaolin. There are three brothers, one at each end of a scaffolding pole and one in the middle, rolling a great slab of porcelain. It is heavy work and exacting, as you need even pressure between the steel and the clay, moving the weight across. And it is midday and very hot. Racks of drying tiles are ranged round the walls. The men work their way round

the space, thinning the slabs hour after hour after hour, turning them to prevent them cracking.

Timings and notes for each tile are chalked on the walls. And the floor is deep in white dust, inches thick, a map of footprints and bicycle-tyre tracks. The dust eddies under the workbenches and it clags your feet and catches in your throat. Their T-shirts are sheened in dust.

I explain what I'd like and the fingers of the young woman in charge fly over the abacus as she notes the thickness of each tile, its length – *a metre is no problem, would I like it longer?*– the timescale. I produce a roll of notes. And she smiles. I worry about quantities. How are they going to get them back to England intact? This is my only chance to get these made so I sit down and double the order just in case. And then double it again.

I come out and it is raining hard. I've been told that up the street is the family that makes eggshell porcelain. This is as complex a skill as any in the city. To make truly heavy porcelain, or to make porcelain that you can lift to the light and see your fingers through, are equally diffi-cult. Eggshell porcelain is notorious. It cracks when nothing should crack. You throw a bowl and throw it thinly. Everything under control. Then you trim it thinly. Here you lose: pick a substantial percentage of the vessels you've made. To dry it, keep it away from heat from any particular direction, from draughts, from damp. When it decides to dry, place it on its rim on a special fired disc and put into your kiln. And fire it.

Unload your bowls. Stack neatly all the cracked bowls to one side of your kiln shed and then carry the rest of them through your courtyard of dogs, chickens, clay, scooters, children and past the well, to your stock shelves in the house where more will crack for no reason at all.

I find the family Xu. I'm given a bowl of faint straw-coloured tea and sit and watch and try and make out the divisions of labour in the fam-ily. A girl of three or four is chattering away with a puppy and there are three sons in the house, moulding and trimming, and the older daughter is cleaning glaze off very small stem cups. A hired

line-painter is squatting, laying a cobalt edge with the fine point of a brush on a board of cups. He does eight a minute. And the mother is doing the washing and the cooking and there is shouting above the radio and the sound of the fans and the men.

The grandmother leads me to the shed, thirty feet long with a kiln and high shelves, takes a bowl and taps it. The sound of the bowl is like a picture of sound waves in the air, it makes a shape through the grey morning. We listen to one bowl and then to another.

She smiles. It is perfect.

And my driver leans on his horn from the street. This is a working city. There is nothing to do, he says, but gamble. Choose mah-jong, cards, or porcelain you'll lose. He is in a spectacularly bad mood, worse than yesterday. Either way you'll lose, he repeats, and hawks.

Chapter five

how to make big pots

i

I visit the big-pot factory early in the morning.

The owner of the big-pot factory, upstream from the city, looks like a Brechtian capitalist, someone painted in Weimar. He is big too, and rolls on his feet assessingly when he meets you and you know he knows you know this. He wears cargo shorts and smokes small cigars.

The courtyard of his factory is crowded with seven- and eight-feet tall blue-and-white porcelain jars. They are narrow-necked and because I have taken against him I look at them and see constriction, breathless-ness, a tightness in the decoration, meritriciousness in their per-fection. I see them in pairs in Shanghai hotels with mirrors behind them and marble underfoot. Or in casinos. Possibly brothels.

I spend the day here, avoiding him. It is so humid that the flies roll through the thick air from the latrine in the fetid alley.

In the early afternoon a lassitude steals in. The dogs stop fighting. The kiln man is asleep, curled up by the door in front of the cooling kiln, his hat across his face, an arc of cigarette butts around him. In the

decoration workshop the dozen kids painting, stencilling designs, carving are behind with their day's work but cannot care. Someone comes in and yells and leaves. The desultory talk resumes. They get 900 yuan a month, a girl explains, and she gives almost all to her mother. She keeps money for cigarettes. A single packet costs twenty but you can get them in cartons with the other girls for fifteen. It is her mobile that really costs.

She is pricking out with red ink a landscape of cool mountains with mist entwined around the peaks and someone auspicious walking along a track very, very slowly with a crooked stick.

The man who joins the parts of the large pots is on piecework, not on a wage. He is paid for finished jars he works on. If they crack in drying, it is his fault and he doesn't get paid. If they crack in firing or are over-fired, so the decoration runs in gouts of cobalt, washing dozens of hours into abstraction, or if someone knocks a pot over in the yard whilst tying bamboo around it for transport, it is someone else's problem. Because he works on through the afternoon, three other men have to stay nearby to lift the next thrown section up. A skinny shirtless man sits near the gate. His job is to smoke and to yell to the other labourers to come from whatever they are doing and lift.

Each section has to be dampened slightly, a fat brush dipped into water and held against the flank of the pot, and then trimmed with a curved steel blade. He holds it at an angle to the turning clay and dry clay dust geysers up and over his arms. He is shadowed in dust.

My father and grandfather did this, he tells me, but I don't want my son to follow me.

The next section is lifted up in a flurry of invective to each other to *straighten it the fuck up.* He works at making the joins disappear, the curve from base to the over-constricted neck, seamless. He does it very well. The ground around his wheel is yellow with porcelain dust, ankle-deep.

Making big pots out of porcelain is something that shouldn't be possible. It is a material that likes to buckle and joining different sections compounds the issue, as any seam is inherently weaker. If you join two parts poorly, one bulges slightly like a stomach over a belt. It is not a good look. If there is any structural weakness lower down, the whole jar will tilt in the kiln or topple and take out surrounding vessels. Or break, so that the fire mouth is blocked and the firing is a disaster, flames pushed in strange directions, intensifying the heat.

Every potter knows this but the lure of making something vast out of porcelain seems unending. It is hubris. The *Tao Shu* records that:

> The father of the reigning emperor ordered some boxes, three and a half feet long and two and a half feet high, and the bottom was to be half a foot thick and the sides a third of a foot. They worked on these pieces for three consecutive years, and made nearly 200 examples, not one of which was successful . . . All these, said the old people of Jingdezhen, cannot be done, and the Mandarins of the province presented a petition to the emperor supplicating him to stop the work.

The cost of trying repeatedly to make these huge vessels cascades.

Imagine the amount of kaolin and petunse, the effort to compound that quantity of raw clay, knead it for the throwers. The throwing of such large vessels requires not only great strength but great skill, as a wobble when throwing a wine cup can be changed without thinking, but on this scale nothing can be altered until the clay returns to your fingers. And that feels an age as you see the slight ripple where you moved too quickly gaining movement, the fault coming back to you, increasing.

For a few years in my thirties I became obsessed with throwing very large porcelain dishes and very tall porcelain jars. Few worked. I managed to drop one pulling it from the kiln. My memory is of *held breath*.

While clay is still in a plastic state you can alter form, rethink. And so, sometimes pleasingly, you find the moments when pragmatism intervenes. 'In the reign of Shên Miao, Jingdezhen was called upon to make a windscreen. It failed and turned into a bed six feet long and one foot high. And this changed again into a ship three feet long complete with tackle.' This sixteenth-century note adds that 'The district and prefectural officials both saw it but hammered it to pieces not daring to forward it to the palace.'

Windscreen to bed to ship to shards, and then into story.

It is what artists do. J. M. W. Turner's painting of the arrival of King Louis-Philippe in Portsmouth harbour became his *Whalers (Boiling Blubber) Entangled in Flaw Ice, Endeavouring to Extricate Themselves*. You paint over the martyr, paint in a lover and retitle. The ode on mourning becomes a lyric on spring. You drop the lid of the huge lidded jar that you have finally made and it becomes 'Jar for a Branch'. And you move on.

So when you have your basin, your jar, you must let it dry very, very slowly. Any dampness deep in the walls will crack the whole vessel as it is fired. There are records of pieces left to dry for a year, in itself a skill in this valley of great heat and great cold. Then there is the decoration and all this is before the firing itself, at which point all the work, the hundreds on hundreds of hours, are as chaff in the wind. You watch as it is placed in the chamber on fine sand and the kiln mouth bricked up. And the best brushwood laid in the firebox and lit, the soft crackle as the firemen warm the kiln as tenderly as they can. Firing pots like this should be measured, as slow as is possible to allow the great vessels to temper to the increasing heat, the building of tempo over the couple of days until there is nothing but fire.

When the final test ring is pulled and the glaze judged to have reached its moment, every aperture in the brick wall at the kiln mouth is clammed with wet clay so that there are no fissures to let in a breath of cold air. The kiln might take a week or ten days to cool.

And then you unbrick the kiln. You unpack. And you begin again.

There are many vivid stories about the true cost of making big pots. The most famous is of a young man who, seeing that these great porcelain vessels would not go right, threw himself into the kiln, 'whereupon the bowls were finished'. This self-sacrificial youth was Pousa. He gained great posthumous fame for his actions and is 'universally known in the town . . . there are images of him in many workshops, looking down from shelves'.

Pousa is 'the idol who watches over the workers in porcelain'. This ubiquity is noticed by Père d'Entrecolles forgivingly as he journeys through his city of possible converts.

My photocopy of his letters now resembles a palimpsest. I've underlined almost everything, and written notes slant-ways on his comments, in taxis and on my knee in the street and leaning against trees. There are stains. Possibly noodles. I hope he'd understand, but I'm not confident about Jesuits and untidiness.

Chapter six

Pousa is a singularly depressing guardian angel for us potters. But an appropriate one as he brings money and failure up really close and personal.

I'm here in a semi-official role. My curation of the exhibition has been misinterpreted into my being A Curator of a Western Museum: Exhibition of Jingdezhen Porcelain. Somehow I've become an opportunity to be seized.

Once this is known, I'm upgraded. I get a driver with a golden Mao on his dashboard, a driver who doesn't spit. This morning I have an interpreter, an interpreter's shadow, a man taking a video, the Cultural Bureau chief, someone from the university. I find myself asking someone if they've come far, like a parodic diplomat. 'Porcelain', I offer over toasts of Maotai, the pungent and powerful Chinese vodka, at lunch, 'is cultural glue.' I have no idea why I say this and I'm not sure how this is being translated and the bewilderment lasts another round of clinked cups until we agree that if everyone came here, to this city and saw this, then we would have understanding, as porcelain is *the road of peace*.

Our little motorcade drives slowly around the campus of the Jingdezhen Ceramics Institute. It is the biggest porcelain campus in the world, they confide to me. It is completely empty as it's the summer holidays, so it feels like the setting for a dystopian movie. Or a horror film. It's been a long day.

Over another meal, shortly after the first meal, I'm shown the Gift. It is the design for the metre-high porcelain vase to be given to the Queen of England to celebrate her diamond jubilee. It is to be yellow, in the shape of a close-fitting robe with six red roses scattered over it, supported on a frieze of ancient Chinese characters that read something symbolic of longevity.

It is tact or politeness that makes me start to say that I admire its skill, but then I run out of steam on this sentence. And the main man, a man with a business card that actually folds out to list in tiny characters the manifoldness of his public achievements, knows I'm lying.

I'm lying because skill is so important because it belongs to someone and this man in his leather jacket is going to screw the skills of so many people to get this Gift done, and fold the credit into the shiny purple lining of his shiny black jacket. Just as he did to get the Hong Kong Gift made. This was to celebrate the return of Hong Kong from being a British territory to China in 1997. A thin porcelain plaque 1.997 metres square had to be made, glazed and painted 'by me'. This was something that was on the edge of impossibility. The shrinkage could be calculated exactly and the clay could be rolled perfectly – I've seen it done by three men and a scaffolding pole in a backstreet workshop in the city – but if it was fired flat on a huge kiln shelf then it would crack. So massive resources were 'made available' and a way of firing the plaque on its side was discovered.

This is how it is always done here. How it always was done.

In this new China there is money, an aquifer of cash just below the surface of the city. You sink your borehole here and it is dry, but you try again there and it gushes and gushes. It could be big pots. Or it could be an exhibition in a museum abroad or a new role in a

development corporation. It could be that you become president of the local chamber of porcelain manufacturers, a prefectural super-intendent, but what it means is that someone now owes you and that you can now afford to build yourself a house with an atrium like a museum in the Midwest, and you are covering the facade with shards.

Somewhere in this long day of meetings and toasts and presentations I feel I've done something or said something and now I owe them, and will be folded, carefully, into obligation.

Chapter seven

Factory #72

i

The city gets more complicated day by day.

Actually, hour by hour.

I've just been told of a man who makes blue-and-white porcelain *because he wants to*. My friend emphasises this. I have to meet the man who chooses what to make in a city full of people who don't have any choice, who never had choice. I'm still reflecting on the brutal economics of paying for broken work from your meagre wages, when all this work is fragile.

His factory is on the site of Factory 72. Under huge rusted gates with an old broken-down guard post on the left as you come in. You bump along and turn up by a run of derelict workshops, stop by a midden, piles of stinking rubbish by the front entrance.

A boy with his laptop open in front of him, headphones on and a soap opera silently playing, is painting a Tang landscape where three sage men with beards, talking of love or loss, sit amongst rocks. I watch for half an hour. His brush stipples two of the three beards.

It is a Sunday afternoon and there are few sounds in this dusty space. A woman blowing gently into each glazed bowl before it is set on its stand in the kiln. The softness of the clink as the carrier pushes the porcelain down the alleyway to the kiln on her barrow with the two bicycle wheels. An elderly man grinding the feet of finished jars to remove any traces of roughness, picking each jar up from a board on his left, twisting it against an abrasive wheel of carborundum, wiping it, placing it on his right.

ii

Laughter from the office where the owner, a slight man in his sixties, sits and makes red tea in a complex ceremony of warming, pouring, discarding and pouring again. Behind him are shelves of books on porcelain. He is a first-generation potter, he tells me, and so has learnt properly, chosen what he is doing. He is obsessed by cobalt and dismisses the stuff you can buy from the shit-merchants in town. He loves 'heaped and piled', the blue decoration of the Yuan Dynasty when the blue deepens towards black when the painter has left the brush for a second too long, a carp rises from amongst twisting weeds towards the air at the top of the open bowl. The word carp, *li*, he explains to me, is a homophone for *li*, profit, and this suddenly makes sense of the ubiquity of these bowls with their strenuous fish, unstoppable in their need to swim higher.

He looks completely delighted that I didn't know.

He draws a folio from the shelves and opens it at a photograph of a pair of temple vases, the kind of porcelain jar I've always hated – pointless, stiff-necked, two handles high up – and tells me that this is his next project.

It is the David vases and I've known them for thirty-five years. I first saw them in the Percival David Collection, a stuffy townhouse in a Bloomsbury square where you had to ring a bell and sign in under a scowling gaze. I felt I was there amongst the treasures by sufferance. I

loved the early Sung pots and lingered, but these vases had their own cases, exuding significance on account of their size and inscriptions and date of 1351 on which scholars have balanced, tremulous with suggestion and surmise, their reputations.

These jars are everything jars. You want dragons pursuing a pearl through clouds? Waves? Peonies? Phoenix? Plantain? Elephant handles? Perhaps you want your name inscribed two and a half feet high at the top? The inscription reads:

> Chang Wen-chin of Te-hsiao lane in the village of Hsin-chou, is happy to present an altar set of an incense burner and vases as a prayer for the protection of the whole family and for the peace and prosperity of his descendants. Recorded on a lucky day in the fourth month of the eleventh year of Chih-chen.

They are unwieldy, freighted. *I gave these* as needy as the donor names in gold strung over a museum doorway.

The owner of the factory explains that his market used to be Japanese high-end department stores, but there is now rapidly increasing interest from rich Chinese buyers. The skill is to make replicas of iconic wares, named pieces, bowls and jars from the great collections, and to make them really well, hence the David vases, soon to be recreated in their dozens, and sold possibly as trios, quartets. And that means getting the cobalt correct for each kind of vessel – for these vases the colour is bright, but there are places where there are difficulties ahead. The elephants are a wash of colour, very difficult to recreate, as the cobalt can look like a badly painted wall. There is no singular blue that can be used across his factory. He is a lexicon of blue.

His pots come from over 700 years of history, from the start of the Yuan Dynasty, halfway through the thirteenth century, to the very end of the Qing Dynasty in 1912. He takes me to his grinding room. It is tiny and airless with a table and three chairs, a little how I imagine a Swiss bank vault to look.

Cobalt is an exalted material.

It was first used as a pigment at the start of the fourteenth century, imported from the mines near Kashan in Persia, down the Persian Gulf, across the Indian Ocean, to the port of Aceh on Sumatra and then on to the port of Quanzhou. It arrived either as pure cobalt oxide – difficult to transport – or as smalt, a compound of cobalt with glass that can be ground down, a process that diminishes the chance of the colour running under the glaze.

This cobalt was the source of stories of fortunes made and lost:

> It is said that a porcelain merchant, having been wrecked on a desert coast, found there more riches than he had lost. While he was roaming about the shore, and his servants were making a small vessel out of the remains of the ship, he perceived stones fit to make the most beautiful blue were common there. He took with him a big load, and they say that such a beautiful blue had never been seen at Jingdezhen. Later on the Chinese merchant tried in vain to find the coast where chance had sent him.

This feels correct for the experience of working with cobalt. You have it right, a blue as clean and lambent as midday and you try it again and it is as turbid as late afternoon before the rain.

Local sources of cobalt near Jingdezhen were tried with disappointing results. 'Collectors go out and gather it and wash away the earth that sticks to it in streams. It is dark yellow in colour.' Once it has been purified it is still 'thin in colour and doesn't fire well, so it is only used for low-quality popular wares'. Cobalt came in all kinds of grades, all colours, brought to the town by merchants 'to sell as speculation', some higher in iron, some in manganese, and it needed interminable amounts of work to make it usable, wash out the impurities.

Cobalt was the source of endless trouble.

Firstly, it was ludicrously valuable. It still is. My Kilner jar of cobalt oxide has been constant over my working life, a couple of kilos bought thirty years ago and jealously guarded. I've used it to attempt to inscribe blue lines into porcelain, give a blue rim to a bowl, colour a glaze. The level has barely gone down. In Jingdezhen decorators were tested to see how economical they could be. One administrator tried to make his decorators work with their hands through a kind of wooden stocks to prevent pilfering. Père d'Entrecolles noticed that paper was placed 'under the stand on which the vase is being painted . . . nothing is lost', the stray grains tapped from the paper at the end of the day, like gold on a goldsmith's bench.

Secondly, it is a material that has to be calcined, that is heated to red hot, either in a crucible in a kiln or on a stove, and then ground carefully in a large porcelain mortar. Here in this room, the system for preparation is no different than that used 300 years ago.

'Those who keep working till midnight are paid double. The aged and very young, the lame and sick, get a living by this work.' It reaches deep into the economy of the city.

And thirdly, it is toxic. If you are exposed to cobalt as dust as you grind it into a paste, if you lick the end of your brush to recover its shape before you dip it again into the blue-black liquid to paint another willow branch, you will absorb a little. You might feel nausea. You might feel breathless. It builds, it reaches deep into you.

This afternoon in the factory as we talk cobalt, we talk of all the complexities, all the trouble and expense it brings with it, except this.

iv

Cobalt allows the world to be turned into stories.

There is a list of *Names of Designs* from the eighth year of the Jiajing emperor, AD 1529 – a particularly unpleasant emperor – to be given to decorators in Jingdezhen. These designs include:

Dragons in pursuit of pearls, gold-weighing scales, playing boys, sporting dragons rising and descending, phoenixes flying through flowers, floral scrolls covering the whole ground, birds flying in the sky, the eight immortals crossing the sea, lions playing with embroidered balls, the four fish *ch'ing, p'o, li,* and *kuei* with waterweeds, waterfalls of the Pa Shan mountains, flying lions, waves and flames supporting the eight mystic diagrams, storks flying in clouds, children playing games, phoenixes rising into clouds of propitious omen.

The list becomes increasingly florid with each interior and exterior possibility adumbrated before giving up in exasperation, 'in a short

Grinding cobalt, Jingdezhen, 1938

summary like this it is impossible to give a complete list of all the different designs'.

Everything is in motion, activity captured through cobalt across and around and beneath the porcelain, with ribbons and clouds and waves, falling water or a gust of wind propelling the stories.

And it seems natural that the world should be refracted into blue and white. The whiteness of the spaces on porcelain can become anything you want, water or sky, the heft of a mountain or the face of a child.

Stories might begin in China, start with the images and names that make up who you are, but as the orders come into Jingdezhen from Ulan Bator, Isfahan, Constantinople, Madrid, Amsterdam, Bristol you start to paint characters and scenes that come to you as sketches and descriptions.

And so you paint pagodas and carp and phoenixes, but you also paint English country houses, and churches and coats of arms, the crucifixion, inscriptions in Persian and Arabic, carnations and tulips, mottos in Latin and knights in armour and Andromeda.

v

A decorator doesn't sit and suck the end of his brush, lean back and ponder the empty vessel, wondering where the river should flow, where the clouds should bank, the fishes swim. Blue-and-white porcelain is, and always has been, a process with many hands. This means skills in many hands. And this in turn means administration, decision-making, planning.

If you can repeat an object with some exactitude then you can send one as a sample, take orders for another. If you can work out how much each bowl costs to produce in porcelain, cobalt, firing and wages, factor in wastage, make sense of transport out of the city, then you are on the way to standardisation. Standardising helps everything. It helps the man at the wheel, the man who trims the pots, the man

who carries the boards to the drying racks, pushes these stem cups into the glaze, runs a thumb over the fall of glaze. It helps when you pack pots into saggars, saggars into kilns. And on and on. Each stage is simpler. Each movement more fluent.

'One piece goes through seventy hands', says sharp-eyed Père d'Entre-colles, '. . . there can be no intermission in the work'.

The *Tao Shu* is more brutal:

> the different kinds of round ware painted in blue are each numbered by hundreds and thousands, and if the painted decoration be not exactly alike . . . the service will be neither regular nor uniform. For this reason, the men round the border of the pieces and the blue bands are entrusted to the workers who sketch the outlines, learn how to design, not how to paint in colours, while those who fill in the colours are taught colouring, not designing, by which means the hand becomes skilful in one art work and the mind is not distracted.

Repetition needs you not to think, not to wander as you lay this line down and lift your brush at exactly the right moment, turn the flat edge of a brush to make the hard edge of the grass stem, dip it back into the cobalt, repeat.

And by making one man do grasses, only grasses, the numbers of mistakes drop. You can also identify where things are going wrong and who to punish.

It is difficult to believe that this is how these pots are created. I look at a favourite blue-and-white flask from the early fifteenth century of a bird on a branch. It is a fat little flask, and the bird is singing, and there is so much space for the branch and leaves and the song that I don't see how it could be the outcome of anything more than a singular hand, judging the pauses, allowing a brush to lift slightly at the end of the bough, return over the tail feathers so that the cobalt stipples slightly, ruffled.

There is the boy doing the beards at the other end of the studio. He has half a dozen of the sages on the mountain vases with no faces. Someone else has done the banding, the laying down of the structure of lines that creates the spaces, and someone the mountains. There is practically no one here this afternoon, so I cannot meet the lotus-scroll lady, nor the five-toed-dragon painter. I don't see the moment when all their meticulous labour disappears under a shroud of white glaze, ready for the kiln.

vi

I've got to go. I have a dinner appointment tonight with an archivist and I cannot be late, but I find it difficult to leave. I pass the racks of glazed pots ready to be stacked into the kilns early on Monday morning.

There is something miraculous about the process. I'm with my Jesuit on this. He notes that cobalt lines are a pale black when first painted on to the pot, then they disappear under the glaze, 'but the fire makes it appear in all its beauty, almost in the same way as the natural heat of the sun makes the most beautiful butterflies, with all their tints, come out of their eggs'.

He has seen the work involved, the handing of a bowl from one person to another and the diminishment this entails, but he wants something different – a story of creation, of freedom, individuation.

He is not alone in this. The fire transforms in ways that are not completely explicable. There is a stele dedicated to the god of kilns: 'looking in the kilns with its strong fire, one often sees insects, which must be gods in disguise, moving in shimmering pure water'. There are records of porcelain that 'came out of the kiln with marks produced in the furnace upon the proper glaze, in the shape of butterflies, birds, or fish, unicorns or leopards, or with the colour of the glaze changed to yellow, red, or brown, and how the new forms and colours were sometimes most lovely spontaneous creations of the fire'.

Chapter eight

Counterfeit. Forgery. Sham.

i

Six in the morning and my guide tells me I'm too late. This has to be a universal truism for anyone going to any market and it is always annoying. The best bit of the day, said my mother, was just before you got up, and it still rankles.

There was more Maotai last night. I'd forgotten what it is to be on someone else's expense account, in China.

This is the Monday antiques market, more than 200 people sitting or squatting on the ground with their wares in front of them, some on cloth, some on red cloth, some on red cloth with brocade and others straight on to the concrete. It is packed. Behind the sellers are their bicycles, scooters and carts. Threaded with buyers haggling, picking over the pots and arguing, fingers in the air, counting and discounting. The man with the steamed rice cakes is shouting too and just because it is a market, it doesn't stop scooters with horns weaving their way through. An entrepreneur has a microphone and a single scroll of tigers and is in full cry. A crowd surrounds him, drawn to the static of his energy, unimpressed.

An elderly man sits with his stacks of Sung Dynasty tea bowls around him like the hours on a clock face. They are all here in this market, the storied bowls, named in poems, copied and desired. There is a stack of bowls streaked like hare's fur, and the strange oil-spot glazes where silvery droplets of lead seem to float on the surface of the lustrous black. And my favourite bowls with partridge-feather markings. This man in his Atlanta Braves tracksuit has six.

And there are dozens of white porcelain monk's cap ewers, the Sung pitchers with a jagged profile edge that sell for millions in Hong Kong auctions. A sharp young woman hustling Mao plaques and Long March platters tries to get my attention. Westerners love a bit of Cultural Revolution.

And there is a child with stones. Not scholars' stones, the jagged, ragged striated stones that sat on erudite writers' desks for contemplation, but twenty rounded river stones. He must be eight years old. He squats next to his stones and waits.

Last year, says my guide, you could buy the rejects of Ai Weiwei's sunflower seeds in this market for 200 yuan a kilo, little conical heaps of grey seeds that he had commissioned from the small workshops of Jingdezhen for his vast installation at the Tate Modern in London. They were press-moulded by the million, and you could go and collect a bag of them from a depot and paint a stripe of iron along each side and get paid by weight. There were 100 million made, 150 tons of seeds, and they kept workshops busy for a couple of years.

This year you can't find Ai Weiwei seeds.

ii

This morning there are dozens and dozens of people with piles of shards, each kind separated and zoned, by size, by dynasty, by colour. Celadons from white wares, deep black glazes from the rarer textured glazes, broken spouts and foot rings of bowls and pots still in saggars. There are thousands and thousands of blue-and-white fragments of

pattern with the calligraphic reign marks on the base. Fish, peonies, figures. The leaning figure crossing the bridge. The boy bent into the river breeze on the boat. Three geese arced near the rain cloud. Some grasses in the wind. Quick repeated dashes of brush and cobalt again and again.

And because shards come from vessels and so are all slightly curved these swathes of brokenness ripple across the concrete like a piece of cloth lifting in a breeze.

You buy for research. You haggle for this fragment because it shows you how deep to incise this combed sweep of a willow branch and how shallow a foot on a bowl should be. You buy these blue-and-white shards because the cluster of characters inside the well of a foot tell you when the pot was made: they indicate the reign of an emperor. They have value because you can make a new vase or bowl and insert these characters into your creation and fire it very slowly and you have made a homage worth fifty times what your ordinary pot would make.

My guide takes me for noodles and then on to the street of reproductions. It is opening up already. It is seven feet across, tight with workshops and stores, a woman with her barrow of chillies pushing through. It starts with a bang, a store selling nothing but imperial yellow, five-toed-dragon porcelain, and a cheerful young woman nursing her baby while the deep store blazes with every coveted stem cup, vase and dish stacked eight deep on the shelves. I stumble a little after several hundred yards of what seem to be impeccable Qing porcelains when I come across a run of shops selling twelfth-century porcelains, each of the famous glaze effects in bulk. So what do you want? How much do you want? You want that smoky blue-and-white where the glazes have run and it looks like a landscape in the rain?

I buy seven Tang bowls for $5 each. They have been properly aged.

This is skill, another skill. I watch as a man dips a fat old brush in red clay slip and washes it over the bases of his olive-green jars until it gathers and encrusts in the hot air into that crumbly just-dug-up way. A few shops down there is a haphazard pile of cups and jars —

sixteenth-century porcelains from last week – over which a man is splashing an acid solution. It bites into the glaze and abrades it in a usefully random way.

This level of authenticity – the grasses matted to the insides of my bowls, the cloacal dirt deep in the seams of these gorgeous celadons that I'm coveting and wondering how to get home – is a fabulous flowering of how the market works.

We can do authenticity if authenticity is what you want.

Someone has fired vases into saggars for those who like a bit of rough around their porcelain. I look approvingly at them. There are shops as full as the trenches of the terracotta warriors.

iii

No one is here for aesthetics. They are here to make a living, walking skilfully along a pathway between reproduction and – what is the correct word – fraud? Fakes?

Well, neither of those. This could not be more complex in a country where copying is a valued pathway of respect, a way of learning skills. The repetition of a previous reign's achievements is noble in itself.

And anyway, I add under my breath, I've been trying to make these kinds of pots for decades. That crackle glaze has never come right for me. I would have given anything to have been able to create a bowl like that one, let alone repeat it.

I look at my notes and they are lists, crossed out, repeated, failed attempts at taxonomies for all these reproductions. Objects that resemble X / reproductions of Y / acts of homage to Z. Each of these is a kind of story.

Fake. Fraud. Ersatz. Bogus. Replica. Simulacrum. Counterfeit. Forgery. Sham. How do you make anything at all, map your desire to create a beautiful porcelain bowl, if it is caught up with something made last year, a hundred years ago or 1,000?

This street, on a humid July afternoon, jostles with histories. Stop any-where, allow your eye to pause and you are sold an idea, a chance, a dis-cussion. And after a week here in Jingdezhen, I realise this is what I am starting to love in the *Tao Shu*, this anthology of writings on porcelain from over two hundred years ago. Everything is included in this scrap-book on porcelain; unspooling lists of the great pots of past dynasties, secret glazes, stories of who had this and how it was passed on, shuf-fling anecdotes, sniping at previous scholars. I find more and more reassurance in its randomness, the way in which total authority is given to one list of objects or attributes, only to be countered angrily by the next.

Nothing touches this energetic storytelling by Chinese scholars on their pots.

Stories of the strange life of porcelain thread the literature.

A man comes down on a cold morning to discover that when he emp-tied a porcelain basin, the water remaining at the bottom was frozen, and he saw a spray of peach blossom. On the next morning there appeared a branch of peony with two flowers. 'On the next day a winter landscape was formed, filling the basin, with water and villages of bamboo houses, wild geese flying, and herons standing upon one leg, all as complete as a finished picture . . . The pictures have never been twice alike.'

A man sent a teacup 'as a present to a poor friend, who after his return home prepared tea and poured it into the cup, whereupon there immediately appeared a pair of cranes, which flew out of the cup and circled round it, and only disappeared when the tea was drunk'.

I know all these stories from the inside, own each emotional adjustment as I learnt to make something I could love. As a teenager I pinned a postcard above the wheel in the studio. It was of a celadon tea bowl with a crackle as fine as a skeletal leaf. And I tried to make it again and again, hoping for the moment when it would come to life and cranes would fly out of it.

My seven old and new, priceless $5 Tang Dynasty tea bowls from last week, barely wrapped in newspaper, bump in their plastic bag as I walk back to my lodgings through the soft early evening rain. I'm wondering how to write about this city. The interweaving of histories makes it so difficult to work out which tense to write in; the past isn't very past here, and the present, bumping in my bag, is very, very old. Tenses are fluid and difficult to police.

And there are so many stories that a scrapbook seems the only way of collecting them, a sort of plastic bag for them to bump along together.

By the time I get back I find I've broken one of my seven new Tang Dynasty bowls already. New shards can't be bad, I think, as I add them to my collection on the windowsill in my hostel.

Chapter nine

ten thousand things

i

No banquets tonight. I sit in my tiny room and try to catch up. I email home and the studio, make my lists for tomorrow. And start on the next bit of a novel that my daughter Anna and I are working on together. It is set on the west coast of Scotland and is good on brackish detail of wind and horizons and scrambling through burns. We'd got to a critical moment when I left London, with the two kids and their dog lost on a hillside at dusk, so it is crucial I send her my chapter, my homework.

It is three in the morning.

I'm racing. I am the king of all that I survey. Today, I say out loud as I crack my knuckles and stretch and look out over the deserted street in this strange city of porcelain, today I am to start to create the category of white things. I am going to be as particular as a Talmudic scholar. I am going to feel this, scrunch this up and then send this back, and ask for that one, behind you on the high shelf.

Today I am going to find white. I am the assessor of white and nothing will get past my scrutiny.

Sleep goes, is gone.

I hear objects. With objects it is possible not only to sound them, name them and make sense of them through language, but hear their kinship with words themselves. Some things feel like nouns, words with physicality, shape and weight. They have a self-contained quality, a sense that you could put them down and they would displace the same amount of the world around them. Other objects are verbs and are in flux. But when I see them I hear them. A stack of bowls is a chord.

Sometimes it is embarrassing, like Walt Whitman's *Leaves of Grass*, with lots of emotional noise, and sometimes it is quite cool like a bit of Steve Reich music, with pulses of sound and with patterns emerging and disappearing.

So I walk down this lane in Jingdezhen and there is so much porcelain, so much language, so much speech, that I get lost and it is like streams of words cascading from the top of a page endlessly.

It is like shouting.

And the quantities of porcelain in this place deafen. I knew that it had always been like this.

I read that in the year 1554, the Jiajing emperor sent an order to the imperial kilns for 26,350 bowls with dragons on them in blue, 30,500 plates of the same design, 6,900 cups, white inside and blue outside decorated with blue flowers, 680 large fish bowls, decorated with blue flowers on a white ground, 9,000 teacups with foliate rims in white, 10,200 bowls decorated with lotus flowers, water plants and fish in blue and white on the outside; and on the inside with dragons and phoenixes passing through flowers, 9,800 teacups of the same pattern as above, 600 libation cups with hill saucers decorated with sea waves and dragons in clouds in blue.

And then, that perhaps as an afterthought, as the scribe backs away, eyes down, 600 wine ewers of white porcelain.

And that the next year he ordered 1,470 vessels, but the following year it was 34,891.

I read the history books, the monographs, the scholarly pamphlets and they come up with answers to why all this porcelain was needed at court, but all I can hear is *more, more, more.*

iii

Surely they couldn't break this many pots every year? I want to know where they are stored in the palace once they arrive on their journey from Jingdezhen. There must have been vast storerooms and endless inventories. There must have been rooms for the inventories. There must have been Official Counters of the Imperial Porcelain.

Every day at court there is some religious event, an anniversary, an obligation to offer prayers or obsequies. And objects were needed for these, for libation, incense and ritual offerings of flowers or fruit. And not singular vessels, but sets of them, pairs and trios and quintets that

Page from the *Collected Statutes of the Great Ming Dynasty*, 1587

could be placed to show how perfect and balanced and harmonious the emperor as the Son of Heaven lived and ruled.

There is a record of an order for hundreds of shallow dishes for narcissi, and I imagine walking down one of those endless corridors in the Forbidden City, a paced rhythm of steps and scent.

Another imperial record orders yellow-glazed vessels for the Temple of Earth, red-glazed for the Temple of the Sun, blue for the Temple of Heaven, and white for the Temple of the Moon. *The Collected Statutes of the Great Ming Dynasty* from 1587 show the ceremonial vessels displayed at the Circular Mound at the Altar of the Heaven. There are three tripods in front of the altar, and then a central spine of objects with flanking censers and candlesticks, a dozen dishes to the left and a dozen to the right. And you can be sure that some officer in the department of ritual has checked the protocols, counted them from the stores, placed them as the rules indicate.

This isn't about things looking nice, it is about things being correct.

Sets are a way of controlling the world. If you need this mortal world to reflect another kind of order, then things must match each other. And people must fit in. Mismatched, wayward porcelains would reflect terribly on your ancestors' sense of the afterlife, just as much as a grubby tablecloth, or milk from the bottle rather than a jug might offend the proprieties.

And because time is a constant interweaving of respect for ancestors, this may be the year when you send your order to the kilns to make censers for the altars that resemble those made 300 years before which in turn were made to echo bronzes 900 years before that, piety stepping down generations.

'The ten thousand things are produced and reproduced / so that variation and transformation have no end', wrote Zhou Dunyi in the eleventh century.

This can be a beautiful idea, endless iteration.

But at this moment I'm not an art historian and I'm not a Sinologist and I certainly feel that I can't be a scholar of the history of Chinese porcelain either, because I am choked by porcelain as prescription, porcelain as control.

Because every single one of these hundreds of thousands of porcelain bowls – perfect and balanced and harmonious – has cost so much. This amount of control costs more than I can comprehend. And I can be as severe as I like and cool and minimal, but this white frightens me.

Chapter ten

the monk's cap ewer

i

After nine days here in Jingdezhen, I'm drunk on colour.

And pattern. There is a current fashion for wearing patterned trousers – camellias, leopard print with a different-patterned top, a Manchester United T-shirt, tartan. Handbags are important and these add in quilted or snakeskin surfaces, held with golden clasps and chains, double Cs and Vs, every brand condensed to a glittering mark.

And pots are patterned. That is they have multiple patterns on them; panels from one period held between borders of another, top-and-tailed by acanthus or clouds. And then gilded. Not simply on an edge, like an embarrassed well-behaved English dinner plate, but at the foot of the pot and the rim and where the sky might be on a blue-and-white landscape decoration, so that there are vases that are mostly gold, with figures picked out in a different gold. I've always loved the word *ground* for the surface on which you paint or decorate, the idea that you start and work up, and here are golden-ground pots. I hadn't realised that you could put anything on top of gold. I hadn't realised you might want to, but here gold is not an accent or an aspiration but

a starting point. I walk down Porcelain Street, where the big shops spill great basins and vases over the pavements. The sun is out, briefly, amongst the summer showers. The pots glare. I stumble slightly.

Where did white go? I pick carefully at my steamed buns in the morning and relish one white mouthful after another.

ii

This porcelain is as 'blue as the sky, bright as a mirror, thin as paper, and resonant as a musical stone'. And 200 years later: *this* is like jade. And 'this Kuan porcelain is generally classified as about equal to Ko porcelain. The light green colour is considered the best, the white ranked next, the ash-grey lowest. With regard to the crackling, that with lines like broken ice of the colour of eel's blood is put first, that like plum-blossom petals stained with ink next, fine irregular broken lines last.' The glaze of *this* one is 'marked with crab's claw lines. The best is white in colour and bright in lustre; the inferior, yellow and coarsely worked. None of it is worth much money.' And another 200 years later: *these* porcelains, says the *Tao Shu*, include pieces decorated with vermilion red, with bright onion green, 'vulgarly called parrot green, and with aubergine purple. The three colours, rouge-like red, fresh onion-like bright green, and ink-like purple, when of uniformly pure colour with no stains, comprise the first class. They have inscribed underneath the numerals 1, 2 &c., to record the number of the pieces.'

The connoisseurs sniff, categorise, rank, price, demote.

Celadons, the colour caught between green and blue, get *sky after rain*, and *kingfishers*, and *iced water*, all of which are lyrical. A Tang Dynasty poem compares a service of teacups for the emperor to 'bright moons cunningly carved and dyed with spring water / Like curling disks of thinnest ice, filled with green clouds / Like ancient moss-eaten bronze mirrors lying upon the mat / Like tender lotus leaves full of dewdrops floating on the riverside!'

You feel the poet has only just started his evening and that there are more similes ahead.

What can you compare white porcelain to? 'The best is white in colour and as thin as paper. It is inferior to Ju porcelain and the value comparatively less.' Or it can be as thin as silver. As white as driven snow. Or milk.

It is not much to go on. I want poems that compare white porcelains to smoke coiling up from a chimney, or from incense on an altar, or mist from a valley, or, at the very least, an egret in a paddy field, poised. But the main trope on white porcelains that I can find is they are 'as white as congealed mutton fat'.

iii

Poems are rare. But stories settle around those who made white pots, or commissioned them, or used them, whether they were destitute or the Son of Heaven.

I find my destitute story first.

'The porcelain fabricated at Fou-liang Hsien in the reign of Wanli by Hao Shih-chiu was of perfect design and surpassing beauty. The eggshell wine cups which he made are of translucent whiteness and delicate fabric, each one weighing not more than half a *chu*.' That is, they weighed almost nothing. This maker of white porcelains, who 'devoted all his genius to the fabrication of porcelain', was 'simple and not covetous of gain and used to live in a hut, with a mat for a door, and a broken jar for a window, yet he was a man of culture and not to be dismissed as celebrated for this one art only'.

I love this.

iv

Then I find the story of the emperor who loved white porcelain. It is a perfect story: a tribute of jade bowls arrived for the Yongle emperor

from a Muslim ruler in the Western Region at the beginning of the fifteenth century. The emperor declined the gift and ordered the Ministry of Rites to return them: 'The Chinese porcelain that I use every day is pure white and translucent, and it pleases me greatly. There is no need to use the jade bowls.'

I'm pleased with this shrugging away of jade in favour of austerity. But Yongle's devotion to white becomes more complicated.

Zhu De, the Yongle emperor, was born in 1360, the fourth of twenty-nine sons of the first emperor of the Ming Dynasty. When his father and eldest brother had died, the eldest grandson became the emperor Jianwen. At which point Zhu De marched into the capital Nanjing and started a war of unparalleled bitterness to usurp the imperial throne held by his nephew. It lasted three years.

There are grotesque stories of the lengths to which Zhu De went to wipe out the families of his nephew's supporters, murdering everyone within 'nine degrees of kinship' – grandparents, parents, siblings, aunts and uncles, cousins, children, nephews and nieces, grandchildren – before declaring himself emperor in this sea of blood. And erasing the previous reign from the records.

He named the new reign, Yongle, or Perpetual Happiness. It was threaded with extraordinary ideas, backlit by terror.

In the first year of his reign he issued an edict to create the first great Chinese encyclopaedia, documenting all known records, tracking down missing books and transcribing them. He moved the court from Nanjing to the old Mongol capital of Beijing and started the building of the complex of palaces and temples and gardens that would become the Forbidden City. The scale of this is barely comprehensible. Roads were flooded in winter to create ice tracks to slide cut masonry to the site. The pillars for the main halls were made from trees felled in remote south-western China and brought by boat to the city. He ordered the erection of a vast stele in memory of his father that was to stretch seventy-five metres high. Huge blocks still lie in the quarry where they were cut, too heavy to move. Emperor Yongle rebuilt the

Grand Canal, stretching 1,000 miles from the old capital of Nanjing to the new capital in Beijing. He sent out huge fleets to create new trade routes to Java, Ceylon, India and East Africa. A giraffe was brought back to his court in tribute.

And throughout this, Yongle and his empress Xu seem to have had great devotion. Guanyin, white-robed, accompanied by a white parrot, appeared to the empress in a dream, asked her to repeat a sutra three times and when she awoke she was able to transcribe the sutra in its entirety. The majority of objects created in the Imperial Workshops during his reign carry Buddhist symbols. And a bell of forty-six tons was cast with a hundred Sanskrit sutras and incantations made up of 230,000 characters, whose deep tolling was supposed to quicken the deliverance of the souls of those he had slain.

Yongle invited the leader of the Tibetan Karmapa Order, one of the great Buddhist teachers, to visit and conduct rituals and teachings. The planning for this took years. The Karmapa was met with glory, processions of white elephants conducting him to the palace. He stayed for a year. When it came time for him to leave and start his long journey back to Tibet, laden with gifts and titles, there were portents, the clouds turning into the form of auspicious animals, perfumed rains, light emanating from the Karmapa himself, a multitude of white cranes dancing in the sky.

And for the rituals of supplication and purification conducted by the Karmapa the purest porcelains were created. These are the monk's cap ewers — small, strange jugs for pouring ritual libations with a stepped rim and lip based on the hats of Tibetan monks. The ewers are beaked, a great energetic thrust forward into the spout, as if the water is already in motion and the rim echoes the jagged ridge of a mountain.

Their strangeness lies in their particularity. They are cold, held back, passionate, intense. And they are blindingly white.

It is at this moment, with an emperor and the Karmapa locked in ritual, bringing the heavens and earth in alignment, that the first hidden porcelains are made.

These are *anhua* wares, where the decoration is incised into the porcelain body so that you only catch sight of it as the vessel moves or the light changes. The glaze barely pools over these patterns, so finely are they drawn into the surface. And their quietness is coded: the patterns are of lotus scrolls, Buddhist symbols, sutras. This is white as transcendence. White as meditation.

I'm in a museum, my forehead against the glass of the display case. A Yongle flask is slightly below me. The curators have put some bits and pieces around it, but they fade out as I try and work out this 600-year-old pot. Somewhere there has been sight of a pilgrim flask made in leather, robust enough to bang against a saddle, sling down on the ground when you stop for a rest. And this has been rethought in porcelain. This Yongle flask is a perfect disc, a full moon, held by a foot, rising to a neck, balanced by two handles, a sufficiency of movements and volume, a sort of new planet.

Next to it is the monk's cap ewer. I have been to my first white hill, and now, with this ewer, I have my first white pot.

It takes me an age, but I finally realise that I saw them twenty years ago in the high white air in Tibet. That the monastery I visited was the Karmapa's monastery and that his fierce white porcelain was still there after all these years.

v

Yongle loves white, and he also needs white. It plays a public role.

The foundation of his reign is an act of usurpation, his legitimacy bolstered by cruelty, his place amongst his ancestors in need of consolidation. He needs to create symbols of stability, needs to surround himself with the rituals of devotion.

He orders the building in Nanjing of the Bao-ensi, the Temple of Repaid Gratitude, in memory of his parents. It was an octagonal pagoda of nine storeys, 261 feet in height, with hundreds of bells

suspended from its eaves. In its windows at night, 140 lamps glowed.

And it was faced with white porcelain bricks from Jingdezhen, with colourful glazed tiles at each roofline, surmounted by a gilded pineapple. Each doorway and window was framed with deeply moulded ceramic tiles with complex Buddhist symbols, and each storey had its own shrine so that an ascent of the 184 steps was a pilgrimage route through divinities and saints. It was a spectacular, theatrical place of contemplation. At night when the colour of the roof tiles had faded, the whiteness of the pagoda emerged in the glow of the lamps. Imagine it by moonlight.

White is the colour of mourning in China. To wear white is to express your loss to those around you, keep the world away. To build white on this scale is to mourn on a scale that had never been attempted before.

This white pagoda was one of the wonders of the world, the most complex porcelain construction ever dreamt of. Two centuries after its construction the first European travellers encountered it. It evoked disbelief. The adventurer Johan Nieuhof wrote of it in his account of the Dutch embassy to China, published in 1665:

> The Ambassadors often went to take the Air and view the City: One Day they rode to see the famous Temple before-mentioned, and Plain of *Pau lin shi*, which contains several curious Structures . . . In the Middle of Plain stands a high Steeple, or Tower, made of Porcelane, which far exceeds all other Workmanship of the *Chinese* in Cost and Skill. It has nine Stories, and an hundred eight-four Steps to the Top: Each Story is adorned with a Gallery full of Images and Pictures, with very handsome Lights.

The complexity of its construction was endlessly fascinating to visitors. 'It is an octagonal building of nine stories . . . bright with many-coloured porcelain, which throws off a glittering light like the reflected rays from gems; it is in perfect preservation,' writes British army officer Granville Gower Loch, visiting in 1843. 'The porcelain is

fastened to the tower with mortar, as Dutch tiles are upon a stove, except the projecting cornices and bas-reliefs of grotesque monsters, which are nailed.'

Being a British officer he gives a good account of his ascent and casts a seasoned expeditionary eye over the surrounding territory:

> The ample view from the summit surpassed our expectations. Facing the south, a little river from the distant hills came winding like the Forth near Stirling: it passes by the south and western walls, and helps to supply the canal with water. Towards the S.W., as far as the sight could reach, flowed the princely Yang-tze-kiang, leaving between us and it, as it passed Nanking, a richly cultivated flat of paddy land about three miles in breadth. Facing the north, we look down upon the walls and roofs of a dense cluster of houses – the Chinese city.

And, being British, on the summit of the Bao-ensi – the delicate, codified, personal memorial to an emperor's parents – they know what is appropriate. 'On the top of the highest pagoda in China we drank the health of our Queen in champagne.'

Engraving of the Porcelain Pagoda, Nanjing, in Johan Nieuhof, 1665

Shortly after these officers had celebrated their ascent the porcelain pagoda was destroyed in 1856 during the Taiping Rebellion, its Buddhist imagery shattered. Very little remains. Visitors picked up bits, bought carvings from locals for souvenirs. Three white porcelain bricks sit in the stores of the Metropolitan Museum of Art in New York. The label reads: 'Gift of E. J. Smithers, 1889.'

vi

Yongle's white pots have very small bubbles, so minuscule that they create a refraction and scattering of the light. They have the softness of surface of a winter apple.

The white porcelains of this period have been known since the late sixteenth century as *zong yan tian bi*, or 'bristle hole sweet white' wares. White sugar had only just become known in China.

So I get *white as sugar* as a simile too.

But it is a minatory white. I look at my first white pot, the emperor's monk's cap ewer. And I can't help thinking about Yongle's order to execute 2,800 women in his household, concubines and servants, after rumours of a plot. He moves mountains, creates cities and orders knowledge and he builds white pagodas of porcelain.

vii

I read that the porcelain pagoda is going to be rebuilt. Wang Jianlin, the richest man in China according to *Forbes*, has given 1 billion RMB to reconstruct it as part of a luxury hotel, apartment and mall complex by the Yangtze. On the comments page *LoveChinaLongTime* posts 'Real Estate developers are good! They work hand in hand with the China Communist Party for a harmonious China of the 21st century!!' In this new development the white bricks are no longer part of the scheme. There is going to be more colour, more pattern. And there is going to be gold. Of course there is.

I think I might be in the right city for porcelain but the wrong city for white. I should spend my last day on a visit to the new factory where they make the porcelain mugs for Starbucks and Hello Kitty ware for Japan and Peter Rabbits for the world.

It's the end of school and in the lanes in front of the teashop is a surge of kids in their uniforms. The screens of their phones glow. I order more tea. Write a bit more. Time to get going again into this damp city full of colour.

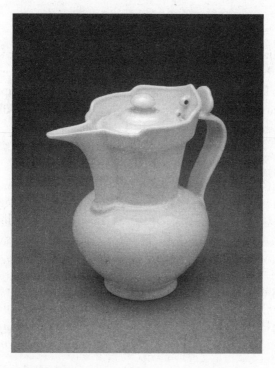

Monk's cap ewer, Yongle Dynasty, 1403–25

Chapter eleven

I read everything. I understand. Continue.

i

I'm running out of days.

I'm not quite sure why but I've been brought out of town to a kiln site. I didn't ask to see another one. In fact, I tried to ask not to see another, but there was a lot of smiling and now I'm in a scrubby field a couple of hours from the city near a mound with a board with a picture of a kiln on it.

This site is by a river. I see a kingfisher, which is lovely, but I want to be elsewhere.

On the way back we stop at a museum. It is like every local museum in the world. I'm sure that this one had a diligent founder who bought this cradle, the churns, the bamboo yokes, the three different scythes, the local fisherman's coat that differs from the next valley and the next, framed the photographs, put the coal in the hearth in the kitchen.

The museum is in the house of a family that held power here until the twentieth century happened to them. It is 500 years old, built in the late Ming Dynasty as a courtyard with fretted balconies running round it and a stage at one end for music and dance. High up by the

eaves are painted tiles of magpies and the wood has reached that shade of ash-grey that I find particularly beautiful and all in all it has a perfect melancholy to it. My guide is explaining to me, slowly, the cases of pots from Han to Qing when I catch sight of the final case.

It is of revolutionary ceramics. But not the safe ones that I had seen before, the Maos and the pretty factory girls wheeling their bicycles to work. These are porcelain models, eight inches high, with clear, clean glazes.

Three women in blue overalls crowd a kneeling girl wearing a dunce's hat. She is bending her head forward, supplicatory. Another shows a boy standing on a chair pointing his arm, stretching his body in denunciation. The third model is of an execution with the head of a man rolling towards us.

You see terror. It is in bright light as if from a comic book. You see the details; they don't go away.

You count: three women to a single girl, the age of the boy – eight or nine – the bound hands behind the back of the man to be killed, four twists of a rope. You feel the exultation of power in this porcelain, the taste of control over other people, grown-ups.

They have been made quickly. The modelling isn't perfect – areas have been rushed or missed. But someone has spent real time on the painting, damn it, getting that head right. I ask who made them, meaning who could make them and when, but my questions disappear in the business of photographs, the itinerary, an emphatic motion towards the waiting car.

The questions burn. How do you get to this place, the place where you make a porcelain model of an execution?

I start, but my guide wants to talk about kingfishers. Do I know the beautiful Chinese character for kingfisher? She sketches it in her hand. Kingfisher feathers were part of tribute to the emperor, she says. A glaze was named after them.

How would you catch kingfishers?

87 *I read everything. I understand. Continue.*

I get to the archive at the Jingdezhen Ceramics Institute very late. It's the old building in the centre of town, and is supposed to have been built by the East Germans in the 1960s, during one of the brief rapprochements between Mao and Erich Honecker.

There is rubbish, real rubbish – a broken TV, two split bags of cement, a spew of Coke cans – in the stairwell. The archive is on the top floor, a long room without air conditioning, so the windows are open to the wall of humidity outside and we all have bottles of water as the first volume of the fifty volumes of imperial correspondence concerning porcelain of the Qing Dynasty is laid in front of me.

It is a volume from the forty-fifth year of the emperor Qianlong. I ask the archivist if we can open it at random. We do.

It is an order to Tang Yin, the superintendent of the Office of Imperial Porcelain at Jingdezhen porcelains for the Outer Office of the Hall for Making *Something*. No one can agree. They want a pair of double-happiness incense burners in imitation of the ware from the Lo kiln in Hubei. And one ditto but in Ding ware. And a single dish in Ju ware for placing washed fruit in. And a single Ru-ware brush washer. And this list, running right to left in impeccable imperial script, ends with the two characters 'the best you've got'.

We turn another page.

A letter from the Office of the Head of the Imperial Household to the prefectural governor of Jingdezhen that they have received 900 objects and that 500 of them were unacceptable as the glaze quality was inferior, and there were chips or breakages. So the payments have been reduced.

And the talk of money starts to animate our hot huddle. My pleasure in the commissioning of goldfish bowls for the Summer Palace is overtaken by the vigorous discussion of the vicious discounts that Beijing demanded.

Or demands. The archive is alive.

We turn again:

> In my five years as Imperial Commissioner for Porcelain, this being the fifth year of the emperor Yang Zheng, I have overseen the manufacture of 152,000 pieces of porcelain. In doing so I have used 30,000 silver thalers of my own – and other officials' – money to make up the deficit. In winter the weather here in Jingdezhen is terrible and it is too cold and then it rains incessantly and it is too wet for porcelain to dry. So I have had to build a small shelter. Out of my own money.

Crammed in, almost on top of this plea for deliverance from this wretched role, are two running lines of reply in untidy and hasty script: 'I read everything. I understand. Continue.'

This starts another conversation. Was it written by the emperor himself or by a private secretary writing to dictation?

Because I'm feeling breathless, I ask for the final volume.

iii

It is the book of the Last Emperor Puyi, who reigned from 1908 to 1912.

We look through for the final order of porcelain from the emperor to Jingdezhen. It takes ages. Pages and pages of the volume are messy, slipshod records of inventories, some torn and over-stained. These are not in court script but in a rapid vernacular. There is someone counting in the room as this is being written. This page is recording losses: an imperial court trying to stem the daily flow of theft, the seeping away of prestige as objects disappear from room and storeroom. Nothing adds up in these pages of porcelain lists anymore.

There are documents reporting that:

according to the guards Yong Kuan and Wen Mou, on the 11th day of the 10th month of 1908, the first storage room of the eastern quarter of Porcelain Store Number Five showed signs that it had been broken into. After investigation, it was revealed that sixty-six pieces of porcelain were missing, including fifty Kangxi marked yellow-ground bowls decorated with green dragons, six green-ground dragons decorated with aubergine dragons and ten Jiaqing marked bowls with clouds and cranes. The guards on duty at the time were handed over to the Shen-xing-si Bureau of Punishment for supervision.

The porcelain thief named Li Deer has been arrested. He has a number of damaged porcelains in his possession.

Li Deer's gang got in by disguising themselves with officials' hats, hid until nightfall, dislodged loose tiles on the porcelain store, hauled themselves up with ropes. They split up and sold the porcelains on.

On the twenty-fourth of the fifth month of 1909, there is an order for 'one white porcelain vase, four white porcelain ju vessels, one white porcelain bowl, and twelve large white porcelain dishes. The vessels will be placed in front of the portrait of the late Empress Xiao Qin Xian for ritual purposes.'

And then the final order.

It is not an order, but a reply on the third of the third month of 1911, to the emperor, then a boy of five. It says that we received your letter, but we cannot fulfil a demand for one hundred seven-inch dishes glazed in sacrificial red. We no longer have the skills. So we are sending a hundred white dishes with red dragons on them.

There are now nine people around this manuscript, caught up in the exchanges. It is an archive but a librarian takes a cigarette out of the packet and lights up. He holds his cigarette like W. H. Auden.

There is no apology here, just the statement of what they are sending. And when this is collectively translated and the silence around apology is realised there is a moment when this is absorbed.

A thousand years of imperial porcelain ends on this. For the first time in decades I feel like a cigarette.

Chapter twelve

i

Rain all night. And a party. Possibly a party? Not one I'd been invited to.

After the day in the archive I gave a talk last night to students in a hall in a factory. It was Friday night – it still is Friday night – and I'd assumed I'd get a dozen earnest potters with notebooks, but it was completely packed. There was no one to translate so I'd been more animated than usual, hoping enthusiasm would be enough to get me through. Then questions. And it had become clear that this was 250 students from a college doing English Comprehension.

Dear God. The poor kids. Me on making pots, when all they want to ask is *Do you like Chinese Food? Do you have a Big Family?*

And in my room I cannot sleep. It's the rain on the tiles and the noise of happy people, ducking in and out, umbrellas, puddles, the whole drink-night-ballet and it's the idiocy of being here so far from my *Big Family.*

And the balloon of energy after talking, the effort to make energy in a room work, keep eye contact, keep light, pitch it right, is deflated. I

feel like I've been on the road doing this for ever. A few earnest years on orientalism, on the influence of Japan in the West. A decade or so talking up why things matter and why it is good to make, from my mid-thirties. Five hard years or so on why objects need histories, and why artists and makers need to write, to artists and makers who don't believe me and just wish someone else would do it for them.

And then the last couple of years about Jewishness, which was a change in subject and in audience demographic. I've been away far too much, breathing out, stretching out the balloon until it is taut, until it floats across the heads of a crowd in a darkened auditorium, somewhere.

How many times did I get it wrong, talking into the darkness about the *Anschluss*, or Proust or Bernard Leach, when all they really wanted was *Chinese Food*?

The rain comes down.

I think of Thomas Merton, the American hermit, sitting in his cabin in the Kentucky woods listening to the rain, 'All that speech pouring down, selling nothing, judging nobody.'

ii

It is three in the morning again. I try and count pots. This is what I do to get to sleep. Because I'm here I count all the bowls and lidded jars and dishes that I've made to emulate Chinese porcelains, the ginger jars and the celadon tea bowls and wine cups, and the large dishes with the pairs of fishes, head to tail, that I made as wedding presents. The bodged, earnest attempt to make pots that had some of the ease, deftness and poise of the most basic bowl from this city. To make myself into a potter through my attachment to Chinese pots.

My tally comes to nothing, scant thousands amongst this roiling sea of objects.

I try and count my childhood pots and my apprenticeship pots and the pots that I made on my own in my first independent workshop on

the Welsh Borders. I moved there straight from university. I was setting out, I was twenty-one.

I count my Herefordshire pots.

Herefordshire is green on green, lichen on old apple branches, ivy in the woods, the rot in the floorboards. A mile away from my workshop was a cottage where an old woman left for the workhouse a generation ago. The stream comes under the door. There are rags in the windows. This feels about right. On the walk up the hill behind the house, scrambling over the fence next to the old oak, and then up the pitch scarified by sheep tracks, your eyes on the steep ground until you get to the hedge line, hawthorn and brambles, when you turn and get the whole landscape of hills unfolded to the Black Mountains, five miles away across the border in Wales. There are a thousand gradations of damp underfoot. There are a pair of buzzards above the copse. There has been a badger here: the red earth is churned.

My friends were in London with jobs, writing, partying, getting on with careers and affairs, and I was making dishes, unglazed, rough oatmeal brown on the outside, and green on the inside, pots to disappear into the landscape. No one bought them. No one liked them. This is usually an artist's trope — as in no one liked them except, say, Peggy Guggenheim — but in my case they were genuinely unlikeable because they had that killer factor for objects. They were needy. And once you recognise neediness in an object, it is difficult to live with. The fluidity of your life with it curdles.

They wanted to change their users, not just make you feel better as you poured your milk in the morning, spooned marmalade from the jar on to your toast, but be a better person. I felt this was the quietist approach to making pots, stealthily changing lives through balanced handles, grounding people through giving objects an appropriate weight, valuing the everyday. Why stand out when you could disappear? But my pots stood out in their quietness, mumbling really loudly, clutching.

I thought Chinese pots were quiet. I lie in my small room transfixed by embarrassment, by that earnest gaucherie of thirty years ago. Dear

God, I thought Chinese pots were *simple*. And I had so deeply absorbed the mantra of truth to materials that I hadn't noticed that the materials I was trying so hard to be true to were highly specific. And odd. Making these pots out of this stoneware clay, glazing them so doggedly with this midwinter palette of browns and greys and moss-greens was an exercise in attempting to get belief off the ground. If I could keep it going then I wouldn't notice that I was channelling an aesthetic from fifty years ago.

There is a moment when the idea that something is a vocation becomes so internalised that you end up a priest, a potter, a poet, and you are just too embarrassed to walk away. And you get caught. There is a bit in T. S. Eliot's *The Confidential Clerk* where Sir Claude Mulhammer, the old financier, confesses that he always wanted to be a potter, but failed from family pressure and anxiety: 'Could a man be said to have a vocation / To be a second-rate potter?'

My workshop was an old barn. I bought the wheels, ware boards, sieves and buckets from a failed pottery, too young to notice their relief as I counted out the £1,000 that I had saved, £20 note by £20 note. And I bought their old kiln bricks and spent a long summer building my own kiln, sawing a wooden former to create the arch of the kiln-chamber, trying to work out how high a chimney should be to create the pull of air to make the temperatures work. The local blacksmith made me metal ties to keep the structure together and soldered blowtorches to make basic burners for the propane gas I was to use for fuel. This came in tall and unwieldy orange canisters.

My kiln looked like a small chapel. I'd crawl inside to stack my pots on the three shelves at the back and two at the front, then brick up the front wall, leaving a couple of gaps as spyholes, light the gas so the flame roared into the kiln, fiddle with the air vents, the pressure gauges, the bricks at the chimney mouth.

There are electric kilns, which are like big cookers. You switch them on and they heat up and they click off. They can go wrong, but their wrongness is quite pedestrian. You can see the mistakes. And then

there are kilns which use wood or coal or gas to produce the heat through fire. And this brings a different level of unpredictability.

I hated it. Over fifteen, eighteen, twenty hours, I'd try and nurse the kiln towards a heat that would make my glazes melt, the colour of the clay change from grey. Firings scared me. The intensity of the fire, the knowledge of just how badly I'd built the kiln, the sound of the kiln straining, the need for this firing to work to make up for the last months, the malevolent lick of flame over my gloves as I pulled out test rings. I knew so little. I'd watch the colour of the kiln change from reds to oranges to yellow to a searing white. I was by myself.

And my Herefordshire tally comes to forty-two firings over two and a half years. Twelve total failures. Twenty mostly wrong and ten OK. So 2,500 pots out to sell, a few hundred chucked from the kiln mouth over the hedge into the stream. A couple of thousand or so broken up for shards. And a pathetic income. Soup bowls were £2.50 each. My girlfriend Sue in London bought a huge black pitcher. That was £12, full cost as she insisted on no discount.

I needed to leave. I needed to find somewhere cheap and far away. This led me to Sheffield.

iii

It was 1988 and the city was in a terrible way after a decade of decline in steel, the miners' strike. The city centre was full of boarded-up shops. In Page Hall, a hill of back-to-back terraced houses on the edges of Attercliffe where the last steelworks were being demolished, I found a house and workshop that had been used as a carpenter's shop. 128 Robey Street was the end of the road. Beyond was Wincobank, a hill of scrub and burnt-out cars. From the top you looked across the cooling towers to the M1 and Rotherham.

It was skinny at the front with a door that no one used, but round the back was a yard with a two-storey outbuilding, a raddled floor and a capsized roof, but enough space to build a kiln and make pots. My

neighbours were mostly Bangladeshi, one generation in, with a seam of old white Sheffielders to put me right on tea and politics and geography.

I rented a van and loaded it with my potter's wheel, and kiln bricks and clay and my books, and left Herefordshire. I was going to be an urban potter. I painted the floors of my house white, built my bookshelves out of pine planks and bricks and put my futon on the floor. I lived, I felt, in bohemian splendour, a tin chandelier in the kitchen and an old steamer trunk of my grandmother's for my clothes, but at almost thirty years' distance I see the squalor more than the bohemia. When I was burgled they took a metal bench for scrap and my stereo and two Hiroshige prints. Everything else, all the shelves of ceramics, shelves of Japanese tea bowls, my Hogarth print of The *The Distrest Poet*, wig askew, dog stealing the bone from his dusty garret, were untouched.

I knew no one. This was a place chosen because I knew no one. I got to work. As I was starting again, I chose white.

I ordered three bags of porcelain.

The very first pot I made at the end of this steep hill was a porcelain jar. It was an attempt to make a mallet jar, a *kinuta*, a form made in the Sung Dynasty and then revived periodically. It is a beautiful shape based on a mallet that you might use to beat cloth, a flared rim from a long neck that emerges from a swelled body.

The porcelain was sticky. It wouldn't draw up. I'd wanted to make a porcelain jar that floated, but this felt like being twelve again, in a school uniform with an apron, Geoffrey watching from his wheel as pot after pot folded under my touch, returning me to failure.

My jar was a few inches high, and heavy. I glazed it white.

I was twenty-four. Wayne and Ricky, brothers of twelve and ten from the next street, came around on the first day, looking for jobs, curious. They helped me unload the van. What's it all about? It was a very good question to ask anyone. It is a very good question to ask.

It is dawn in Jingdezhen when I start to count my Sheffield pots.

iv

I'm not sure if it's the monastic connection, thinking of Thomas Merton in his white robes, trying to make sense of the East from far away, but my Jesuit, Père d'Entrecolles here in the city in his black robes, seems very close.

I've read and reread his two famous letters from this city.

Being a Jesuit he was very good at detail – have you ever heard of a sloppy, disorganised Jesuit? – and his letters are immediate and wry and often very funny. He likes people, assesses them with candour, expects to be taken seriously, but I realise that I've been reading the letters for colour, for information, checking on how kaolin gets purified.

For three centuries they have been translated, gutted for information, quoted, misunderstood, returned to for gleanings. His thoughts and images recur. And his words too. He borrows *petunse* and *kaolin* from the potters here in Jingdezhen and these two namings of materials stay sentinel over the fierce attempt to find the Arcanum, the mystery of porcelain in Europe and America.

In this place which seems to be all about sending things far away, I'm thinking of him sending these ideas home.

v

I wonder how he felt here. Not homesick. It would be a trespass to suggest that he lies in his bed thinking of the greenness of Limoges where he grew up, that the rain sounds different *here* from *there*. It would be trespass to think that he knew of the white clays of home. But I know he had a very rough time when he arrived in China.

Père François Xavier d'Entrecolles was thirty-five.

He had entered the novitiate at eighteen and had been a priest for seven years, before being singled out for this mission. He landed on 24 July 1699 in Amoy. He had been travelling for eighteen months on a

succession of ships, starting in a convoy of the French king's led by the *Amphritrite*, stopping at the Canary Islands, then the Green Cape, a Portuguese archipelago to the west of Senegal, then round the Cape of Good Hope, Bengal – where he changed to the much smaller *Joanna* – on to Madras then Batavia, and finally, to China. Other fathers embarked or were left at ports along the way.

He writes to his friend in Lyons that Father Burin was fortunate to have died en route to China.

He lands. Matteo Ricci, the first great Jesuit missioner to China, a century earlier, had warned against his fathers having too much contact with Europeans. They should be amongst the Chinese for as much time as possible.

Some fathers were chosen for the capital. Others for the provinces.

Père d'Entrecolles was sent by himself to Jao-tcheou, a dozen miles from Jingdezhen. There was not a single Christian there and when he wanted to purchase a 'crumbling house to live in', there was opposition from the local Mandarins. The first Christian, he writes, was the builder who constructed the chapel.

It was imperative that the fathers learned both to speak and to write the language. Ricci warned that learning Chinese was not like learning Greek or German. It was *altra cosa*, something else. Ricci's own translation of Confucius' *Analects* and the *Great Learning* were used for language training for missionaries who had just arrived. This tells you everything.

I think of Père d'Entrecolles assailed by the noise of a new continent, its smells, the grip of the humidity on your limbs, hearing the rise and fall of voices, not knowing how to stand, or bow, or whether to look in someone's eyes, or avert your gaze, what the shake of a head means, how to eat, what this food is, what this food was. He is here and you are supposed to stay and put aside any thoughts of return to wherever home might be, whoever home is, and all that the rhythms of these night rains in July tell you is that you are you away, away, away.

vi

'One rain, and all the flowers gone / Third watch, and all the music still / except what strikes my ear and stays my sleep / from a windy branch / the last drops fall.'

Above all I think of this new language that Père d'Entrecolles has to learn. Merton called his night rain 'this wonderful, unintelligible, perfectly innocent speech'.

Chapter thirteen

Men in black

i

Know your witness.

It sounds so straightforward. Père d'Entrecolles isn't a footnote. What he saw and why he saw it is the story.

I want him out of quotation marks, away from the academic swell at the bottom of the pages of cultural history. The encounter between Jesuits and China has been firmly and repeatedly shaken down by historians of science, by Sinologists and by Jesuit apologists. It is a terrific story. But these shelves of informed, passionate reorderings of these decades are nothing to the walls of material, the scale of the writings of the Jesuits in China themselves. These are the books — pace them out. These are the archives — fathomless.

Did they do anything else? This is a real question. The imperative to write was central to a Jesuit's mission. Wherever you were — stuck in some remote part of a country or across the city — you would write letters and reports on every aspect of your spiritual and temporal life to your superior with regularity. Writing was an act of self-reflection, a

catechising of yourself before God. You write and you send. And you wait.

But you have not been sent to this country to have problems with your faith, though the fathers are pragmatic enough to know that this happens, but to be alive to knowledge, to look hard and note and learn, to order your thoughts and make them coherent. You are God's spy abroad in a new world. You are a witness. Write it down. Write it down with exactitude.

I find the only known manuscript of Père d'Entrecolles in the Jesuit archive in Chantilly. It is a couple of pages. And pleasingly, it is a listing of all the points he wants to make about his time in Jingdezhen, an index of his life in the city. He has beautiful handwriting. It flows.

ii

Père d'Entrecolles made friends. He made converts amongst the potters of Jingdezhen. He founded a school 'with small classes for the education of children', and wrote to Paris of how he longed for funds to create other schools: 'it would be necessary to pay for a good teacher, schooling is to be free; the master is respected by the parents and treated with honour'. The missionary would supervise both the master and the students. 'This teacher could also, by entering into contact with the families, encourage an appreciation for Christianity.' The children called him *Mr Dr*.

His Chinese was fluent. He wrote that he had been looking into some of the old books on the region in which he was stationed, the gazetteers which map the history and economy of the area, and making notes about what they say and what he sees. He was conscientious, so well regarded, that on 20 March 1707, though far from the capital, he was elected superior general for the Jesuit mission to China.

In other matters he was lucky. His luck came in another friendship, that of 'the mandarin of Jingdezhen who has honoured me with his friendship'. Lang Tingji was appointed governor of

Jiangxi in the summer of 1705 and stayed for seven years before promotion took him away; these seven years overlap with Père d'Entrecolles. There is a silk handscroll portrait of Lang sitting on a rock over a ravine in a pale blue robe that bunches up over his impressive paunch, leaning on one hand, the other nonchalant on a knee, and he radiates capaciousness. You look at him and think conversation. You look again and you see his astuteness. He knows the drop to his left.

Lang was adept. Every March and May he sent gifts to the Kangxi emperor of fine ink-cakes, a speciality of the region, a present suitably matched for a scholarly Son of Heaven. And the records show that the emperor gave Lang gifts of deer meat from the annual imperial hunting expeditions, an expression of favour in return. Through Lang, on the second day of the third month of 1709, Père d'Entrecolles sent the Kangxi emperor sixty-six bottles of wine 'and other imported Western

Silk scroll painting of Lang Tingji by Lu Xue, c.1697

rarities'. The emperor was very pleased, and told Lang that in future all offerings should be recorded in detail. This was noted in his vermilion endorsements.

The emperor got given a lot of presents, delicate scientific instruments and grand artefacts, inlaid and gilded and resplendent. It took a French priest in the provinces to send the emperor of China some wine.

Lang was born a bondsman, the class which the emperor favoured for complex assignments, and was the son of a governor, but his interests were his own. Lang loved porcelain. He 'makes for his protectors at court some presents of old-style porcelain that he has the talent for making himself. I can say that he has found the technique of imitating ancient porcelain, or at least of recent antiques. For this project he uses a number of workers', wrote Père d'Entrecolles.

So the Mandarin and the missionary looked at the city. One saw porcelain. The other saw people at work.

iii

The Mandarin saw possibility.

With an emperor who knows what porcelain can do, came the chance to impress. This was a city in the ascendant with new glazes, new porcelain bodies and new ways of decorating.

All emperors get porcelain made for them. Some care. Some don't. And no matter what the art historians say, imperial porcelain can be *exceptionally rare*, or *important*, but it can also be *vulgar*, or *odd* or just *banal*. With Kangxi porcelain, it is *informed*.

So for the sixtieth birthday celebrations of the emperor, Lang commissioned dishes. Where someone less adroit might go for, say, carp, Lang came up with a magpie and three persimmons, a malicious Ted Hughes magpie, red-eyed, guarding the fruit. And a dish of four geese, two eating, one looking up and one in flight. There were also dishes

and small saucers painted with peaches, the fruit so adeptly shaded that you feel your fingers hover.

These dishes referenced poems. The emperor writes and writes. To quote or allude was to bring yourself nearer to him. So allusions multiplied in the porcelains of these years, they glanced at poetry, or novels or philosophy, or they sat down, and illustrated. Some large vases have continuous narratives – imagine the action of unrolling a scroll so that you see one part of the story at a time. A vast phoenix-tail vase ascends from fisherman near the base, through mists and hills, streams, and waterfalls, geese flying, all the way to scholars in their craggy retreats. Others have panels, or reserves, in which actions can be placed like frames in a cartoon.

Older styles returned, but in moderation. And Lang encouraged skills. The copper-red glazes – known as *sang-de-boeuf*, or oxblood, in the West – were named *Langyao* after him. These glazes come near the top in terms of technical impossibility, layerings of clear and copper-rich glazes allowing for depths of colour.

Take this brush washer, made in the year of their meeting, one of a set of eight peach-bloom vessels for the scholar's desk, objects that would be arrayed for use and for contemplation as you drop water on to the stone, grind the ink, pick up your brush. The set are all curves, volumes that seem on the point of deliquescence like late summer fruit.

And the glaze named 'drunken beauty' in China, or 'peach bloom' by a Western scholar, softens the form even more. I don't want to think of the late-night glowing pallor of a drunk, so think of a peach. Really think of it, how the colour changes from yellows to pinks, blooms as imperceptibly as dawn, how the fruit gives slightly under your thumb. This glaze, too, is ludicrously difficult to achieve. Copper-lime pigment has to be sprayed through a long bamboo tube with a fine silk covering at the end on to a layer of transparent glaze, on to which you then put another layer of transparent glaze, before you fire it.

These effects are perfect for an emperor.

It is late porcelain. Forms are truncated or elongated, or transform demotic objects – chicken coops, turnips, horses' hoofs – into objects of princely contemplation. Here is multiplicity, a covered box with a hundred boys at their games, a vase spendthrift with butterflies, or extravagant simplicity.

It is partly the slipperiness of the surfaces. This is what porcelain looks like: figurative, decorative, colourful, and delinquent. Expensive.

Kangxi is late porcelain. It is clever and it knows it. It is, I realise, an idea of porcelain.

iv

My Jesuit looks across the city and sees the work.

He sees people so poor that their bones are buried in pits, rather than in tombs. He sees clay-makers who can't leave their compounding to come to church unless they can find someone to take their place. Cobalt-grinders grateful for work in old age.

He writes a letter about how things are made, but it is actually about compassion.

He is a witness. He is to stay in China for forty years until he dies. But he sends his letters home.

The *Amphritrite*, the ship that brought him to China, loads up to start the long journey back to France. It takes nine months and it arrives at Port Louis with letters from the Jesuit missions and bales of silk and lacquer and 167 crates of porcelain from Jingdezhen. This is advertised in the *Mercure galant*, the gossipy What's On for the court at Versailles. There is to be an auction.

New stuff from China.

Chapter fourteen

the emperor's Tea Set

i

I'm going home. I'm done.

I spent this morning interviewing two elderly men. They were both sculptors and both had created figures of Mao during the Cultural Revolution. It was an extraordinary few hours. I hope I can read my notes.

We are on the way to the airport. I hate to be late, really hate it, but my driver with his golden Mao is sanguine.

We stop in what might possibly be yet another research facility that the East Germans started and abandoned. I'm hopeful that there might be a plaque or a picture of First Secretary Walter Ulbricht. Name cards are swapped and amongst all the kitsch – vast porcelain vases with kittens – I catch sight of Mao's imperial Tea Set.

This is a great moment for me.

The Tea Set – it demands capitals – consists of an ovoid teapot, teacups on saucers, a sugar bowl, a coffee pot and a wine ewer and eight wine

cups, some cake plates and a cake stand. All in bright, radiant, good morning revolutionary-white with candy-pink sprays of peach blossom across each one. It is New Dawn, Great Leap Forward Porcelain, and it is unaffectedly suburban. That is, it doesn't look cheap, it looks Proper.

It looks like how the best china should look, something to put into a glass cabinet and bring out for guests. Nixon perhaps. Cup of tea, Mr President? A cake? Milk?

The story is this. Mao liked presents, like every emperor before him. And Jingdezhen, having offered tributes in the form of many hundreds of thousands of Mao busts, ceramic badges and plates with happy workers wending their way home from the steel mills, had yet to receive a specific request or commission from the Great Leader. So in the late 1960s the Jiangxi party started to think about what would be appropriate. A new seam of clay of startling purity had been discovered in Fuzhou in Jiangxi Province and this was mined, refined and prepared. Instructions were issued to the Jiangxi provincial party committee for the creation of 'new wares'.

Nothing was more important; the mission was assigned the number 7,501. It was Year Zero One for Jingdezhen.

The records tremble with anxiety. 'The organisation and management of the project is extremely tight. All personnel involved in the project have had strict political examination.' Checkpoints were set up.

Very quickly there was panic. The ten tons of raw materials were found to be insufficient and Red Guards were transferred to the project to speed up the refining. No one was allowed to rest and home leave was cancelled. Technical problems were judged as indicative of insufficient regard for the Leader. This is a crime punishable with death.

Then came the agonising decision about what they could make. Objects that were neither historicist (see what we have lost), nor scholarly (do you know what this unusual glaze is Comrade?). The porcelain could not be overtly decorative either. This was a revolution, so no vases and no goldfish bowls.

So it had to be useful and skilful and new: a tea set.

Twenty-two kilns were fired over the next six months and two sets of 138 pieces were finally delivered to Mao's compound in Beijing in early September 1975. He approved.

Mao died a year later. And the special seam of clay was sealed up for ever.

Which makes me happy. I'm finally on my way to the airport and I've seen his Tea Set at last. It is perfect imperial porcelain from Jingdezhen. And I smile over the sealing up of the seam of kaolin, an action that was historicist and scholarly, and utterly lacking in utilitarian purpose.

ii

On the plane back to Shanghai there is so much porcelain carried on by the passengers — in brocade boxes and wrapped in newspaper in plastic bags — that the overhead lockers are filled and the lavatory is requisitioned to store it.

I sit next to a charming man who works for the Pakistani air force who is on a six-week tour of military facilities. Jingdezhen makes helicopters, he tells me. He has bought a model for his five-year-old son, who he misses terribly, and shows me photographs of the boy clowning around for his father in bright sunshine. Then I realise why dozens of model AC313 helicopters have also been brought on board.

I'd missed the helicopter side to the city. He'd missed the porcelain.

Part two

Versailles – Dresden

Chapter fifteen

the latest news from China

i

I'm back in London. I unpack my six intact bowls bought in the market, the shards picked up on the hillside, my lump of kaolin from my first white hill and arrange them on my desk. I shuffle them: the life history of an object.

And I'm full of plans for my second hill, my second white pot, the next part of my journey following the trail of porcelain. I need to get to Dresden, the city in which the mysteries of porcelain were uncovered at the start of the eighteenth century, as soon as I can. To get there, I am starting to realise, means a dogleg through Versailles and the court of Louis XIV. I'm tracking the Jesuits and this is where they are, this is where ideas and images of China come into focus. And because this is where porcelain is talked of, I need to listen.

I have taken to writing on my white studio wall. There are swooping arrows for the journey that I've taken so far, and dotted lines for what is to come, the months of my journeys crossed off, lists of books to reread and books to buy. My map of white porcelain is becoming less legible. Sometimes I think it is like a blackboard in some MIT lab,

clever and suggestive. Today, in high spirits, it looks like a weather system coming in, unsettled ahead.

In the studio I look round and I'm not sure if anyone has noticed I've gone and returned. The studio hums. A maquette of the gallery in New York where I'm exhibiting in eighteen months has been delivered. The gallery is huge and so is the model. It reveals in intimidating detail just how much there is to do. There are the new glaze tests out of the kiln arrayed on a long table. I'm hoping to extend my range of whites, but these are pallid hues, not full whites, and nowhere near what I need.

I have the latest news from China. I have porcelain and I have photographs and interviews.

Big deal. The bookshop in Shanghai airport had twelve shelves of new books on China, five of which were about how to do business there and a couple on understanding the Chinese Character. There is a television documentary on labour conditions in electronics factories in Shenzhen tonight. The auction houses say that Chinese art is the next thing, billionaires buying back their patrimony for their private museums. Ai Weiwei is exhibiting at the Venice Biennale and is under house arrest in Beijing.

Everyone who comes back has news from China.

 ii

China illustrata. Sapientia Sinica. Nouvelle relation de la Chine. Carte nouvelle de la Grande Tartarie. Un jésuite à Pékin: Nouveaux mémoires sur l'état présent de la Chine. Etat présent de la Chine. China Illustrated. The Meaning of Chinese Wisdom. A New Report from China. A New Map of Tartary. A Jesuit in Peking: New Memoirs on the Present State of China. The Present State of China.

And from the mathematician and philosopher Gottfried Wilhelm Leibniz, *Novissima Sinica*. The *very* latest news from China.

It is 1690 and in Paris and twelve miles to the west in Versailles, every-one has news from China. Some of it is partial. Some conjectural. Some is even true. Not only does everyone want a bit of China, every-one wants control over a bit of China. And to understand porcelain you need to piece together the fragments of story and news that men-tion where and how and why it is made.

You write a letter home from the missions. But who reads it? It is news for whom, exactly? Who opens the Jesuits' letters? How are they received in Paris?

They are received with avarice. They are exhausted, wrung out. They are rewritten. At each point on the journey documents are examined for knowledge that would be of use to the community itself – the letters' primary function was to act as a way for the Jesuits, dispersed across the world from Mexico to Macau, to overhear concerns. There is 'special care' taken of letters from the foundation of the Order in the 1540s 'that in every place they should know about the things that are being done in other places, which knowledge is a source of mutual consolation and edification in our Lord'.

This, though, is only the start. Then these letters would be edited for publication for the world and tidied up, sometimes ascribed to a par-ticular father, sometimes the names of the fathers become *by various hands*. This is the Jesuits' intellectual force: their capacity to reach fur-ther into China than anyone else can, their resolve in using their mis-sionaries, their skill in calibrating what these men study, how they write home.

In Paris a young king keeps track of this young emperor in China. The new Académie Royale des Sciences, established early in his reign in 1666, listed questions for a Jesuit expedition to China:

> Whether the reverend Jesuit fathers have made any observations of longitudes and latitudes of China . . . About the sciences of the Chinese, and about the perfection and defects of their mathematics, astrology, philosophy, music, medicine, and

pulse-taking . . . About tea, rhubarb, and their other drugs and curious plants and whether China produces some kind of spices. Whether the Chinese use tobacco.

Someone is asking questions and these letters home are responses.

From early in Louis XIV's reign there has been constant traffic of news and conjecture, a back swell of flattering comparisons. Leibniz, busy around the courts of Europe, makes direct parallels between Le Roi Soleil and the emperor, the Sun King and the Son of Heaven. Around the king and his advisers there is an overlapping babble of voices, rumours of discoveries, theories as to the meaning of Chinese rites, architecture, moral codes. The books tumble out. What you can tell the king about China and how you can massage it gives you an edge.

Father Joachim Bouvet, two years journeying back to France from the Chinese missions, eagerly jumps overboard into the surf and struggles to the shore with his packet of letters from Beijing, leaving silks, porcelains, tea on board. He knows what is most important. 'If these two great monarchs knew each other', writes Bouvet in October 1691:

> the mutual esteem they would have for each other's royal virtues could not but prompt them to tie a close friendship and demonstrate it to each other, if only by an intercourse in matters of science and literature, by a kind of exchange between the two crowns of everything that has been invented until now in the way of arts and sciences in the two most flourishing empires of the Universe.

He works up his *Portrait historique de l'empereur de la Chine* with a dedication and presents it to the king.

This is the point. If Louis XIV understands the character of the Kangxi emperor, France will be blessed by having direct knowledge of the secrets of China, the Arcanum of the East. These secrets are intellectual and they are mercantile and they are very practical and they include the glorious secret of how to make porcelain.

And if the Kangxi emperor understands and respects the king of France, then China will see the light of Christ.

And all this activity around China, says Leibniz with beautiful concision, writing to yet another French Jesuit, is '*un commerce de lumière*'; enlightenment stretching both ways. This is a tremendous idea and a beautiful image, one of an equality of concerns, a correspondence of civilisations, of light.

As Leibniz writes to his friend Sophie, the wife of the elector of Hanover:

> I will thus have a sign placed at my door with these words: bureau of address for China, because everyone knows that one only has to address me in order to learn some news. And if you wish to know about the great philosopher Confucius . . . or the drink of immortality which is the philosopher's stone of that country, or some things which are a little more certain, you only have to order it.

He is one of the gatekeepers. If you want to know about Chinese mathematics, the *I Ching* as a coding of chance events, Chinese characters and their relationship to hieroglyphs, you go to him. Leibniz has been to visit Father Francesco Grimaldi in Rome, just back from the emperor Kangxi's court, and written up copious notes on fireworks, glass and metal. I realise to my surprise that my hero, the father of rationalism, is anxious to keep ahead in this new, congested field of China Studies.

iii

How do you convert the emperor of China? By surrounding him with the evidence of rationality. Or by making yourself indispensable.

For the century from the first Jesuit landing in China to Louis XIV taking his throne, the Jesuit fathers bring tribute from European courts

to the Chinese courts: presents of clocks that chime with Chinese melodies, pictures that reveal gardens stretching into the distance through glorious, unknown perspective, prisms to send rainbows across a room. These are held in special regard: 'a Tube made like a Prism having eight Sides, which, being placed parallel with the Horizon, presented eight different Scenes, and so lively that they might be mistaken for the Objects themselves: this being joined to the variety of Painting entertained the Emperor for a long time'.

So they get kaleidoscopes too. But however delightful these *objets* are, you can be sure that the Son of Heaven has palace stores stacked with other diversions.

So visitors to the court bring the theatre of knowledge. Sextants, astrolabes and armillaries, telescopes; instruments that have to be demonstrated. They present the spectacle of geometry and astronomy to people who are steeped in these arts and want to know more, ask searching questions. By the time that the fathers come to China, there has been a board of astronomy for 1,600 years and an astronomical observatory for 300 years. The concept of space in which heavenly bodies float has been established, and star maps and globes created centuries before those in Europe. The work of the great Arabic astronomers has been studied and absorbed. During the last few generations there has been a falling off in this knowledge.

It is accuracy that is offered. The Jesuits' instruments allowed for their unerring calculation of both lunar and solar eclipses. There could be no more visible manifestation of their abilities than to predict and watch a shadow steal across the sun or moon.

'Thus the Holy Religion', writes the astronomer and Jesuit Father Ferdinand Verbiest, who has won the ear of the Kangxi emperor, 'makes her official entry as a very beautiful queen, leaning on the arm of Astronomy, and she easily attracts the looks of all the heathens. What is more, often dressed in a starry robe, she easily obtains access to the rulers and prefects of the provinces, and is received with exceptional kindness.'

The young, scholarly Kangxi emperor is passionate about how things are made. The emperor asks this father, while he has time, to design a cannon and he agrees. And this new instrument is soon put to use and they work well.

There is self-interest in most things, but this makes me wince.

And I think of Père d'Entrecolles, sending him some wine with even greater pleasure.

iv

So to the news.

Kangxi is studying with zeal.

> That prince, seeing all his empire in a profound peace, resolved, in order either to amuse or to occupy himself, to learn the sciences of Europe. He himself chose Arithmetic, Euclid's Elements, practical Geometry, and Philosophy. F. Antoine Thomas, F. Gerbillon and F. Bouvet had orders to compose treatises on these matters . . . They composed their proofs in Tartar . . . The fathers presented these proofs and explained them to the emperor, who, understanding easily all that was taught to him, admired the solidity of our sciences more and more, and applied himself to them more and more.

Lessons in mathematics are held daily.

Tutoring takes place in the Great Interior, the Hall of the Nourishment of the Mind, located in the western part of the Forbidden City. This is close to the Imperial Workshops, 'the location of His Majesty's Academy of Arts'. Bouvet says that the emperor wanted to have more Jesuits working for him 'in order to form in his palace, with those who are already there, a kind of academy subordinate to your Royal Academy'.

Père Jean-François Gerbillon: 'We were shown into one of the Emperor's suites, named *Yang sin tien*, in which some of the most skilled craftsmen, painters, turners, goldsmiths, coppersmiths etc. work.' These ateliers produce maps, bronzes, jade, gold and wooden objects, cloisonné enamels and armaments.

The emperor wishes to improve glass manufacture in China. Are there any fathers who understand glass? Can we find someone quickly for Him?

The emperor takes lessons on the harpsichord. A visitor hears him playing a 'Western iron-wire zither with one hundred and twenty strings, made in the palace workshops'.

The Son of Heaven, 'having much suffered from his upheavals in his family and palace, fell ill and as Chinese medicine didn't manage to heal him, he had recourse to Brother Rodes who succeeded at the beginning to make his palpitations stop and then to heal him, thanks to the wine of the Canaries'.

Following his return to health, on 20 March 1692 there is to be an Edict of Toleration, allowing Christians to worship freely.

The French king is to send the Chinese emperor what he desires.

Chapter sixteen

the porcelain pavilion

i

Versailles is desire realised. It is also crowded and jostled with need that can find no satisfaction.

As in the court of the emperor Kangxi in Beijing, there is a press of people hoping for preferment. Everyone comes to Versailles. There are nobles, and ambassadors, cardinals and legates and monks, and courtesans and itinerant philosophers. How do you get the ear of a king who has decided to rule without a council? Through his Jesuit confessor? Or through his current *maîtresse-en-titre*, a hunting companion, his architect? Each of these people has access of sorts, but how do you persuade a man to do anything for you, give you a position, when he has no needs? You wait as he passes on the way to the chapel in the morning and cough and hope to catch his eye.

Jean-Baptiste Colbert, Louis' formidable minister of finance, is said to be the only man who can talk to him straight about how the money works, how to pay for palaces or cannons. Everyone else works by a delicate gavotte of suggestion.

So you lay things at his feet. Alongside all the news you bring stories, or music, yourself.

Or you bring objects. You come like the embassy from the king of Siam, heralded by trumpets, with tributes of gems, tortoise shells, lacquer furniture, bronze and silver and 1,500 pieces of porcelain, a procession of notables up the Escalier des Ambassadeurs, under a new and splendid glass roof, so that the sun illuminates your entry.

You arrive in the newly completed Hall of Mirrors. This hall is 240 feet in length of glittering reflections, silver tables and gilded statues holding candlesticks with martial triumphs painted above. You are dressed in ikat robes, you wear conical hats. You lay treasure and then more treasure before the king on his throne. *More* works well with Louis.

And this palace is a satiety of sound and texture, a *galerie de bijoux* for the gems from Siam, galleries of pictures and statues and tapestries. But all this news from China of an emperor in his palaces attended by workmen who can fashion anything from jade or gold, of the king of Siam with his storehouses of gems and porcelains, is provocative. It is not that Louis wants to emulate these potentates, for that implies a relationship of deficiency rather than equality, or indeed superiority.

It is that he wants new places to stage desire.

ii

Chinese porcelain arrives at Versailles. The rooms of the son of the king, the grand dauphin, have 381 pieces of Chinese porcelain according to a sumptuously illuminated inventory of 1689. Number 111 in the inventory is '*Un Vase couvert en forme de Buire de Porcelaine*', the Gaignières-Fonthill vase, not yet named, another treasure amongst all the other clotted treasures. Number 112 is a gourd, dead-leaf colour, decorated with white flowers. Number 113 another. The lid is broken.

And images of porcelain arrive at court too, including the first pictures of the odd, spiky porcelain pagoda of the emperor Yongle. Nieuhof's

book has been published in Dutch and then French, in German and Latin by 1656, and finally, in English. There are 150 illustrations, real pictures rather than conjectural whimsy. In the book the pagoda is rising high above knots of tiny people with parasols, bowing formally to each other, mountains framing its distinctive profile. Pagodas start to sprout up in the most surprising places, copied in cobalt on to blue-and-white dishes for export from Jingdezhen, then turning up in the background of fantasy Chinese landscapes amongst the willows. The Delftware factories in the Netherlands start to create pagodas as tall as a man for tulips, turning window apertures into slots for one glorious parrot bloom after another.

And the new *French Dictionary*, just published by the academy in 1688, rhapsodises over the pagoda: '*Il y a dans la Chine une Tour appelée Tour de porcelaine*', this porcelain tower is one of the wonders of the world. 'All of the pieces of porcelain are inlaid with extraordinary craftsmanship, so much so that the joins are barely visible.'

Mme de Montespan, Louis' *maîtresse-en-titre*, is witty and beautiful and needs diversions. She needs to be taken away. So the king builds her a porcelain pavilion, the Trianon de Porcelaine, a place that they can escape to for intimate dinners, for music, for making love in a Chinese bed below a ceiling painted with Chinese birds. And that is it. A building to take you away from the dogged, costive formalities of court into a space that has a different emotional register, an altogether elsewhere. It is a mile away, a mile of slight delay.

Louis Le Vau, the king's principal architect for his palaces, designed a central single-storey building five windows in width, flanked by two smaller lodges, set in a walled garden. The pavilion had a high mansard roof on the ridge of which ran lines of small blue-and-white vessels. Other urns punctuated the facade and there were panels of tiles with scenes of oriental luxury. Inside the fantasy took hold. There are a few contemporary engravings of it, and if you disregard the filler stuff of courtiers on prancing horses and stray dogs in the foreground, the impression is of a low, handsome building with lots of pots stuck on to it.

It isn't a pagoda at all, of course. But it *is* a pagoda, in that it is outside, singular, peculiar and terribly expensive. And an absurdity. What are all those pots doing roosting up there, and there, and there?

And the urns and jars are not porcelain either. The pots were Dutch faience, decorated to look like Chinese porcelains. The problem is that the French can't make porcelain. They have to buy it, or be given it, and even with the great minister Colbert's stern prohibitions against foreign goods, faience from Delft alongside French ceramics has had to stand in for the real thing.

The Trianon de Porcelaine was thrown together, and was damp from the start.

There is a dip in the ceiling. Faience isn't normally supposed to be outside in rain and ice; the glaze starts to shiver and peel. Tiles slip on the plaster and lath walls. You might not notice this by candlelight, as the music soars and returns around you and your lover, but fantasy can be a little ramshackle at dawn.

Not much is white here in Versailles, but the ermine hem of a gown, the face of an actress, lead-white, light up the glare from the banks of candles on a stage. The glass ceiling over the Escalier des Ambassadeurs leaks too.

Etching of the Trianon de Porcelaine, Versailles, c.1680

Chapter seventeen

cream-coloured, provincial and opaque

i

I'm here in Versailles because everyone else is here. I list my Jesuits first, then my philosophers. And then the rest. Finally I add the younger sons from royal households on their *Wanderjahre*, their gap year from court.

The seventeen-year-old Prince Augustus of Saxony, removed from Dresden because of a liaison with a lady-in-waiting, arrives in Paris on 14 June 1687. He is travelling under the name Graf von Leisnig. This journey is in order to perfect his princely virtues.

Prince Augustus stays for three months. Two fifths of his allowance goes on wine and a fifth on clothes. God knows how much goes on women. He visits Versailles and is received by the king. He is taken to see the Trianon de Porcelaine in its disrepair. A decision is taken early in July to demolish it, to make way for a new Trianon in pink marble and golden stone. For a different lover. Augustus is just in time.

Colbert announces that he intends there to be porcelain made in France. He doesn't care if it is *contre-façon*, counterfeit, fake. He wants *porcelaine.*

Colbert, brilliantly, has analysed how money can be raised through investment in the commodities that bleed the king's coffers dry. Alongside the five trading companies that are to span the world, including the Compagnie des Indes Occidentales and the Compagnie des Indes Orientales, he has set up companies or given support for their foundation.

Mirrors, for instance, are a monopoly of the Venetians, and hence punitively expensive, so he establishes the Manufacture Royale de glaces de miroirs, which not only supplies the mirrors for Versailles, but garners customers. The Siam embassy orders 4,264 mirrors to be shipped back, alongside telescopes, two globes – one terrestrial and one astral – harnesses for elephants, and pleasingly, seven large rugs from the royal carpet-manufactory at Savonnerie. Tribute one way becomes income the other.

Royal privilege has been given to the Reverend family who establish themselves at Saint-Cloud – a useful distance between Paris and Versailles – to 'produce faience and to imitate porcelain in the manner of the Indies'.

The king's brother, the duc d'Orléans, has his palace at Saint-Cloud, and starts to fill both the Palais Royal in Paris and his country seat with porcelain.

At Rouen, they are achieving porcelain of a kind. A factory there has also been given a royal privilege. They too have 'found the secret of making true Chinese porcelain'. It is blue and white – a good clear white – but the materials they are using are deficient. As no one knows what the true constituent elements of porcelain are, you have to trial diverse materials. This means adding various kinds of ground glass to the clay in order to achieve a simulacrum.

Saint-Cloud porcelain is warm and milky, slightly ivory, sometimes white, depending on the economies in materials, or in milling, or the fuel they use. These kinds of porcelain are called 'soft-paste porcelains'. Their glazes are easy to scratch.

And they are not translucent. Their opacity is a rebuke.

These *contre-façon* porcelains with their grotesques and arabesques painted in cobalt blue — an urn sprouting flowers that swag down to a Chinese roof, a bough turning into a winged woman — are Edward Gorey porcelains. Everything looks pleasant on the surface. You look again and everything is slightly wrong.

iii

I'm stuck on the description by Colbert of this porcelain as *contre-façon*. It suggests passing off one thing as another.

I keep coming back to it. It takes me uncomfortably back twenty-five years to the end of my Sheffield street as I try out my new white. What am I going to make now that I have abandoned the countryside for an urban life? No one needs pots here. *Jobs* would be useful.

I am going to make kitchen porcelain, try and make ordinary things out of this extraordinary material. I make bowls and mugs and large coffee cups and saucers, espresso cups, ginger jars. This is my project. It does not come easily, as porcelain is both too facile, it slips between your fingers like water, and deeply intractable. The longer you spend working on a pot, the less it responds.

And because I've read Edward Said on orientalism, I'm not interested in authenticity, per se, just a conversation with the Orient, the elsewhere that I love. So I don't decorate them. I've put away childish things — the orientalist shorthand of willow trees, a branch of something — and I start impressing seals into the wet clay.

In studio ceramics there is a tradition of putting your personal seal on the base of the pot, and sometimes a studio mark to show where you

made it. Bernard Leach had *BL* and *St Ives*. I have had *EdeW* and, briefly, *Cwm* to register my habitation on the wet Welsh hill. Now I push a Japanese seal, *made in the West, discount ware*, into my pots. My attempt at an Empire of Signs.

Show your workings, said the exam papers at school, show where you have come from, your pathways.

This is belated adolescent white. Lonely white. Impatient for grandeur, and complexity and transcendence, white.

If you picked up my Sheffield porcelain, you would work this out. An elderly friend, a Viennese émigré photographer who lived in mono-chromatic austerity drinking and eating only off the pared-down por-celains of Hans Coper and Lucie Rie, examined my bowls. Tell me dear boy, voice lowers and strengthens, the 'w's plosive 'v's, *vy the veight*?

The weight, I say twenty-five years too late, was not my intention. They were not light, porcelain is light. They were rarely translucent, porcelain is translucence. And they were not particularly white. I'd built my own kiln again for reasons of desperate economy, and I struggled to get it to fire to the high temperatures necessary to give porcelain its salient qualities, 1,280 degrees Celsius and above. The hours would unravel, expensively, roaring with yellow heat.

Porcelain is the promise. It takes me away. Up the road and through the demolition sites of Attercliffe, past the building site where they promise the biggest shopping centre in England, on to the motorway at Junction 31 and four hours down to London in my van to see my girlfriend, to take my porcelain to the shops and galleries. I am twenty-four and I make Sheffieldware.

It is cream-coloured provincial porcelain, *contre-façon*.

iv

The Grand Colbert for all his icy brilliance is nowhere near discovering the Arcanum, laying true French porcelain at the feet of his king. You

can put as much money into the project as you want, but it remains earthbound. It does not ring true. In the factories at Rouen and Saint-Cloud they are missing something crucial.

Colbert has, however, found a young tutor for his son, a mathematician from a good aristocratic family in Lusatia, on the border with Poland.

And this is where the story lifts into the air.

This young man with the unwieldy name of Ehrenfried Walther von Tschirnhaus is my next witness, my next lead in the journey into porcelain.

He has come highly recommended to Colbert by both Leibniz and by Baruch Spinoza, the Dutch philosopher and grinder of lenses. Colbert is exacting in all things, from taxation to the maximum number of hours it is possible to work in a day. He insists that the members of the Académie française arrive on time and are not allowed to leave before the cessation of the session. Colbert likes the idea of this severe young man named Tschirnhaus, and is pleased that 'his ignorance of the French language would compel him to speak to his son in Latin'.

Chapter eighteen

opticks

i

So I put a portrait of Tschirnhaus on my wall. I'm not sure how accurate it is. He has a high forehead and a good, direct stare, but the engraver was mostly interested in his wig. I wonder if I will call him Ehrenfried, or Walther, or if he is to be Tschirnhaus. We stare at each other.

The young German mathematician was also twenty-four when he reached Paris and his first position as tutor for Colbert's son. To be a mathematician, a philosopher, an enquirer into the properties of the world, you need someone to support you. You cannot be brilliant without a sponsor. Tschirnhaus was adept at making friends, good at learning how to create an impression, the result, I am convinced, of being the seventh child in a family.

He was the youngest son, born on the family estate in Kieslingswalde, Germany. It wasn't a grand house, more old rectory than schloss, comfortably set amongst the rolling Silesian hills and birch woods. And it was a modest household, the family unusual amongst their neighbours in their fierce attentiveness to education — something due perhaps to the mixture of a Saxon father and a Scottish mother. Unlike

other boys who could have spent their hours fencing and hunting he was given private lessons in mathematics. At seventeen he left home for the University of Leiden to study medicine, mathematics and philosophy. It was at Leiden that Tschirnhaus met Spinoza.

Spinoza was the exception to every rule. Spinoza had given away his patrimony to his sister, was independent of patronage, expelled from the Jewish community of his birth, excoriated by the Christian, he was living as a private scholar, making his living from grinding lenses. Imagine meeting him as a young man. His writings strip away your remaining pieties.

Spinoza gave Tschirnhaus his first letters of introduction. They were to the secretary of the Royal Society in London and to Isaac Newton. He was on his way. For four years he travelled in Holland, Italy, France,

Tschirnhaus, 1708

England and Switzerland, a series of extraordinary encounters with philosophers and ideas. And it also feels slightly enchanted, one letter of introduction leading to another, one door opening to a year in Paris with Colbert, another to a visit to one scientist in The Hague and then to another in Milan until you see a beautiful diagram, a map of thinking about the world.

If x means y, go to z.

Tschirnhaus began work on his first mathematical equation, *A method for removing all intermediate terms from a given equation*. He published it in the *Acta Eruditorum*, the journal of empirical learning across Europe. These are four pages of brilliance in which he takes on algebraic equations and sets down 'some things concerning this business, enough at least for those who have some grounding in the analytic art, since the others could scarcely be content with so brief an exposition'.

Idiotically, I buy the Latin exposition of *The Tschirnhaus Equation* from a bookseller in Amsterdam, and in one moment prove how caught up I am in the world of ownership when his exposition is about thinking, simplifying, lucidity, cutting away the extraneous. It is about brevity.

I pay far too much. Who else wants these four pages?

ii

Tschirnhaus's journey towards his discovery of porcelain is a series of reflections and mirrorings.

Optics are at the heart of debate because light is a problem. How does it move? How fast does it move? Where does the heat come from? Lenses and mirrors are provocative artefacts, bending and intensifying light, exploding distances, bringing planets and dust into focus. Porcelain is white and hard but lets light through. How can this be?

Caute, be cautious, says the ring on Spinoza's left hand in his room in the village outside Leiden. He grinds his lenses, day after day,

deepening then eliding the curves, working out his problems as the fine white silica dust settles on the bench. He has written, amongst everything else, on the rainbow.

Light causes fearsome argument. No one can agree.

Isaac Newton's *Opticks, or, a Treatise of the Reflexions, Refractions, Inflexions and Colours of Light* examines the question of how light is not modified, but separated:

> I procured me a Triangular glass-Prisme, to try therewith the celebrated Phaenomena of Colours . . . I have often with Admiration beheld, that all the Colours of the Prisme being made to converge, and thereby be again mixed, reproduced light, intirely and perfectly white . . . Hence therefore it comes to pass, that *Whiteness* is the usual colour of *Light* ; for, Light is a confused aggregate of Rays indued with all sorts of Colours, as they are promiscuously darted from the various parts of luminous bodies.

Newton writes to Leibniz: 'I was so persecuted with discussions arising from the publication of my theory of light that I blamed my own imprudence for parting with so substantial a blessing as my quiet to run after a shadow.'

To be a young philosopher is to be part of this turmoil and it seems that everyone on his journey across Europe grinds lenses, dreams of telescopes, writes about prisms and rainbows, sends instruments across the world to delight the Chinese emperor, makes mirrors or employs them to create great heat.

In Lyon Tschirnhaus meets François Villette, the inventor who has demonstrated a great burning mirror in the Petite Galerie at Versailles in front of the Sun King, illuminating the whole room using only the mirror and a single candle. In Milan, Tschirnhaus recounts to Leibniz, he has spent time with the scientist and mathematician Manfredo Settala who uses burning mirrors to melt materials, and has talked to him of its potentialities for ruby glass and porcelain.

For a lay audience, the burning mirrors are spectacle with the power of the sun brought into close and exhilarating contact, the surfaces of the mirrors 'so accurately formed and so well polished that a piece of lead or tin placed in the focus began immediately to melt, stone and slate became instantly red hot, pumice stone melted, and copper and silver melt in five or six minutes . . . wet wood kindled in an instant, water in small vessels boiled'.

There is terror too in this sublimity. You see the way that materials change in front of you, impossible to experience if the substances are shrouded in fire inside a furnace.

So Tschirnhaus, young and engaged, works away at the issues that vex his contemporaries, writing on catacaustic curves, 'the envelope of light rays emitted from a point source after reflection from a given curve'. And, of course, he starts to make his own lenses. He is starting to focus.

iii

And I have to focus too.

I'm writing this in the very early morning. I can't sleep at the moment, so I'm sitting at the kitchen table at five with a blackbird noisily announcing itself in the garden. It is August and there are chestnut trees in the road outside the house in full pomp, so that the light that comes in is dappled. The glass in the windows could be a little cleaner. There is a water jug on the table, and I'm watching the light play on the wall opposite me, and there are shudders like ripples in a stream, and a rainbow and great Gerhard Richter-like smudges across the top that move across an installation I made last year for Sue, seven stacked dishes inside a white lacquered cabinet. The top dish is gilded on the inside so that there is a reflected halo above it.

I don't know what is going on with light at all.

I want to draw lines across the kitchen, sweeping parabolas across furniture and floors, mark the changes minute by minute by minute.

I do know that light is demonstrably an area for the 'investigation of difficult things by the Method of analysis', as Newton memorably put the challenge of scientific experimentation. This is simultaneously an arena of poetic and metaphorical possibility. Spinoza, after all, has compared human nature 'with a regular or flat mirror that reflects all the rays in the universe without distorting them'. Newton has wondered whether colours and the musical octave might be analogous. Do colours have harmonies?

If so what is the sound of white?

My only certainty, buoyed by sleeplessness, is that light is part of this journey towards porcelain. Keats wrote in the margin of his copy of Milton's *Paradise Lost* of 'A sort of Delphic Abstraction a beautiful thing made more beautiful by being reflected and put in a Mist.' By which he means, I think, I hope, that he too sees the beauty and is thoroughly confused.

I am caught up in my weather system, the turbulence of optics and mirrors and philosophers.

Chapter nineteen

the first mode of formation

i

To grind lenses you need to understand optics. To make lenses you need to understand glass and glass seems to be the pathway to porcelain.

To make a lens of scale, you need technical brilliance in casting glass and in mathematical ambition in working out the equations for the refraction. But it also means you need to understand how to communicate what you need to others. This is far from the experimental grinding of your own lenses at your own bench in your own study, turning it in your hand against the stone as the silica dust rises to you as you breathe, and settles.

The acknowledged expert on glass was Johann Kunckel. He had translated and added to the great Italian textbook on the art of glassmaking, *Ars vitraria experimentalis oder Vollkommene Glasmacher-Kunst*, with its beautiful engravings of glassmakers in their workshops. Kunckel had held the position of court alchemist in Bohemia and Dresden, as well as Berlin, and taught at the university in Wittenberg. Rather too many positions. He was an exemplar of how hard it was to be clever and still be in need of a patron.

His career had been spectacular. When he was thirty, Kunckel had been entrusted with the keys to the alchemical library of the elector of Saxony in Dresden and told to find the secret of making gold. Instead, he found a way of making red glass with a new solution where metallic gold particles are dispersed so that the light turns red. On page 195 of his great book he coughs, and you see his mixture of pride and anxiety:

> Here I wish to indicate a better way, and to briefly teach [the making] of red or ruby glass, if it were not regarded as such a peculiar rarity by my gracious elector and master. Whoever does not believe that I can do it may come and see it. It's true: for now it is too rare to communicate.

Red glass is spectacular. A vessel of red light! 'It cannot be more beautiful', wrote Kunckel.

His first masterwork was a red chalice made for the elector of Cologne; it's over an inch thick, 'the stem of a very fat knot', and twenty-four pounds in weight. This glass could be blown so thickly that it can be cut and faceted like an enormous ruby. There was a rumour that blood was involved in the manufacture. Imagine the archbishop at early morning Mass holding up the chalice; what is being transubstantiated in this light?

Augustus the Strong had ruby glass in his *Schatzkammer*, his treasury in Dresden, mounted in gold at foot and rim to hold the vessels clear of the dust and ground. They were placed near the ivories and enamels and Chinese porcelains.

Kunckel was now in Berlin. He was sixty, a difficult age to be so shadowed by fame and by bad luck. His glassworks had burned down and he was out of favour with Berlin and was meant to be paying back his new patron his vast salary received on the promise of glass and gold. Glass is esoteric. Kunckel was working away at it from a small island near Potsdam; a place to keep secrets.

Tschirnhaus learns a great deal from Kunckel. He sees ways of melting and refining and transmuting, sees a blowpipe that glassmakers use to produce a 'very fine and concentrated flame'. He understands that 'many possibilities are concealed in this art'. He sees furnaces that are well constructed, materials that are properly graded, workmen who know what they are doing, move through a congested workshop with crucibles of molten glass. He sees process and result, testing and recording, idea and action, conducted in a complex, noisy workshop not in private.

And he also notes that the lives of experimental philosophers, men attached to the courts of difficult, irascible rulers, are never secure in their positions, that making ruby glass – or any object of desire – is never enough.

So as Tschirnhaus watches men at work, their fluency in movement, he makes notes. And he writes 'No artisan is unaware why he carries out a task, and it is no secret to him that certain materials and efforts are necessary to him even if he does not know that philosophers call these things causality.' Tschirnhaus comes to understand haptic knowledge, the ways in which it is possible to know something complex without having the need, or the means, to articulate it in language, 'a person can perform intellectual and other operations without knowing how they actually work'.

Tschirnhaus frequently gives the example of the way in which we use our hands without any knowledge of their physiological structure. Thus we can admire the manual ability and skill of a watchmaker who does not know anything at all about the *way* in which his hands function, but is still creating an object of true complexity.

Where others might not pause, Tschirnhaus pauses. Where others might patronise those who make something, Tschirnhaus shows respect.

He has made the extraordinary step of watching how objects are made and he has learnt from this. And now all he needs is money for a tremendous idea that is coming into focus, the idea of creating porcelain.

He is not poor. He is married and his wife Elisabeth Eleonore von Last is redoubtable. His father has died and he has inherited the family woods and fields: she has said that she will manage the estate for him. He could return to a life of dilettante experimentation in Kieslingswalde – shoot hares, write letters, note possibilities for the composition of porcelain, check astronomical positions with his telescopes and send them to journals – but this would mean that his Idea was rehearsed on walks in damp Silesian fields.

He turns back to Paris.

He has been writing *Medicina mentis sive artis inveniendi praecepta generali*, Medicine for the Mind, or General Precepts for the Art of Invention. It is a passionate and lucid book on the art of perfecting 'our understanding as best we can', and he hopes that a dedication to Colbert might result in something. But his mentor dies just as he arrives. Tschirnhaus is named the first German member of the French Royal Academy of Science, a distinction cited in the *Mercure galant*, but there is no stipend forthcoming, no folding into a position in the intellectual life of Paris. Tschirnhaus dedicates his book to the king anyway.

There is a plump Pegasus in flight across the title page, a baroque mane and an extravagant tail streaming behind. I feel this is a kind of self-portrait but the thirty-seven-year-old Tschirnhaus is barely off the ground.

ii

If you are interested in optics or mineralogy or funding a dictionary of philosophy, you are lucky to get two minutes of the attention of a margrave who lives for killing stags or boar in inventive ways. You are in some endless corridor of some windy schloss, and there is the clatter of men, scratching themselves, impatient for the off with their noise and weapons and rolling obscenities, and you are trying to tell His Serene Highness that you need money – a great deal of money – for a wind-furnace to test the melting point of iron ore.

There is a different way.

I settle down with his book *Medicina mentis*. Tschirnhaus thinks that it is possible to analyse the products of the arts in a philosophical manner, that boats, bridges and buildings should be considered as arts of invention. These objects can train what he calls the 'active imagination' because they exhibit 'all the possibilities to the imagination'. In fact, I realise, he takes on the world as possibility – as you walk down the street there is nothing in the material world that you encounter that cannot be brought into this space of reflection. And at each point of this reflection, as you pause and look with dedication at this lamp post, that gateway, you recreate the manner of its creation, move through the series of actions that caused it to come into being.

Above all he is interested, he writes, in 'how to obtain what should be observed', in the 'first mode of formation' of things. How something comes into being is critical, a kind of poesis.

When I read this my heart swells. This is the rubric of my journey to my white hills, this tracing of the first formation of porcelain from white earth into something other.

Tschirnhaus is describing with a passionate lucidity the value of looking and thinking about how an object as an idea comes into being.

And then I find that he likes bridges, which is a mark of true sophistication in my eyes. The first piece of writing about art that truly mattered to me as a maker of things – structures – was an essay by the art historian Michael Baxandall, in which he argued that the Firth of Forth Bridge was an artwork. And Primo Levi, my hero, wrote in *The Wrench* of 'the advantage of being able to test yourself, not depending on others in the test, reflecting yourself in your work. On the pleasure of seeing your creature grow, beam after beam, bolt after bolt, necessary, symmetrical, suited to its purpose.'

By which Primo Levi, a chemist who spent his working life analysing the chemical composition of paint as well as being a writer, means that method is interesting. Be very careful when you describe how

something is made, how it comes into shape, as process is not to be skated over. The manner of what we make defines us.

And so Tschirnhaus starts to work. He has used his burning lenses to see what melts and when it melts and what doesn't change under this intense heat.

Things, substances, matter; the corporeal world is under siege.

Spinoza holds ideas and decisions only valid if they are *sub specie aeternitatis*, from the perspective of eternity. Newton's prescription is to enquire diligently into the properties of things and Leibniz writes in a tremendous letter to Tschirnhaus, that 'no one should fear that the contemplation of characters will lead us away from things themselves: on the contrary it leads us into the interior of things'. He talks of *rei naturam intimam*, the inner nature of the thing. Interiority has become an idea.

And for Tschirnhaus, philosopher and mathematician and observer of how the world changes, porcelain is an idea to be scrutinised. It is compelling as it is a seemingly intractable white material through which light can pass: it brings together two of the principal concerns of his fellow philosophers, China and light, into one great query.

And then, because he looks to matters of first principle, he analyses with pragmatism where to go with his idea, who will help him to make it fly, where he will find the resources he needs.

His wife Elisabeth is from a family attached to the court in Saxony. And Saxony is rich in geology, raw materials. And thirdly the Saxon court at Dresden has a group of men who are known to be experimenting with refining and smelting, the technologies of fire.

And so Tschirnhaus, and his idea of porcelain, go across Europe to Dresden where Prince Augustus, the young visitor to the Trianon de Porcelaine, is now King Augustus, the elector of Saxony.

And if Tschirnhaus goes to Dresden, so do I.

Chapter twenty

gifts and promises and titles

i

Dresden is Florence on the Elbe, the greatest baroque city in Europe, a *Schatzkammer*, a treasure house. It is my Second Porcelain City.

There have been the worst rains for a decade. The television shows rolling news of the floodwaters, dizzying footage from helicopters of a brown land flattened into water. As I walk across the Augustus Bridge from the station, the river is the colour of pewter. It has burst its banks. Lamp posts and the roofs of the bus shelters on the embankment are just visible in the turbulent water. There are sandbags ready. And it's June.

If you go straight on, if you go left, if you go right, you meet palaces and churches and picture galleries, the opera house, academies, pleasure gardens, treasuries. The skyline is domes and spires and towers, urns and statues. It is gold. It is movement, piled on top of movement, extra, surplus, refulgent, more.

Of course it is.

This is the city of Augustus II, by the grace of God, king of Poland, imperial vicar, grand duke of Lithuania, Ruthenia, Prussia, Masovia,

Samogitia, Livia, Kiev, Volhynia, Podolia, Smolensk, Severia, and
Chernihiv, and hereditary duke of and prince elector of Saxony
&c., &c.

I have to learn my way round this city. Tschirnhaus has thrown his lot
in with Augustus, so I have to learn my way around Augustus, around
the &c., &c.

ii

I do know where I should go first.

Over the bridge I turn right, walk past the opera house, under a
ridiculous archway held up by cherubs into the Zwinger, the Rococo
set of pavilions around a pleasure garden that King Augustus com-
missioned in 1711, all runs and rills. In the far right-hand corner is
the Mathematisch Physikalischer Salon, the Royal Cabinet of
Mathematical and Physical Instruments. These rooms are the first
public science museum in Europe, the American curator tells me
with animation, his hands unfolding and folding in complex wave
patterns. It was open if you were properly dressed and paid a fee.
Downstairs is a long room in which the world is assessed and

Engraving of Dresden, 1721

measured and recorded, an odometer made for an elector's travels across his kingdom, instruments measuring distances in mines, ceremonial scales, a clock that describes the heavens, the movement of the planets, a golden celestial globe moving minute by minute; Mercury takes thirty-two years to complete its circuit.

And up the stairs is one of Tschirnhaus's burning mirrors.

I stand in front of it. It is an arc four feet across of copper held in a perfectly constructed wooden frame that tilts and rotates to catch the Saxon sun. There are very small, deep striations and pockmarks on the surface of the copper mirror where fragments of something have exploded during an experiment.

As I move towards it, my reflection changes and distorts. Of course it does. But I hadn't expected that sound changes too. My voice becomes

Tschirnhaus's burning lens, made in 1686, photograph from 1926

clearer and louder and deeper the nearer I get, as I say to the curator, *it is beautiful.*

And there are lenses in these galleries. I was not prepared for how strange they are. They are a world in themselves, one in which you exist, transformed, reflected and distorted. There are only a few things – a dew drop on a leaf, the meniscus on a glass of water – where you glimpse what a parabola is.

I look at them, into them, through them, and I think of the moment that Lewis Carroll describes in *Through the Looking-Glass* when the world relaxes and materials become easy: 'Let's pretend the glass has got all soft like gauze, so that we can get through. Why, it's turning into a sort of mist now, I declare! It'll be easy enough to get through . . . And certainly the glass was beginning to melt away, just like a bright silvery mist.'

I'm a little apprehensive about Dresden for myself and for Tschirnhaus. All kinds of adventures happen through the looking glass.

iii

This is Augustus' city. On 27 April 1694, after the unexpected death of his older brother, Augustus has become elector of Saxony.

He has spent much of the previous years on his travels, visiting courts, spending money. This has prepared him. He knows about splendour, clothes, women, ambition. Three years later he has also become King Augustus II of Poland. He has achieved this with the simplest of gestures – by leaving his Protestantism at the frontier and becoming Catholic – thus allowing him to spend huge quantities of money and be elected to the Polish throne. This has gone down very poorly in Saxony, which is Lutheran, and even worse with his wife who believes in her clean-cut prayers.

'The king would fain be a second Alcibiades, famous alike for his virtues and his vices', writes a visitor to court. 'He is noble, full of sympathy and of heroic courage . . . He is envious of the fame of others. Ambition and a lust for pleasure are his chief qualities, though the latter has the supremacy.'

His appetites and his strengths are inexhaustible. He bends horseshoes, rides for hours, picks up metal bars, faces down elk in his great forests of Bialowieza in Lithuania. Here there are wolves, bears, lynx and bison, 'so mighty that three men may be seated between its horns', and capable when cornered of ferocious attack. At court there is fox-tossing. Foxes, badgers and wild cats are released to run into nets which are drawn tight so that the animal is thrown high into the air and killed. Augustus holds the end of the net with a finger, casually, the other end held by several men. Sometimes the men dress as satyrs and the women as nymphs.

It is said Augustus has two wives, as he is a king with two kingdoms. He has official mistresses who become countesses when he has tired of them and then he has a rolling programme of lovers who are servants and minor aristocrats and actresses and girls who have caught his eye, and everyone's sister and even, possibly, his lovers' daughters.

This is called gallantry.

He is August der Starke, the Strong, and he has *droit de seigneur* over his court, city, and principalities. There is a prodigious number of bastards. I read *La Saxe Galante: Or, The Amorous Adventures and Intrigues of Frederick-Augustus II, Late King of Poland, Elector of Saxony, &c., Containing Several Transactions of his Life not Mentioned in any other History. Together with Diverting Remarks on the Ladies of the severall Countries thro-which he travell'd*, a bestseller across Europe from the 1720s.

It is as ghastly as it sounds.

He is, according to Thomas Carlyle, a Man of Sin.

Augustus is rebuilding his city.

> Next to gallantry, his greatest delight has been in military and
> civil architecture, and as to his cognisance of this art, there can
> be but one opinion. Even though however he has never carried
> anything to completion, because his weakness for universal
> applause causes him to make such frequent changes in design,
> that in spite of many and varied commencements nothing is
> ever concluded.

When he is not fighting battles on a Polish plain against the Swedes,
Augustus' attention is on Dresden. It is a battlefield of stonemasons
and wagoners, an affray of rubble. The Elbe is choked with barges
of timber coming downriver to moor near the bridge. Streets are
closed as he has demolished and continues to demolish his
patrimony. There has been a fire, which has allowed for some scope,
but now he has some serious plans. This will be another Florence, he
says to his mistress Maria Aurora Spiegel, but it is winter and there
is deep mud and two seasons of dust ahead. Then a new mistress,
Anna Constanze, and then more mud. He loves this one. She needs
a palace as a present, and she will get one.

There are gifts and promises and titles, and the sun smiles on you, and
the king remembers your name days and birthdays, and there are
presents at Christmas and at New Year. A visiting embassy, a treaty, a
marriage, are all occasions for something to be handed over, jewellery,
gems from Saxon mines, local silver, dogs and horses, camels, wines
from Tokaj that had been given to him by other rulers, passed on like
unwanted gifts. You gauge where you are at these moments. Who
knew that you needed an emerald hat brooch before you saw Count
Seifersdorf wearing one as he bends towards the king at a reception?

And this is the problem at this court as in Versailles, as in Beijing. You
need faith that the sun will rise and will shine on you. You cannot be
agnostic in a place like this. You gain all animation from hope. You

can fall out of favour. And be forgotten. There is heated gossip of Constantini, the Italian actor and impresario, who led the French troupe a hundred strong and was the man in the know in Dresden, who was locked up in the fortress of Königstein for six years for an indiscretion, perhaps propositioning a royal mistress. He is only thought of and released when Augustus needs entertainment.

The baron Pöllnitz remembered the court of Augustus as 'plays, masquerades, balls, banquets, tilting at the ring, sleigh rides, tours and hunting parties . . . the plays and masquerades were open to anyone who was well dressed'. He continues listing all the pastimes, until the court sounds like a vast cruise liner, the courtiers like passengers, unable to disembark.

Chapter twenty-one

the shuffle of things

i

Scit scat goes the king's attention.

There is a state that was recognised and named *accidie* by St Thomas
Aquinas, where a monk is at such a pitch of lassitude, such disengage-
ment with the world, that he cannot do anything but sit. He implies
that you need to be clever to be afflicted, to have run through all con-
jecture and possibility and be in the words of John Berryman 'heavy-
bored'. I think of Augustus and *accidie*, stalled, 'heavy-bored', in his
palaces. He is not indecisive so much as endlessly decisive, each
decision another attempt to get his pulse moving.

Berryman, who knew a lot about how compulsion shades addiction,
goes on, 'moreover my mother told me as a boy / Ever to confess
you're bored / means you have no / Inner Resources'.

The king's inner resources are non-existent. He wants more. What did
he miss the first time round? He returns to the unwrapping of a new
automaton, the display of a new grey stallion in front of him at the steps
to the court, all sinewy neck and sweet sweat, a table confection, a girl,

because the pleasures of ownership have become of shorter and shorter duration. The automaton has emeralds for eyes, which is a nice touch of the court jeweller Johann Melchior Dinglinger. The stallion is perfect for tomorrow's hunt. The sugar and marzipan model of the seven wonders of the world is novel enough for tonight. The girl is tall.

The *moreness*, the excess, the repetition brings back the chance of feeling, sensation, a constriction in his breathing and a release that is life.

More is the drama of Dinglinger's 'The Throne of the Great Moghul', a golden centrepiece for a table encrusted with 5,223 diamonds. A great ruler sits enthroned under a baldachin at the top of a flight of golden steps. Everything and everyone ripples away from his presence, ensconced high above the seething scene of servants bearing gifts, nobles and retainers. Two rulers, Mir Miron, 'the lord of lords', and Chan Chanon, the 'prince of princes', have arrived. The lord brings elephants, camels and horses led by handlers with turbans of mother-of-pearl and gold. The prince brings with him stretchers covered with carpets on which are lacquers, jewelled ewers and chalices. Chests are opened, filled with more gems, guns embellished and chased with intricate golden threads.

This is a choreography of the baroque, all techniques of the enameller, goldsmith, lapidarist, sculptor in step together. It is a vision of what a *Kunstkammer* should be, the idea put forward by Francis Bacon of:

> a goodly, huge cabinet, wherein whatsoever the hand of man, by exquisite art or engine, hath made rare in stuff, form, or motion, whatsoever singularity, chance and the shuffle of things hath produced, whatsoever Nature hath wrought in things that want life, and may be kept, shall be sorted and included.

The world, animate and inanimate, kneels before the king. The scale of Dinglinger's piece – five feet wide by four feet deep – means he looks down on the 137 figures of animals and men like the Great Moghul himself.

It is like playing with his own embassy-of-the-king-of-Siam-at-Versailles train set, of adoration and applause.

Looking down works well for Augustus. Balconies, for instance. Horseback, most days.

There are the pleasures of being envied and the pleasures of being feared and the pleasures of looking down on a sea of new possessions but of all the pleasures, *More* is the only thing that works.

ii

Augustus is self-evidently extremely able at spending money. Money goes on women, buildings, gifts, entertainments and dinners, war, a four-poster bed with a million guinea-hen and peacock and pheasant feathers woven into the fabric and undone to create a feather room. Money gushes out. As quickly as his ministers try to dam the flow of gold from the treasury, Augustus opens a new breach.

And now he spends on porcelain.

When Augustus became king there was porcelain in the royal collections. Sixteen pieces of Ming Dynasty ware were given by Ferdinand de' Medici to Christian I of Saxony in 1590. But by the time Augustus dies, he owns 35,798 pieces of porcelain.

He has, he admits in a letter, *la maladie de porcelaine, die Porzellankrankheit,* porcelain sickness. 'Are you not aware that the same is true for oranges as for porcelain,' he says, 'that once one has the sickness of one or the other, one can never get enough of the things and wishes to have more and more.' By his death he has the largest collection of porcelain in the West. He has changed the possibilities of how porcelain can be made and used. He is the emperor of white.

Augustus has started with the Chinese blue-and-whites that have come in through the Netherlands. He has been buying Kangxi porcelain in bulk, the large lidded jars, the dishes, the vases, all the

wares that Jingdezhen is creating. The kilns of the first porcelain city burn day and night to make porcelain for this obsessional man.

And now he is buying Kakiemon. This is the Japanese porcelain that is being imported through the Dutch, who since the 1630s, have the only concessions to trade with the Japanese. The Dutch East India Company, Vereenigde Oostindische Compagnie, controls this trade brilliantly, commissioning particular types of porcelain from both China and Japan, shipping them and releasing and then choking back supply so that demand becomes greater and greater.

These Japanese porcelains feel different. The quality of the clay itself is a bit warmer than the Chinese for a start – a milky rather than a bony white – and then there is colour. The colours of Kakiemon are dense and rich and clearly delineated with the blue of the night sky, carmine reds, yolky yellows and a purple that is used for painting peonies and actually has that velvet bruise of a peony. The green is as surprising as the colour of willows in spring. These are enamels, used both under and over the glazing, with touches of gilding on rims of accuracy rather than delicacy.

The images are much closer to the dynamic spaces of an ink painting of a landscape than you might expect from a pot. Here is a dish with a craggy pine tree. It is old and is now no more than a gnarled trunk, its foliage a few small clouds of green that have lodged by chance up high. An implacable pheasant sits in the tree looking away from us. It has obviously been sitting there for a while. Its tail feathers are long. A phoenix heads off at the top left of the plate. And the rest is just a milky-white nothingness. There is no attempt to tidy it up or repeat bits of decoration to set up rhythms. It is image, a story, and it is emptiness.

This is what makes this kind of porcelain so irresistible. The quail at the scattering of millet is focus and greed and not-being-clever and everyone gets that. And come to think of it, the phoenix is just a cour-tesan being oh so special off and about.

These Japanese porcelains in rhythmical patterns of five, seven and nine, are for glorious display. In Dresden in the porcelain galleries at

the Zwinger there is a particular group of Kakiemon that I love. A huge and rather smug lidded jar is in the centre, flanked by a pair of trumpet vases that flare in parallel to the swelling jar, that are then flanked by another, slightly smaller, pair of jars. These repetitions are part of the seduction, rhythms set up across the vessels held only a few inches apart, so that this bird in the arched bamboo – intrigued by the figures below, the woman with the fan looking up – talks to another bird, and another, and another.

Augustus' agents go to Amsterdam to try and buy the finest, most expensive groupings as they arrive. And he is now so angry at the delays that he is contemplating sending his own ship around the world to buy porcelain from the orientals and bring back cargo just for himself. To Saxony. Landlocked Saxony.

How is he going to do this? Sail down the Elbe past Wittenberg and Hamburg to the North Sea, all the way round the Cape of Good Hope and on to Cathay?

iii

I know how this porcelain feels. Japan is where my porcelain changed.

I had escaped Sheffield for a year in Tokyo on a scholarship, learning Japanese at a tough language school in the mornings. I spent the afternoons with my elderly Great-Uncle Iggie, or making pots. Sue was working in Tibet. We wrote a lot. It was a strange, lonely year.

For the first time in my life, I could make pots without anxiety. I had no need to sell them, or exhibit them or explain them. And I was amongst others, in a cheerful studio with students and retired old men, and commuters dropping in for an hour to work on a tea bowl before starting their long journey back home on a train. There was a substantial contingent of elderly women making containers for flower arrangements. We had a little show in December and complimented each other.

My pots relaxed. I picked up a bottle I'd thrown in porcelain, and squeezed it gently. Picked up its pair and did the same, placed them next to each other so that the gestures met. They looked better together. It made sense.

Coming back to London, Sue and I decided to live together. I found a studio in South London nearby, across a scrubby park, and started to make a new kind of porcelain.

My pots had shed their learning. Hard profiles had become soft, they asked to be picked up and held. Everything became simpler, everything became celadon. The runs of prescriptive pots disappeared and I found that I was making bowls and teapots and lidded jars. These were vessels, not obligations.

And the first time I showed them, I sold everything.

I started to make small groups of porcelain. Thinking of all the traffic of objects, the shipping out from China and Japan, I called them *cargos*. *Cargo 1* was a wonky grid of forty-nine celadon vessels on a plinth at an exhibition in Edinburgh. Everything else – the jars and the teapots and beakers – sold on the first night. My cargo stayed unwanted in the window of the gallery for the whole month. I gave it to Sue.

I put the second cargo of seventy cylinders, each with a slight tear at the top of the rim, across a wooden floor in a shop in Knightsbridge. It was bought by a fashion designer. There was attention and there were invitations to exhibit and I was photographed looking serious against a brick wall outside my studio. My pots were photographed against brick walls in warehouse conversions. Minimalism is back, said the magazines. This is the new white.

Above my wheel I pinned a great eighteenth-century list of *porcelain wares to be sold at auction*: a cargo.

iv

Cargos of porcelain arrive here in Dresden most days.

And though there is no reason why Augustus shouldn't spend money on what he loves Tschirnhaus has seen with some precision where the money goes. Some wag at court has come up with a new naming for porcelain: '*Weissener Gold*', white gold. The Chinese are Saxony's porcelain bloodsuckers, *porzellanene Schropkopfe*. There is an equation that appeals to the mathematician here, involving the substitution of Saxon porcelain for Chinese porcelain, a moving of figures from one side of the page to another.

Making porcelain in Dresden could be a success on the scale of a Colbert.

Dresden has been built on generation after generation of astute husbandry. Saxony possesses the most productive mines in Europe: 'the entire huge mountain mass along the Bohemian border is all tunnelled through and hollowed out. There is one mine shaft next to another and ... all ravines ring with the sound of hammer mills', wrote a traveller of the Erzgebirge, the Ore Mountains, west of Dresden. They are rich with silver ore, tin, iron and copper, seamed with precious stones, amethyst and agate and topaz and garnet.

There is great pride in the industry. Augustus sees himself as the First Miner and has beautiful miner's tools recreated in precious metals, a miner's lamp in gold. There are festivities where miners parade before the guests, dinners with mountains made from marzipan in which caves with sweetmeats gleam.

And in the centre of Dresden is the Goldhaus, an experimental laboratory for the king, a place of pragmatics, a testing-ground for research into these different minerals and ores, the earth and clay of his kingdoms, and the analysis of their potentialities. It had been established for a century, codifying and regulating mining, surveying the kingdom, taxing everything. The Goldhaus was a community of shared interests, natural philosophers, courtiers, alchemists, a wealth of men with knowledge of minerals and mining.

Augustus listens to Tschirnhaus's idea of an academy of the sciences, similar to the one in Paris, and to the much heralded one at the Kangxi emperor's court in Beijing, funded by the establishment of useful industries. Glass first and then porcelain.

The king is taken by some parts of this, particularly the emphasis on moneymaking manufactories: he thinks the establishment of glass factories is a good idea and is intrigued by the porcelain. No money from Augustus is vouchsafed. Tschirnhaus starts work in the Goldhaus. The king, needless to say, is in a hurry.

Chapter twenty-two

a path, a vocation

i

Tschirnhaus picks up the pace of his experiments on creating porcelain.

Using his burning lenses he melts Dutch Delftware. It puddles to glass. In a letter to Leibniz on 27 February 1694, he writes of an experiment in which he melted a piece of Chinese porcelain with the same equipment, identifying the principal constituents as alumina, silica and calcium. He has made a dense and milky stone out of a piece of good Jingdezhen porcelain. Leibniz is intrigued and asks for a piece of this 'new porcelain'. Tschirnhaus sends him a piece 'on which the gold has been melted'.

And Tschirnhaus is using the furnaces here in the Goldhaus too: 'I'm not sure of the contents yet until the samples are back from the kiln, it could be that the fire is too weak.' And he has also experimented with making high-temperature furnace bricks – crucial if you want to fire porcelain – and has made trials of metallurgical smelting crucibles that contain test substances, a kind of saggar. He has fired these for about five hours and taken them from the kiln when still hot. This proves that they can withstand thermal shock.

Tschirnhaus is on his way towards porcelain. But he cannot get the temperatures high enough with his burning lenses, nor with the furnaces that his colleagues use, and melting is not the same as making.

He writes cleanly. His prose is undecorated. It rises and falls without rhetorical ascent. His lenses are lucidity. I think of him and realise that the context in which he is working, thinking, trialling materials is critical.

He is in an environment that is strange and congested, filled with fumes and heat. The Goldhaus is a series of spaces where techniques for embossing coins and for refining and mixing metals are trialled alongside more experimental technologies. The largest room is the *Laboratorium*, in which ore processing takes place. It contains retorts, crucibles, nine smelter furnaces and a blast furnace, as well as a distillation furnace for finer work. Beyond this is a small round room filled with scales and weights for assaying – checking the purity of gold and silver – and then there are smaller vaulted rooms for special materials and the smallest of all for books and documents. As the rooms get smaller, their contents become more rarified and access to them becomes more restricted.

It is a place of accretion. It is not that I had imagined a laboratory bench, good light and ventilation, but I hadn't registered the scale of the congestion of materials and equipment in these rooms. I hadn't realised the tumble of ideas and methods.

Because this is Dresden, there is an inventory. Actually, I realise after conversations at the archives, there are inventories of the inventories.

Where do you want to start? a pleasant archivist asks me. This is a good question.

I can understand that a king or a court chamberlain might want to know of the treasures in the eight rooms in the palace devoted to the *Kunstkammer*, the three rooms of the library, the extent of the coin collection. The inventories of the ivories in the care of the court turner and the inventories of tapestries in the care of the court bedmaker must be useful

for the keepers of these offices of state. But this compulsive noting is not only to make sure that nothing gets lost, making sure that you are not culpable when the king demands that his guard wear green Turkish uniforms last used for a visit thirty years before, it is because time in this palace has a particular quality. It is not an act of piety to preserve and then document the artefacts of your forefathers, it is rather that in Dresden you live in the continuous present of the glorious House of Wettin. Everything that has happened to your forefathers is still happening.

So when looking at the inventory for the Goldhaus for a century before Tschirnhaus arrives – 'eight bowls of vitriol with foam still in them . . . a cupel filled with green water' – and the inventory for the year in which he walks in, there is just more stuff.

Nothing seems to leave. If you come in you too may never leave.

ii

The Goldhaus is a place of alchemy. The smallest of the rooms contains the experiments for turning base materials into gold, the notes of successive alchemists who have offered themselves to the elector of Saxony. The records of the alchemist glassmaker Kunckel are in there, somewhere.

Alchemy takes no set path. Wandering might well be part of it – alchemists are notoriously keen on the image of themselves as free spirits, off on their *Wanderjahre* through the university towns, the villages, the odd tavern, princely courts. There are lots of princes in the Holy Roman Empire who have rich tables.

There is a stock bit of reminiscence where the alchemist turns to us, the audience, the king and says that he learned 'from barbers, bathers, learned doctors, wives, those who make a habit of black magic, from alchemists, at cloisters, from nobles and commoners, from the clever and the simple'. But it can't all be on the road. To learn how to transmute takes a certain amount of staying still as well. Alchemy is, after all, a work of fire to be skeined with goldsmithing and distilling,

disciplines that require you to know the colour of flame, the sound of a melt, the distinction in fumes.

Here in the Goldhaus, transmutation is sought after and found. It is not only chaotic with materials and the apparatus to transmute them, it is full of competing ideas and theories and possibilities. So I take a very deep breath.

If Tschirnhaus is here then I too have to spend time with alchemists. How difficult can it be? The answer is very. I give them fierce concentration. I have to.

The writing on alchemy is serpentine and mazy. One idea turns into an image, an image into a reference to an authority from Egypt, Syria or Greece. When I pick up Basil de Valentinus – a popular writer during this period – I find that he gives twelve keys for alchemical progression towards the philosopher's stone, each one illustrated with a woodcut. You see a sun, a skeleton, an unrobed woman, a king, a queen, a walled city and a shattered tree, and know that it is none of these things.

Engraving of an alchemist, from *Twelve Keys of Basilius Valentinus*, 1678

The twelfth key is of the alchemist in his workshop, with the sun and moon seen pendant through a window. This alchemist is firmly in control, bellows and books and a set of scales carefully set out on his bench. He is bearded, of course, and rather dapper in his conical hat and he is gesturing towards a crucible out of which grow flowers that droop to left and right while the sun and the moon hover above. There is a furnace in full fiery tumult. And at his heels, an insouciant lion devours a serpent.

I stare at it.

It gets worse. In the library I borrow a *Calendarium magicum*, eight pages dense with the seals of the archangels, signs of the winds and stars, figures and tables tacky with hermetic knowledge. Tacky is right. It looks a little like everything possible has been thrown at it, and shaken to see what sticks.

This is dangerous stuff.

It is dangerous not merely because it is disapproved of, though that is reason enough to be careful. There is a common notion of alchemists as *Betrüger*, fraudsters, on the par of pedlars who are out to con everyone, from women at the market to prince-bishops with their false promises. There are stories of these men and the dreadful punishments exacted on them, bedecked with alchemical symbols on a gilded scaffold where a sign hangs stating, *he should learn to make gold better*.

It is also difficult because of its seductive pull. Turn lead into gold. Turn light into a rainbow. Turn clay into porcelain. Change the world in one grand catalytic moment.

Here is poesis again, the coming into being of something new. But where with Tschirnhaus it is careful, what is promised with the sprinkling of one powder on to another in alchemy is an exhilarated moment of change, a roll of drums, a trumpet blast of gold.

In Pieter Bruegel the Elder's *The Alchemist* the workshop is chaotic, the children feral amongst the distilling basins, the broken equipment scattered, experiments half abandoned, an apprentice gape-mouthed

at the bellows as the alchemist at his books points like St Jerome at the unholy mess.

Look what I have created, he smiles, as his wife shakes nothing from her empty bag. Outside the window is the future; the children trail towards the poorhouse door. *ALGE MISTE*, says the title; it has all failed in Flemish.

Or, in German, everything is rubbish.

iii

I wake up at three. I am furious, choked. I've been struggling with this alchemical stuff and the more I read about the philosopher's stone, the transmutation of base metals into gold, the more anxious I get. And there is a constant about alchemists. They seem to be aware of their solitary nature while making a big deal of the handing on of knowledge, the choosing of who to pass it on to, adopting initiates. This idea of the transmission from Albertus Magnus to Thomas Aquinas to Paracelsus and on, is compelling. A writer at the start of the seventeenth century notes that 'you will find [the alchemist's] primary transmutation to be of himself: a goldsmith becomes a goldmaker, an apothecary a chemical physician, a barber a Paracelsian, one who wastes his own patrimony turns into one who spends the gold and goods of others'.

Alchemy is one of those subjects that hums with credulity. It is about healing and about eternal life, and endless burning lamps, and it is all very tenebrous and I feel I'm slipping, slowly, viscously, into some kind of operetta. Alchemy seems to be a series of exclamation marks. Last night I foolishly googled something alchemical – *Calculus alba calculus candida*, 'the white stone of revelation' – and the screen lit up with invitations to buy cultic equipment, pulsating advertisements, descending circles of oddness.

In these hours before dawn my worrying swims around – money, new studio, the exhibition that I'm failing to make pots for – until it settles

on the core. I do my breathing exercises until I realise, with no surprise at all, that the fury is with myself.

I remember a moment at fourteen, fifteen, when the desire for anything to make sense was so strong that making pots was irresistible. It was the feeling that *something* was being handed on in those long hours in the workshop, *something* that had come down from one potter to another across centuries, which had the feeling of being part of an elect.

What was being promised to me? A path, a vocation, a discipleship. I remember starting work in the pottery workshop. I'd been allowed to come after school each day to practise my throwing and this was a privilege not lightly given. At the end of the day Geoffrey gave me a broom. And after work for the next six years, I'd sweep up the dust. I'd scrape down the asbestos boards on which we dried pots.

The dust catches in my throat. The dust is beautiful, hazing the air. I sweep and sweep and by the time I come back from the dustbin with my empty pan, there is more to sweep up.

I think of Hermann Hesse's *The Glass Bead Game* for the first time since I read it in exhilarated adolescence. Disparate bits of the world slotted into place, making sense at last of purpose, study, disciplined knowledge. Everyone is allowed a foundation myth. It helps if it has some coherence, but it is not crucial. I'm not sure how forgiving I can be to my teenage self, setting out for the Hesse.

At this distance I start to wonder about Geoffrey too. I honour his memory, but who needs disciples? Who hands the broom over and tells a boy to sweep?

iv

Tschirnhaus has transmuted himself into a useful member of court, working steadily on his experiments, promising the king moneymaking ventures, hoping for payment, hoping for porcelain.

As there are still gaps in his knowledge he goes back on the road for research, to see if by looking again he can see what he has missed.

He goes to Saint-Cloud.

> At Saint-Cloud I bought various pieces in the porcelain manufactory. Afterwards, however, they fell apart by themselves, because a lot of salt is used in the composition. They offer it at an expensive price, much higher than that of good porcelain, hence the sales are quite poor . . . The oven and machines for grinding were the best, although they were not perfect, as they should be. Otherwise, everything else was familiar to me. The blue colour that he uses is far too black. In sum, I think this manufactory will fail.

He returns to Versailles.

> I was once again at Versailles, in order to examine the crystal chandeliers very carefully, which the first time had not been possible. I was also at the Trianon because of the lovely porcelain and at Marly to see the curious water machine.

He meets possible collaborators.

> I spoke with someone called Schuller . . . Then he showed me some very beautiful pieces, which the Dutch had liked so much that they wanted to pay a lot of money in order to have him in Delft. I hope he will be of service to me in my porcelain plan.

And he goes to Delft.

> I went to Delft and made myself carefully familiar with their so-called porcelain workshops. I especially learned how they glaze, how they stoke their kilns so that nothing clings to what is being fired, or also how nothing becomes impure during the firing. These things are quite unknown in our land.

But it is still not clear what he needs to make porcelain, or, indeed, who might help him on this journey.

Porcelain, says Tschirnhaus, is the bleeding bowl of Saxony. Augustus wants it, needs it so badly that *more porcelain* becomes a subject at court. He has many mistresses, but this particular *maîtresse-en-titre* holds sway against all others.

The king is in debt. He is at war again. A fire in his royal castle in Dresden, vast and grand but old-fashioned, has made him think of tearing down the whole building and starting again, creating a new palace worthy of a man who is both a Catholic king and a Protestant elector. He has in mind something akin to Versailles, and is keeping abreast of the plans for the new palaces in Berlin. Augustus feels thwarted by this city, full of burghers and churches, hemmed in by the river. He has courtiers and lovers and alchemists and flunkeys and soldiers. He needs gold, porcelain, victory. He hopes for gold, porcelain, victory.

It is the autumn of 1701. And there are rumours of a nineteen-year-old boy in Berlin, an apothecary's apprentice who has found the philosopher's stone, transmuted gold in front of reliable witnesses. And then has disappeared.

My story of Tschirnhaus and his porcelain is about to transmute too.

Chapter twenty-three

extraordinarily curious

i

I'm back in Dresden trying to piece together the next bit of the story of porcelain, the autumn of 1701 when the rumours of this boy swirled around the city.

It is late November and colder than I could imagine. They are putting up the Christmas decorations, and preparing the Christmas markets. The windows are barricaded, fat with stollen.

Dresden is an echo chamber. For Tschirnhaus, just back from his tour of the ceramic factories in the Netherlands and France, it is news of the greatest consequence. Not only does he work alongside alchemists in the Goldhaus for whom the discovery of the philosopher's stone is Revelation itself, his great friend and interlocutor Leibniz is involved.

Leibniz, who knows everything about everything, knows the pope, Newton, Spinoza and the king of England, writes to Sophie, the wife of the prince elector of Hanover, and says that 'the philosopher's stone has suddenly appeared here in Berlin and then disappeared in the blink of an eye . . . I am extraordinarily curious to see what will develop

because I hesitate to believe it, but don't quite dare to neglect so many witnesses.'

The great man goes round to interview the apothecary Andreas Zorn at his shop in Molksmarkt 4 – *Friedrich Zorn, Pharmacopoeus* on the door – and reports being *'im grossen und ganzen alles bestätigt'*; more or less satisfied with his account of the matter.

Which for the philosopher of scepticism, is tantamount to issuing a papal bull on the matter.

'Extraordinarily curious' is a terrific phrase for this moment. It is three days after gold has been created through alchemy and the boy, Johann Friedrich Böttger, has disappeared and the soldiers of Frederick I, the king of Prussia, margrave and elector of Brandenburg, are searching for him. Herr Zorn has been interviewed by Friedrich and asked to explain (a) who this young arcanist is and (b) where he is, to which Zorn has to say that he has (a) no real idea anymore and (b) no idea at all.

How can you teach a country boy, and put food on the table, and treat him well, and have raised not just an arcanist but The Arcanist under your own roof?

Insultingly, King Frederick I asks to see the gold the boy has created – 'a piece of gold, of the value of thirty ducats' – and takes it for his specimen cabinet, so that Zorn is left without his gold. Soldiers are sent to find the boy but the boy has gone.

Leibniz interviews the witnesses to this momentous event and they all concur on what they saw.

On the night of 1 October 1701, a Tuesday, Herr Zorn and his wife Frau Zorn, both people of good reputation, and two friends gathered, in an upper room of the house. The friends are both men of God, deacons.

There were some preliminaries. Böttger wanted to use pure lead for the transmutation. One of the deacons suspected this had been

tampered with and suggested silver, producing fifteen silver coins that weighed three loths. Böttger agreed 'smilingly'. There was some nonsense around who used the bellows – a deacon again – and Böttger made it clear that the fire must be very, very hot.

It took an hour to get to temperature. The boy asked a man of God to add his silver coins to the crucible. They clattered, made the right noise. The charcoal sparked and glowed under the crucible. The boy took a fold of red powder that a mendicant friar called Laskaris had given him, and kneaded a lump of wax around it and dropped it in. There was a flash of flame and then thick and unpleasant smoke. The crucible trembled. They waited. He picked up the crucible with tongs and poured it slowly, no colour, just liquid heat. There was silence. It cooled, gelid.

And there was gold blooming like pollen across the surface until it is gold itself. A piece of gold worth thirty ducats.

My apprentice, says Herr Zorn to Leibniz, created gold in front of our eyes: 'in my presence he produced three loths of gold from two coins . . . it has withstood all tests'.

ii

Leibniz, who is good at questions and keen on proof, tests this story, prods it hard. Several further points of interest emerge.

Firstly, that Böttger has been experimenting for some time, much to the disapproval of his master. He was a bright lad from the country who he has taken on as a favour to an old friend. Sad circumstances, widowed mother, penury, and so on. This boy is remarkable. Very quick to learn, adept at grinding and preparing, but there were rules, as in any well-ordered household in Berlin. The *Defecktor*, the anteroom where powders and medicines were kept, was out of bounds, as was the laboratory with its stove and chimney where Zorn experimented, and this is where Zorn has found the boy unconscious from fumes. He once set the laboratory on fire.

Secondly, that this boy has run away before, and his mother had to come up from Magdeburg to plead for him to be taken back as an apprentice. Which he had done.

And thirdly, that there have been some intriguing visitors to Herr Zorn's apothecary. Kunckel, the great glassmaker, has been a frequent presence and has got to know the boy well. And the mendicant friar called Laskaris from Patmos had rung the bell of Zorn's in the Molksmarkt to buy honey and pepper – or possibly 'a healing cream' – and had spent a great deal of time with the boy, passed on the red powder without charge and has also disappeared.

Leibniz can get no more out of his witness Herr Zorn, this anxious man, caught between fury and outrage and perplexity about his lost apprentice, wondering how this story is going to reflect on his house of probity, his long years of quiet calm thrown into turmoil.

I see Laskaris walking steadily, deliberatively, down the road, the traffic of horses, children, pedlars, the ordinary weaving around him, untouched, walking his road from Patmos, the rocky island of revelation and visions to who knows where, leaving behind him stories and confusion.

iii

And then the rumours really start. It is late October and the fugitive boy has been seen everywhere.

For a month there are conflicting stories. It emerges that he fled from Berlin to Wittenberg in Saxony, was arrested after a violent struggle in which some pots were broken, and has been kept closely confined. He is a valuable boy. No one wants to let the boy escape, so he is moved to the fourth floor of the castle and his guard is doubled, he is not allowed to talk to anyone. And his satchel and case, 'containing test ash, a flask with the tincture, mercury, other utensils, *Calendarium magicum*', are taken away and locked in a vault, secured with three locks, each key held by a different man.

Shady characters appear. A messenger from Berlin offering safe conduct. Others accusing Böttger of being a mere thief, of stealing a valuable ring. Three dark figures are heard in a tavern talking about the goldmaker and a disreputable man in a habit gets into the castle courtyard asking about his whereabouts. Zorn's son-in-law turns up. Böttger's stepfather even arrives with a letter saying that his mother is grievously ill, asking for sight of the boy.

Berlin wants him back, but Augustus is determined to keep this goldmaker for himself and orders that the boy be brought to Dresden and his notebooks and alchemist's equipment sent to him in Warsaw.

Sophie, wife of the elector of Hanover, hearing of all this, writes back to her friend Leibniz, 'I pity the poor goldmaker. More people are fighting over him than fought over the beautiful Helen of Troy.'

It is more apposite than she can believe. The walls of Dresden and the walls of Troy are now under siege for the hand of impossible, truculent beauty.

Chapter twenty-four

there is no gold

i

On 25 November, just before dawn, Böttger and his gaoler start the heavily guarded journey to Dresden on the back roads, to avoid any chance of Prussian banditry.

A courtier rushes with the new suitcase to Warsaw. There are constant letters between the two courts. Augustus himself writes to the boy assuring him of His Protection. And on 26 December 1701, the king and a courtier prepare to make gold, following the instructions of the boy. This does not go well. A dog knocks over the mercury, and though the borax and the alchemical tincture melt there is a sintered mess. No gold.

Who lights the fire? Who pours in the tincture? Whose dog?

There are flurries of letters. Could Böttger be more exact about the order in which the experiment unfolds? Could he write down his experiments properly? Well could the king explain, counters the boy, how it is possible to create gold if you are under the duress of imprisonment with no 'calmness of atmosphere'?

Even though it is terrible winter weather, the reports say that Böttger 'spends his whole day without his underclothes, completely bare except for his dressing gown'. And he keeps his hands in a tank of ice-cold water in which there are fish swimming, trying to catch them 'until his arms were swollen'. He gets so wet that 'one night when His Serene Highness came to him, he had to convince him to put on dry and different clothes'.

I think of him trying to catch the fish, hour after hour after hour, the gold slipping and twisting away. You'd lose all feeling in your hands and then in your arms and then you'd lose yourself.

Böttger is moved and given a small laboratory in Dresden, in a 'miserable house'. He is by himself, still a prisoner, only given the chance to breathe fresh air from an attic window. He is to fulfil God's purpose and be kept safe, says Augustus, from those 'snakes' who wish him ill.

The boy demands more and more materials, two barrels with minerals, bottles of nitric acid, a refining furnace, tongs, crucibles, spades, coal, mortar, tin, glass flasks, distilling glasses, ampullae, wood. He needs *Testasche*, a mixture of wood and bone ash, used to test the value of minerals. He demands more freedom, fresh air, space away from the capricious men who supervise him, he needs reassurance. He needs books. And newspapers and some beer, Freiburg for preference. He writes to his mother asking what people think of him at home, what Zorn thinks.

His letters are intercepted and censored. Augustus writes that Böttger should proceed with calmness, that he will gain his freedom 'after he gives all his knowledge', that he will 'remain with us until we release him'. And if the king dies, then he will be free. Which the more you think about it, the less generous it becomes.

So that is that. It is bewildering and it is utterly clear. All you see of the world is a patch of grey sky when you are allowed into the attic. All you know of the world is what you read in the demeanour of the men who guard you, and that changes like the weather from cold to colder. All you hear of the world is the echo of servants from the mansion across

the way, and music, sometimes, the tremor of life being lived. And church bells. You are dependent on a king, who is capricious as God.

Böttger writes to the king, pleadingly, obsessively, manically: 'Your Majesty has never had such an important creature as me in his hands . . . so I will now in God's name do the thing he has divinely appointed me to do.' He swears an oath:

> Written and signed in the name of God, at free will and sealed, by good and healthy mind. I hereby promise and guarantee Your Majesty, I will never and at no time, without the permission and the most gracious will of Your Majesty, leave the Electorate of Saxony. I also pledge and promise that all my knowledge, which might be useful for Your Royal Majesty and your land, especially my knowledge of the Arcanum, will be given to you in writing, truthfully and uprightly, without any fault or evil intent. And everything else which is of my knowledge and in the field of Chemistry.

If he goes against the oath, he will suffer 'the eternal punishment of God and the loss of eternal bliss'. He sends the king his captor an amulet.

Augustus replies on 25 December 1702, 'because of the Holy date, I want to submit my best wishes and ask God to give his blessing on Böttger and success to his planned works'. He thanks the alchemist for his gift. 'I keep it as requested, by my chest.'

ii

Böttger needs to make gold but there is no gold.

How can you trace back your thin trail of an idea to its source, make it breathe, get up, and walk? You sit surrounded by all the piles of materials you have ordered and it is clear that you are totally lost.

Böttger is at sea in the needs of others. He receives a letter from

Kunckel who has been following his 'young friend's instructions' on the philosopher's stone and is also completely lost; 'How strong should the first degree of fire be? What am I doing wrong? There is a red powder remaining, which can't be suffused . . . my lead was unchanged . . . I suppose I am doing something wrong.'

There is a sort of grand dereliction in Kunckel's hunger, not just for money – though God knows he needs it – but for a return to honour, the completeness of getting something right again, for this abject need for advice from a boy.

Böttger needs supervision. And finally the court machinery gets something right. Pabst von Ohain, the official in charge of all the mining in Saxony and a metallurgist of great seriousness, interviews Böttger and sends him to the Goldhaus to work under Tschirnhaus.

iii

So my mathematician and my alchemist meet. Tschirnhaus is fifty-one, the writer of *Medicina mentis* and member of the Académie française, interlocutor of Newton and Spinoza, friend of Leibniz, a feted maker of burning glasses, a man in search of porcelain, poorer by the day.

And Böttger is twenty and scared and may have discovered how to turn lead into gold.

It is not clear who needs who more.

Chapter twenty-five

'double, or even triple amount of effort'

i

Tschirnhaus watches.

Böttger runs away, is caught and brought back. He swears eternal fidelity to the king. He lies. He promises gold by this time next month, by Whitsun, 'by next Peter and Paul Day a sum of 300,000 thalers'.

He is given chances and rooms near to the Goldhaus that open on to the Zwinger gardens. He is given assistants, books, materials, wine. Böttger receives 4,000 ducats from the king, and four days later another 2,800. He is allowed to play billiards and pray in the chapel and to dine with others. 'Herr von Tschirnhaus would join us.' He runs away again. He blames 'bad people' who have tricked him, lied to him.

Tschirnhaus sees a boy who has no experience and who lurches from idea to idea, who has no real sense of empirical method beyond that of an apothecary's apprentice taught to compound pills for gout, lotions for bee stings. He sees arrogance. Dear God, Böttger is arrogant. I'm

lucky, Böttger says to the other workers in the Goldhaus, I'm an orphan, he tells people. I'm not from around here. I have gifts. I know people. He is cool in responses. He blusters. He needs attention. He is solitary. Alchemy is *donum Dei*, a gift of God. It means he is elect.

It is frustrating to have this storied youth in the workshops, hear the swell and slap of excitement that follows in his wake, but Tschirnhaus is pragmatic. He has spent twenty years watching work in glass workshops and factories for faience, seen grinders of lenses, men building bridges, compounders and refiners and assayers. He is a mathematician and can see how patterns unfold, how you need time to follow an idea through all its possible permutations. And he senses another kind of quickness in Böttger, sees the runnels that allow his ideas to go there, or there, or there, separate and join up like quicksilver in a dish. The boy is intuitive with materials. He can cut corners.

Tschirnhaus explains his idea.

Tschirnhaus's own trials go on and on, testing and compounding for porcelain. It must be hard, returning day after day to your tests, opening a kiln, opening a crucible to find another sintered, coagulated expensive morass of minerals, another good idea turned to a stony mess. He works very hard. He works those around him very hard: 'Kohler and I had to stand nearly every day by the large burning glass to test the minerals. There I ruined my eyes, so that I now can perceive very little at a distance', wrote one of his assistants of these years. Böttger works on other experiments – how to make silver from non-precious ores – alongside his goldmaking. And Tschirnhaus draws Böttger closer into the porcelain tests.

There are oaths sworn on both sides. And then more oaths. 'I, Ehrenfried Walther von Tschirnhaus, hereby swear and promise that all of what Herr Johann Friedrich Böttger passes on to me for His Royal Majesty, I won't reveal to anyone, and I will keep silent until my grave about all information I receive on the Arcanum.' More documents are raised, considered, copied and signed and sealed. There is a series of guidelines for how the gold would be distributed from the

Arcanum. Money is to go to miners and their widows and towards a Saxon Academy of science.

I realise that they are all scared about money. Each of them feels poor. They have every right to feel worried too, as money isn't simple at court. I had imagined that the court functioned with the king paying wages or salaries, but it is more fragile than that, a series of binding ad hoc agreements, throwaway remarks and whimsy backed up by threat. There are ventures that Augustus invests in and ones he owns, but it is not clear how he regards protocols or documents. Sometimes bills pile up, tradesmen complain, courtiers are left with debts for wages, equipment, entertainments. It is possible to make things in the hope that Augustus will buy them, and then wait years to be paid. Augustus doesn't clear the payment to the jeweller Dinglinger for a particularly sumptuous coffee pot for fifteen years. He is capricious. This means that sometimes money flows, and sometimes not. Huge sums beget huge expectations.

Tschirnhaus has spent a decade in pursuit of porcelain. He could throw it all over and just go home, but he needs to finish his idea, draw the curves into perfect tension, make a conclusion.

Augustus has had to pawn his jewels to fund the civil war in Poland.

Böttger is in chronic debt against the moment Zeus will spill gold in showers and ravish him like Danae.

ii

On 5 March 1705, exhilarated, Böttger sits down and writes to the king. 'I can happily recognise that we expect within eight days to have the sum of two tons of gold if God gives us luck.' This is the colossal sum of 2 million thalers, enough to win the war, conquer Sweden, build a palace for the latest mistress and the one after that.

And again there is no gold. Augustus has tried fear and he has tried collegiate empathy. His patience is at an end. Böttger has 'used

three times the amount of time he initially asked for and has now revealed that despite all his studiousness, the processes haven't worked'.

The king is returning to Poland. Böttger is to be brought, under guard, the fifteen miles from Dresden to a 'secret laboratory' at Albrechtsburg Castle in Meissen, 300 feet above the Elbe.

iii

Meissen is hell.

Hell means fire, of course, and that means the heat that makes you faint, knocks you at the back of your knees, fells you mid-sentence. But it is fumes that define hell. Before you are aware of the roar of the furnaces, the smells, the light and the dark, you get the fumes. The 'secret laboratory' is partly below ground, but the windows are almost completely bricked up to prevent onlookers, so that the ventilation is terrible. There are twenty-four kilns of different sizes, 'running night and day', and the fumes are appalling. 'In summertime', writes Böttger, 'there is

Albrechtsburg Castle, Meissen, 1891

a cruel heat day and night.' It is terrible 'to eat, sleep and work in the same room . . . alongside the unbearable fumes from the coal and other unpleasant substances'. Some are noxious and they disorientate you, your eyes lose focus, you cannot feel your hands and you are nauseous. If you burn coal in a room like this, carbon monoxide creeps unknowingly into your lungs.

The light is livid.

There are too many men for these spaces. Five *Berg und Hüttenleuten*, miners and smelting workers, are sent from Freiburg to help Böttger with the hard work of mixing and grinding materials and firing the furnaces, there's a specialist in building and repairing them, and there's someone who keeps the notes. In these confined rooms, with guards outside the doors and more guards outside the castle, they are to work on the 'secret task'. Every visitor is recorded.

They are few. Tschirnhaus comes and Pabst von Ohain, but otherwise there is no one to release the pressure. Which increases week by week. There is an order from the king on 13 April 1706 that 'all possible studiousness should be applied to speed up the works . . . it should be done with double, or even triple amount of effort'. Tschirnhaus replies on the workshop's behalf, that they are at risk of danger to their health. How can they make more effort?

They are buried. They can hardly breathe. Sleep has disappeared. They are penned like animals in a peasant's barn. They are in a castle high up above the Elbe with wooded hills unfolding softly in all directions and there is *no air*.

And Böttger spirals back into his manic behaviour.

He knows he is on the cusp of something. He is recording what happens when he mixes X with Y, Y with Z, and there are piles of rubble as Böttger orders kilns to be pulled down and rebuilt with different sized and shaped chambers for burning wood and coal. He is searching for 'the inner nature of the fire'.

He writes to the king and his words are scattered, his sentences ending everywhere:

> With huge joy and burning desire, I would like to have reported to His Majesty the lucky result of my work . . . with even bigger desperation and consternation of my mind, I have now to experience . . . that all the effort and hard work, which was connected to the aim of the life, was without result . . . I see disappearing all desire to live any longer.

Böttger wears no shoes. He worries those around him. He talks about Daniel and the lions' den, St Paul, Job punished by Jehovah. His speech is rapid, slow, nowhere.

iv

Between 27 and 29 May 1706, Tschirnhaus and Pabst are at the castle for a kiln opening.

The kiln door is unbricked and the tests drawn and it is clear, immediately, that one test is different. This has been made from a combination of red clay and quartz. It is a simple vessel, a crucible for gold making, and it is unusually hard. It is also intact, it hasn't cracked in the firing, and it hasn't cracked when it was plunged into the bucket of cold water at the fire-mouth. It is dense, a red-brown, closer in feel to a stone picked up from a riverbed than to terracotta; stroke it with your fingers and it is cool.

It is also beautiful. Startlingly beautiful.

Because materials are queries – can we make glass, grind alabaster to dust and re-form it, create porcelain, melt and fuse gem stones – they need scrutiny. Tschirnhaus and Böttger look at each other. This test is a material that makes you think of cornelians, of alabaster, but it has the most kinship with the Chinese red pottery that the king has bought at great expense from his agents in Amsterdam. These wares

don't feel like clay objects so much as carved sculpture, they are unglazed with finely worked surfaces with relief decoration or engraving of adamantine precision. A tiger sits, bored, on the cover of a teapot. A vine trails languidly round and over becoming a handle for another, there are leaves and tendrils and grapes covering the vessel.

If this test is what it appears to be, this is possibly a new kind of material, a red *Barcelin*, porcelain. And if this mixture works with red clay there is the surmise that it could also work with white.

Tschirnhaus and Böttger call this new material, with some tenderness, jasper-porcelain, *Jaspis-porzellan*, 'since it surely merited the name of a precious stone, one manufactured through art'.

It is not gold and it is not white gold but after years of grey and ashen vessels that need explication it is something extraordinary to show the king. He loves it.

v

And I love this jasper-porcelain, too. It is known and written about, but it should be loved. It has a strange quality of newness to it, even after 300 years.

This fine-grained clay is used for objects, bowls and jars of unimpeachable austerity, as clean as any Bauhaus vessel. It is perfect both for engraving and for casting, perfect for medals. And what doesn't need commemoration in this busy kingdom? A return from war, a victory, some marriage.

These vessels leave the castle at Meissen for the workshops of the lapidarists, jewellers, decorators and gilders to be turned into objects that are perfect and rare, rich and strange. This red coffee pot has tendrils of painted foliage with a garnet gleaming in the centre of each flower. Vases and hexagonal tea caddies take oriental-style shapes and clothe them in a thick black glaze as slow as treacle. Some of these black wares are decorated to look like lacquer, each plane of a teapot carefully

delineated with gold lines like braiding, the spout ending in a gilded griffon's beak. Some are copied from Japanese models, plum blossom, girls with parasols, a scholar at his desk become a little more Saxon, a little heavier.

And they are wrong, in the way that footballers' tattoos misquote a bit of Sanskrit, or a line of the Talmud entwined in roses on a bicep gets it wrong. *But I'm serious* is the message.

> These red porcelains are the best new thing for only a handful of years. And then they get shelved, put higher and higher up in the Meissen warehouse. They are counted every year for stocktaking, each year a little dustier. Ten years after they open their kiln there are still 2,000 pieces left in Meissen, 1,000 in Dresden, thirty-six in Leipzig, all waiting for some margrave up from the country who has missed the fashion and wants to buy these beautiful, red-black-brown, new and gorgeous wares. vi

There is a porcelain plaque celebrating the achievements of Böttger on the ramparts overlooking the Elbe, put up sometime in the 1950s. Early one morning I go off to see him, talk it through man to man. The memorial is stranded amongst some municipal planting. It is an arctic day, the wind whipping off the river, so I nod to him and keep going. A ginkgo has shed its leaves so gold drifts round the foot of the monument.

I find a café as near to it as I can and sit with my notebook, order coffee.

My coffee consumption is rising again. My kids monitor me. If I am snappy around clearing the table after supper, they ask me how much I've had. I'm now on lots. They ask for details. And I realise that I don't count pots of cafetière coffee carried up to my desk in the studio, only espresso. When I started my journey I didn't think that the flat white existed. I think of them as chasers.

By this point, feeling assailed by archivists and my need to check lists of inventory numbers of when porcelain entered the collections of Augustus the Strong, I realise that I am just coffee. My sentences are shorter by the day.

You want the details of who worked in Meissen, an experiment in the Goldhaus? The records are here in Dresden: lists and inventories, letter books, accounts, memoranda and edicts, the scraps on torn bits of paper next to the perfectly scripted. There are 'secret files' on Böttger archived here, but does that mean there are *secret* secret files that I am not allowed to see in these archives?

How can there have been so many documents from these weeks, 300 years ago? Reading *Stasiland*, Anna Funder's exploration of the culture of informing and information in the GDR, it is striking how fear drives the compulsion to keep records. If you know that everyone around you is recording what you have said, who you said it to, then self-protection lies in the completeness of your notes, the reach for a pen as automatic as the tapping of a cigarette from a packet, lighting it, inhaling.

I assume this is how the court at Dresden works, the dispersed anxiety of Count Y briefing against Baron X who has the ear of Prince Z. But then I slowly realise that all this note taking is because the Arcanum is mythic, part of history, a kind of proximity to Events that no one could have anticipated. Were you there when the lame walked, the fig tree died, when mercury turned to gold, porcelain was created?

I order an Americano to follow my espresso macchiato and look at these beautiful black-brown hues of coffee with affection, raise my cup in the direction of Meissen and their dense and dark jasper-porcelain. My hand shakes, just a little.

Chapter twenty-six

promises, promises

i

For Tschirnhaus and Böttger there is such excitement at the idea of something working, that the king is drawn in and even the gold making is put to one side. And the laboratories in Dresden are extended, to speed up experiments. The summer goes in heady trialling of red clays. And there may be a clear horizon and focus and optimism – and even a promise of autumn – but on 4 September 1706 Böttger has absolutely no rights, no say.

Tomorrow the vaults are to be cleared and sealed. His papers are to be taken away. He is a chattel, to be removed at a day's notice, to be bundled up under guard and hurried out and down and into a carriage to Königstein Castle, because the Swedish armies are approaching and he is *valuable property*. All the precious treasures from the *Kunstkammer* at the castle in Dresden are arriving in the morning, to be guarded in this fortress, a slab of sandstone 250 metres above the river.

A child might imagine life as an ascent, a graph line leading to the left and up, shedding as you go, but for Böttger it is actually a return to the

same point again and again and again. Here he is again, back in a cell in a castle, five years after his first imprisonment.

ii

The salient fact I find out about Königstein is that it was used for the detention and re-education of delinquent youth, *Jugendwerkhof*, in the GDR. That it has been a prison. To try and draw Königstein you take a wide black marker and move left to right. Done. No need for windows.

I open the file on the new prisoner. Carefully remove the first sheet. There are three reports from the first day, 6 September:

A gentleman with three servants. Cause of detention: unknown. Monthly bill of eighty-three thalers, twenty groschen to be paid by HH Augustus.

Königstein Castle Commander Ziegler: Who is this prisoner? The prisoner cries.

Böttger: I have no books. My room is too small and no one knows who I am.

And on it goes, day after day of reports and letters. Everything that Böttger thinks, or needs, how many people he meets and how far he walks in his cell – ten metres and then turns and walks ten metres back. What is your advice? Can you remove him please? And what he is singing, his letters to Tschirnhaus – who promises to teach him geometry and lend him books – then what he reads, then his promises to make gold, his promises to make porcelain, his promise to make it all okay.

And then the fact that he has made friends with another prisoner in the neighbouring cell, Romanus, the disgraced mayor of Leipzig, the *Betrüger*, fraudster, maker of promises. And that the prisoner has been spending a suspicious amount of time in the lavatory. We investigated and found a bundle of notes secreted behind a panel, plans for escape. We have increased the guard.

On 3 June 1707, Böttger writes to Augustus saying, 'I need to see you. Things of great importance. It is my great hope that with the help of Herr von Tschirnhaus, I can within two months present something great. Please come to Königstein *for at least two hours*.'

Five days later, Böttger is taken from his cell and brought to Dresden where he meets with Tschirnhaus and Augustus. It is only five in the morning. He promises to make translucent porcelain. And he requests red and white clay, bolus, fine sand, chalk, alabaster, brick clay, wood for burning.

He is taken back to Königstein. And three months later, Böttger accompanied by Tschirnhaus is brought to a new laboratory in the vaults of the Jungfernbastei underneath the city walls in Dresden.

I close the file. I have got him back to Dresden.

And all I can think about is the collateral damage of Böttger's fantasies of escape, slipping past the guards unrecognised, passing borders, making new lives in glory, hallowed and famous and special, lit up by gold. I think about promises and all I can see is Romanus.

Böttger promised to get him out and it is a detail, a small one, but Romanus died in Königstein in 1746. He sees his wife once. He never sees his daughter.

How many more broken promises can Augustus and Tschirnhaus put up with? How many can I?

Chapter twenty-seven

half translucent and milk white, like a narcissus

i

The new laboratory in the Jungfernbastei was convenient as it meant that Augustus could keep close to these new experiments and Böttger could be well guarded. But its vaults were low, and it was close to homes, so firing kilns was perilous.

On 15 January 1708, they open a kiln in their new laboratory. It holds seven trials, using a new white clay from Colditz and an alabaster in different proportions.

N1 clay only

N2 clay and alabaster in the ratio of 4:1

N3 clay and alabaster in the ratio of 5:1

N4 clay and alabaster in the ratio of 6:1

N5 clay and alabaster in the ratio of 7:1

N6 clay and alabaster in the ratio of 8:1

N7 clay and alabaster in the ratio of 9:1

In the archives at Meissen I hold this page of notes. Böttger has written them aslant, quickly, in German and dog-Latin, scattering alchemical symbols: 'after five hours in the kiln . . . first had white appearance, second and third collapsed, fourth remained in shape but discoloured . . . last three *album et pellucidum*', white and translucent. Five is *optimum*, the best.

They hold the tests up to the scant light.

It is twenty years since Tschirnhaus started his trials for a porcelain body for a pure white clay through which light can pass. It is eight years since a young, scared apothecary's boy was brought to Dresden. It is five years since they were brought together.

It is 400 years since porcelain first arrived in Europe from China.

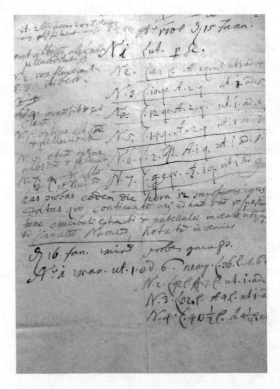

Page from Böttger's notebook showing his first porcelain tests, 15 January 1708

In a smoky, murky vault, slung alongside the billets for soldiers, porcelain has been reinvented. It has come into being.

ii

With this mixture they trial again and again until they can make small vessels. The court potter Fischer, whom no one likes, is asked to make pots for them. And Tschirnhaus makes himself a little jar. It comes out 'half translucent and milk white, like a narcissus'.

I love this. My mathematician's milk-white jar.

And the pace is now frenzied.

The accounts are cinematic. 'Every half an hour they looked into the kiln, like cattle, and the glow made everyone jump back, it was so hot that big stones were pulled out of the vaults and the hair on their heads was singed away and the tiles got so hot that big blisters developed on their feet.' There was real danger that the heat of the kilns could ignite the wooden structures above them on the ramparts.

Augustus arrives with Prince Fürstenberg to inspect. As they enter they feel 'the ghastly glow hitting them'. The prince would have preferred to turn around, but Augustus wants to see the kiln in action. It is hellish with noise and heat and Böttger looks like a 'chimney sweep'. He has damp rags wrapped around his head.

He opens the spyhole and the king and sceptical courtier see the saggars appearing darkly amongst the flames. The men draw a saggar out, and inside is a white teapot. This glowing pot is taken with metal tongs and thrown into a bucket of cold water. There is a loud bang. Böttger then takes the teapot out of the water and it's still intact. And according to the records, though 'the glaze hadn't completely melted', it was otherwise 'completely successful'.

Something has gone right.

Security at the vaults is ramped up. Ninety soldiers are detailed. Large pits to store the clay are made. A bigger kiln is commissioned and 1,000 white bricks ordered from the Glasshouse. An order goes out across Saxony to all civil servants that samples of local clay and brick clay are to be sent to the laboratory to be analysed. You suddenly see the reach and power of this king. You see what five generations of investment in the mineral-testing laboratory of the Goldhaus means to the king of Saxony.

The workshop trials all the new clays coming in. Their recipe for *Kalkporzellan*, or chalk porcelain, settles on nine parts of Colditz clay, three parts of white Schnorrische clay and three parts of alabaster.

On 24 April 1708, Augustus signs and seals a decree establishing the first porcelain factory in Dresden, the first porcelain manufactory in the West. Everyone gets titles, promotion and the promise of money.

I read this decree. It is the sigh of a nugget of gold folded thoughtlessly into a velvet pocket, the wash of royal appropriation over anything you do, or know. It means you cannot really impress the king as he owns you, what you know and what you will know.

And Tschirnhaus refuses his elevation to the Privy Council, saying that he doesn't want a title, 'until this thing is in a state where I am justified to use one'. I feel so proud of him pausing at this moment of exhilaration.

On 9 October, Tschirnhaus and Böttger fire the first cup of true unglazed porcelain, the first white, translucent vessel.

And two days later on 11 October 1708, Tschirnhaus dies.

He is fifty-seven.

His room is sealed, but his papers cannot be found. It is said that someone has stolen them within hours of his death. His servant flees with gold and samples of the white porcelain and is arrested and questioned, but denies any knowledge of Tschirnhaus's notebooks.

Böttger writes briefly, 'I have lost a very high and worthy friend, His Royal Majesty has lost a very loyal servant . . . If God will have it, his place will be filled with an equally loyal and able man, but I have my doubts.'

The same day he announces to the king that the first porcelain in the West has been created, that he has finally cracked the mysteries of the Arcanum, is in possession of the knowledge to create porcelain, has discovered white gold. This new white material is *Böttgerporzellan*.

iii

I now have my second white object in the world. I am very slowly building up my installation, collection.

The first is my monk's cap ewer from Jingdezhen, made for the emperor Yongle, sweet-white for a man who needs and desires purification.

And now I have my white cup from Dresden. It was made for Tschirnhaus. Augustus the Strong may claim whatever he claims, but this is an idea that comes from a compulsion to think something through, not an order to sate a desire.

It took my mathematician a very long time for it to come into being. I look at it very closely. Watch closely the moment of formation, Tschirnhaus writes in his book, the moment that one thing becomes another, and I take him seriously.

I see his childhood in a noisy family in the country, his lessons with Spinoza and his conversation with Newton, I see him learning to grind lenses, learning to make great mirrors that focus the rays of sun until he could make one small part of the world melt. I see him in conversation about China, about porcelain, about the interiority of materials with Leibniz. I see him here in Dresden, navigating the court and its echoes and rumours and endless edicts, coaxing a febrile, scared boy into work, continuing to experiment year after year. I see how he brought his method and a boy's intuitions into charged connection and compounded porcelain.

Amongst Tschirnhaus's possessions – alongside his books and 'curiöse Sachen', or 'odd things' – was a wooden toy, used in mechanical demonstrations. It was a hand span across, a 'v' of two slightly inclined rails and a beautifully turned double ended cone. You place the cone at the base of the ramp and it goes *up*.

That is what the world does. It may be explicable, but it remains extraordinary. In my hands there is a white cup. It is modest, but this is my alchemical moment where, for the first time in this journey, I have clarity about *how* an idea can come into being.

This is a different white.

iv

In that winter of 1708, there were terrible frosts across the whole of Europe. In London, William Derham recorded lows of minus twelve degrees Celsius; 'I believe the Frost was greater (if not more universal also) than any other within the Memory of Man.' Trees explode. People freeze in their beds, animals in their byres. The Thames, the

Meissen porcelain cup, c. 1715

Baltic, the lakes at Versailles are ice. It is the Great Frost, Le Grand Hiver. Everything is white.

The *Dresdner Merckwürdigkeiten* announced that 'the cold was so persistent, that you couldn't heat your living rooms and birds fell to the floor as the air was so cold'. On 10 February 1709, it suddenly got warmer and the melting started, so the Elbe flooded terribly. A fortnight later, new snow fell. At the beginning of March the snow melted again and there was a new flood.

The obituary of Tschirnhaus is published in the *Acta eruditorum*. And then he disappears into footnotes, in the way that people can flare and illuminate an idea or a place and be gone. In Bruegel's *Fall of Icarus* in the Musée des Beaux-Arts in Brussels a perfect ship is sailing on as Icarus disappears into the sea. A ploughman continues his work, unconcerned. Auden gets it perfectly: 'the expensive delicate ship that must have seen / Something amazing, a boy falling out of the sky, / Had somewhere to get to and sailed calmly on.'

The expensive, delicate ship moves on.

v

It is announced that there is to be a new factory at Meissen to create this white porcelain invented by the Arcanist, Johann Friedrich Böttger.

It is announced that there is to be a visit to Dresden in the summer from the Danish King Frederick. There will be a foot tournament emulating Roman combat, night jousting in the riding school with seventy-two participants dressed as gods, the Danish king as Mars and Augustus as Apollo. There are to be banquets that go on to dawn, a castle resting on ships moored in the river, attacked from both banks with cannons firing tracer shots, the cipher of the king of Denmark high up on the tower, the castle illuminated in various colours, a large number of images set in flames.

I read the reports of the visit. 'The air was constantly full of fire.'

Chapter twenty-eight

the invention of Saxon porcelain

i

Dresden is affecting me.

My notebooks have bullet points. I write up my report card for *Porcelain 1719 / Saxony / France / Netherlands / China / England*, without even noticing this efficiency.

Saxony remains pre-eminent. The Arcanum is no longer secret. It is still secretive, but there have been defections and lurings away by offers of better working conditions elsewhere. There is already a porcelain factory in Vienna. Every ruler wants his own little manufactory.

Böttger has just died. He was given his freedom five years earlier in 1714, six years after they pulled the first white cup from the kiln. On hearing the news it is said that he 'continually laughed and ridiculed everything'. His biographer, Johann Melchior Steinbrück, noted that Böttger thought freedom 'consists of just following your own moods', which seems fair enough after thirteen years of imprisonment and threat. He adds that Böttger was negligent, forgetful, loose with money, had poor health, a childish demeanour, vanity, was fearful,

irrational, had moods, was jealous and lacked gravitas. And that he lived openly with his mistress in the house he had bought in Dresden like a man of importance. This is marked on my report.

As are his epileptic fits, vomiting and dizziness from ingesting mercury, sustained carbon monoxide poisoning from the furnaces and silicosis from the dust.

The obituaries are tough. 'Not only in life did he experience damage, nuisance and threats, but it has also continued after his death.' Böttger left chaos. Steinbrück's summation was that the Arcanist:

> didn't like to be convinced. He was jealous . . . he spent lavishly when experimenting; he was indecisive and liked to postpone important things and easily went from one thing to another, often starting new things before finishing the old . . . He was inventive . . . He was vainglorious . . . He loved the attention . . . He was suspicious, but naïve . . . So this is the inventor of Saxon porcelain.

ii

Saxon porcelain continues to innovate without Böttger, without Tschirnhaus.

The innovation has been extraordinarily rapid. The white porcelain was first shown in 1713, at the great fair at Leipzig. There were few potters who could handle this sticky white compounded clay. They had to be trained. Jewellers and turners, gilders and modellers and decorators too, had to work out how to use porcelain. The preciousness of the material, rather than its plasticity, was its most significant feature. Porcelain is a new technology, lit up by new desire.

I have a small cup and saucer from this year, kindred to my Second White Pot. I find these very early white porcelains moving. The branch of prunus across the cup is not great, the very small leaves are a bit wobbly. It could be lighter.

It is the kind of porcelain cup I recognise, aspirational.

Desire changes everything. Augustus pushes, constantly. Within a year or two of this porcelain being sold this cup would have been too simple for him. It would have been decorated and gilded. In 1720, it would have acquired the two slightly curved crossed swords in blue on its base as a cipher, a trademark. It would be Meissen.

iii

I spend a morning in Albrechtsburg Castle, high above Meissen. This is where Böttger was imprisoned and where Augustus' manufactory grew out of the laboratory from one cellar to another, across into rooms in the adjoining buildings, up and up through the castle until great runs of medieval halls were being used. The central hall with its Gothic vaults is partitioned off for decorators, another airy space becomes three floors to hold the store of saggars. A plan from a hundred years ago shows 304 rooms in use by the manufactory.

It was madness, of course. The kiln rooms were an inferno. The huge walls of the castle cracked with heat. The run of rooms near the kilns were warm whilst everything else was appallingly cold. This is a castle, a cliff face of a building seven storeys high, on a bluff 300 feet above the Elbe. It is perfect for keeping secrets, but as a study in how time and motion work, how to make, decorate and fire delicate porcelain, this is incredible.

The white clay comes down the river from Colditz, mined in the Erzberg mountains, and is carried up the hillside to the lowest of the cellars to be washed of impurities. The wood for the kiln comes the same way and is dried in sheds on the riverbank. Two pairs of horses turn a great grinding mill here for the other minerals. Wet clay is kept in another cellar and then is brought up to the throwers and modellers on the top floor, up a dramatic Gothic spiral staircase. It is a wide staircase, almost four feet across, and shallow. But try carrying a basket

of kaolin up 200 steps on your shoulder. Then try going downwards and round, with a board of pots.

Who has precedence as workers climb upwards and downwards? The sounds of breaking porcelain are commonplace here.

Albrechtsburg is now a nineteenth-century fantasy of a fourteenth-century castle. In the 1860s, in the spirit of pride in the new Saxony, the porcelain manufactory was cleared out of the castle in Meissen where Böttger was imprisoned. It was given a clear, flat factory site in the town. It is still there. And this castle is made good again after the depredations of 150 years of porcelain making. Wall paintings of moments in Saxon history are painted: Duke Albrecht off on pilgrimage to Jerusalem, triumphs in battle – ceiling bosses are decorated with coats of arms, fireplaces are re-carved, medieval tables and antler chandeliers brought in.

Böttger is a star here. On one wall he is shown as the alchemist, the *Goldmacher*, open-shirted, he sprawls in a chair grasping a glass of beer and a long-stemmed pipe, wild-eyed, as arcanists stoke a fire. It is choreographed chaos. On the other wall he crouches in front of the king, a courtier in green silk behind him, a worker in the foreground, and he displays porcelain. There is a light emanating from the white cup. It glows like the Christ child displayed to the Magi.

Tschirnhaus is given a little cartouche high up. You wouldn't notice him in the glamour. He wouldn't recognise all this fuss.

iv

The porcelain recipe is a secret.

No fragments could be disposed of in a place where they might be gathered and studied. The quantity of waste can be measured by a huge cellar that was used as a tip for shards. The floor of the cellar rose and rose. Several years ago archaeologists in the castle found a room two metres deep in fragments.

Once the Arcanum was lost in the late eighteenth century and Europe was scattered with manufactories, baskets of jagged, broken porcelain were tipped over the side of the hill. A landslip of white porcelain.

Meissen becomes the white hill. It is my Second White Hill. In this cellar I stoop, and embedded in the compacted floor are crescents of white.

Chapter twenty-nine

porcelain rooms, porcelain cities

i

It is eighteen miles from Meissen to Dresden and for Augustus the great joy of having his own manufactory so close, is that he can wave his hands, bring ideas into shape, order gifts for the congeries of people who shift and clog every entrance to the court. And because the king collects, his courtiers collect too.

The money remains complicated, of course. There are Chinese vases that he wants from the collections of Frederick William I of Brandenburg and Prussia, over three feet tall, made and decorated in blue and white in Jingdezhen. They are not for sale, which makes them irresistible. So in 1717 he conjures a plan to exchange these vases for a battalion of 600 dragoon soldiers, pots for people. These soldiers have crossed over from Saxony at Baruth. Each monarch declares that this is a gift and no money passes hands. The eighteen vases that formed the centrepiece of this exchange become known as the Dragoon vases. The battalion take the Meissen cipher, the two crossed swords, as their banner. The soldiers become the Dragooners.

With the quantities of porcelain arriving here, where and how Augustus displays his porcelain in his city becomes an imperative.

I'm listening to court music from Dresden on my headphones as I walk through the city and there is a phrase played on an oboe that keeps being picked up by the violins and taken out and aired and then given back. And what I hear is a sort of return to structure, the singular becoming clearer and then becoming plural and hidden, and then re-emerging. In the beautiful phrase of the American philosopher John Dewey, describing art as process is like the flight and perching of a bird. You are in it. Then you pause and see what *it* is. And then back to absorption, the flight of music.

This is at work with the feeling for how porcelain phrases build up into complex melodies, while bringing you back to single pots. This is still a recent idea as Augustus starts to arrange his great collections in Dresden, find ways of animating the thousands of vessels he is buying, the thousands he is commissioning from Meissen.

Porzellankabinette, porcelain rooms, have currency in courts and palaces across Europe. The late English Queen Mary employed a young Huguenot architect, Daniel Marot, to create rooms at Hampton Court and at Kensington House. He has style of the *more is more* kind: his beds finish in ostrich plumes, his surfaces oscillate like the breathing flank of some thoroughbred animal. Chimney pieces were covered in porcelain garnitures, dishes and small vases were on brackets on every wall, pots lined the architrave where the ceiling started its curve. In his engravings Marot shows shafts of sunlight coming in, mirrors and lacquer panelling adding to the theatre, hundreds of pots becoming endless chambers of thousands.

This manner of displaying porcelain became hugely popular, much to the fury of Daniel Defoe. 'The Queen brought in the Custom or Humour as I may call it, of furnishing houses with *China*-ware which increased to a strange degree afterwards, piling their *China* upon the Tops of Cabinets Scrutores and every Chymney-Piece to the tops of the Ceilings and even setting up Shelves for their *China*-ware, where they

wanted such Places, till it became a grievance in the Expence of it and even injurious to their Families and Estates.' This seems an excessive reaction, until I remember that Defoe has some knowledge of clay. He is the owner of a failing tile works in the Essex marshes, put out of business by the Dutch. *Grievance* is a good word, for Defoe, policing other people's extravagance.

For these rooms embody excess. At Charlottenburg in Berlin Frederick I created a room for Sophie, Leibniz's correspondent and the clever one in the marriage. Here it is so layered that porcelain is not only reflected in mirrors but recedes into the walls. There are jars in front of dishes resting on brackets on glass, niches running round the room for tiny pots, painted Chinese figures with dishes as hats. Images weave across different dimensions.

Augustus has seen how other rulers use porcelain and is dismissive. He remembers his visit to the Trianon de Porcelaine at Versailles almost forty years ago. What is the point of having a pretty little pavilion sitting damply in your parkland to show your visitors, or a room somewhere up near the library or a music salon with some rows of vases on the chimney piece? It would look like you had used up all your porcelain!

So the work has started on Augustus' Japanisches Palais across the Elbe. It is vast. The roof of the palace sweeps down like a pagoda. You enter through a great gateway and see a courtyard beyond you. All the columns are held up by crouching oriental figures. The toes of their sandals sweep up. You go right up a run of shallow steps, and when you reach the first floor, you will be in a long room which contains nothing but the beautiful red and brown *Jaspis* porcelains from China and Japan. And then the double doors at the end will be thrown open and you will enter a room furnished entirely with celadon porcelain. And on. Through blues and greens and then purples. Through different colours and patterns of porcelain, each space opening on to the next. It is a fugue state, a journey through the spectrum of porcelain. You end up either in a chapel of white porcelain or a small and perfect space of white and gilded porcelains. It is music.

The Japanisches Palais is to be the greatest building of porcelain since the emperor Yongle ordered the pagoda in memory of his parents three hundred years ago.

Augustus orders a painting showing 'Saxony and Japan who quarrel over the perfection of their porcelain manufactories ... The goddess [Minerva] will graciously bestow the award of the struggle into Saxony's hands. Jealousy and dismay will prompt Japan to load their porcelain wares back on to the ships that once brought them here.'

I remember that early in his porcelain madness, Augustus dreamt of sending ships to the Orient – Japan or China – to buy up what he could. It is different now.

ii

On my final day in Dresden the temperature drops even further. As I've never been inside the Japanisches Palais, I make an appointment. The porcelain is long gone. Thirty years after Augustus died the great displays were stripped back, room after room of different glazes and patterns, and moved to the cellars. In the 1860s, 'duplicate' porcelain was sold or swapped. The French porcelain manufactory of Sèvres did really well out of this trading. An educational museum of ceramics was planned. It never happened.

Design for the Japanisches Palais, Dresden, 1730

I get stuck here, thinking of the breaking up of Augustus' collections, wondering why 'duplicate' should have been a problem, as duplication, multiplication was the only imperative in his life.

The palais has been home to the coin collections, to the antiquities collections, the state library and for a hundred years, an ethnographic museum and geological museum have been here too. It has been a Dresden lumber room. And it is now almost deserted. Most of these ethnographic collections have gone, off to a new museum in Chemnitz. Three white vans are parked aslant in the great courtyard. A few lights are on. A conservator comes to meet me. She has been working for eighteen years on a decorated, panelled wooden room from Damascus, bought a century before, dismantled and stored, forgotten as objects and collections came and went, shipped to the fortress at Königstein during the Second World War, retrieved. It is a room of perfect proportions, to sit in and talk, Arabic poetry on panels high up, painted cartouches of fruit amongst the flowers.

The poetry, she says, was chosen so that it would offend no one who came, Muslim, Christian or Jew.

And in her vast workshop overlooking Dresden, the rooms of the palais that used to be the rooms for celadon porcelain, with half-conserved panels on the floor, she brings out small cakes, makes green tea and serves it in glasses.

I couldn't get to Damascus, but I realise that Damascus has come to me. We talk about porcelain and she finds photographs of great dishes of Chinese blue-and-white from Jingdezhen displayed in rooms in Damascus and Aleppo, waiting to be taken down, placed on these carpets of flowers, heaped with pilafs, shared with family, guests, travellers.

It has taken me over twenty years to get here to the palais.

I had an ink sketch of one of these rooms pinned up above my wheel for a very long time. It was a challenge. Did I want to make porcelain that could be shuffled around, or could I make more of a demand on the world, shape a part of it with more coherence?

I made my own porcelain room for an exhibition at the Geffrye Museum, a kindly brick-built eighteenth-century almshouse on a grim and busy road in the East End of London, now a museum for the history of the domestic interior. Another artist, a maker of baroque and highly coloured ceramics, and I were each given a space and a modest budget. I said yes on the turn of the conversation. I reckoned that the last porcelain room had been commissioned towards the end of the 1770s, a mirrored room of porcelain confectionery, spun in gilded nonsense for some Italian palace.

I wanted to be able to feel what it was like to be surrounded by porcelain. It was a stage set in MDF, rather than marble, in a temporary exhibition space in the basement rather than overlooking a deer park, or the Elbe. But theatricality was part of every porcelain room ever built. And this felt fine.

For it to be a proper room I needed a wall and a floor and a ceiling and light. The wall was 400 cylinders, each four inches high on fifteen shelves. Repetitions and returns as clear as any bit of Philip Glass piano music. On the floor were black industrial bricks. I put seventy shallow dishes into a thin channel, a line of grey porcelain inlaid into the ground like a sustained note.

Light came in through a porcelain window. I'd thrown huge cylinders, trimmed them as thinly as I could and cut them into panels. I dried these very slowly between boards and fired them with trepidation over several days. Then I held them up to the light. They worked. They were translucent; light filtered through, just. It was a sort of dusty,

slightly yellow creeping kind of light, but lucid. I saw my hand through my material, darkly.

And I made an attic.

Attics are places where you try and forget. They are stuffed with cast-offs, broken toys, places where you store the things you cannot legitimately dump – wedding presents, children's drawings, abandoned musical instruments, suitcases that might come in useful for some over-specified holiday that isn't going to happen. And they are places where the most valuable things go.

But in my porcelain room I wanted a place for the ideas that haven't been completely realised, working notes, marginalia, drafts crossed out. Why would I want to keep this? Not for authority, but rather for the humanity of it, the crunch of shards in the yard of the workshop.

So, I put a garniture and some lidded jars and a line of pots that I'd tried out on the shelves before realising their proportions were slightly clumsy, and they looked beautiful in the shadows above me.

Beautiful because you cannot see them in their entirety, pinned down and accessible. They were safe, I suppose. Not safe from being handled, used, but safe from being got at and documented and sold. It is not that being shadowy gives you gravitas or mystery, or that you are clothed in some borrowed seriousness. Rather, shadows push profiles away. You can gain the shape of an idea by losing its particulars.

We had an exhibition opening about which I can remember very little except that my little boy of three adored the room next door with its pineapples. And that one person after another after another told me how frustrating it was not to be able to see what was in the attics. Why weren't they lit?

This was my transitional moment as a potter. I now made *Installation*. I hovered excitingly near to *Architecture*.

And I heard *Grievance*.

I'm racing again. I know I should be calmer, but calm and this strange city are not aligned for me. I have no·time left. I have so much to see again. I need to check the colour of the celadon wares that Augustus commissioned for the Japanisches Palais so I run back across the Augustus Bridge, turn right and run through the courtyard of the Zwinger.

I catch my breath in the porcelain galleries. They hum gently as visitors admire the exhibits.

These spaces were never intended for porcelain. They weren't used for this until the Soviet Union shipped back the treasures of Dresden, taken to Moscow for fraternal safekeeping in the days following the entry of the Red Army in April 1945.

In 1958, Augustus' porcelain returned – mostly – alongside the other great objects from the *Kunstkammer*. The Zwinger, in ruins from the bombing, began to be restored and in 1961, it was reopened.

I range back and forth. The galleries are magnificently wrong. Garnitures of Kangxi *famille rose* from China and Kakiemon from Japan sit on giltwood tables. There are fragments of 'porcelain room' display in the niches, plates and vases on brackets in perfect symmetry. Some of the Dragoon vases are here on a plinth. There is the model of Augustus the Strong on horseback. This was the subject of endless despair. How can you make a sculpture in porcelain where horses' legs can support a figure? One huge room of these galleries holds the menagerie of porcelain animals, created over twenty years by the great sculptor Kändler, displayed on a rocky outcrop under a bell tent of swagged silk. The alarm goes off every ten minutes as someone tries to get close to one of the huge porcelain figures of the rhino or the lion.

There are vitrines for some of the famous dinner services – the Swan service made for Count Brühl, where the pellucid plates are modelled so that fish and birds seem to emerge out of water. There are coronation services and marriage services, and the whole unfolding of

Meissen as Everything. Porcelain for harlequins and bands of musicians, fountains and ruins for table decorations, candelabra, crucifixions, busts, cutlery, walking sticks. Porcelain for tribute and gift and diplomacy, for display and for intimacy. And painted with classical scenes, and landscapes, and phantasmagorical creatures and butterflies, birds, insects. The celadon wares flare up on a wall. They are bluer than I remembered them.

There are helpful cases for comparison, and the wall texts are terrific, and clear. Lifetimes of scholarship and connoisseurship are here. And it is not that I'm expecting authenticity – great dinner services on tables a hundred feet long, the menagerie lit by candles, though that would have been a nice touch – it is just that it seems so tame.

It has been admired so much that it has expired, grandly. The fierce, brilliant, terrifying idea of white has been smothered. Tschirnhaus has disappeared, gilded.

Porcelain has become bourgeois. It becomes my eight-lobed bowl, fat with summer fruit. It becomes the 'gilt-edged Meissen plates' brought in carefully by the servants under the sharp eye of the mistress of the house during an endless dinner of fish and boiled ham with onion sauce and desserts of macaroons, raspberries and custard in Thomas Mann's *Buddenbrooks*. It becomes expensive and collectable. It is here that porcelain becomes possible for many things; it is re-inscribed as a commodity rather than a princely secret. This particular rewriting should feel fine. After all, each piece of porcelain in the collections has its cipher, a reign mark from China, or a factory symbol and its inventory number, and many renumberings. Every document seems to be annotated. When I go back to the great first notebook entry of porcelain being discovered, *album et pellucidum*, I realise, painfully late in all my research, that it is not only Böttger's handwriting on the page but that someone else has written up the notes too.

This whole city is a palimpsest. There are contemporary restorations of GDR rebuildings of the palaces and treasure houses destroyed in the war.

As I leave the Zwinger through the archway under the Stadt Pavillion I notice a plaque on the left commemorating its rebuilding with the help of the Soviet Union. It is undated. But there is a footnote, a smaller plaque, also undated, which tells you that the original is from 1963.

This, I think, must be early Post-Wall Confidence, 1990.

In the taxi to the airport I chat to the driver about the Lebkuchen and Stollen that I bought last night at the Christmas market, and she tells me that the market was *not good*. The proper one is elsewhere. I always seem to get markets wrong.

Chapter thirty

i

So I finish *Saxony* and write *Good Work*.

France: Shows Promise. In France, the porcelain factory at Saint-Cloud
continues to make *contre-façon* wares. They are still beautiful, still
wrong. The grand dauphin with all his beautiful Chinese porcelains in
the rooms at Versailles has died. The Fonthill vase, recorded in a draw-
ing by the aristocratic antiquarian M. de Gaignières, has disappeared.
There is a new king, Louis XV, nine years old.

Delft is simple. Nothing much has happened in the twenty years
since Tschirnhaus visited. There is still no proper porcelain. *Must
Try Harder.*

ii

And then I get to *China 1719*.

In China, Père d'Entrecolles looks after his parishioners. And his
fellow Jesuits too, who are a quarrelsome lot. Rome isn't helping. The

archives stress how loved he is. He is still in Jiangxi Province, still travelling to Jingdezhen.

His first great letter from Jingdezhen has been printed in the Jesuit *Lettres édifiantes et curieuses*, edited by Father Du Halde, and is attracting attention.

His great friend, the Mandarin Lang Tingji, the maker of porcelains for the emperor, is now very grand indeed. He is not only the governor, but he is responsible for the 1,100 mile long Grand Canal that links Beijing to Hangzhou.

The French have done the Kangxi emperor proud. He loves the way that the enamels work on porcelain, he loves his harpsichord, his mathematics. They sent him a good Jesuit glass expert, a Bavarian, and there are now *Imperial Glassworks*. These are a great success. The emperor has sent this new glass to Peter the Great in Moscow, and forty-two pieces to the pope.

But it is enamels which have been the greatest success with the Kangxi emperor.

At this moment, Father Matteo Ripa writes that:

> His Majesty having become fascinated by our European enamel and by the new method of enamel painting, tried by every possible means to introduce the latter to his Imperial Workshops, which he had set up for this purpose within the palace, with the result that with the colours used there to paint porcelain and with several large pieces of enamel which he had brought from Europe, it became possible to do something. In order also to have the European painters, he ordered me and Castiglione to paint in enamels.

Unwilling to be enamel painters, they have painted so badly that the emperor has excused them.

Others have learnt *with dispatch*. And these porcelains, with their soft

pink and carmine colours, *famille rose*, are remarkable. This new palette brings new stories. The first examples to reach the West have been met with astonishment.

I read a description of the emperor. He is *Kang-hi*, that is, the Peaceable.

> then in the forty-third Year of his Age: His Stature was proportionable; his Countenance comely; his Eyes sparkling, and larger than generally his Countrymen have them; his Nose somewhat hawked, and a little round at the End: He had some Marks of the Small-Pox, which yet did not lessen the Beauty of his Countenance.

I look hard at his portrait. All emperors look like Dorothy L. Sayers, legs planted firmly apart, hands on lap, solid, unknowable.

iii

And then I reach *England 1719.*

A German prince, George of Hanover, has been king of Great Britain for five years. He is possibly the only German prince uninterested in porcelain. He brings his servants, wisely imports his cook and a few bits of Meissen. There are no porcelain factories in England.

And a young boy is starting out on the long walk from Devon to London. It is 207 miles, a week's solid trudge, from Kingsbridge church to No. 2 Plough Court Pharmacy, off Lombard Street. William Cookworthy is to be a working lodger. He cannot pay the fees for something so formal as an apprenticeship. He is a charity case, who is to have six years of training in chemistry.

Part three

Plymouth

M.ʳ
Wᵐ Cookworthy's
Factory Plym:
1770.

Chapter thirty-one

The Birth of English Porcelain

i

To find my third white cup, I'm home in England.

A London winter. Nothing much to complain about, except that the studio leaks. There is now so little room that we have to carry pots and vitrines outside to crate them up.

Part of the problem is that the tiles have come back from Jingdezhen in a dozen crates of ridiculous heft. I need seventeen intact tiles, I've worked out, for my exhibition in Cambridge. Nothing has broken in transit, though I step backwards off the tail lift of the lorry and feel bruised and stupid. I have 121 beautiful, thin, celadon-glazed miraculous porcelain boards, some slightly rippled, a few with a gentle tilt. I find a very small chip in one corner. This is, I reflect, why there is so much Chinese porcelain in Europe. Everyone orders far too much from anxiety.

I've seen a factory for sale. It is vast, eight times the size of our studio here with a double-height hangar and a floor of offices, each partitioned into tiny rooms. *No Obstructions On Stairs.* A hatch for *Enquiries.* One man works up here and one down in the factory.

They made cartridges and repaired shotguns and rifles. There is a room lined with zinc panels for gunpowder and there are seventy years of wooden boxes from Germany with *Explosive* written on them, stacked up, filing racks of bird scarers and duck lures. There is a safe they can't move. No one, says the man, has guns repaired anymore. The firm has been going since the middle of the nineteenth century. He is matter-of-fact but it is sad.

It is very melancholy. It is very cold. I love it.

You could do a project here, say architect friends, record it all properly, keep some part of it. They are completely right. I should. There is work to be done – an exhibition for New York – and time is getting short, so it all gets stripped back and the offices and the dully glinting room of zinc put in skips and my new studio is painted start-again white. Fierce White.

ii

England and porcelain.

This should be the easy bit. After all that aristocratic stuff, I'm here in market towns. I know the landscape. If Dresden was Technicolor with mistresses and escapes, England promises lots of experiments going wrong. There is a different speed here, and I have to think my way into how to pace thirty years of doggedness.

I'm also a little anxious about writing about desire for porcelain. It is universal, of course, but the English keep their desires very well muffled up and it may prove trickier to locate.

England 1719. A young boy is starting out on the long walk from Devon to London. In terms of storytelling I wonder about how many times I can write about setting out.

In terms of white porcelain, *setting out again* makes complete sense.

iii

It is a story like any good eighteenth-century novel. The frontispiece for *The Life and Times of Wm Cookworthy* would show the hero – fifteen years old, Quaker, solid and earnest with his pack on his back walking towards London. The first chapter would skim the death of his father, the industrious home ruined, the seven young children, the further catastrophic penury when the South Sea Bubble takes all savings and ends with a letter of invitation, an offer of work in an apothecary's workshop.

And then the long walk from known towards an unknown future.

The known is deep England, a village folded into small valleys and oak woods. There are creeks that fill from the estuary and flood. It is a slow bit of country as the roads are narrow and claggy in winter, damp most of the year, dusty for a surprising month or two, then impassable again. The colour is mud and lichen, strong unambiguous colours.

The unknown starts as you walk up the three wide shallow steps flanked by a curved handrail to the double front doors of a pharmacy. Open the doors and you come into a generous hall leading to the room with a large window letting light and air into the shop where Silvanus Bevan and his assistants compound their medicines, lotions, ointments, draughts and tinctures at a long counter.

I realise that it is just like the pharmacy in the Molksmarkt in Berlin where Böttger started out.

Chapter thirty-two

Three Scruples make a Dram

In the pharmacy are blue and silvered jars on shelves arrayed against the back wall and the impression is of efficiency, of organisation. This is a modern druggists with a young owner – Silvanus Bevan is twenty-eight and newly qualified – and the *Pharmacopoeia Londinesis* or the *New London Dispensatory*, with its authoritative tabulations of remedies, is there for the studying and annotating.

There is work for a boy in learning how to grind down and remake the composite parts of a world into warily dried pills to cheer 'the Heart and Vital Spirits'. You go to bed and your mind ticks. *Three Grains make a Scruple / Three Scruples make a Dram / Eight Drams make an Ounce*. And then it is five and you rise from your pallet bed in the attic – too cold or too hot – and wash in the cellar where the pipe comes in.

The household gathers for silence as this is a Quaker house. And then your day starts and your hands and arms are in cold water all day. You must wash the flagstone floor and you must wash the pestles and mortars, the copper basins, the spoons and scoops, the measuring pans, the bottles and stoppered jars, the phials. You feed the stove which is drying agrimony and centaury. You run out up the stairs and out into

the yard to help the men unloading straw-wrapped boxes, barrels that are rolled down into the cellar.

What do you know about what is precious in this place, where a pinch of this saffron-coloured powder could buy the hillside behind your village? You start to learn who is who amongst this flow of people coming and going through the gateway into Plough Court and up the three steps into No. 2; the doctors, pedlars, tradesmen, travellers, the desperate and the ill, the importunate, the pious and the curious, the poor, the Venetian ambassador, charlatans, Newton, fellows of the Royal Society, Sarah the duchess of Marlborough, Quaker Elders.

You are sixteen, seventeen, eighteen and on the threshold.

And it is not just people crossing this threshold. From Pennsylvania come specimens of American plants such as ginseng and copper ore,

Watercolour of No. 2 Plough Court, London, c. 1860

bezoars from Persian mountain goats, powdered pearls from Antwerp. These materials are a kind of cosmography, a mapping of the world.

And objects come in for Silvanus Bevan's collection too. He has the forelimb of a mermaid and fossils and he nurtures herbs and rare plants, and may have forsworn some of the esoteric ingredients favoured by apothecaries of the previous generations, like powdered swallow and human tears.

Knowledge here is an ebb and flow.

There are books arriving all the time, in Greek, French and Latin. Bevan goes with his assistants to lectures, assemblies, experiments, Meeting. This household has not been blessed with children, but it has as much noise as Quakers can handle. 'Let him have a care he mistake not one thing for another' is the rubric of the great *Pharmacopoeia*. Gradually you learn 'the election of simples', the identification of plants, seeds, berries and leaves, how milkwort differs from soapwort and all the varieties of English plants from adder's tongue to yarrow. How it looks, how it smells, the ghost of its aroma as it crumbles into dust in the shallow dish where you prepare plants for decoctions. You learn preparations.

You learn how to think.

Thinking is through the hands as well as the head. After a couple of years you can tip a phial of X or Y and tell by the speed it moves whether it has the correct viscosity. When you levigate, 'make into a smooth, fine powder or paste, as by grinding when moist: a method of separating fine from coarse particles', you change the direction of the pestle in the heavy mortar. This is apprenticeship: the moving of learning from head to hand to head. No short cuts repeats the clock.

No short cuts, said Geoffrey during my apprenticeship thirty-five years ago, no mistaking one thing for another.

No short cuts, I said to my first apprentice, some twenty years later.

Chapter thirty-three

A Quaker! A Quaker! A Quirl!

i

The business of this house is both deeply abstracted and deeply practical. This is the Quaker way.

The Quakers at this moment are in ascendancy. Since the Act of Toleration of 1689, they are allowed to worship freely without the fear of imprisonment. But as they refuse to swear all oaths including the Oath of Allegiance, they cannot become Members of Parliament, cannot ascend the hierarchy of the state, become justices of the peace, serve on juries. And they cannot attend grammar schools or go to either of the English universities. As the days of the week and the months of the year are tied to pagan names, the Quakers have recalibrated the calendar so that Sunday is now the First Day and January has become the First Month.

They hold themselves apart with their sombre dress, those wide hats and close bonnets, self-contained. Sixty years ago, it was the stocks. Thirty years ago, you might be arraigned. Now you get the odd shied stone from that knot of boys that forms and re-forms like a murmuration of starlings in autumn; A Quaker! A Quaker! A Quirl!, they yell,

and the stones come over. You are not to respond or curse, but running is allowed.

This pushes the Quakers' entrepreneurial energy into alternative spaces and ideas. In all those shared silences at Meeting – long and measuring and unfolding – you look at those around and there is a kind of assessment in these hours as you wait for God to call on your fellow Friends to speak.

The houses in Plough Court off Lombard Street were perfect for this careful knitting together of home and work and community. They have enough space for a workshop and apprentices. As in every part of London, there is a special timbre to belief in these few streets. Down in the east, in Spitalfields, there are the Huguenots, but here is Dissent with its collection of printers and doctors, and now chemists, merchants and coffee importers.

London is huge and chaotic, but this bit of territory is easy to map.

The Friends' Meeting House is in White Hart Court in Gracechurch Street, four minutes away from the pharmacy if you are in hurry to get to Meeting. A watercolour shows a sea of bonnets, women on the left-hand side and men on the right-hand side, a few colourful visitors in the balconies. Though it is flooded by light, it is a study in umber.

In the shop, Silvanus and his assistants are dealing with agues, melancholy, bee stings, astonishment, dropsy, the pox, green sickness and gout, a woman who needs to know whether she is with child or not. The art of the apothecary is complex. It necessitates looking at the person standing in front of you and assessing their needs.

Silvanus, wrote Benjamin Franklin, another visitor to Plough Court, was 'remarkable for the notice he took of countenances', manifested through his talent for cutting 'strong likenesses' in ivory. Silvanus's little ivory plaque of William Penn, all curlicued wig, shows a real man, substantial, confident, with his chins looking into the distance, pausing before speaking.

For William Cookworthy this art of taking notice, being shrewd, is another part of *not mistaking one thing for another.*

ii

And this fits with the obsessive record keeping that is part of Quaker life.

As the Quakers have opted out of the trappings of the state and conduct their own ceremonies, they keep lengthy records of marriage, permissions, wills, inheritances, the poor, grievances and concerns. There are ledgers and fair-copy letter books that minute the tremors of unease around the behaviour of a particular Friend, the caution of anything that might rebound on the image of the Friends. There is always the threat of exclusion, the sanction of removal from the Friends, and this necessitates more noting.

This ordering of life is easily understood. You know where you are.

All this accounting and counting and recounting on this earth helps to strengthen the rectitude needed for the final accounting to God.

I'm not sure how long I would last before the stern questioning of the Elders.

My methods in gathering material, noting it, and keeping clean records, my archival habits, are shot.

A couple of months ago, unable to sleep in the middle of the night, I bought William's *Patent for Porcelain* from an online bookseller as I wanted to have it in my hands. I thought it might emit some tremor of all the aspirations of the old man. It was as ridiculously expensive as my four pages of Tschirnhaus bought during my research last year. When it arrives from the bookseller, it is perfect.

And now I can't find it.

My papers and files are in disarray with notes on China buried somewhere by Meissen, with Tschirnhaus on top of this, and now the complete works of Defoe and the letters of Leibniz.

Do I have to stay awake until I'm in some fugue state to find it?

And God help me, I think, as I look at my desk. I've got rid of the Jesuits and landed myself with the Quakers.

Chapter thirty-four

a greater rain

i

William Cookworthy is twenty-one in 1726 and after six years in London he is set on his way to Plymouth.

In the established Quaker way, Silvanus is setting William up with a modest loan as Bevan and Cookworthy, Chemists, in Notte Street: 'That part of the Town where Merchants do most congregate, a street that runs down towards the Quays, Customs House, Exchange and other offices connected with the Port.'

It could not be a better start for this young man.

The house is in a garden, useful for herbs, on one side of which stand the chemical laboratory with its benches, shelves and still, and a dispensary. It is seven windows wide, four storeys high, dressed in Portland Stone with a steep flight of steps to a beautiful pedimented door with an eagle about to take flight.

I am following William. We're on first-name terms.

I've had Jingdezhen and Versailles and Dresden. I've had my fun and I'm off into the West. Plymouth is a busy port, set within the folds of grey-green wooded hills, the rivers running deeply out to the Channel, the grey-green town hugging the crescent of land. Dr John Huxham, William's new neighbour, writes of the place:

> The town of Plymouth is situated at the Bottom of a very large Bay, lying quite open to the southerly Winds; on the East and West it is sheltered by very high Cliffs, at the Bottom it is terminated by Marble-Rocks, yet so as that an Arm of the Sea runs up a great Way into the Country on each Side of it . . . From the Bottom of the Bay the Country rises continually till you come to the Dartmoor Mountains at about ten Miles distant from the Town. – I have therefore described the Situation of the Town, that, amongst other Things, some Reason perhaps may be assigned why there falls such a Quantity of Rain here yearly.

This is not so much a landscape as a weather system.

It is a place prone to 'sudden and sometimes severe changes of the weather', writes Dr Mudge of Plymouth. The sky is lead, pewter, tin, sometimes mackerel, while the ground is 'very dirty in wet weather, from the currents which pass along the middle of the streets'. In the British Library I spend a happy morning with Dr Huxham, who has used his barometer three times every day to record *Observations on the air and Epidemic diseases from the year [1727] to [1737] inclusive*, so that I know just how damp William gets in the morning, as he walks out at noon and as he takes his dinner and falls into bed in this new place.

His days are to be marked, charted either as 'Some Quantity of Rain', 'A considerable Quantity', 'A greater Rain' or 'Continual and heavy Rain'.

The town and the dock are congested, febrile with sailors and whores, pressgangs and navy fixers, chandlers for sailcloth and spars, rope-makers and block-makers. There is a constant stream of carts for the merchants in the woollen trade handling the coarse wool from West Country flocks and serge cloth for export, and boats coming in from Cornwall with tin and copper. There are the morning sales of pilchards caught with seine nets, and then three times a week there is a market of produce, butter, chickens and corn. Plymouth has rare and wonderful auctions on the quayside of prize goods, seized from whoever we are currently fighting – Havana snuffs, notes William – and there are hogsheads of sugar, rum, rice, tobacco, and every colonial produce landed here.

Wherever there are ships and cargos there are disputes, so this town has its attorneys. Then there are the doctors Mudge and Huxham, surgeons, bankers, auctioneers, the officers of the Royal Dockyard, and the clergymen they keep to preach respect and temperance to their sailors, and sundry ministers for the growing numbers of Dissenters, for Plymouth, like all ports, is a dangerous quivering balance of respectability and mayhem.

William is to be a retailer and a wholesaler to doctors and apothecaries throughout Devon, Somerset and Cornwall and to the immediate population in Plymouth. He rides out on his grey mare to Plympton, Plymstock, the South Hams, Buckland, Tamerton Foliot, Bere Alston, villages whose names read like the lists of esoterica for his apothecary's cupboard.

William Cookworthy Esq. is already a little stolid in his Quaker broadcloth, a white cravat at his neck, his wide-brimmed black hat and the steady pace of his horse.

William has called her Prudence.

Chapter thirty-five

covering the ground

i

At first, William's journeys are to drum up custom, connect with the scattering of customers who need ointments and potions and tinctures. And to see his family; his mother and sisters still live in Kingsbridge, some twenty miles away. But then he is invited to visit Meeting in the villages in the deep countryside with sometimes only a few Friends in a room, and he starts to preach.

In the deep lanes there is trefoil and comfrey, the simples which he can take back to his new laboratory. Slowly he starts to use these journeyings more systematically.

Riding covers the ground and you can see over the hedges, see the lie of the land. And you are at the height of a branch of crab apples, *Malus sylvestris*, or damsons, *Prunus domestica*. But the roads in this part of the country are notorious. Some of them are barely roads, more loose assemblages of ruts and potholes, flung together. Celia Fiennes, a generation earlier, nearly broke her horse's neck and her own, riding to Fowey from Looe, and Thomas Tonkin lost sight of an eye from a bramble overhanging a narrow sunken lane on his Cornish travels to research the

history of the county. If the mist comes down on Dartmoor, who knows what will happen to you. There are unfenced mine workings all over the country, sheer drops that take you, your pack and your horse. Beware rising water and incoming tides and quicksands, and beware the Cornish.

But when you are walking you find a different reading of the landscape. And he walks.

The stone of the cottages changes, for instance, as you climb higher towards Dartmoor. Here between Boscombe and Edgefield the road turns from a brown and cloacal mud to a paler slip. You are on the edge of a tilt in the rock. Walking allows the welter of anxieties to settle, of course, allows for a rehearsal of ideas. It also brings pleasure.

On a bridge in spring you feel the calligraphic shock of a kingfisher over the water below. A sudden shower and a stream like a vein of silver emerges on the hillside. You pause and lean on your stick to talk to the parish road-mender and idly turn the fragments of gravel with your toe, and turn them again. Here in autumn the stream washes over the track and carries silvery gravel from the hills to your right.

You have deep pockets. The skeleton of a weasel, some hazelnuts, and now a handful of this gravel. It looks as if it contains iron. Though how much iron is something that you can only discern in Notte Street tonight when you get home.

When you are walking you see movement that becomes men. And then you see mines. Sometimes you pass a couple of figures and a pickaxe, a scraping into a hillside, some baskets, a stream for washing ore, a tethered horse; freeminers working a tin-stream. They have rights to divert streams and cut fuel, bounding rights to 'search for and work freely for tin' over areas of common land.

ii

Other workings speak of money. They need ladders, and pulleys, waterwheels, sheds for the mine captain, stacks of expensive timber,

handpumps. The great mounds of overburden – loose earth and rubble and stone – tell you of shafts sinking eighty feet, fathoms down to reach copper, tin, silver and lead. There is mercury here, in a barrel, and another of arsenic for testing.

As he grew up in a Devon village, William knows what rural poor looks like with the sad smudge of smoke from a chimney, an exhausted line of cabbages, a clutch of children in a door. But this huddle of shacks near the pithead is different. Here children as young of six are sorting the ore in the mud. This is not clean, or tidy: it is improvident, wasteful, dissolute.

William is appalled. He wonders if the endemic colic is caused by the horrific drinking of cider amongst the labourers. Is it caused by lead poisoning? He notes that the plates of the cider mill are covered in lead.

This 'crusty, rocky slip of a country' is jagged with pitched battles between men from different mines, cockfights, gambling, casual piracy, wrestling matches that end in disfigurement, riotous revellings, drunkenness. It is attended by illness, racking coughs, lungs aspirant for air, repeated breaks to limbs, head injuries from falling rock, bloodshot eyes, lassitude and torpor, a hand that shakes and shakes. What connection is there between this weather, this landscape, this poverty?

The young apothecary has left Lombard Street far behind. This is his new threshold.

How do you weigh up dangers? The mines are full of 'Poisonous Damps', strange vapours where a man can sit down to rest and be found the next day, 'his elbows resting on his knees, in a kind of sleepy nodding attitude . . . cold and stiff', 'where a father and son were walking through the Adiot, when the son stepped into an old short drift and instantly fell down dead. The father, on observing this, followed the son to give him succour, and shared the same fate.' Mines are the underworld.

This is an alchemist's land and a mineralogist's dream, but it is shaken up and deranged. Material science means a trialling and essaying of the ground, an assessment of what this rock means, where riches lie. In Saxony, this has been done for 150 years, in the Goldhaus of Augustus, where they have charts and tabulated specimens of ores and gems from across the land.

But William walks across a landscape where knowledge is so local that the vernacular barely crosses from one valley to another. Lodes obey no logic; this lode is heaved to the right, or to the left, up or down, by a cross lode, a *contra*, a *gossan*, a *slide*, a *flookan*, or the like, 'pursuant to the idiom of our Miners'.

This is not a passive bit of country, some Wiltshire estate with elms halfway towards the river, some cows for placid scale. It is an active, angry land, caught up and congested.

To understand it you have to understand the accent of this crooked place.

Chapter thirty-six

shillings, pebbles, or buttons

It is money and ownership.

William soon understands that who owns the land is critical. All land can hold a mineral claim, an offer for the rights for a share of the profits. Cornwall has its own legal system for the ownership of mineral rights, its own courts — the *stannaries* — to decide on penalties for infringements. There are complex disputes over the inheritance of mineral rights. It is possible to own almost nothing of almost nothing and still live in hope of riches.

There is so much money to be made here, so much money to be lost, that everything needs to be done at speed, the shaft lashed together, barely propped. Your claim can lapse. You can wager your work against the future, buy credit for food and beer for your rights. You can buy a month of possibility on a few fields.

This is a landscape of speculation.

It isn't just the rich who become richer. It is 1735 and to William, upright and prudent, used to his profit-and-loss ledger, everyone in Plymouth and in Cornwall seems to be speculating. There are the

Friends who are buying shares in prize cargos on the value of a hold full of snuff and tobacco. Everyone has heard of the mine where £100 was invested and in the first week £4,000 of copper ore was raised, £2,800 in the second week. Everyone knows the prices. These first years that William is in Plymouth, it is £7, fifteen shillings and ten-pence a ton for copper. It matters because you are paid in complicated ways. You listen to the fluctuations in price as keenly as a trader in the bazaar knows the way that gold is heading.

You see what speculation brings – estates and livings and titles. Thomas Pitt, over at Boconnoc, near Lostwithiel, is the grandson of 'Diamond' Pitt who made a fortune in East India acquiring the largest and most beautiful gem ever seen, and selling it on at vast profit to the dauphin in Paris.

The Tinners, with only their coats on their backs, illiterate, can still 'assign the properties of a parcel of Copper or Tin Ore, with the utmost accuracy, by the help of twenty shillings, pebbles, or buttons'. Buttons or diamonds.

Chapter thirty-seven

Letters Edifying and Curious

i

The year 1736 'begins with a Melancholy aspect, for the gloomy South wind blows, and perpetual Rains fall', records the indefatigable Dr Huxham of Plymouth, noting his barometer, but William Cookworthy is very well.

He is doing so well that he can afford a wife.

Sarah Berry is Quaker, naturally, the youngest of a large and respectable Somersetshire family and the young couple have to declare their intentions to the Plymouth and Taunton Meeting so that they can be examined and 'certificates of clearness' produced. They are married early in the year 'with good order'. They begin their married life in sober comfort. William and Sarah, known to everyone as Sally, are blessed with five daughters, Lydia, Sarah, Mary, and then the twins, Elizabeth and Susannah, so that this becomes a noisy Quaker household.

William has visitors. He walks. He reads. Being in Plymouth, rather than, say, London or Bristol, does not alter the velocity of his reading.

Weary metropolitans always underestimate provincial life, the ways in which information, periodicals, knowledge are sensed and seized, consumed. This is a port, of course. You can see news coming round the headland, hear it in the shocking amount of noise as cargos are brought ashore. There may not be so many lectures and public experiments as in the courts off Lombard Street, but early evenings become long nights of reading and conversation here as a Greater Rain drums in the street.

There are many conduits for books and papers. France is closer than London, and books, like rum, sidle in and are shared convivially. His neighbours are erudite. Sometimes, I think, it seems like every doctor and apothecary and cleric in the West Country in the eighteenth century was writing a book about the place they are in.

William is drawn to pragmatic men, to the application of ideas back into the world. It is less problem-solving. It is more looking hard at

William Cookworthy c. 1740

the world and problem-creating, stubbing your toe against the intractability of what you don't know and can't find, and then kicking it with intent.

Knowledge is in English sometimes, but it often arrives in Latin and French. German is tricky. And this means that you spend your time tracking ideas through mentions and notes and shrugs of dismissal in several languages. There are journals that offer abridged versions of lectures, synopses that worry you through their elisions. What is being missed out? You order *An Abridgement of the Philosophical Discoveries and Observations of the Royal Academy of Sciences in Paris* every year and devour its contents. This year there are some Observations on the Bezoar, a paper on the Flux and Reflux of the Sea made at Dunkirk, an examination of the silk of spiders, something tendentious on the eclipse.

Certain names keep coming up, returning, retreating.

It is like at a noisy dinner when you become more and more attuned to the shape of a name, until you hear it reverberating. *Du Halde* is insistent. This is where you have to put aside your Quaker broadcloth. Much of the news from the most occluded parts of the East comes in dispatches from the Jesuits. Father Du Halde is the editor of their *Lettres édifiantes et curieuses*, flimsy annual reports that act as bulletins from the Unknown World. They come out irregularly, like all the best periodicals – It's here! It hasn't folded! – and into the hands of novelists and philosophers and scientists, and William in Notte Street.

And in 1735, Du Halde collects seventeen of these letters into four splendid volumes, vast and lavish, with beautiful unfolding maps and illustrations of silkworm factories and palanquins full of Chinese ladies. The title page shows a boat, laden, perhaps, with porcelain, in the harbour of a Chinese port, surrounded by Chinese figures, with *Confucius the Celebrated Chinese Philosopher* illustrated on the facing page. The books are published in English the next year, and then are printed again and again.

And there is another name that keeps turning up – a Swedish metallurgist, Emanuelis Swedenborgii. He may well write in Swedish, but William reads him in Latin. Swedenborg is the superintendent of the mines to the kings of Sweden and the writer of a substantial book in three volumes that examines the composition of the mineral world. He is particularly good on copper, and copper is a perennial interest as it provokes conversation on your doorstep, on the quayside, whenever you ride westwards into Cornwall.

Swedenborg is a natural philosopher, fixated on the transformation of shapeless energy into regular structure, grand rhymes that echo from

Diagram of divining rods, from *Mineralogia Cornubiensis*, 1778

the planets to grains of sand. But it is also clear that he is a deeply practical man, not only the inspector of mines but intrigued by new ways of discovering mineral seams through the divining rod, the *virgula divinatoria*.

William has taken it up with enthusiasm. He has learnt how to use it first-hand from the captain-commandant of the garrison in Plymouth, a truly respectable man and, 'by many experiments on pieces of Metal hid in the earth, and by actual discovery of a Copper mine near Okehampton', has become convinced of its efficacy. There are different pulls, William writes in a pamphlet, the strongest being gold, then copper, iron, silver, tin, lead, bone and finally coals, springs and limestone. But be careful he says, 'in metallic countries, vast quantities of attracting stones scattered through the earth . . . and, even about town, bits of iron, pins &c. may easily be the means of deceiving the unwary'.

He is straightforward about divining. This is not mystical, but a practical approach to exploring the world. And he writes that 'either the Hazel or the Willow actually answer with all persons, if they are in health and use it moderately and at a proper season'.

Evidently the sight of this Quaker chemist, serious and meticulous, with his forked stick criss-crossing an empty field, has produced ridicule. He writes in the pamphlet, 'I would advise in case of debates, not to be too warm and lay wagers on the success, but unruffled, leave the unbelievers to their infidelity.' When lodging at Carloggas with his friend Richard Yelland, he 'went about the country with a dowsing rod looking for materials'.

William has become an Adventurer.

Chapter thirty-eight

i

This is not adventuring in a haphazard way. He has his apothecary's shop to run, his family to feed and preaching at Meeting to prepare for. His training and his cast of mind aren't whimsical. With information like this, you sift and dry, and weigh, and measure. You test and then you retest. Two sources make an enquiry. Enquiry can start an adventure. This search is purposeful. The names in all those journals have begun to cohere around an idea, a possibility. William is a fisherman, and this is where he begins to cast his line.

When he reads the second volume of Du Halde's great book on China and has enjoyed the runs of chapters, 'Of their Prisons and Punishments for Criminals', 'Of the Plenty that reigns in China', 'Of the Lakes, Canals, and Rivers, as also of their Barks and Vessels of Burden', 'Of the Chinese Varnish or Japan', he reaches at the bottom of page 309, a chapter 'Of the Porcelain or China-ware'.

This chapter changes his life.

This chapter reprints the two letters of Père d'Entrecolles, written from Jingdezhen twenty years ago. Porcelain, says the learned father, is made up of two kinds of stone that must be refined and then mixed together and fired at sufficient heat. One is kaolin and the other is petunse.

This is extraordinary. It is the Arcanum in black and white. It is a map of clay. William notes it, as do others. Josiah Wedgwood, aged fifteen and working in his brother's workshop in Burslem – one of the scatter of pottery towns in Staffordshire – copies it out into his common-place book. Smallpox has permanently weakened this boy's right leg so that he cannot throw pots on a wheel. He dedicates himself to experimenting, to understanding method: 'Beautiful forms and compositions are not made by chance.' Across the seas, extracts are also printed in the *South Carolina Gazette*.

William is not alone in his adventuring. When the mist clears, the rains are blown away, you see that this landscape is alive with prospectors.

Others have made a wild surmise about the white rocks of Cornwall and their use for porcelain – not the kind of hard, translucent Chinese porcelain that William is after, but the soft-paste porcelains that are springing up across England. This kind of porcelain is the Saint-Cloud kind, creamier, opaque. It feels warmer, when you pick it up, than the Chinese or Meissen kind, almost as if they have been passed from someone else's hand.

Some use frits, ground-up glass or other forms of silica like fine white sand or flint, others are experimenting with bone ash. This last ingredient whitens the clay body and helps prevent the biggest problem for these porcelains – their propensity to 'all wear brown and [be] subject to crack, especially the glazing, by boiling water'. These wares are fired much lower than proper porcelains and the constituent elements never fully combine to form a glassy whole.

They are a beautiful simulacrum, a white surface on which to paint your peonies, colour your shepherd boys, but 'readily stained in use, and scratched even by the friction of a silver spoon'. They even change with the weather, notes one disgruntled commentator.

One possible ingredient that seems to work is a white stone, known on the north Cornish coast as soap rock. It is:

> a fine and beautiful clay, of a firm, compact and regular texture, considerably weighty and hard, of a smooth and unctuous surface . . . it does not colour the fingers, but drawn on a board, &c., marks a white line; it does not adhere to the tongue, nor does it melt, but when chewed, has an unctuous softness, and is quite pure and free from all grittiness . . . the finest is generally white, sometimes with a yellowish hue, elegantly veined and spotted . . . it so greatly resembles hard soap, that it has obtained its English name of soap-stone, and that of steatite from our suet, from its resemblance to the hard fat of animals.

It is found near Mullion Cove, on the raggedy bit of the coast that seems to be nothing but cliffs and wind and it is mined God knows how, and at God knows what cost, as the mines flood at every high tide. This soap rock is 'much coveted, and barrelled up for London, the reasons concealed, but for the porcelain most likely, or glass manufacture, or both'.

These factories – Chelsea, Bow, St James, Worcester – are friable: chip one person off and a new one is formed. Robert Brown is said to have hidden in a barrel in the workshop of the Bow factory to see what was being added to the paste. He has now started his own porcelain works in Lowestoft. Alexander Lind, starting a porcelain manufactory near Edinburgh, reports that he has managed to see the furnaces at Bow and Chelsea, 'which were what I chiefly wanted to see', by accompanying an aristocratic visitor.

Another Arcanum. Another set of secrets.

Everything is a secret around porcelain. Everything is locked up. The secret formulae themselves are 'deposited, locked up and secured in a box with three different locks and keys one of which shall be in the hands of the inventors', the others with the investors.

For goodness' sake, in Meissen they are making dinner services, dozens of perfect dishes of the lightest, whitest porcelain, while here in England there is an air of desperate casting, a scraping together of investors, promising and promising, uncertain of outcome. *A General Description of All Trades* remarks that potters 'stand little Chance to set up for themselves, unless born to good Fortune'.

Or born elsewhere.

Chapter thirty-nine

china earth

On 30 May 1745, William writes a letter to his friend and client Dr Richard Hingston of Penryn, a Quaker surgeon, 'Dear Richard, My Eastern and South-Ham journeys hath kept me of late so much abroad that I hath not had opportunities to write to you.' He apologises for the damage to the pillboxes which are normally well wrapped. His latest order has just been sent by sea to Falmouth. Has Richard been following the sales of prize cargos in Plymouth and the Friends who have been involved?

And, he goes on, evidently picking up an old conversation:

> I had lately with me the person who discovered the CHINA EARTH. He had with him several samples of the china-ware, which I think were equal to the Asiatic. It was found on the back of Virginia where he was in quest of mines and having read Du Halde, he discovered both the petunse and kaolin, but it is this latter earth which he says is essential to the success of the manufacture. He has gone for a cargo of it, having bought from the Indians the whole country where it rises. They can import it for £13 per ton and by that means afford their china as cheap as

common stone ware, but they intend to go only about 30% under the company. The man is a Quaker by profession, but seems as thorough a deist as I ever met with. He knows a great deal about mineral affairs, but not *funditus*.

This traveller has brought with him examples of new porcelain, talked of where the real materials for its manufacture lie. He has sketched a possibility. William listens.

The weather changes here within the quarter-hour. This mostly means you come home drenched, whatever you were expecting at breakfast. But today, staying with Friend Nancarrow, a superintendent of mines, you set off with a whippy little wind in your ears. It is a June morning and early, but you are glad of the thickest broadcloth you have and within your quarter-hour you are baked in your good black preacher's coat.

You are passing Nancarrow's works, so you stop to draw breath, and unwrap your stock from your neck. You take a drink of water from the brook that cuts down the hillside and you watch the labourers who are mending the furnace that drives the engine to pump water from the mines. It has split and they are caulking it with a local white clay from the moors, they tell you, spreading it into the cracks like a paste. As the furnace heats up, this white clay bakes on to the metal to fill the fissures. It is the use it's commonly put to, 'mending the tin furnaces and the fire places of the fire engines; for which 'tis very proper'.

Lives can change within the quarter-hour too. You take some of this white earth between your thumb and forefinger and it crumbles only slightly. Spit on it and rub again and it is a paste that spreads across the pads of your fingers and dries whisper-thin. Might it be? You know it. You take a knuckle of it home.

And the other material: the petunse?

You have been talking again. This time to some bell-founders in Fowey. You are asking them about the different materials that they use, and notice that the heat of the molten metal had fused some of

the stones used to line the mould. What fuses in this way? You take a handful back. This same rock, you realise, white with greenish spots, has been used to strengthen the gun emplacements at the Plymouth garrison.

What does William see? He sees one material changing into another. He sees workers, Creation, the great rhythm of change. And because William is truly interested in people at work, he asks questions and then he listens to replies.

He comes back to Notte Street with geology on his boots, up the road from the docks.

Chapter forty

a shard, which, by leave, he sometime broke

This isn't a bad place to make a living. William is doing well enough that he can repay Silvanus, and finally put *Cookworthy and Co.* above the side gate.

And though this is a carefully run and prudential family, there is the odd dropped plate, a handle swiped from a cup in the scullery sink, and one day a Chinese plate – one of the precious set that his midshipman brother Philip brought back from his time at sea – is severely chipped. And William, for whom the world of things is an Adventure, keeps on going and breaks the plate into shards.

The glaze hugs the porcelain clay tightly, a Cornish shoreline of white. It is a different hue from their crockery. 'I have, now by me, the bottom of a Chinese punch bowl, which was plainly glazed, when it was raw or a soft biscuit; for the ware wants a great deal of being burnt; it being the colour of coarse whited brown paper', he writes. And it has broken in a different manner too, sounded in a different way in its demise.

All porcelain sounds differently at the moment it hits the floor.

Sometime before, Quakers had been urged to 'refrain from having fine tea-tables set with fine china, being it is more for sight than service . . . It's advised that Friends should not have so much china or earthenware on their mantelpieces or on their chests of drawers, but rather set them in their closets until they have occasion to use them.' He has a use for them now.

He starts to break pots.

He becomes known for it. In a memoir written twenty years after he died, a pious Quaker writer says that William always asked permission before he broke your pots, 'a shard, which, by leave, he sometime broke', but this is so firmly stated you know that it cannot be true, that here must be a secret history of casually snapped saucers, cut fingertips as he traces the line of the break, silently below a table, before 'shewing the owner the excellence of the texture'.

There is now a shelf of shards in Notte Street. Fossils, minerals, books. And shards. There is now a shelf of shards in my studio too. Broken tea bowls from a hillside in China and a crescent from the floor of Albrechtsburg Castle, surreptitiously gathered.

'To acquire a competent knowledge in Mines, &c., a long residency in their vicinity is certainly necessary', writes Dr Pryce, the expert on the geology of Cornwall. 'Much study is weariness of the flesh', says Ecclesiastes. You need to stay still. You need to know what study means. These sentences sit next to each other.

William is now forty, energetic and long-time resident in the West Country, much studied and quick-witted and curious to take bits of Cornish rock home. He has seen a rock melting to make a viscous white puddle, then harden until it is as strong as metal.

Chapter forty-one

silences

i

Sally dies.

She is only thirty-five, the girls are nine and seven and five and the twins are two and a half, for goodness' sake, and what are you supposed to do with a God who knocks the earth from under you as totally as a shaft giving way, takes away the ground on which you walk? You are voided. And again. Elizabeth, the older of the twins, dies eighteen months later. She is four.

You are changed by grief. You are the same man but you know what change means, that one substance cannot recover its previous state, and this is it.

For two years you are 'removed' from the world. The world comes up Notte Street and rings on the dispensary door, runs round the corner of the kitchen chasing a top and bumps you, asks you, again, to explain about the drying of simples in crucibles, but you cannot hear it or feel it or answer it.

It is a kind of optics this living, with some things very close and in terrible focus, and some things opaque and very, very far away.

'I have long dwelt in the house of mourning', he writes to his friend Richard, who has lost his own wife.

ii

For these two years it is said that William is so deeply distracted that he does not work. His mother comes to live in Notte Street to help with the children and his brother Philip, crooked, somehow damaged by his years away, is brought into the household as an apprentice. Their youngest sister comes to live with them.

In the following years he takes up the strict observance of dress and adopts the peculiarities of speech 'that distinguished the strict Quaker'. He dresses now in black, he addresses you as 'thou'. He lives with a new intensity. He is obsessed with an idea, an image. In the Quaker doctrine of the Inner Light, God is in direct communication with you. There is no need for liturgies or priests.

You come into Meeting. It is a simple building. There are pews, the windows are glazed clear. You still yourself, quieten both the first levels of distraction – the sounds of the rain outside Meeting, the rattle in the window frame, Lydia's persistent sniffle – and then the second levels – your anxieties around your mother, whether you have ordered enough moschatel and powdered oyster – until your truant mind comes into an equilibrium, 'an inward silence and attention' as he puts it. This is when there is the chance of clarity, of Inner Light.

iii

William is breaking down. He wants to 'drop the doctors with their methodical wordiness and reasoned Pedantries', but the doctors are his friends and he is a man of method and reason.

He misses Sally.

He misses her so much that he needs to know how and when he will be with her again. I cannot bear the thought, he writes to Richard, of being separated for ever from those I love, 'for well am I assured that true friendship survives the grave'.

Chapter forty-two

Tregonning Hill

i

William returns to porcelain.

He goes back to the hills and he digs here and then a little bit to the right. He stoops and brushes the soil away, breaks a piece of this crumbling stone into a cloth bag, moves on. He tests his idea through the turf, pushing aside the bracken, hawthorn, dog rose, scrambling across stream beds, slipping on these wet declivities, scanning rock-falls on cliffs, noting unexpected shadows emerging as dusk falls that show where the earth gives way.

He starts to experiment with the materials he discovers 'in the parish of Germo, in a hill called Tregonnin hill', nine miles along the coast from Penzance.

There are two kinds of rock here. They are closely allied. One is a kind of granite that the locals call growan or moorstone. This is what he has seen being used by the bell-founders. It is, he writes in a beautiful memorandum of eight pages written long afterwards:

compounded of small pellucid gravel, and a whitish matter, which indeed is Caulin petrified. And as the Caulin of Tregonnin hill hath abundance of Mica in it, this stone hath them also. If the stone is taken a fathom or two from the surface, where the rock is quite solid, it is stained with abundance of greenish spots, which are very apparent, when it is wetted.

'This is a circumstance noted by the Jesuits', he adds, like the good scholar he is, joining the stone from the hills of Jingdezhen noted by Père d'Entrecolles to his own damp Cornish slopes. This growan is the first ingredient of porcelain, the petunse that 'gives the ware transparency and mellowness, and is used for glazing', looked for across Europe, theorised over by mineralogists and doubted by alchemists, found only in the back country of the Cherokees in Carolina. And it is present here, 'in immense quantities, in the county of Cornwall'.

Amazingly, he adds, 'the whole country in depth is of this stone'.

The other rock is kaolin itself, the white clay that he saw the men mending their pumping engines with.

> This material, in the Chinese way of speaking, constitutes the bones, as the Petunse does the flesh, of Chinaware. It is white talcy earth, found in our granite country in both the counties of Devon and Cornwall. It lies in different depths beneath the surface . . . It is found in the sides of the hills, and in the valleys; in the sides, where following the course of the hills, the surface sinks, or is concave, and seldom, I believe, or never, where it swells or is convex . . . I have a piece, by me, of this kind, very fine.

William continues, 'This earth is very frequently very white.'

And he knows it is caulin, kaolin, because he has started to experiment. Every scrap of surmise has to be tested. *In depth.*

I must follow William. So I go to Tregonning Hill.

When I was a child, an elderly archdeacon gave me his collection of minerals and fossils, collected in the late nineteenth century by him and his brothers. Many were annotated in pen or with small labels, locating afternoons from ninety years before:*Diss April 17th 1880*. Ammonites and trilobites, ferns and the hipbone of an iguanodon, were passed over with a geologist's hammer and chisel in its leather case.

And he gave me a packet of Victorian *Geological Survey of England and Wales* maps. I had sheets 351– 8. Penzance, up on my wall as a child near my cabinet of things found, things given, things dug up.

It is still a beautiful map, a field of washed nectarine pink for granite, sweeping up from the snub nose of Land's End, scalloped by the two great bays of St Ives to the north and Mount's Bay to the south, polka dot for Blown Sand, before meeting a pale green tide of Mylor Series Fine-grained Slate. A spattering of magenta Greenstone falls from west to east. And my hill – William's hill – sits in a protective ring of pink dashes. Pleasingly, England doesn't fit into the carefully calibrated square and the map ends in a drift of contours.

This is Cornwall, so there is a key for mineral lodes containing silver, arsenic, copper, iron, manganese, lead, antimony, tin, uranium and tungsten. And an hour after unfolding the linen-backed map, I am still tracing and prospecting my way through this landscape, from mine and seam and lode. Habitation seems so uncertainly placed against intractable geology. But then the mines come into focus and then the railways, and then the slew of shaft and mine.

I park near the Methodist chapel, a dozen miles from Penzance. It is seven in the evening in July and almost cloudless. A lane leads up past some cottages and becomes a stony track, steep, banked with deep bracken, foxgloves, scabious, red campion. There are gatekeepers, small brindled flashes of butterfly, tumbling everywhere. A few calves

are asleep, heavy in the shade. It is very quiet. A dog sets up on a distant farm.

As pilgrimage routes go this feels pretty good. In my mind Tregonning Hill was an effortful climb but this is an easy track up to the top, a few twists around declivities where a clay working has given way. At the top there is a granite war memorial and a trig point and you can look around you, down the cliffs to St Michael's Mount, across to Penzance and on to the end of England. I can just pick out the odd chimney for a tin works amongst the patchwork of farms and fields and woods. But mines disappear.

I've brought a piece of porcelain with me.

It's a sweetmeat dish, a low moulded scallop shape with some very limited blue decoration around the outside, a few half-hearted sprays of flowers. And it is chipped, of course, which is how I could afford it from the quiet Kensington gallery where I bought it before this journey. The base is beautiful, a few iron spots, a piece of something gritty stuck fast and left on by some Devon boy at the Plymouth works who, in 1770, late on in the abbreviated life of William's porcelain, should have ground it down to an alabaster smoothness, but didn't. And it's grey. It looks like badly washed linens.

This is my Third White Hill. And what I have in my hands is Cornish white.

iii

William experiments. He is fifty. Fifty is very close for me too.

He is mixing, grinding, calcining. He has no apprentice on his books, but his brother. Do the girls help him, watching the clouds of milky clay settle in a trough in the yard, running from the pump to the still with a bucket, from the still to the trough to pour again? Do they scrape up the wet clay on to boards to dry it, pick at it behind their fingernails, watching as it reveals the estuary lines on their hands as it dries?

He puts the two pure materials together, 'equal parts of the washed Caulin and Petunse for the composition of the body; which, when burnt, is very white and sufficiently transparent'.

William has done it. He has managed what only Tschirnhaus and Böttger have done before and created a new porcelain body. No emperors or kings are involved, no imprisonments and no theatrics. He has worked it out entirely on his own.

And now he wants to turn this clay body into something, transform his academic quizzing, into a pot. He needs to work out how to glaze and then fire a vessel. So, remembering the good Jesuit father, William uses the same materials that went into the clay as the base for the glaze: 'These, barely ground fine, make a good glaze. If 'tis wanted softer, vitrescent materials must be added. The best, I have tried, are those said to be used by the Chinese, viz. lime and fern ashes, prepared as follows.' And he is off.

William starts to involve other people. Someone needs to be sent to Tregonning Hill, to heave a basket of growan down the track. Someone is off collecting a lot of ferns, I realise, as I know from weary experience how many sackfuls you need to burn for a cupful of grey ash.

He is not so removed. This private journey becomes a conversation, the private world is reaching others, 'many ingenious men', neighbours, men of learning and capacity.

I realise that William's way of moving through ideas is like the air and flame in the kiln, with lots of free ascent and play, motion and discussion. Tschirnhaus would have understood.

It is becoming his obsession, a vision to make porcelain whiter than the Chinese. To make something so white and true and perfect, that the world around it is thrown into shadows as the blackthorn does when flowering in the hedgerows in early spring.

And William's obsession is also a sort of exhaustion of white. It is a way of keeping himself turned to the world, keeping himself away from all the absences in his life. Obsession can be useful.

Chapter forty-three

brighter in white objects

i

I'm now unexpectedly six months into my English journey.

It is, of course, ridiculous to make porcelain and try to write.

Just as the porcelain is coming into focus, a heat haze of white, William also starts to write a book. How on earth is he going to differentiate his time, I want to ask him, will you zone it so that you do your making, experimenting, talking in daylight and banish the words into the night? The pronouns slip and slide. I want to ask him if I'm really going to try and interweave the two, a notebook on his bench, like I'm doing this week.

William, now widowed, an Elder, a little myopic and properly stout, as respectable and pragmatic as any Quaker caricature, is trying to make porcelain and he writes.

He hearkens to his friends' advice and is 'committing his knowledge of chemistry to black and white'. These are his colours, of course. William is also reading of other people's visions, and this is when his nights and days meld. Visions can happen to anyone and Emanuel

Swedenborg, the practical, engaged scientist, the inspector of mines, evangelist for the divining rod and writer on copper, was in a London tavern when darkness fell, and he was vouchsafed a vision of a man telling him of the End of the World. This was not some general miasmic terror-vision, but one in colour, threaded with detail. Since then, Swedenborg – with increasing regularity – has been visited by angels whose teachings, of course, need careful exegesis.

One night, for instance, he had a vision about porcelain. In a market-place, filled with detritus, stands a palace. It disappears. And in its place there come plenty of beautiful vessels, 'porcelain ware it seemed to me, recently put up there . . . everything was still being arranged'. Swedenborg writes this down: visions are for sharing.

But what does it mean?

Acolytes are spreading Swedenborg's pamphlets, translating his texts from Latin. William has been sent some and is captivated. He decides that it is imperative to bring into English 400 pages of Latin. He begins to translate.

ii

I sit in the archive of the Swedenborg Society in Bloomsbury and open the first page of *A treatise concerning Heaven and Hell, containing a relation of many wonderful things therein, as heard and seen by the author, the Honourable Emanuel Swedenborg, of the Senatorial Order of Nobles in the Kingdom of Sweden. Now first translated from the original Latin.*

I'm a little daunted by William's translation of this text. It is a slow, obsessive, tidal wash of notes and references to Scripture. And the epigraphs from Isaiah – *This is a rebellious people, which say to the seers, See not* – and Proverbs – *Where there is no Vision, the people perish* – make me pause before starting my work. I am here to understand not to judge.

There is a 'want of simplicity'. Christianity has been in a state of falling away from its essential spirituality. There has been an undue

exaltation of man's natural rational faculties and powers, 'it chains down the mind to the object of the senses, and things of outward observation, and totally indisposes it for the consideration of things inward and spiritual'.

This is the Preface and I feel this is a proper Quaker talking, measuring his words like a chemist uses his scales, a corn-factor pouring the grain.

And then it just goes completely and utterly wayward and Swedenborg is breathless with elixirs and angelic orders. The world is an interpenetration of the unseen and the seen, there are gradations in the spirit world similar to the ones that we know of. Everything we see has an angelic correspondence. 'All nature', he writes beautifully, 'is a theatre of divine wonders'. It is like reading Blake turned to footnoted prose, a relentless Swedish version of a Beat poet. I remember performance poetry from my childhood on a 1960s campus and it shares this same satisfaction with bearded men taking up space with words, the same utter assumption that someone is listening.

'To me it has been granted to associate with angels, and to converse with them, as man does with man', writes Swedenborg. The earth is not as you see it. There is a sagacity in bees, there is a genius in trees. Everything coheres around God as light, the sun, illumination.

And everything, everyone, every angel, is relentlessly ranked.

It takes me 300 pages of this book to work it out: this is what white means.

In Swedenborg's world, the angels at the sepulchre have 'raiment white as snow . . . their garments shall walk with me in white, for they are worthy'. White is truth; it is the glowing cloud on the horizon that shows the Lord is coming. White is wisdom. It is judgement and the subject of Swedenborg's treatise *De equo albo; On the White Horse mentioned in the Revelation*. White brings us all into focus, it dispenses clarity, 'the same light gives pleasing colours in one object, and displeasing colours in another; indeed, it grows brighter in white objects'.

It reveals. It is Revelation itself.

I finish the book. And I start it again. I realise that I have missed a crucial sound that runs through it, a hum that I have only half been aware of. On my second reading, I hear it properly. This is a book about white. But it is also a book translated by a widower, someone who is still married, still living in his marriage.

We are to remain married after death to those we were married to on earth, writes Swedenborg and translates William. This is complete and total heresy, the vision of Marriage in Heaven, eternal Conjugal love bathed in the light of angels, 'as a moon, glowing white like the moon of our earth and of like size, but more brilliant'.

It is a book about white as grief and white as hope.

Chapter forty-four

thoughts of whiteness

I've finally moved into my factory. There is an exhalation as crates are moved, and kilns reconnected. The heavy boxes of Jingdezhen tiles are moved again, with swearing. We mark out on the new black concrete floor the disposition of tiles and Chinese pots for the exhibition in Cambridge.

Upstairs, where the offices used to be, is my writing room with books.

On my white wall, I have my white texts.

There's quite a lot of poetry, some good bits of Wedgwood, some problematic, orotund Goethe on colour and light that I can't fathom, but know that I must get to grips with if I can put aside a few days. A week? Have I got a week for Goethe?

And then I have Herman Melville's *Moby-Dick*, Chapter 42. 'The Whiteness of the Whale'. 'In many natural objects, whiteness refiningly enhances beauty, as if imparting some special virtue of its own, as in marbles, japonicas, and pearls.'

Then I have his extraordinary sentence, 'the elusive quality it is, which causes the thoughts of whiteness, when divorced from more kindly

associations, and couples with any object terrible in itself, to heighten that terror to the furthest bounds'. This sentence stretches across the wall, cutting through everything.

Thoughts of whiteness is underlined, repeatedly.

My desk is in the middle of the room at right angles to this wall. I face a window with opaque glass. There are security bars on the other side so that as the light waxes and wanes the lines come and go. When I'm lost it looks like a prison.

When it is going well these shadowy bars are like a beautiful, fugitive Agnes Martin drawing.

When it is going well the wall of words are exhortatory. They seem to connect my travels and my making together into cadence. I have my shards to my left as I write to keep me on track.

What is white? It is the colour of mourning, because it folds all colours within it. Mourning is also endless refraction, breaking you up into bits, fragments.

Part four

Ayoree Mountain – Etruria – Cornwall

WEDGWOOD

Chapter forty-five

an Idea of perfect Porcellain

i

The white earth of the Cherokees, *unaker*, shown briefly to William Cookworthy twenty years before by a mysterious man from America who proclaimed he had made porcelain, has reappeared. This earth is a white promise. It has been talked of for years. A patent to use this earth, 'extreamly white, tenacious, and glittering with mica', was granted to the proprietor of the Bow Porcelain works but it came to nothing. It glitters and it thwarts.

This time the earth has turned up in Bristol. A young Quaker merchant, Richard Champion, has received it from his brother-in-law in America. It is August 1765 and Champion has passed on to another china manufactory a 'box of Porcelain Earth', from the 'internal part of the Cherokee Nations, 400 miles from hence, on mountains scarcely accessible'. But he has kept a little back.

Champion is twenty-one and recently married, part of a Bristol clan with family interests both in ships and in the shipyards. He is a man in a hurry to prove himself, keenly involved in the politics of the colonies, as the family trades with the West Indies and America. Richard is

both politic – he has six ships – and moral, a member simultaneously of the Society of Merchants dedicated to self-interest, and the Bristol Society for the Relief and Discharge of Persons Confined for Small Debts dedicated to their victims. His self-confidence borders on the alarming. He writes Public Letters using the name of Valerius Publicola, protesting against injustices on behalf of 'gentlemen of fortune and reputation . . . uninfluenced and independent'.

White earth piques the interest of Richard Champion, so much so that when he sees William trialling porcelain, he decides to become involved.

Champion sees a Public Friend with an idea, an amiable family man, a preacher, a man of good works, a little removed from modern business, well regarded, but a touch provincial. William, he senses, is a man with a limited sense of how to get things going, a man who starts up Works and gives up Works. He senses opportunity.

William, in turn, is glad of the energy emanating from Champion, this young and positive Friend. Their new business is to be based in Plymouth, closer to the raw materials. Premises will be taken. 'Experience must determine the best form and way of using this kiln,' writes William cheerfully, ''tis the only desideratum wanting to the bringing of the Manufacture of Porcelain, equal to any in the world, to perfection in England.'

That, and access to the materials themselves, of course. These lie on the land belonging to Thomas Pitt.

Access is delicate. This isn't a straightforward request for copper or tin prospecting – sign here, bang on the table Cornwall stuff. William is anxious that this shimmering possibility of Chinese porcelains made from minerals under Cornish hills might seem 'mere fancy and Chimera'. What will happen if Thomas Pitt, this rich young man, takes no noticed of it, shrugs and turns away?

Pitt is thirty, politically savvy and well travelled, having spent years on the Grand Tour. He has come back a connoisseur with views on architecture which he is keen to try out in his Cornish estates and at Camelford House in London. William asks his friend Dr Mudge to intercede as he is more businesslike, less like an old Quaker. We all know, William writes, of those who have engaged in 'an Imprudent Undertaking'.

I realise that the last thirty years of my life can lay claim to this exact description of making porcelain.

Terms for the raising of the clay are agreed and William starts to write to Thomas Pitt in the winter of 1766. Three dozen long letters survive in the municipal archive of the Cornish Record Office, a single-storey prefab building on the edge of Truro, grounded in car parks. This is

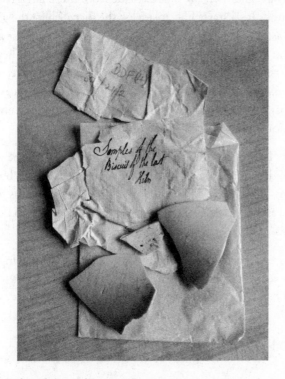

Shards from Cookworthy's porcelain experiments, c.1766

the front line of research. The folder is waiting. I'm given white gloves and left alone.

Each one is folded three times, addressed to *Thos Pitt*, Piccadilly, London, a red seal-mark heavy on the outer fold, carefully scripted.

And I'm immediately floored.

I'd expected words but three little fragments of porcelain fall out of the first letter, wrapped and then folded into scraps of paper, annotated with the exacting notation of a chemist, broken by the snapper of saucers. 'The inclosed Samples are not sent as proofs that I am a good Potter, but that the Materials which enter the Composition are at least the Equal in quality to those of China.'

They are as sharp as when they were snapped.

He sends a fragment of Common China Ware, and Part of a Jar of Nankin Ware, and then two shards made from the 'Materials that rise in thy Lands'. It's a start. The 'Inside of the piece where the glaze was applied Vastly too thick', writes William. This is no surprise as 'no person is at present concerned with me but my Brother'. They have built an Essaying kiln, which does not contain above fourteen small pieces, and are going to trial it. They are going to use Newcastle coal as it is 'Vastly cheaper than Wood', and undersell everyone else with their glorious, perfect, economic china.

Five weeks later he writes in good spirits that in *three weeks* he will be able to send a Cup or a Jar. His brother Philip and he have built a larger kiln – a Trifle of a kiln one foot square – and from this firing they have two vessels, marred by falling Spar which has stuck to the glaze but it gives 'an Idea of perfect Porcellain'.

For William, porcelain becomes an Idea as it comes into being, marred, sharp where broken, but an Idea.

Chapter forty-six

Ayoree Mountain

i

In Stoke-on-Trent, Josiah Wedgwood is in his pomp. His creamware has taken England by storm. After years of methodical testing he has discovered 'a Good wt. [white] Glaze' that works with his beautifully constituted earthenware. His new ware is finely made, can stand the shock of boiling water, and is contemporary in its clean colour. It is 'Ivory', he writes. He has delivered the first set to Queen Charlotte, who has graciously allowed it to be named *Queen's Ware*. 'How much of this general use, & estimation, is owing to the mode of its introduction - & how much to its real utility & beauty?' he asks in a letter, reflecting happily on 'how universally it is liked'.

He hurdles problems and anxieties. This week – a week of fair March weather in Plymouth – he writes: 'Don't you think we shall have some Chinese Missionaries come here soon to learn the art of making Creamcolour?'

He is like Augustus the Strong goading the Japanese to come up the Elbe and load up with Meissen.

China Earth from America has piqued the interest of Wedgwood who seems, I am finding, to be both omniscient and omnipresent.

Wedgwood writes to his business partner Thomas Bentley that:

> I find that others have been dabbling with it before us, for a Brother of the Crockery branch call'd upon me on Saturday last and amongst other Clays he had been trying experiments upon, shew'd me a lump of the very same earth which surprised me a good deal and I should almost have thought myself robbed of it if it had not been much larger than my pattern. He told me it came from South Carolina.

Decisive, he puts a plan together to send a man to the scarcely accessible mountains to get him some tons of this clay, to possibly buy the mountains themselves. This white earth is perplexing, but Wedgwood is not a man to be held back. He has the self-confidence to consult and take advice.

He looks at maps, at Hyoree, Ayoree, Eeyrie, somewhere. Taking out a patent is a form of madness as it will clag him in lawyers and parliamentary shuffling and show his hand to other potters when getting the stuff dug out of the mountains is the imperative. This is an annoyingly slow and expensive imperative as he finds that the earth must be carried nearly three hundred miles overland 'which will make it come very heavy'.

It is now May and he has to arrange the new showrooms in Pall Mall and 'Vase madness' means whirling requests and decisions. What do you do if you need something in a hurry? You find the right man. He is recommended Thomas Griffiths, a man who 'is seasoned to the S. C. Climate by a severe fever he underwent at Chs. Town & has had many connections with the Indians'. He is down on his luck and ready to travel. Terms are agreed.

Everyone, I realise, comes to Wedgwood first.

A French nobleman, Louis-Léon-Félicité, duc de Brancas and comte de Lauraguais, has been in Birmingham chivvying Erasmus Darwin. He 'offere'd the secret of making the finest old China as cheap as your Pots', Darwin reports to Wedgwood.

> He says the materials are in England. That the secret has cost him 16,000£. That he will sell it for (2,000). He is Man of Science, dislikes his own Country, was six months in the Bastille for speaking against the Government, loves the English ... he is not an Imposter. I suspect his scientific Passion is stronger than perfect Sanity.

The news gets to William Cookworthy a little later. An old friend has told him that the comte has spent a fortnight sniffing around Scottish granite, a substance not far removed from moorstone, and has been pushing hard for a patent for porcelain.

When I read Wedgwood's letters, I think of him and all the great princes and their chamberlains and decrees on the decisive ordering of porcelain. I go and see the French nobleman's beautiful plate in the Victoria and Albert Museum. It shows an insouciant butterfly, barely able to make it across the pearly French porcelain sky. And I see the Cookworthy brothers, the chemist and the sailor, opening up their Trifle of a kiln in the garden at Notte Street and gingerly passing their slightly damaged Idea backwards and forwards.

ii

It is June and we're in Plymouth.

William's new porcelain venture needs investment and a patent. Everything will be ready in a month. 'Thou will be pleased to take the Town Attorney's Opinion about this matter.' William and Champion take their time and get the lawyers in. It is a classic start-up.

The house and pit for washing the clay has been honestly executed. The bricks from Bristol have arrived for the kiln, the mason has cut

and polished the stone for the mill to grind, a ton of pipe clay to make the roughly thrown saggars is on its way. William has taken 'a part of the Cockside Storehouses Sufficient for the Carrying on of Our Experiments, tis the most Convenient Spot for the purpose about our Town'. It is six guineas per annum.

It is now July. On the 16th, the seasoned Thomas Griffiths pays seven guineas for passage and one pound ten shillings for a cabin, and boards the ship *America* to sail across the Atlantic to find and then buy white earth from the almost inaccessible mountains of the Cherokee nation. And bring it back. He arrives in Chas' Town Bay on 21 August – a miserable, hot and sickly time – to start his journey into the nation of the Cherokees.

Map of Cherokee country, 1765

This stretch of country is beyond any law. It is six years since the end of the Cherokee War and there are hunters and unpaid militiamen and displaced settlers in the backcountry. The ragged new settlements, an inn of sorts, a blacksmith, hovels appear, sketchily, amongst the black oaks, hickory and ash. You look after your horse well, keep travelling and you keep your wits with you.

Griffiths buys three quarts of spirits, a Tomahawk for twelve shillings and sixpence, and sets out. He falls into conversation on the road with another trader, a rare sight as you can travel for thirty miles without seeing anyone. Two days before a set of thieves, 'the Virginia Crackers and Rebells', had robbed and murdered five people, just here. Carry your pistol in your hand, now, he tells Griffiths, there are 'two fellows ahead that he did not like well'. His companion advises don't stay in that house, stay outside; 'the people were all sick and lay about the rooms like dogs, and only one bed amongst 'em'. If you wake up, your horse will be gone. Griffiths buys 'corn for my horse and potato bread and a fowl for myself, which I boiled under a pine tree, near the house, where I slept part of that night'.

It is now September. Griffiths journeys towards the white earth: progress slows in Plymouth.

William has wildly underestimated the difference between making a test with his brother in the backyard and real production. He describes it and it is like seeing the Industrial Revolution in very slow motion.

In Plymouth, the arch of the kiln has come down:

> in the Course of the experiment, which prevented the Fire from reaching the top of it . . . We were also unfortunate in the bottom of our Safeguards cracking by which means the powder of Spar which keeps the vessel from sticking fell down into the Bottom of the vessel under it . . . We shall set about Repairing our kiln tomorrow . . . I have no Question but we shall do very well in this way too whence we come to make an object of it.

The test pieces were cold and rather grey. They looked slightly, unpleasantly, viscous, like the bloom on the barrels of mackerel. It is porcelain, no doubt about it, but who would want this Cornish version? It rings alright, a relief after the dull timbre of the last pieces, but I pause here and register that they are making shards, day after day after day.

On 17 September, Griffiths joins up with an Indian woman belonging to the chief of the Cherokees. He arrives at Fort Prince George, the first settlement in the nation, about forty miles from the Indian Line.

His luck is in. He has arrived just as 'most of the Chiefs of the Cherokee Nation' have gathered to choose delegates for a peace conference with the 'Norward enemies'.

Griffiths writes:

> after I had Ate, drank, smok'd and began to be familiar with these strange Copper Coloured gentry, I thought a fair opportunity to Request leave to Travill through their Nation in search of anything that curiosity might lead me to; and in particular to speculate on their Ayoree white earth. And accordingly the Commanding Officer . . . desired to be very particular on the subject. This they granted, after a long hesitation, and severall debates, among thoughtfulness some more seem'd to consent with some Reluctance: saying that they had been Troubled with some young Men long before, who made great holes in their Land, took away their fine white Clay, and gave 'em only Promises for it.

Suddenly you are there, listening.

You hear that you are not the first. So who has been before? And when? Promises have been made, and promises broken. And then you hear anger and then anxiety. They do not care to disappoint as you have come in good faith, openly, but 'they do not know what use that Mountain might be to them, or to their Children'.

The moment lightens, passes. Their white clay will make fine white punchbowls and they hope they will drink out of them and they all shake hands and settle the matter, and Griffiths leaves, crossing the Chattooga River and it is a terrible journey, very rotten and dangerous roads, and he is 'a littler in Fear of every Leaf that rattled'. And he is ambushed by a storm, eighteen hours of sleet until there is 'scarce life in either me or my poar horse' and he reaches an Indian hut, 'when I advanced near the fire, it overcame me and I fell down'. The squaw wraps him in a bearskin and blanket, and feeds him and his horse.

November. On the 3rd, he gets to the Ayoree Mountain:

> Here we laboured hard for 3 days in clearing the Rubbish out of the old pit, which could not be less than twelve or fifteen ton; but on the fourth day, when my pitt was well clean'd out, and the Clay appear'd fine, to my great surprise, the Chief men of Ayoree came and took me prisoner, telling me I was a Trespasser on their land, and that they had receiv'd private instructions from Fort George not to suffer their pitt to be opened on any account.

You are stopped again and this is very difficult, as there is now a price to be paid of 500 cwt of leather for every ton, a huge price.

Griffiths writes again, 'this proves of very ill consequence to me, as it made the Indians set a high value on their white Earth', and there are four hours of strong talk before they shake hands.

> In Four days from this I had a ton of fine clay Ready for the packhorses, when very impertinently the weather changed and such heavy rains fell in the night, that a perfect Torrent came from the upper mountains with such rapidity, that not only fill'd my pitt, but melted, stained and spoil'd near all I save and even beat thr'o our wigwam and put out our fire, so that we were nearly perish'd with wet and cold.

The rain also washes the stratum of red clay into the pit and stains and spoils a 'vast deal of white clay'.

This is a severe winter. Apart from the rains, it is bitter and the Tennessee River freezes over and the pot is 'ready to freeze on a slow fire'. There are now regular and troublesome visits from the Indians, but Griffiths gives them rum and music and they part well, if carefully; 'they hoped I should want but a few horse loads of white clay and pray'd I would not forget the promise I made 'em, but perform it as soon as possible'.

He will come back with porcelain made from their earth.

It is 20 December 1767. In pelting rain, high in the mountains of the Cherokee Nation, an Englishman is making safe five tons of white earth, packing it into casks, battening, preparing a train of pack animals.

On the same day in Plymouth, William writes to Pitt. 'You said we were in sight of land. I am vastly mistaken if we are not now Entering our port.'

Here too, it is a day of Greater Rain.

ii

The packhorses are loaded with white earth and on 23 December Griffiths takes his leave of this cold and mountainous country with the frosty weather breaking, and 'the mountain paths being very narrow and slippery we killed and spoiled some of the best horses and at last my own slipt down and rolled several times over me; but I saved my Self by laying hold of a young Tree, and the poar Beast Tumbled into a creek and was Spoiled'.

'I had', Griffiths writes, 'Severall hundred Miles to Travill, besides the loss of a fine Young Cherokee horse.'

Griffiths loads five wagons with five tons of clay to take down through the backcountry to Charleston, where he pays for porters and rum for

the wagoners and for coopers and two casks and buys sundry sea stores and 'On the first of March I agreed for freight and passage with Capt. Morgan Griffiths of the Rioloto, bound for London', £73 and ten shillings with £70 for the freight of the clay. And Thomas Griffiths bids farewell to Charleston and sets sail.

There is an unmerciful sea. 'On the fourteenth Aprill we arrived in the Downs and on the Sixteenth, Capt. Griffiths, Mr John Smith, and my Self Left the Ship in the pilots charge at Graves End, and came to London, by Land.'

Thomas Griffiths pays £3 and ten shillings to bring 'things on shore and attending the Clay when the Ship lay in the River' and delivers Josiah Wedgwood his white earth, the *unaker* of the Cherokee, from the other side of the world.

As promised.

Chapter forty-seven

C.F.

i

This is a cold winter in Plymouth too and there are problems at the works. It's an unstable compound, fissile with animosity. It is a new works and skills chafe at each other. No one is quite sure what they should be doing.

It is easy to hire people to work for you and easy to lose them. Speculative porcelain ventures come and go and potters have a reputation as cussed and independent. This instability leads to short contracts, to potters off and away to the next place, as itinerant as tinkers, travelling tinsmiths, preachers without a congregation, dogs.

For the new manufactory, they've bought a set of moulds from a recently failed factory in Staffordshire, a set of the seasons, some cherubs with a goat, a ewe and her lamb, and a sphinx that looks a little like a Devonian donkey. These models are not the latest style. In fact they are already fifteen years old when the straw-lined crates are carried into the China House and unpacked.

Three pieces, large cider tankards, are made for the next firing in March, each with an invocation dribbled on to the side in cobalt. *Plymoth Manufacy*, they say with a slight lilt. I come from Plymouth, Plymouth made me.

And each one has its rebus on the base, two strokes of a brush, a sort of figure 2 with a tick across the bottom stroke. This is the symbol for tin, and it is William's answer to those swaggardly Meissen swords on the base of those perfect plates, the apothecary's way of saying that he knows where he comes from.

Each of these tankards is placed dead centre in a rough clay saggar. The kiln is stoked initially with wood until the brick kiln is trembling from the heat and the flames, one short length pushed into the fire-box, a pause, a judgement, another. Then after two hours of this rhythm it changes and there is coal to be shovelled in. Sound changes slowly. The boys are meant to be at the mortars, preparing moulds for next week, cleaning the barrels of kaolin, but everyone is pulled back to see the kiln, fetch water for the men. Each hour is recorded. The passage through the spectrum of orange to scarlet to carmine into the blinding white heat where test rings are pulled out on long metal poles as long as fowling-pieces and plunged into buckets to sizzle. They take five minutes to cool, heads bumping to see how the glaze is melting. Each one matters. Early in the firing the surface is open, cratered. There are pores from glaze to clay. Twenty minutes later and the surface is moving together, though still pitted. This test looks like lichen. He paces round the workshop. Everyone wants to stop. This is mad-ness. Sixteen hours shovelling coke, naked to the waist, feeding this kiln, this man's obsession. Look at the notes, this is two hours longer than the last firing. Another twenty minutes and another test is pulled, the glazed ring swings and settles in the water and it is bright and clear and white.

This is the truth, says Swedenborg. You will see the heavens open and the Lord's raiment will be white.

279 *C.F.*

And 'The affections of the mind are translucent through the face.'

It stops.

Bricks are put across the chimney to keep in the heat. The doors are clammed with wet clay. The men wash smuts from face and hands and chest from barrels outside the door. Gulls wheel overhead. The kiln still hums. You have to leave. You have to turn away and go home, walk over Coxside and then up to Notte Street, through the side door and hang your hat, wash in the scullery, open the parlour door. You open your notebook and sit. You still thrum.

Patience will reward the virtuous man.

And it is near dusk the next day when you break the clay from the front of the kiln, and the bricks are piled scrimshanks rather than in the neat pile you ordered and out comes the first saggar and it is placed on the floor and the lid is broken off and you see, immediately, that it has worked.

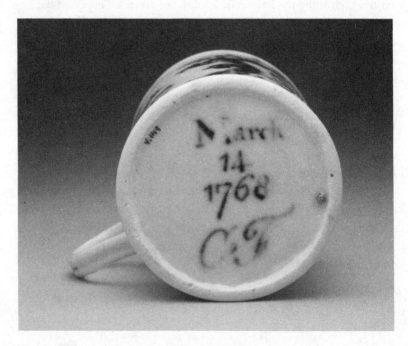

The bottom of Cookworthy's porcelain tankard, 1768

You hold it by the handle. You tap it. It rings clear. *Plymoth Manufacy* around the arms of the city, smudged, and some flowers, smudged. Plymouth made me. And on the base *March 14 1768* and an italic *C.F.*, *Cookworthy Fecit* in cobalt blue. Cookworthy made me.

The white earth has become this white vessel. It is the first piece of true porcelain ever made in England and this cider tankard with its vernacular handle and its curly italic inscription, its smudged symbol for tin on the base, is already slightly out of date.

This is William's white pot, my third.

on Englishness

i

So that is that. I've got my third white pot. Jingdezhen, Dresden and now Plymouth.

There is a tenderness about this pot of William Cookworthy. It comes into being through walking and noticing and picking things up and feeling texture, through listening intently, openly, to men working by the side of the road. It is a Quaker pot. It carries its earnestness and is unembarrassed. It is a chemist's pot; the tin cipher on its base is beautiful and proud of where it comes from. I'm from here, it says, and there is a burr in the fall of the words.

And its whiteness is a special whiteness, too. This porcelain tankard, so smudged in execution, is a pot for angels.

My shelf is pleasingly full of pots and shards. I can move them back and forth and I should now be able to get back to making my own with real attention. There is the exhibition in Cambridge to organise. This promises a great deal of pleasure, with days looking at Chinese porcelain in the stores of the collection. And I have to pick up my pace

with making for New York, too. I come into the studio very early to get a couple of hours of throwing when I can.

English Porcelain 1750–1800 isn't part of the plan. But the truth is I simply don't know what happened next beyond the very bare bones of the story – that the ROYAL WARRANT FOR COOKWORTHY'S PATENT was published, and that things got sticky and that Plymouth didn't become the Dresden of the West Country. I need to find out how William reacts when it goes *wrong*.

And because I've lost my precious four pages, £95 of real money, I have to go and read The Patent humbly in a library. It is beautiful. It is the first patent I've ever held and it has a perfect cadenced formality. This is as it should be.

> William Cookworthy of Plymouth in our County of Devon, Chemist, has by his petition humbly represented unto Us, that he hath, by a Series of Experiments, discovered that Materials of the same Nature with those of which the Asiatick porcelain is made, are to be found in immense Quantities in Our Island of Great Britain.

At this point all he has to do is wave his hands and be orotund which he does happily, scattering capital letters across the page.

> The Ware which he hath prepared from these Materials, hath all the Characters of the true porcelain in regard to Grain, Transparency, Colour and Infusibility, in a degree equal to the best Chinese or Dresden Ware, Whereas all the Manufactures of porcelain, hitherto carried on in Great Britain, have only been Imitations of the genuine kind, wanting the Beauty of Colour, the Smoothness and Lustre of Grain, and the Great Characteristic of genuine porcelain, the sustaining the most extreme degree of Fire without melting; That this Discovery hath been of his Knowledge and Belief in regard to this Kingdom is new, and his own; the Materials being even at this

time and applied to none of the Uses of Pottery but by him, and those under his Direction, and that he verily believes this Invention will be of great advantage to the publick. He therefore most humbly pray'd Us that we would be pleased to grant him Our Royal Letters Patent for the sole making and vending this new invented porcelain, composed of Moorstone or Growan and Growan Clay.

Then William sets his hand and seals the document on the eleventh day of July, in the eighth year of the reign of George III. And then, finally in 1770, the Plymouth Manufactory becomes the Plymouth New Invented Patent Porcelain Manufactory.

ii

I've put time aside for these first porcelains. And for William. I'd thought this English journey would take a summer and it is now a good year. I try and work this out, feel my way into my habitation of his aspiration. I ask him how can you be English and make porcelain? Where in this damp country can white porcelain come alive? Does it stay exotic, an import, a quixotic enterprise, or can it naturalise?

I ask myself the same. Where does porcelain belong?

You put a pot down and the space around it changes. You put groups of pots down and you are playing with much more complex rhythms. Five years after coming back from Japan I started putting my groups into buildings and museums and galleries.

My first attempt was at High Cross House, a modernist house built in 1932, with huge windows and a flat roof and an aspirational sun deck to catch the Devonian weather, gaze on the oak woods. It had tubular furniture and plywood cupboards and should have been in St Tropez. It had become an archive and the archivist was in search of projects.

I made a huge lidded jar for the great slab of a fireplace, a line of dishes to catch the rain on the sunroof. And I hid groups in the unused

cupboards. You could slide back a door and find porcelain jars waiting. A critic complained that she couldn't find the exhibition.

This was my start. I made porcelain to put amongst the shelves of poetry and along the kitchen table at Kettle's Yard in Cambridge, a beautiful huddle of cottages holding paintings and sculpture, books and pots. I made huge Dragoon vases to put along a grand and stony corridor at the palatial Chatsworth. Each installation was a query for me.

I seemed to hide everything I made, put it in the shadows, around corners, in the cupboards.

iii

The Plymouth Manufactory is up and running. All the hands are briskly at work. Most of the ware is coming out clean. The saucers are mostly straight though the safeguards are still cracking, which is dispiriting, so they have come up with the rather desperate idea of making them out of pot shards stuck together, as if that would work. And they have made an experiment to see whether contracting the holes which lets the flame up to the roof of the kiln might not help us. 'It did not help but hurt us, however the Product of this kiln together with that of our former Experiments hath been sold for upwards of Twenty-two pounds.'

I sigh over 'Selling your Experiments'.

This is the 'selling your seconds' moment. You have a sale coming up – possibly before Christmas when everyone needs a milk jug or a small vase – and potters make their income. The kiln has not behaved and you are faced with boards of pots that are almost right. They aren't chipped. There is an odd wobble in one of the jars, and a bit of warping on the larger bowls that is quite attractive but the glazes are a little over-fired. What do you do?

You should break them up.

According to the great Wedgwood, who is having his own thoughts about the pots that go wrong – the *Invalids* and *reprobates* as he calls them – if you sand the bases down of some warped vases you can screw them to new plinths, and no one will know.

You write a card with SECONDS on it and prop it up and watch them disappear into the world.

iv

I know this moment, as I look at the glazing of the porcelains. Glaze is clothing for the clay body. I have a cracked Meissen plate from 1768 – two chaffinches on a branch, moths on the scalloped rim, a gilded edge – and it is seamless, the glaze has fused with the porcelain. Think of a glaze covering a body. The fit is couture, neither a sense of constriction, nor one of too much latitude, just easy movement.

'WHENAS in silks my Julia goes', I think as I turn it in my hands, 'Then, then methinks how sweetly flows / That liquefaction of her clothes.'

I look at these pots. West Country porcelains look foxed like the pages of an old book, a little grey on the edges. They are an unspooling of lop-sidedness and distortion, tiny fissures in the base where the clay has opened up during the cooling of the kiln, gaping ones where there was a making fault. There seem to be minute fragments of adherent clay. I recognise each and every imperfection in the glazing. I call them out, know them as my own. There is some running in the cobalt decoration of a tendril where one of the lads has pressed too hard with the brush and got the thickness wrong or a tongue of flame has lingered. There is pinholing, open dots like the spores under the frond of a fern where someone in the workshop has left dust on a pot before glazing it, or the heat wasn't great enough to completely melt the glaze. And here are rivulets of arrested glaze. Too thickly dipped into the barrel? Another firing that didn't quite reach temperature? And here the glaze has scaled off because it is too thin.

Each thing that has gone wrong is attributable to several factors, but I blame the weather.

Now you examine it, the gilding isn't great, either.

I turn to William, quizzically. What were you thinking of?

V

The going wrong speeds up. Or perhaps, if we slow the film, many things that have been going wrong are now visible.

The Plymouth Manufactory are going to have to go back to the subscribers, as the money has run out – they have spent twice as much as they expected. As a quick moneymaker, William is going to make porcelain mortars for apothecaries.

His translation of Swedenborg isn't yet published. He is supposed to be running an apothecary business, but I find out what he's really up to in his notebook in the Plymouth archives, green, waxed and split. After lists of ingredients for pills there is a fair copy of a letter to the governor of North Carolina, on the nature and usage of cobalt, the black mineral that blooms blue on porcelain, makes willows, swallows, lovers on a bridge, carp rising in a pool, a butterfly on a chrysanthemum.

William has been refining cobalt blue from the ore:

> black-blue glass . . . plainly proving that as the other Enamel
> Colours are from Metals, as the Green from Copper, the Black
> & Red from Iron, the purple from Gold, so the blue is from
> this semi-metal, this little Discovery makes the whole affair of
> Cobalt easy, Scattering that Cloud of Mystery which the
> wrongheadedness of the German writers hath spread over it.

William enjoys dispelling Mystery, whether it comes from China, Cornwall or from Germany, and cobalt is a tangle of suppositions and stories. Its etymology reveals this: *cobalt* comes from *Kobold*, the name given to underground spirits in Germany. They live, some stories say, not just below the surface but within the rock itself. They blow out your lamp, knock the wooden spar that holds the roof of the mine up,

crumble the earth below you, steal your food, your flask of water, your pick. If you are a miner you pray for protection but they are recalcitrant, unappeasable. They entice you to extract the wrong minerals, fooling you with this seam of silvery ore, the glimmer of gold, only for you to find after you have sieved it and ground it and washed it that it is worthless. There is something in this assonance of malignancy, hiddenness and depth that rings with truth.

I'm reading this upstairs in my studio with my dog asleep at my feet. In the last couple of years I've started to use black glazes. I haven't fallen out of love with my whites, but needed to see what the shadows around black pots might look like. I use cobalt in one of my favourite new glazes, a lustrous black like a midsummer's night sky with sparks of gold, as dark as a starling's wing. It needs only one per cent. And a little more, two to three per cent, in the denser glazes, the matt pewter-coloured glaze that we call basalt, and the new one that isn't quite right yet, a blistering black with pits and craters like a slither of obsidian.

Cobalt stains. I have an idiotic need to feel cobalt oxide and run down to the glaze room, open the plastic box and pour a scattering of the blue-black powder into the palm of my hand, rub it between forefinger and thumb, and when I scrub my hands I still have a skeletal tracing of toxic ore that stays with me for days, as I trace William and his passion for cobalt.

The world is very big for this Plymouth chemist, I realise. He holds Cathay and Carolina as he crumbles the ore between his fingers. And as the start-up is running aground, this is what William is doing, crumbling ore, led and enticed further into white and blue. He treats the works as a laboratory, a testing place for ideas not as a business.

I realise I've spent the last bloody week thinking about cobalt.

William is happily astray.

Chapter forty-nine

endings, beginnings

i

What are we going to do? William asks Pitt. It is a good question.

This September morning in 1770, there is a jeremiad of problems.
Two of the three boys who work in the manufactory are sick. Objects
that should have been the same height, but weren't, have been taken
from the kiln, there are cups that were not ground down straight and
which stand crookedly.

The coal that was used last week for firing the little kiln has weakened
the structure. They will have to use wood. But there is no wood to
be bought. Four kilns have been ruined through the badness of the
wood, all an ill colour. Pitt's steward is going to send a barge of wood
down the coast from his estates, but William is apprehensive about
it. It won't be dry enough after a week on the sea, uncovered to the
elements, and too small, unbark'd.

So William has been talking to the commissioner of the docks who
advised him to apply to the Admiralty, 'that we may have some timber
from a ship that is to be sold. He is decent to help me as there are some
who would put the prices up to thwart me.'

So he buys a boat, and all the spars, masts, the decks are axed into timber and then sawn into lengths three feet long and stacked by the workroom. And this takes the throwers, who are now the labourers, several days. William has been at work on Swedenborg's *De coelo et inferno*, his Treatise concerning Heaven and Hell, polishing the Latinate rolling phrases, coming down late one afternoon to Coxside, to his Idea of Porcellain, and there is a puddle of salty water spreading over the floor of the workshop from his pile of sodden, expensive timber.

The sodden timber is dried – how do you dry timber in a warehouse by the sea in Plymouth? They decide to use it in the autumn firing.

Drawing of Cookworthy's kiln by Champion, 1770

The kiln before this last one of the sample pieces which was taken out was a most beautiful piece of China Ware, it possessed every character of the Asiatic, viz. colour Body Glaze & Blue in the utmost perfection, every Body was in rapture & I believe there were not a man who was that would not have taken £1,000 for their shares, when (to our infinite mortification) the Kiln Out of several hundred pieces there was not a single one free from smoak.

The wood, impregnated with seawater, has salted several hundred pieces of porcelain which is yet another disaster.

I look carefully at this porcelain touched by the salt fumes in the kiln and think they are beautiful, a slight autumnal haze touching the manes of the lions, couchant.

ii

William has to really think this through.

> I have the least dislike to making the Experiments . . . I have many years since read Du Halde's Description of the Furnace used by the Chinese . . . it hath always appear'd and Appears to me an Unintelligible piece of Nonsense and could never be given by anyone who hath any knowledge of Pottery Maters. And I have often regretted that so good an Act of the Materials for China Ware and the Chinese ways of Managing them should be closed with such a wretched an Act of their burning the Ware.

Poor old Père d'Entrecolles, blamed for not paying attention to the firings in Jingdezhen, not writing up his notes in appropriate Jesuit thoroughness.

For the first time, William also blames his 'Treacherous Memory'. He is now sixty-five and, by my calculation, cannot have slept for several years.

He has been talking through the future with Pitt and Dr Mudge and Champion and a decision has been reached. Plymouth was never going to be the perfect place to make or sell their wares, the garrison and the gentry now well stocked with sweetmeat dishes and cows, the transport to London expensive and tricky. More capital shrewdly applied would transform matters. The Plymouth New Invented Patent Porcelain Manufactory has reached a place where fresh management might be able to take it further.

Bristol, suggests Champion, would work well.

iii

There is a deep breath and then the running down, the settlements, the sales of equipment from the factory. Some material goes to Bristol, to its next incarnation – the firebricks from the kilns, shelving, the old cordwood, the safeguards. And the barrels of kaolin and moorstone, the paste, the beautiful black cobalt.

The last firings of teapots and sauce boats have *Plymouth 1770* written on the bases, souvenirs of this first enterprise. The tin cipher is to be changed to something less peculiar, less alchemical, when it restarts.

'Mr Cookworthy's Mills are occupied by a Mr Robinson', the venal Mr Veal having found a new tenant. People disperse. Many are to go with Champion to Bristol, some off to London and some to other manufactories.

Within weeks new hands are sought. 'China painters wanted for the Plymouth new invented patent porcelain manufactory. A number of sober, ingenious artists capable of painting in enamel or blue may hear of constant employment by sending their proposals to Thomas Frank in Castle Street, Bristol.'

The new dispensation settles itself. The recapitalisation is considerable, nearly £10,000 invested by new Friends.

William decides to assign the patent to Champion for a fee and a percentage, and walk away.

It is 1772, forty years since he married, almost thirty since he found kaolin and petunse on Tregonning Hill, twenty since he started his experiments, four since *C.F.* rang true on his porcelain tankard in the china manufactory on the wharf.

He walks down Cornhill with his son-in-law, to the printer and bookseller's James Phillips in George Yard in the City, to collect his first copy of his translation of Swedenborg's Heaven and Hell and he is in very good spirits.

Of the making of books there is no end, says the Prophet. But in this case there is an end. 'Mr Cookworthy was at the whole expense of the publication', says one record. It has cost him £100 and some years. He 'could not forbear being diverted with the translation of such a work having been made and published by a Public Friend. He joked about his being taken to task for it, and being asked what he really was.' The day before they had been to see a beached whale in the Thames and he assays a joke, the joke, 'Some say he's a grampus, and some say a porpoise, but for my part I don't know what he is.'

His Quaker friends are appalled by William's version of Swedenborg. John Wesley has been reading this 'brainsick man'. The sobriety of Quakers is imperilled by such metaphysical nonsenses.

If you make God in your own image, then William's God is an interested God. Not kind, perhaps, too many bereavements have knocked away that pietism, but good on detail, and definitely good on surprise.

This is why a potter would write.

William sets off home to Plymouth and the weather he knows. It is three days on a terrible road. He has had an idea for distilling seawater on long voyages and is working on a proposal to cure scurvy for sailors with barrels of sauerkraut.

Chapter fifty

a cunning specification

i

Richard Champion is now proprietor of his very own porcelain manufactory. He has strong views on what to do.

It is clear, for instance, that Plymouth has been laggardly in matters of style, with its clutching at this muse and that tankard. A good hard look at fashion tells him that tea wares are steady, but that colour is an issue of some moment. A waspish critic tires 'with looking daily upon the chaste black, blue, and quaker-coloured grounds, and seek to revive my ideas by a little variety. The glossy, creamy surface of the Sèvres, Dresden, Vienna, and other porcelain . . . refresh my imagination.'

In Etruria, Staffordshire, Wedgwood's analysis that month is that:

> The Agate, the Green & other colour'd Glazes have had their day & done pretty well & are certain of a resurrection soon, for they are, and ever will be a numerous class of People, to purchase *shewy* & *cheap* things. The Creamcolour is of a superior Class, & I trust has not yet run its race by many degrees. The Black is sterling, & will last forever.

He is able to distribute different kinds of ware, different colours, to different markets, of course, with his pattern boxes and catalogues and now his travelling salesmen.

Champion doesn't have these resources, but is focussed on developing patronage. He hits on the idea of the factory making oval porcelain plaques, with armorial bearings of the well connected, framed in baroque cartouches of ribbons and flowers.

Wedgwood, of course, has been there before him. 'Crests are very bad things for us (Potters) to meddle with', pointing out that you can't get rid of a crested piece as a second. Who wants someone else's coat of arms? It is like a misspelt gravestone. Champion's are unglazed which at least gives them one less opportunity to crack, warp, blemish, though they do all these things. They are soon in circulation; 'Lady Rockingham as well as myself are exceedingly obliged to you for the very elegant China flowers.'

Then there is the issue of the patent, whose terms he wants to extend. Another fourteen years should see clear the competition and see Bristol flourish.

Champion is a busy man in a very busy city. Due in great part to his efforts, Edmund Burke is returned as Member of Parliament for Bristol in 1774, and Mrs Burke is grateful for the celebratory porcelain tea set. *Liberty* is on the left wearing a Phrygian cap and holding a spear with a shield bearing the Gorgon's head, with a voluptuous *Plenty* on the right clutching a louche cornucopia. A pedestal stands between on which are inscribed the Burkes' coats of arms and *a token of friendship to J. Burke the best of British wives* in Latin. The scales of justice and a flaming torch appear where there is room and then, because this is an English Revolution, there is a nice flower border to round things off.

Like all good English Revolutionaries, Champion is also presented to Queen Charlotte. She expresses her interest in the manufactory and its progress, and is given a porcelain floral plaque. Perhaps, thinks Champion, she is getting slightly bored with the ubiquity of Wedgwood's Queen's Ware.

ii

In February 1775, Champion presents a petition to Parliament for extension of patent for fourteen years beyond the original term. It comfortably passes in the House of Commons, guided by Burke. In the House of Lords he is well supported by the duke of Portland and friends; the duchess of Portland is grateful for the 'very beautiful pieces of porcelain'. Burke tells Champion to prepare for this grilling as he heard 'the Wedgwood people think of giving you opposition'.

This is an understatement.

Wedgwood has also been spying on Champion to find out what materials he is using. The whole matter is referred to a Committee of the Lords. Burke is concerned and stresses that the examples Champion brings to the committee are good enough. They are. Champion has it all covered and 'there are two sets of Beautiful tea China; one from Ovid's metamorphosis, different subjects to each piece, an exact copy of a Dresden set'.

Mr John Britton, Champion's foreman, is also examined by the committee. He is bold and shows that *Bristol* is the peer of Dresden in hardness, that *Bristol* can be made in any Degree of Thickness, that *The Bristol China* will stand hot water, that the Gold will not come off. The committee are very well briefed on what to ask and under pressure he admits that they can make Plates, but have had great Difficulties. He produces shards and examples of Bristol porcelain and one of the peers 'involuntarily provides the Committee with more fragments of Champion's china' by dropping a beautiful cup. These shards too are examined and are found to be nearly transparent.

There is discussion. And then '*Ordered*, That Leave be given to bring in a Bill for enlarging the Letters patent.' It looks like Champion has won.

This is where, in the language of the Midlands, it all kicks off.

Wedgwood, on behalf of himself and the Manufacturers of Earthenware in Staffordshire, begs leave to represent: 'That the further Improvement of the Manufactury must depend upon the Application and free Use of the various Raw Materials that are the Natural Products of this Country.'

And then, he adds, coolly, that Mr Champion is not 'the original Discoverer but the purchaser only of the unexpired Term of a Patent granted to another Man, who, for want, perhaps of Skill and Experience in this particular Business, has not been able during the Space of Seven Years, already elapsed, to bring to any Degree of Perfection'.

It is 'a cunning specification', says Wedgwood.

Champion replies that he, like everyone else, greatly respects JW and that JW deserves his great fortune, but why has he gone around Staffordshire stirring up the potters? Can't he leave others to their little bit of the fruit of their labours? Don't underestimate the work of moving from a 'very imperfect to an almost perfect manufacture'. Undoubtedly there was lack of skill, but think of the skills of Mr Cookworthy, the manager, the workmen.

Seven years is cruel: think of how long it took Dresden!

On 10 May 1775, Wedgwood counters with a really substantive *Petition from Manufacturers of Earthen Ware*. On the 16th, there is a petition from the Merchants in the Port of Liverpool who object to any restriction on free trade. 'Free trade' is clever, I think. Lambent words.

Wedgwood keeps up the pressure.

He publishes his *Remarks upon Mr Champion's Reply to Mr Wedgwood's Memorial on behalf of himself and the Potters in Staffordshire.* He says that he employs ten times more people than all the china works in the kingdom put together to make his Queen's Ware and he didn't need a patent.

Wedgwood sends them a lengthy case. It is a brilliant bit of footwork.

He writes that William Cookworthy 'entirely failed in fulfilling the obligation' to describe the principal operations of his making porcelain, the proportions in which the materials were to be mixed to produce the body or the glaze, nor the art of burning the ware, which he knew to be the most difficult and important part of the discovery. It is a pretended discovery. It has not been shared.

Champion wants a monopoly of stones and earth. He wants to interrupt the progress of other men's improvements, asserts Wedgwood.

A hundred years ago, he continues, Burslem and other villages in Staffordshire were making milk pans and butter pots, but gradually through a succession of improvements in quantity and quality they are now making £200,000 worth of useful and ornamental wares. There were innumerable experiments for Queen's Ware: the public required them and expected them. There are 'immense quantities of materials in the kingdom that would answer this end; but they are locked up by a monopoly in the bowels of the earth, useless to landowners, useless to the manufacturers, useless to the public'.

Crack, crack, crack, go the arguments. 'This won't do for Josiah Wedgwood,' he would say in the throwing room and break the offending vessel with his long and accurate stick.

Champion suggests a meeting. It lasts six hours. Wedgwood is tricky and his lawyer is trickier. An amendment is made. Champion can have exclusive use of Cornish materials for porcelain, but not pottery, if he publishes the exact specification of the body and glazes.

Which he does.

Chapter fifty-one

Gray's Elegy

Five days after the new patent is crushed, Wedgwood gets in a carriage.

> I thought it would be proper to take a journey into Cornwall,
> the only part of the kingdom in which they are at present to be
> found, and examine upon the spot into the circumstances
> attending them — whether they were to be had in sufficient
> quantities — what hands they were in, at what prices they might
> be raised, &c.&c.

He takes with him the potter Mr Turner of Lane End, and his
formidable agent Thomas Griffiths. Three days later they are near the
seat of Thomas Pitt and as he is 'a friend of mine as well as Mr
Champion, I wished to wait upon him to let him know what had been
done respecting Mr Champion's patent'.

The visit is charming. Their host lives up to his reputation as a man
of taste. Wedgwood writes in his journal:

> we found him at home, & he took us a walk before dinner,
> down a sweet valley with hanging woods on each side, & a clear

purling stream . . . when we came to a fine old beech tree in the bottom, by the side of the brook, the roots of which were visible in various folds above the surface, Mr Pitt laid himself easily down, and repeated those fine lines in Gray's Elegy, in a country church yard.

Once Wedgwood's carriage has disappeared, Pitt writes directly to Champion:

I know nothing concerning the Act of Parlt. more than what you had written to me, till Wedgwood call'd here . . . Wedgwood says your specification is a light-house, teaching the trade precisely what they are to avoid, which will only serve to bring them safely into Port. The two grand Pillars of our Porcelain are the Clay and the Stone, and the rest is mere corrective or manufacture, of which depend upon it, Wedgwood . . . knows more than all of us put together.

If Wedgwood knows the ingredients for their porcelain body then all those hours at Notte Street, the letters and samples and shards, the procuring of moulds, hiring of attorneys, anxieties and aspirations, the dreams of the Dresden of the West Country, are in ruins.

Pitt thinks of Gray's 'Elegy' and its penumbrous mood steals over him.

'There at the foot of yonder nodding beech / That wreathes its old fantastic roots so high, / His listless length at noontide would he stretch, / And pore upon the brook that babbles by.'

Wedgwood, Pitt adds, 'is now gone into Cornwall to visit and procure samples'.

Chapter fifty-two

a journey into Cornwall

i

I read Wedgwood's *Journey into Cornwall* and think what a good travelling companion he must have been.

I've spent so long with William that I realise that my pace has come to match his, and that I am developing the slightly ambling gait of a benevolent Quaker, stopping to look at this, intrigued by that, perpetually waylaid.

And Wedgwood's pace is tremendous. He has a peg leg, and his passage through life has a fast and rhythmic stamp to it. He casts an appraising eye over the landscape as speculator, property developer, geologist, mineralogist, potter, sorting information for use. He listens to the price of labour, asking how much the day rate for labourers is now, how much it was then, checking whose land he is passing through. He is noting and collecting as he goes, carrying away 'specimens of every kind' for his Cornish catalogue.

You sense him as a compass trembling the whole time, reading the distances to the sea and the passage to port, port to Etruria. You see

him standing at the carriage tapping his cane for Mr Griffiths and his friends Mr Turner, another potter from Staffordshire, and a local apothecary Mr Tulloch to get a move on. It is not that he isn't enjoying himself – 'we had a small turbot and another dish of fried fish for supper, with another dish or two, and all for about 9d a piece' – it is just that he is here to find growan and is impatient.

He clambers out of his carriage on the fourth day: 'We were now in the midst of the mines, & hillocks thrown up from them, being within 2 miles of St Austle we were extremely eager to examine their contents. The first we saw where the men were actually at work, was a shaft from which a great quantity of indurated clay, as we should have thought it, was thrown up. It was of a whitish colour, felt rather smooth to the touch.' This is not it, but they are close.

Wedgwood is as grand as Augustus. He is the first miner.

ii

Cornwall lies in front of him like one valuable lode, as he picks his way through the hills, enquiring how much the Worcester factory pays for its soap rock, how long this lease remains, whose steward he should talk to over terms and contracts. He is in a long line of Adventurers. 'The landscape abounds greatly with mines', he notes, 'and in some parts the grass is totally destroyed, so that it has a very singular, & indeed a very dreary aspect.'

They journey down over several days, 'to the furthest point of the Lands end which terminates in large & rugged stones, upon which we clambered as far as we could with safety, to say we had been at the very farthest point, when we gazed for some time with a kind of silent awe, veneration, & astonishment, at the immense expanse before us'. This sublimity completed 'we turned about, and it was with a transport of joy, that I cried. Now I set my face towards Etruria again.'

And they work their way back.

They stop at Tregonning Hill, the place where William had his revelation thirty-five years before, the synapse that connected the stone of the hills of Jingdezhen with the rising ground near Penzance:

> We had heard much of the excellence of the growan clay & stone on each side of this hill. Mr Borlase says (in his Natural History of Cornwall) that he was told by Mr Cookworthy that the stone of the hill is the most proper for porcelain – We stopt therefore on the side of the hill, & sent for some of this clay, which we saw dug up . . . We took samples of both the clay & the stone, & from the slight view then had of them, & perhaps likewise from being so much prejudiced in their favour, we concluded they were both good, though when I came to try them carefully, at home, I found them otherwise . . . We were much pleased to see such an immense quantity of the materials, sufficient to supply all the potters in the world.

I feel a trespass here on William's epiphany. Wedgwood, the ventriloquist for the Staffordshire potters, is now speaking for all the potters in the world.

At St Stephen's, near St Austell, the tempo changes again. Here, Wedgwood meets a farmer, whose lands have both clay and stone, but he finds the

> wife entirely averse to his selling the estate, indeed she told him she should not sell it, for she said if the estate was in money he would soon drink it; but he should sell us the clay at the common price. Upon asking what that was, she said 10/per ton, mine rent. We let them know in answer to this, that they were much mistaken in supposing these materials confined to St Stephen's, for we had met with them nearly all the way to Lands end, & had the choice of many places to fix upon, that we were leaving that part of the country immediately; and that they then must fix, even that morning, whether they would have us or not. We were then asked what we would give per ton, we

answered, Nothing, for we would either buy or have lease of, the land, with the materials in it, to get what we had occasion for; & if they chose to treat with us upon those terms, it was very well, otherwise we had nothing further to say to them.

Wedgwood leans on his stick. You know that this is what he enjoys, the calculation of position and opportunity, the offer and reply. 'The farmer then said he would lease us stone & clay in the estate for so many years, & asked 20 guineas a year rent for them. I offered 10. He accepted it.'

So that is that. 'Having now completed our business in Cornwall, by having got a firm & secure hold of these raw materials upon reasonable terms, and left Mr Griffiths there to conduct the business, we left St Austle after dinner, & slept that night at Liskard and the next day, we set Mr Tolcher down at his own house at Plymouth.'

Wedgwood doesn't call in on the other Plymouth apothecary in Notte Street on his way home to Etruria. With trophies.

Cornwall was always a landscape for Adventurers, for speculation. Cornwall, *on our own terms*.

Chapter fifty-three

Thoughts Concerning Emigration

i

Champion is in trouble.

He has his warehouse at No. 17 Salisbury Court, Fleet Street, for the sale of his porcelain, but sales are poor. On 2 March 1776, he advertises again in the *Bristol Journal* and plays the nationalism card, 'Established by Act of Parliament. The Bristol China Manufactory in Castle Green. This China is greatly superior to every other English Manufactory. Its texture is fine, its strength so great that water may be boiled in it. It is a true Porcelain composed of a native clay.'

And the Bristol China Manufactory stumbles to an end. Like Plymouth.

There are all kinds of endings, all of them untidy, and this one shares the tumbleweed feeling of energy trickling away, debt, grand possibilities diminishing month by month. This was to be the new Dresden, but the plates keep warping. Your English Arcanum, the delicate balancing of growan clay and growan stone, has been printed in the *Monthly Register*. Anyone can have a go. Wedgwood is back in Etruria

with God knows what contracts signed, deals achieved. But bankruptcy looms here in Bristol.

Champion owes a huge amount of money and to some serious men of business. I find an inventory for the sale of another bankrupt pottery in Bristol around this time and realise the problem. The whole quantity of 324 pot boards, three benches, one pounding trough and one mixing trough, a clay chest, three complete wheels and wheel frames, working benches, moulds and drums, a kiln ladder, salting boxes, lignum vitae blocks and a hand mill, are valued at only £10. The 'Old iron pot in the Yard' is four shillings and sixpence.

His assets are negligible, a word that crumbles scant as rust.

The premises are sold off to a pipe maker. The investors cannot be paid back fully, and Champion is brought before Meeting in Bristol to explain himself to the Friends. He is unable to. The remaining stock is auctioned, the men dispersed.

ii

The only thing of any value is the patent. Champion goes to Etruria in the hope of selling it on.

The Josiah Wedgwood Works take up six acres alongside the new canal for bringing the clay and coal in and transporting out the jasperware, figures, Queen's Ware. Four hundred people are employed here. It is a place of careful disposition of time and Wedgwood is counting.

> Amongst other things, Mr Champion of Bristol has taken me up near two days. He is come amongst us to dispose of his secret, his Patent etc. Who would have believed of it – he has chosen me for his friend and confidant! I shall not deceive him, for I really feel much for his situation – a wife and eight children, to say nothing of himself to provide for, and out of what I fear will not be thought of much value here, the secret of china making. He tells me he has sunk £15,000 in this gulf and

his idea now is to sell the whole art, mistery and patent for £6,000.

And, he adds, it is 'one of the worst processes for china making'.

Wedgwood knows this, as he has been experimenting: 'You can hardly conceive the trouble these white compositions give me . . . I am very sensitive of their variations, but find it almost impossible to avoid them.' He gives Champion a list of other potters to try.

On 24 August 1778, Wedgwood writes to Bentley: 'Poor Champion, you may have heard, is quite demolished. It was never likely to be otherwise, as he had neither professional knowledge, sufficient capital. Nor scarcely any real acquaintance with the material he was working upon.'

He adds, casually, 'I suppose we might buy some Growan stone and Growan clay now upon easy terms, for they prepared a large quantity this last year.'

iii

Champion is on his knees. He publishes *An Address by Richard Champion to the Pottery* to garner support. There are, remarkably, enough takers for a new factory, the New Hall China Manufactory, to start under the guidance of men with professional knowledge. Champion can walk away.

And in a moment of brief, tremulous balancing of political power, friendship and patronage, he becomes joint Deputy Paymaster General under Burke with a stipend of £500 per annum and a suite of rooms in Chelsea, substantial enough for the children. He makes a misjudgement about money with a clerk, which is noted and which embarrasses his patron, reflects badly on his abilities, if not his probity. Months later the government changes. Champion has even less to tether him.

In 1783, Wedgwood publishes and distributes gratis, *An Address to the Workmen in the Pottery, on the subject of entering into the Service of Foreign Manufacturers*. It deals with 'the dangerous spirit of emigration'.

In 1784, Champion emigrates with his wife Judith and seven children. They are on board the *Britannia*, on 20 October, as they pass the Lizard, the last of England, rich with soapstone, riddled and hollowed by mines for the porcelain trade.

> The last sight of the British shore sunk deep into my heart, and left an impression which will not be easily erased. The evening we parted from it was serene and the sun dipped his beams to the Westward in a calm and unruffled ocean. The Lizard Point was in view . . . the gathering distant clouds, seemed to tell us, that it was time to leave infatuated Britain.

He writes and writes in his journal, and by the time they land in America it has become a hundred pages of a pamphlet: *Thoughts Concerning Emigration*.

iv

They are going to South Carolina, to live in Rocky Branch, a tributary of Granny's Quarter Creek. This is ten miles north of Camden, 130 miles from Charleston, 'where the heat is less intense', and where the provisions are cheap and there are 'no musctoes'. 'I came to America in search of the Virtues of Simplicity, so becoming in a new Republic', he writes to a friend.

There are no more letters from Burke, who has crossed over from one party to the other; he is 'spared the pain of correspondence'.

The family bring some things with them. Most precious is a memorial, thirteen inches high in unglazed porcelain, a figure of a weeping woman leaning on an urn supported by a pedestal. She is clutching a wreath and her eyes are closed and every part of her is heavy.

It is very white.

The urn simply says Eliza Champion and has her dates. She was four-teen. Champion has spent time on this memorial, writing a long, sad Latin inscription from Virgil on the cornice of the pedestal.

And then because he cannot stop, the whole of the plinth is covered in his writing, small and careful and urgent, necessary:

> We loved you my dear ELIZA, whilst you were with us. We
> lament you now you are departed. The Almighty God is just
> and merciful, and we must submit to his will, with the
> Resignation and Reverence becoming human frailty. He has
> removed you Eliza from the trouble which has been our lot, and
> does not suffer you to behold the scenes of horror and distress

Engraving of Champion's memorial to his Eliza, 1779

in which these devoted Kingdoms must be involved. It is difficult to part with our beloved Child, though but for a season . . . Happy in each other, we are happy in you Eliza, and will with contented minds cherish your memory till that period arrives when we shall all meet again, and pain and Sorrow shall be thought of no more. R.C. J.C.

And on the pedestal 'This tribute to the memory of an amiable girl was inscribed on her coffin the 16th October 1779, by a father who loved her.'

He has finally made something real and true out of porcelain.

v

Wedgwood has been painted by Stubbs, is a fellow of the Royal Society, a member of the Lunar Society. Alongside teacups he makes fossil cups for mineralogical specimens, measuring cups for use by chemists, druggists and apothecaries, mortars that 'will be of great Use to *Chymists, Experimental Philosophers* and *Apothecaries*'. He writes to James Watt, the mechanical engineer and developer of the steam engine, that 'I never charge such experiment pieces to anybody, & it would be unreasonable in you to expect in this instance to be favor'd beyond the rest of mankind.'

Wedgwood is using a good French white clay, finer than the American. He has tested the clay from Sydney Cove, brought back by Captain Cook, found it wanting. The Green Frog Service, 957 pieces strong with all the principal views of the whole of the United Kingdom, has been delivered and is in use by Catherine, empress of all the Russias, in her palaces in St Petersburg. Several of the views show the picturesque sights of Cornwall, its moors and rocky coastline.

He writes to his friend Dr Erasmus Darwin, who is writing a long poem, *The Botanic Garden*, in which the whole of creation is explored in Swedenborgian rhythms. Darwin has got to Clay and Wedgwood

wants the Chinese to have their fair share of the acclaim: 'I am a little anxious that my distant brethren may have justice done to their exertions in the plastic art.' He tells Darwin to read the letters of Père d'Entrecolles on 'Ka-o-lins and Pe-tun-tses'.

Wedgwood is a great man. 'I hope white hands will continue in fashion', he writes to Bentley, thinking of how his new wares look as they are picked up.

And in Etruria, in his new and beautiful redbrick house overlooking the new canal, Wedgwood muses to his business partner Bentley on the value of white earth:

> I have often thought of mentioning to you that it may not be a bad idea to give out, that our jaspers are made of the Cherokee clay which I sent an agent into that country on purpose to procure for me, & when the present parcel is out we have no hopes of obtaining more, as it was the utmost difficulty the natives were prevail'd upon to part with what we now have . . . His Majesty should see some of these large fine tablets, & be told this story (which is a true one for I am not Joking) . . . as has repeatedly enquir'd what I have done with the Cherokee clay. They want nothing but *age & scarcity* to make them worth any price you could ask for them.

It is the story of scarcity that matters. 'A portion of Cherokee clay is really used in all the jaspers so make what use you please of the fact', he writes, cannily.

All the famous jasperware, the hard blue neoclassical cameos and vases and garnitures in their Horatian self-confidence, one enunciated, grammatically correct vessel after another hold a part of *unaker*, of a promise made, hands shaken.

The world and its geology are in obeisance.

Chapter fifty-four

a road trip

i

I think I have finished with *unaker*, but the whiteness of this clay and its ownership, its contested provocative storyline, bothers me. It is partly because I cannot feel the distances involved, and partly because I haven't had it in my hands, that Cherokee clay doesn't quite seem real.

Ben, my oldest son, has finished his exams and it is the dog days of July and he is kicking his heels, and though he doesn't explicitly need to come on an expedition to find a seam of kaolin, this changes a research trip into a family one and is legitimised. He can be my map reader and we can stay in motels and do the road trip father/son bit. We work out that we could get to Carolina for five days and find Champion.

A week before we set out, I'd mentioned this trip to a New York friend – an expert on Impressionism – over coffee in the studio. He knows the Quaker graveyard, he shrugs, as if it was the most natural thing in the world. Watch out for the turning off the main road, it is easy to miss. If you get to the Holiday Inn you've gone too far. If we went two miles east, he added, we would find white clay.

He volunteers his art-historian son to meet us by the grave, down a lane, a mile outside Camden. His grandparents are buried here; their family have lived next door on Mulberry plantation for 200 years.

This is our first time in the American South. We head down from Charlotte on back roads. We pass signs for the Holy Church of the Living God, Landmark Pentecostal Church, the Restoration Ministries, Ebenezer Church, Mt Calvary Zion, Fellowship Tabernacle, Damascus Congregation, the Holy Church of the Living God. And Baptists by the mile, any style. *Repent* says one sign in red, outside a tumbledown shack. And then *REPENT*. It is hot and humid. Good weather for repentance.

We meet my friend's son near a memorial to Civil War soldiers, a Confederate flag staked in a grave, under a tall magnolia tree, a month past flowering. There are three dusty arched headstones in a row. The smallest is the oldest.

Sacred / To the Memory of / Richard Champion / And Julia, his Wife / Natives of Bristol, England.

Ben cleans them up, while I wander over to break a flower off a rufus shrub. I've brought a small porcelain cup glazed in white with me that I made last month. I fill it with water, place the flower, and I stand briefly and think of aspirations and emigration and disappointment. We leave.

And as we walk back to the car, I think that no one should bring their son on a graveyard tour.

ii

At Mulberry, a beautiful brick four-square house, self-confident in paddocks, we meet the manager of the estate. She picks up a geological survey and takes us in a pickup to a bluff above the Wateree River, a bend where there was one of the greatest burial mounds for chiefs of the Mississippian people, twenty feet high, one stratum of coloured

earth added each time a chief died, but now ploughed and pillaged to a mild rise amongst the tall grasses. They were great potters.

The estate manager drives over the rutted ground at speed, a finger on the wheel, her other hand scrolling for pictures of the rattlesnakes five feet long, that they shot outside the house last month. Which takes her on to the plenitude of water moccasins and then on to the 'gators that are increasing here, and then on to how to deal with poachers. At intervals we stop and grab the shovel, and dig hopefully at the red earth.

And then on a slipway from a lake, surrounded by pines, and poison ivy, there is lighter clay, more ochre than white. The son of my friend goes to look and is back seconds later having surprised a large black snake with concentric white bands. This is a snake our guide approves of, as it eats rattlers, which shows some sangfroid I think, as I crouch and dig some earth and crumble it between my fingers and it feels good, plastic, possible.

It is kaolin, china clay. Champion is buried on a seam of kaolin running all through this country, beautiful and unprotected.

That evening we drink to Champion. And go our separate ways; back to Mulberry, off to the art world in New York and Ben and I head west to the Appalachians.

iii

Down through the Appalachians, twisting on the fall of the land, are waterfalls. We stop and scramble down and there are Turk's cap lilies, and a clematis that is ludicrously beautiful, and butterflies out of a Henri Rousseau painting. Or from a Frenchman's porcelain plate.

At Franklin, 'small, dull and cautiously unattractive, but mostly dull' – Bill Bryson – we stop briefly in the museum. I ask about the history of Cherokee clay and the elderly gentleman tells me, without a pause, that he doesn't know about that, but did I know that the Cherokees didn't live here *first* but took the land off other people?

Franklin is a street ringed with Fatz and Walmart. We share breakfast with a posse of retired bikers on a trip south on their Harley Davidsons. The fried food is delivered with terrific courtesy. But *damn*, the coffee. I ask about mines and the receptionist tells me about the gem mines here and that you can go panning, $20 a bucket.

We spread out our maps and drive up Route 28 to a marker by the side of the road commemorating the finding of the Cherokee clay. It was unveiled in 1950. I've brought a photograph of Hensleigh Wedgwood, chairman of Wedgwood Ltd, proudly standing next to the new sign after its unveiling. We are above the river but this is nowhere near a hill. A man twitches his curtains from the house opposite. The trucks thunder past us. We are in the wrong place.

Finally, we end up at Jerry Anselmo's Great Smokey Fish Camp. He is walking across the yard when we pull in, a bear of a man in fatigues, a Viet vet cap. He looks like Hemingway. He narrows his eyes like a sailor.

I've rehearsed this. Excuse me, I'm going to say, but did you know / are you aware / it is a long story / I'm so sorry to bother you.

Wedgwood / Cherokee / England.

We've come a long way. Can we please dig up your land?

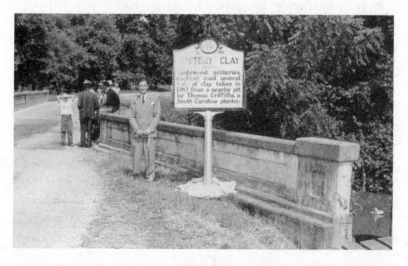

Hensleigh Wedgwood and the Cherokee clay memorial, 11 August 1950

The camp is beautifully kempt, with banked kayaks and tubes for riding the river, and rods and serious stuff, bait and knives. And as I try and explain why we've come, he reaches down to a bucket of earthenware shards and pulls out a couple, rimed, blackened and gives them to me. He asks us to make ourselves comfortable outside and while his wife makes us coffee, he begins to tell us his story.

After the war he saw the way the world was going and started to work in conservation, came up from New Orleans twenty-eight years ago, saw the land and loved it. And bought it and loves it more, day by day. As the city creeps out he has bought fields and woodland to prevent development, and has put the land into a trust. He knows names and stories. He talks of the mining for talc and marble and kaolin, the lumber businesses that felled whole ridges of trees. And he tells us of the Trail of Tears, the expulsion of the Cherokee from their homelands across the border into Oklahoma in 1838. Of course he knows the story of the white clay.

We are not the first to visit him – there have been academics and writers, and local historians – but he is expansive and generous with his time. Send me what you write, or I'll find you, he says, and hunt you down, and he laughs and throws a shovel in the back of the truck. He drives us in his pickup down to the crook in the Little Tennessee River where the Cowee town used to be, the mound where the Cherokee tribes buried their dead. This is the creek where he found bushels of shards. It is deep and shaded by old stands of trees.

The shard in my hands came from this place, he tells me. It is part of the rim of a jar – quite a substantial one – and there is rope or basket impressed decoration that gives it texture. And the maker has run a damp cloth over the rim to make it smooth and then used a fingernail to notch the underside. It feels poised, fluent making. The inside has been burnished. I wonder at its date. It could be eighteenth century. There are records from traders who travelled through these mountains before Thomas Griffiths arrived on his mission from Wedgwood that the Cherokee 'make earthen pots . . . of very different sizes, so as to contain from two to ten gallons; large pitchers to carry water; bowls, dishes, platters . . . basons, and a prodigious number of other vessels of

such antiquated forms, as would be tedious to describe, and impossible to name'.

They were known for their pots. And as he drives us through this landscape, each hill and twist of the river, each creek coded with names and stories of the Cherokee, it becomes clearer that the traders and officials and chancers who came through found people who had deep knowledge of the different clays. And were using them in complex ways. They were using the white kaolins here for pipes, not just because it is a fine clay that burns cleanly, but because white is a central ritual colour. It symbolises peace. A flag of white cloth painted with red stars would fly over the national council, the floor of the council house spread with white deerskins. White gourds and a single white vessel for use in rituals of purification would lie on a white bench.

And *unaker* was used both to insulate their houses – 'wattled with twigs like a basket' in the words of an eighteenth-century traveller, and then 'covered with clay, very smooth, and sometimes whitewashed' – and to make them beautiful. Imagine the luminescence of a white space, the faintest glimmer of mica. A porcelain room.

The Europeans didn't 'discover' this hillside of white clay. The white pipes and these white houses drew them to this seam that the Cherokees were so anxious to keep un-despoiled.

He takes us up the hill behind his house where the land opens up and there is a high bluff, fringed with pine and hickory, an arc of ochre earth forty feet high. There are brambles hard against it. And a scar of white ten feet high. It is *unaker*, the Cherokee clay, impossibly silvery white.

We come back the next day with a ladder and a shovel and we dig. It is soft and it crumbles and it glitters with mica, as beautiful as my Quakers said it was.

I've brought a piece of Wedgwood jasperware from 1780 made from this clay.

It is from my mother's family. They lived in Cheshire in the eighteenth century and were prosperous and a bit conventional like a

Cheshire farmhouse, lawyers and clergymen and merchants. And they had one of the first of Wedgwood's Portland vases. There is a story that it was chipped and thrown away.

This is all that is left from their great china collection and I'd planned to bury it here, or break it, or find a symbolic act of reparation, fulfil the promise of a punchbowl made 250 years ago. A return.

But now I'm here, these actions all feel too precious, so I just give it to Jerry to say thank you, and he sends us off with baseball caps for the rest of the family with *Great Smokey Fish Camp* in italic stitching and my bag of Cherokee clay and a bearhug.

The mist is banking up the valley. I've made it to my Fourth White Hill. I count them: Mount Kao-ling, then Meissen, Tregonning Hill and now Ayoree. It is Ben's first white hill.

I realise, cheerfully, that I've left the final white pot in very good hands.

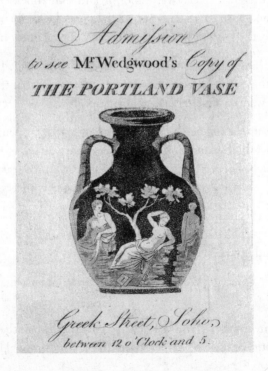

Admission ticket to view Wedgwood's copy of the Portland Vase, 1790

Chapter fifty-five

i

It is 1790.

In China, Qianlong is emperor. He is Kangxi's grandson.

In Jingdezhen, they are making versions of Wedgwood's jasperware.

In Dresden, the porcelain in the Japanisches Palais has been stripped out, crated in the cellars.

In Meissen, they are making porcelain altarpieces, six feet high.

In Paris, the chemist Antoine Lavoisier is using a Tschirnhaus lens to experiment on the combustion of diamonds.

In Paris, the young English collector William Beckford is buying up collections. He finds a Chinese ewer glazed in a sea-green, decorated with daisies, mounted with silver, and brings it back to his estate at Fonthill in Wiltshire.

In America, the first trading ship, the *Empress of China*, has left New York for Canton. She returns with boxes of porcelain, of a 'greyish and orange peel glaze'.

In Camden, South Carolina, Champion has died. Some months before, he tried to present George Washington with two reliefs, one of Benjamin Franklin and one of the President, made from 'native Porcelain'. The President was too fatigued. Champion's neighbour has set up a pottery and calls his first son Wedgwood.

In Plymouth, William Cookworthy, much admired, has died and been buried in the Quaker graveyard.

And in Cornwall, the lease of William's and Champion's quarry on the moor is now available: 'the premises are unoccupied and the Lessees all dead or absconded'. The new bidders are all from Stoke: Wedgwood, Derby, Coalport, Spode, the New Hall China Manufactory, all keen on raising their own china clay and china stone.

ii

The world flows and ebbs, tidal with feelings.

And things silt, gather and block.

I want to go back to the figures in the landscape, go down some long track and knock at an inconsequential door and ask the farmer's wife if her husband has stopped drinking, what the money did for them.

I want to see how one action brings on reactions, how a handshake and ten guineas per annum means that the hill needs a track, and then a shed, and then the track needs widening. That the man becomes men and then boys, digging, and that the brook is deepened for washing growan.

You watch and you see a slight flicker, as far away as the buzzards, a boy collecting moss. It is used to fill the joints between the granite setts of each pan where the clay is dried. He is paid sevenpence a day.

You buy the hill. And the place changes. The few trees are gone. It is not that it was beautiful before, but Carloggas is now a 'bleak heath, thinly bespotted with huts and common mines'.

It is transport costs that are high, not labour. And the losses from clay becoming dirty lying on wharfs, theft, careless handling. This means warehouses and a harbour, and then a better road. The new road is dusty with stone.

And the moors change and the road widens and the spoil tips grow and the streams slow as the waste sand and mica make their way to the sea, silting.

iii

And the white clay from the moors is loaded on to boats from the new quays in Cornwall, Fowey and Charlestown and St Austell, and it travels all the way down past Land's End and across the Bristol Channel then up the coast of Wales to Runcorn and then is transferred to narrow boats pulled by horses and then it comes down the Trent and Mersey Canal – sponsor J. Wedgwood – and it passes through the Harecastle Tunnel under Kidsgrove Hill and under innumerable bridges to the Potteries, to Stoke-on-Trent. The air is so dark from the smoke of the chimneys that there are days when there is a dense pall and no sun at all.

Fresh Air from the Potteries.

Postcard of Stoke-on-Trent, c.1903

This is becoming the greatest city for ceramics in the world. By the 1830s its scale rivals that of Jingdezhen. It is a difficult city – I correct myself – a difficult clutch of towns. Tunstall, Burslem, Hanley, Stoke, Fenton and Longton.

Everything here is pressed into service. Arnold Bennett, who grew up here three decades later and eviscerated it in his novels records 'ragged brickwork, walls finished anyhow with saggars and slag; narrow uneven alleys leading to higgledy-piggledy workshops and kilns; cottages transformed into factories and factories into cottages, clumsily, hastily, because nothing matters so long as "it will do"; everywhere somewhere forced to fulfil, badly, the function of something else.'

I think of Père d'Entrecolles noting the saggars and shards turned into walls, the porcelain bodged and repaired. And the work passing through seventy hands, the division of tasks into smaller and smaller skills. This happens here. Everyone is pressed into serving this make-shift, shameless industry, turning out more; more porcelain, more bone china, more cheap white wares. More quickly.

I find another witness, another careful man. Dr Samuel Scriven, appointed in December 1840 to visit the factories and workshops here. 'I have visited and thoroughly examined no less than 173 of them', he wrote, and 'I feel great pleasure in recording the gratifying fact, that throughout the whole of my visits, whether in the factory or workshop, the cabin at the pit's mouth, or in the humble cottage, I have been received with the utmost respect, kindness, and hospitality.'

He goes down Trentham Road to the *China Factory, Messrs Minton and Boyle*, then opens the door of the *Dipping or Gloss House*. He records the temperature inside and out, *Ther. 62, open air 48*, and then the name and age of the worker *George Corbishley, aged thirty-seven*.

It is 170 years ago, but you hear him:

> I have worked as a potter 25 years; as a dipper 6 years . . . Have never suffered in health yet; have known many others suffer; they get their limbs drawn, and lose the use of them. Have known persons

die from it; the last man that was at this tub did. My hands are constantly in the mixture; don't know what the mixture is made of; they don't tell us; think it is not so bad as it used to be.

The scourers, cleaning the dusty glazed work, 'complain of being stuffed up in my chest; I cannot lie down at night; my throat is always sore; and I have a constant cough, with difficulty of breathing. Have never had medical advice; 'tis no use while I am at work here. The flint dust is very bad.'

'This woman's voice is scarcely audible. She is suffering, in common with many others, at this work,' writes Dr Scriven, listening. 'I shall never recover the use of my limbs,' says a young man. 'If I ever get well, I should never go back to the dipping-house again. I don't know what the dipping is made of; the masters never tell us that; nobody knows but him and his head man, but I think there is something very bad for the limbs, as I have seen it strike into others before.'

Girls working in a slip house, Stoke-on-Trent, c.1900–1910

And then you hear children. Josiah Bevington, aged eight, mould-maker. William Mason, aged twelve, working in the plate room at Wm. Adams and Sons, who turns a jigger for John Joplap.

Dr Scriven records if their parents are alive and if they are working; there was a strike three years before and many are still unemployed. You get detail on how much each part of the family earns, how much they contribute to the household.

You hear about the work. The boy at the dipping tub and the boy who helps pack the kilns and the boy who runs moulds and wedges clay for Wm. Bentley who 'licks me sometimes with his fist; he has knocked me the other side the pot-stove for being so long at breakfast; half an hour is allowed, but he makes me work before the half-hour is up'.

And the girl who makes cockspurs, the three-cornered clay supports that keep each plate apart in the kiln. You press damp clay into a mould and tease it out when it's dry.

She is No. 279 in the two large volumes of Scriven's *Children's Employment Commission, Appendix to the Second Report of the Commissioners – Trades and Manufactures, Part I. Reports and Evidence from Sub-Commissioners presented to both the Houses of Parliament by Command of Her Majesty*, 1842.

Hannah Lowton, aged six:

> I make cockspurs for Mr Holland; I don't know how long I have been to work; mother is here too, father is dead; I can read, cannot write: I went to day-school, I don't go to Sunday-school. I get 1s. a week; I come sometimes at six o'clock, and sometimes after; I go home when mother does at nine o'clock. I've got a brother and a sister, one makes cockspurs, t'other runs moulds. I like to come to work. Father died of cough. They called it decline.

Hannah Lowton works for Messrs R Hall and Co.'s Earthenware Factory, Tunstall, who make the *Select Views Series* and the *Picturesque Scenery Series*. These are views of aristocratic houses of England and the

Palace of Saint-Cloud, France, full of porcelain, buried deep in a blue border of fruit and flowers, each plate held in the kiln by a cockspur.

iv

I go to Stoke. I go to Tunstall to see if I can find the factory where Hannah Lowton worked. It is a carpet warehouse.

I go to Etruria to nod to Wedgwood – his hall now a Best Western Plus Hotel offering comfort and convenience – and to the Gladstone Pottery Museum to see the bottle kilns, and past my favourite building, the Wedgwood Institute in Burslem, built in mid-Victorian-Venetian splendour with JW enthroned above the tympanum where Christ should be.

And later that evening I walk up to the Church of the Resurrection in Longton, not from some grave-fixated tic, but to see the church itself, built in 1853 by George Gilbert Scott. It is very good Gothic, rather severe and plain and unemotional, as you might hope from these towns, and it too has changed, a new name and now owned by the Antiochian Orthodox Church.

The church was built for a new community. The Longton Freehold Land Society acquired Spratslade Farm for £5,000 and announced the purchase by placing a notice in the *Staffordshire Advertiser* on 20 July 1850. They held their first annual meeting which was very well attended. Tea was served. There were to be 190 plots, 500 to 600 square yards each. By 1864, there were 500 houses here for workers in the ceramics factories.

This new estate was called Dresden.

There is where the Dresden Porcelain Company was founded. They, usefully, put DPCO on the base to distinguish themselves from the other Dresden with its crossed blue swords. This company made Kakiemon-style porcelain for the hotel market until they too changed their name, changed their mark, amalgamated, went under. Disappeared.

Part five

London – Jingdezhen – Dachau

Allach

Chapter fifty-six

Signs & Wonders

i

Several years ago I had an invitation to make an installation for the Victoria and Albert Museum in London.

The old Ceramics Galleries that stretched along the top floor on the Cromwell Road side of the museum were being renewed. The invitation was very open. Would I respond to the collections? I could be anywhere in these galleries, it could be any scale. I had a year.

When I was a boy I would walk up the stairs and then more stairs. You had to be resourceful to navigate your way through Medieval Metalwork, and not get lost in Enamels. You reached the top. There were very few places that you could see out of or even sense the museum below you, the spaces seemed completely self-contained, one enfilade gallery after another after another. In each direction there were armies of vitrines holding pots. Who would dream of building such high rooms with such spectacular volumes for a cup or a dish or a bowl?

There were very few visitors. Sometimes even the warders were asleep.

The display was regimented by country or epoch. It came from a time before interpretation. You were given a vitrine of Sèvres, or medieval jugs or Lowestoft porcelain and expected to get on with it.

ii

I walked and walked these galleries. And I worked out what I wanted to do. I wanted to be present, but not obtrusive. I drew a red ring on the plans inside the dome. I wanted a red metal shelf of porcelain high up at the point where the curve of the dome sprang from the walls; it should float above the cornice, away from the dome, porcelain held in space.

I wanted it to be a gesture, as easy as a hand on a shoulder.

And if you stood aslant on one of the mosaic circles that make up the floor in the entrance hall – shaking your umbrella, shifting in that moment of coming into a museum, the adjustment to echoey spaces – and looked up at the square aperture in the coffered ceiling, you would see a red arc. And a white smudge of porcelain held 150 feet above you. I called it *Signs & Wonders*.

iii

The red shelf holds 425 vessels made out of porcelain.

It is my memory palace. I thought of the porcelain in the collections of the museum that I have loved, looked at it again and walked away and sat at my wheel and made my memory of it. It was a kind of distillation, the intensity of the after-image you get from looking at anything hard.

What is left of that garniture of seven porcelain jars when you have looked away?

It feels a long time ago. Putting them so high up was, at one level, simply a way of putting things out of harm's way. With a high shelf,

things don't get knocked. And I liked the idea of it as a kind of attic, with things in the shadows, as I did at the Geffrye Museum.

But looking back, I was making these pots during the day in my last cramped studio with a small red maquette hanging above my wheel. There were boards of finished pots jumbled up with work ready for me to trim, buckets of porcelain ready for me to throw, and lists on the walls, a calendar with the day of the install ringed in red. That is the day they would close the galleries and board over the aperture and the scaffolding towers would be in place and the thirty-seven-metre powder-coated aluminium shelf brought down from its fabricators in Lancaster and lifted into the museum. All my porcelain had to be ready. There would be hard hats.

And at night I was trying to finish my book about netsuke, about loss, about the way collections fall apart, how memory burns an image of such intensity that you can be 10,000 miles from where you grew up and reconstruct how one object stood next to another, trying to make the circle join up again.

I didn't know how to end the book. My advance had been spent long ago on research trips to Vienna, Odessa. I'd look at my lists of the places I hadn't been, the graves that I felt might make something click into place if I went and stood and paced, the notes to check the post-marks on letters from a hundred years before. There must be a cultural history of dust, I wrote.

I handed in my book late.

And a week later at the opening of the Ceramics Galleries, a bemused royal glances up at my installation seventy feet above us and asks me *how it will be dusted* and *have I come far?*

I don't know, Ma'am, I reply to the first question.

And yes, I think, I have.

iv

The red shelf holds three kinds of porcelain.

There are my memories of Chinese pots. There is a whole episode of bowls on stands that have some kind of kinship with Jingdezhen. And secondly there is my conversation with the porcelain from all the factories that spilt out across Europe in the eighteenth century. There are my versions of a Meissen dinner service up there, and garnitures, parts of porcelain room arrangements.

And thirdly there is industry. Because I throw my work on the wheel there are many kinds of vessel that I cannot make. As I wanted porcelain dishes to be part of the shelf I asked for a wide, generous meat dish to be moulded in a factory in Stoke-on-Trent.

Industry which means modernity, seriality, perfection, the run of objects that don't just approximate to each other, but are each other. It is standardisation, it's the on and on and on of things in the world. It's the polar opposite of everything that making pots by hand in a workshop strives for, the warmth and gesture, the judgement that changes from object to object. It is beauty and sublimity and disappearance.

The polar opposite of the handmade. But polar too, in their coldness, their endlessness.

'I tried to think a lonelier Thing / Than any I had seen – / Some Polar Expiation – An Omen in the Bone / Of Death's Tremendous Nearness', wrote Emily Dickinson, her poem sitting jaggedly on the empty white page.

And it is closely allied to revolution. Up there are matt grey cylinders against a fiercely white dish, the graphic sparks of constructivist porcelain from Revolutionary Russia. And there are the graduated run of whites into greys of Bauhaus ceramics from Germany.

This is where I need to go. It is the last part of my journey, revolution, *Porcelain 1919*.

Chapter fifty-seven

<div style="text-align: right;">*1919*</div>

i

'Lenin is seated at The Rotonde on a cane chair', wrote Le Corbusier. 'He has paid centimes for his coffee, with a tip of one sou. He has drunk out of a small white porcelain cup. He is wearing a bowler hat and a smooth white collar. He has been writing for several hours on sheets of typing paper. His inkpoint is smooth and round, made from bottle glass.'

This is the revolution. It is perfect and smooth and white. It works with focus. It is strong. One sou suggests a slight lack of generosity. It is laconic. It is black espresso in a small white porcelain cup.

Revolution is everywhere. I have a new notebook.

Germany is strikes and disorder on the streets. There is no money. On 8 and 9 October 1919, duplicates from Augustus' collection of porcelain held in Dresden are sold to fund the new republic by Rudolph Lepke's auction house in Berlin.

There is hyperinflation, decades of savings disappear. The film reels show pictures of wheelbarrows of banknotes. The zeros multiply by

the hour. In Dresden, they resort to making coins out of red stoneware, the *Jaspis-porzellan* that Tschirnhaus and Böttger invented on their way to white. These keep value.

English revolution 1919 is moderated by an anxiety to offend.

Roger Fry, artist and curator, has just closed the Omega Workshops, created to revolutionise the decorative arts. He made wobbly white cups which were turned into wobbly white industrial cups. He upholds the supremacy of Sung Dynasty bowls, 'we realise that the precise thickness of the walls is consistent with the particular kind of matter of which it is made', which means fitness for purpose, icons of abstraction.

I note, under *money*, that Cornwall in 1919 now produces half of the world's kaolin, china clay, and the three major firms extracting it from those contested moors have become English China Clays.

ii

Russia is more dramatic. I hope that when I read Lenin's speech delivered at the All Russia Congress of Glass and Porcelain Workers – from his *Collected Writings Vol. 31* – that he is going to announce the dawn of a new history in porcelain. But it is dull stuff on grain production punctuated with applause and . . . prolonged applause.

That is slightly the problem with revolutions. There are an awful lot of speeches to sit through.

In Russia, everything is to be mobilised to create a new world. Anatoly Lunarcharsky, as the first Soviet People's Commissar for Education and head of the People's Committee for Public Enlightenment, organises a competition called 'Crockery for All'. The question is asked *What do we want from a plate?*:

> The cultural revolution, like the bugler's trumpet, is
> summoning for examination and revaluation everything which

mobilises or poisons our consciousness, our will and our readiness for battle. In this 'parade' of objects there are no non-combatants.

The Imperial Porcelain Factory in St Petersburg has been renamed the State Porcelain Factory and reorganised to 'serve and not alienate the state'. This is pragmatic as it allows artists and decorators to be workers and to stay on. And as there is a huge stock of blank porcelain to use up. Most of it has the mark of the double eagle of the tsar already printed on the back.

What should this 'porcelain nursery for a new nation' do with these blanks? There are no non-combatants, so paint them with slogans and aphorisms, scatter the symbols of revolution in dynamic enthusiasm across this snowy porcelain ground, write *Golod*, Hunger, and leave it at that.

A report from 1920 orders the representation of 'modern life and ideas; daily life and cultures; story telling, epics and poetry', so the parade ground gets mothers, soldiers and sailors and partisans, women sewing banners, a factory worker giving a speech.

This is perfect. Porcelain is perfect for speeches.

Its whiteness is like the clearing of the throat, a hushing of attention as the speaker looks down on us and shuffles his papers – the thickness of the pile tells us it is a man – and begins to occupy space.

iii

This whiteness is a revolution.

Artists are invited to work at the factory in Petrograd. Kazimir Malevich, maker of manifestos, angry and anxious and competitive, takes a standard porcelain plate and places his hard red and black concretion of shapes off to the edge, takes a cup, does the same, unsettles it.

He is making *architectons* in his studio, stacked and cantilevered geometric forms made out of plaster that look as if they are templates for cities, objects to start arguments with. They are white.

> The blue of the sky has been defeated by the suprematist system, has been broken through, and entered white, as the true, real conception of infinity, and thus liberated from the colour background of the sky . . . Sail forth! The white. Free chasm, infinity, is before us.

These objects look as if they could go on and on replicating, until they take up infinity.

Malevich makes a porcelain cup – a wide and open cappuccino kind of cup – and cuts it in half, makes it solid. He makes a solid of white porcelain. He makes a teapot into an *architecton*, angles tilting back, volumes repeating.

These objects are both tough and beguiling. They make me think of 'The Auroras of Autumn', my favourite poem of Wallace Stevens where 'being visible is being white, / Is being of the solid of white, the accomplishment / Of an extremist in an exercise . . .'

Other revolutionary artists are making objects out of images and he makes images out of objects. You want a manifesto? Here it is. You take an idea of an object for use and you paint over it, whitewash it, so that you end up with a teapot that cannot be used. A simple cup as combatant, revolutionary porcelain.

He has form. His *Black Square* is 'painted over a variegated composition made up of geometric elements'. *White Square on White Background* was too. One of the picture's corners looks like it has been crudely cut off. It isn't that he hasn't time to prepare a new canvas, stand back and ponder, it is that there is more pleasure in painting over something. White over black. Erasure is thrilling.

Malevich writes about this: 'But even the colour white is still white and, to / Show sign / Can be taken in. And so there must be a difference / Between them but only in the pure white form.'

This drifts a little but this doesn't matter much as he is painting, making, curating and writing revolutions. 'The problem arises when Malevich stops painting and begins to write brochures,' sighs Lunarcharsky.

iv

There are too many white objects. I need to concentrate.

In the spring, after *Signs & Wonders*, I have my first exhibition in a London gallery. I make white squares of timber, lined with plaster, and then make vessels, glaze them in different kinds of white, arrange a few in each of the series of cabinets. I make a black square lined with charred oak and put a single black vessel, off centre. I show them along a long wall.

'It is from zero, in zero, that the true movement of being starts,' wrote Malevich.

And I call my exhibition, *From Zero*.

When I go early one morning to spend time alone with my work, I like this line of installations a lot. It is an idea unfolding.

Opposite this line is my first vitrine, *Word for Word*. I have put porcelain behind glass and it is like a page from the Talmud, large vessels and smaller ones, words and commentary sitting in close proximity.

I sit on the floor. The title works the more I think about it. It is from another poem by Wallace Stevens. His poems with their passionate abstractions are pretty much a constant in my life. I wonder if I should have stolen another line from him and called this show *Farewell to an idea*.

A title is a letter of promise in a pocket. Sometimes a title brushes alongside a remembered view or is a conversation overheard, a line from an inventory, a favourite melody, a street. Sometimes it is a provocation; the claiming of a shared space with someone I care about. Sometimes it is a stone thrown in the opposite direction to distract attention. Giving a work a name is the start of letting it go, making a space to start again.

I remember this hour. This is a rare hour, happy with work, ready to begin again.

Chapter fifty-eight

red labour

China 1919 is chaos. When will there be a revolution?

The Last Emperor, Puyi, is thirteen years old and stranded in the Forbidden City with his household, as the warlords ebb and flow.

The court is chaotic. Objects disappear from the treasure houses and stores. Eunuchs are arrested. When the young emperor announces he is going to visit the Palace of Eternal Happiness to inspect the imperial treasures, it burns down overnight. He starts to move things out of the palace.

Collectors circle. The English connoisseur Percival David is buying imperial porcelain that has been placed in banks as collateral for loans. 'Those were days of unexampled opportunity to a buyer with knowledge, judgement, and an ample fortune.' He buys a pair of very blue-and-white temple vases with interesting inscriptions and brings them back to London to study more closely.

And Jingdezhen is in decline. There are strikes. Markets have disappeared, along with the emperor. Who is going to commission porcelain in the turmoil of the collapse of the Republic? Trade routes

are disrupted. Merchants no longer visit the city to make orders or to buy. Banditry means that everything from mining clay to shipping wares out along the river is dangerous.

Living conditions deteriorate quickly. 'The whole town was as utterly crapulous as any I had seen in China; nothing could really be called clean,' reports an American visitor. 'The stench of human excrement, of never-washed people living in sty-like dens, the mangy scalps and ulcerated skins, and all the filth, diseases with which China, particularly its southern half, swarms, were everywhere.'

Bonded labour is prevalent here. 'The few owners and master potters of the great potteries who remained in the town spoke freely,' wrote the fearsome journalist Agnes Smedley in her travelogue *Battle Hymn of China*.

Potter in Jingdezhen, 1920

They seemed utterly unconscious of the feudal nature of their industry. Little boys of seven or eight, they explained, were apprenticed to master potters, who housed and fed them. The owners paid the apprentices one dollar a month, through the master potter, who kept twenty cents of each dollar as 'compensation for teaching the craft'.

With the remaining eighty cents, the apprentice tried to meet all his needs.

A master potter might have ten to fifteen apprentices, who remained *jhay tso* – 'confined by a belt' – until their families bought their freedom and they became master potters. To buy the freedom of an apprentice is beyond most families.

With something like amused pride, a pottery owner explains that:

> apprentices had almost every kind of disease – tuberculosis, malaria, and a variety of interesting intestinal diseases. They had no money to buy medicine, he added. As if displaying a choice exhibit, he called a young boy of ten and asked us to note how green the boy was from malaria. But even when sick, he concluded, the master potters, out of the goodness of their hearts, still fed them.

In the early 1930s, Jingdezhen was on the periphery of the Northeastern Jiangxi Soviet, the first site of Communist government in China. It is not a large city, but it is an industrial city, a place where the organisation of labour is laid out before you. It is a difficult city. It is an early site for recruitment for Communists.

Smedley, a devoted follower of Mao, was not an impartial observer. She was angry and engaged and wrote that during the early year of the civil wars, the Chinese Red Army had occupied Jingdezhen, but instead of

> destroying the kilns, it had allowed the owners to operate their kilns, but with many changes. The years of apprenticeship had

been shortened and during them both apprentices and master potters received regular wages from the owners. Joint committees of owners and potters managed the industry, and inspectors enforced the reforms. This system continued until the Red Army was driven out. The feudal system was then reinstated.

Revolution promises a future to Jingdezhen. How long do you have to wait?

'Before and after the Red Army occupation, potters and their families had small family shrines in their dark, insanitary homes,' wrote Smedley. 'Painted on the wall above each shrine was a mystic drawing, representing the spirit of the Red Army. In front of this the potters bowed in worship and burned incense.'

Chapter fifty-nine

Bright Earth, Fired Earth

i

And so I get to Germany and revolution. Up on my red shelf in the dome are also my Bauhaus pots. They are stacks of porcelain.

The Bauhaus is revolution in itself.

When Walter Gropius is made director of the Bauhaus in Weimar in 1919, he declares that this school will 'raze the arrogant wall between artist and artisan, and clear the way for the new building of the future'. *Bauen*, building, gets used a lot in the manifestos. It suggests that learning is a process of bringing component parts together, in different ways. Architecture is a kind of large-scale building set. Imagine the wooden blocks that children play with, learning about balance through pleasure as towers topple and bridges give way; this is *Bauspiel*, playing with form.

This is how pots fit together too. You learn to be a potter here by throwing elements and joining them to make objects. A teapot needs a spout, a body, a lid, lugs for a handle, but, says the ceramics master, they can be like *this*, or like *this*.

Lucia Moholy photographs these pots — greys and whites and blacks — in graphic combinations, on the edge of a table. Everything returns to the image. The world is to be rearranged, played with in order to find the most dynamic way that objects and rooms and buildings and people can work.

What are the potters doing here? Is it a laboratory or is it an art school or is it a factory? We must find, writes Gropius after examining their pots, 'some way of duplicating some of the articles with the help of machines'.

The Bauhaus potters are making vessels by hand that yearn to look like pots made by machines. The designer, Wilhelm Wagenfeld, clever and astute across glass and metal, was rueful: 'dealers and manufacturers laughed over our products ... Although they looked like cheap machine production, they were in fact expensive handicrafts.'

This hurts. And the cheap/expensive uppercut rings true.

In the revolutionary Bauhaus, you make your pots with definition and hard angles and you glaze them with clean glazes to catch an aura of the machine. You do this because repetition is the rhythm and the pulse of the moment.

'We don't live in a time when the cultural face is determined by ceramics,' writes a critic with asperity in the magazine *Die Form*. 'The preferred material of the 1930s is not clay but metal ... concrete and architectural glass.'

Or a white material that is clean, barely clay. *Porzellan* is the coming material.

ii

You want the most modern vessel? Open *Die Form* in 1930 and there is Marguerite Friedlander's porcelain for the Staatliche Porzellan-Manufaktur in Berlin. She is a young potter, trained at the Bauhaus, and this is her first industrial commission. It is stacked as if it has just

been taken from the kiln and it stacks beautifully. And by the side, is a photograph of distilling vessels and a mortar.

All porcelain aspires to this, returns to this. You need the clean severity of the chemist's bench, the grammar of the alchemist, to make your porcelain. Here is Tschirnhaus again, and his need for crucibles for his experiments, Wedgwood giving away his porcelain retorts to colleagues at the Royal Society, William Cookworthy making mortars for apothecaries in his Coxside Works in Plymouth.

'There will always be a need for mortars.'

When Philip Johnson curated *Machine Art* at the Museum of Modern Art in New York in 1934, this is what he chose. He displayed capsules used for drying or incinerating chemicals from the Coors Porcelain Co. In the catalogue he gave the prices. They cost from fifteen cents up to twenty-five cents. 'In spirit, machine art and handicraft are diametrically opposed. Handicraft implies irregularity, picturesqueness, decorative value and uniqueness . . . The machine implies precision, simplicity, smoothness, reproducibility.'

Johnson, just back from his tour of the Third Reich, wants 'vases as simple as laboratory beakers'.

iii

And in the Third Reich this is possible.

The first exhibition celebrating a vision for the new Germany opens in Berlin on 21 April 1934. It is called *Deutsches Volk, Deutsche Arbeit* – German People, German Labour. It has been designed in part by Mies van der Rohe and his partner, the designer and architect Lilly Reich.

You enter up shallow steps. The columns to the building are the handles of four gigantic sledgehammers, twenty metres high. A cog holds the swastika on the roof above you. Inside the building is a spectacle of machinery, pistons, the engine of a train. There are vast images of German workers pouring steel, men deep in mines, women

in endless fields of wheat. This is the theatre of materials, resources, possibilities, of people extending into a future. There is a wall of salt. The cover of the catalogue shows a circlet of whitened oak leaves.

The exhibition celebrates work and work is about repetition and repetition is what saves the individual, brings you towards the perfect oblivion of the collective good.

And Lilly Reich, given the brief to display ceramics, installs thousands of undecorated porcelain vessels. They are stacked deeply and they are stacked high. Nothing is out of place. There are hundreds of bowls, thousands of cups, thousands of plates. It is a parade of objects, as white as the tunics of the gymnasts, twisting in perfect synchronicity in the new, white-columned stadia from Leni Riefenstahl's films.

Reich calls her installation *Bright Earth, Fired Earth*. German earth is transfigured through fire, 'reduced by fire to purity'.

Chapter sixty

what whiteness, what candor

i

I love Wilhelm Wagenfeld's work. There is a lamp he designed early on at the Bauhaus that is a poetic balance of sphere and column. And his *Kubus* range of stacking glass containers from 1938, perfect for a refrigerator, are *Bauspiel* in themselves, useful and concise in the use of materials. They sold them in the MOMA store in New York in their expensive classics section. I'm wondering about him and if he made porcelain. And a vase, a bit too full to be totally beautiful, comes up on the screen of my laptop. And Allach.

It is not the name of a factory I know, so I google it.

It is in Dachau, near Munich.

ii

The thing about research is that you go down a road – mining regulation in Cornwall or shipwrecked porcelain – and it goes nowhere and that is three days of your working life, and you turn round to trudge back, kicking stones.

But I'm intrigued and buy a book on this Allach porcelain.

Buying a book is my default holding position. It arrives a week later, a small black hardback with a photo of a porcelain statue of Athena on the front. It is in English, published by Tony L. Oliver, from a suburban street in Egham, Surrey, in 1970.

> It was the unique circumstances that prevailed in Germany in 1934 that made it possible for the very best Artists, Designers, Potters and all persons associated with the manufacture of fine porcelain, to be taken from the many world-famous factories that existed in Germany at that time, such as Dresden, Berlin, Rosenthal etc., and be employed at the previously unknown factory at Allach. It was this unique concentration of talent made available for its production that enabled Allach porcelain to be of such a high quality, and consequently highly desirable.

The back flap lists books and colour postcards of *Uniforms of the SS*.

And I open it up and Illustration No. 1 is a photograph of Hitler and Reichsführer-SS Heinrich Himmler 'examining with apparent approval, a selection of Allach porcelain figures. 1943.' The figures look like eighteenth-century Meissen. Hitler is smiling, avid.

Concentration of talent is hard. They were made in the camp at Dachau.

iii

The story begins in 1935 at Lindenstrasse 8 in Allach, a suburb to the north-west of Munich, with three committed members of the SS. They are the painter Franz Nagy, the sculptor Theodor Kärner, and the artist Carl Diebitsch. They build a small factory attached to a sub-urban villa. The plan is to create porcelain worthy of the party.

The plan quickly comes to the notice of Himmler who arranges for a substantial capital infusion of 45,000 Reichsmarks from his personal

office. The PMA, the Porzellan Manufaktur Allach, is founded. Himmler believes in art for every German home, but 'first of all in the homes of my SS men'. Having his own porcelain factory would give him control, allow him to show off his cultural reach, raise money for the causes he holds dear. One of these is the German Winter Relief, the official NSDAP charity founded by Hitler after he was appointed chancellor. This charity has enormous kudos in the party.

'20 million porcelain soldiers on the march' is the slogan for March 1938, as Allach sells porcelain soldiers and little porcelain badges with soldiers on them to raise money for impoverished, loyal citizens of the Reich. It is the week of the *Anschluss*, when German soldiers marched across the border into Austria to be met by delirious crowds.

An article, *August und die Porzellansoldaten*, Augustus and the Porcelain Soldiers, is published at the same time. It tells the story of King Augustus the Strong and his passion for porcelain and how he traded a whole 'porcelain regiment' of dragoons for a set of vast blue-and-white vases. It goes on to emphasise that this regiment fought in the Battle of Kesseldorf for Prussia and that it defeated the Austrian army.

iv

Having your own porcelain factory allows you to give gifts.

In Himmler's SS there were interminable rites of gift-giving. Alfred Rosenberg, the theoretician of the party, was hard at work creating new rituals, new arcana to embed the people in their culture: Christmas became *Julfest*, an ersatz Nordic winter celebration, with sacred fire and candles and music.

So Allach makes *Julleuchter*, *Jul*-lanterns to sit on the festive tables and glow as the family celebrates the new year, the new start for their country.

And birthdays, and weddings, and the birth of a child to SS members – some of whom would become Himmler's godchildren – all warrant presents of Allach porcelain. And there are porcelain bowls for

presentation at the party rallies at Nuremberg, sporting medals, plaques to celebrate the *Anschluss*, a presentation vase to Hitler for his fiftieth birthday in 1939, huge white vases for the niches of the Chancellery. Who could have foreseen such demand for porcelain?

The factory in Allach becomes too small and at the end of 1940 it moves to Dachau concentration camp.

There are many advantages of having the factory here.

There is the immediate gain of using the prisoners. The Allach Porcelain Factory – as with the porcelain manufactory in Meissen – is losing skilled workers to the Eastern Front, and here they can draw on inmates. The few prisoners brought in from the camp in 1941 grow to over a hundred by 1943: 'since the summer we have tried to cover the loss of skilled workers who we've lost through the war by supplying our factory with prisoners, and the results in the moulding, forming and glazing departments are *äusserst befriedigend*, highly satisfying . . . We are all trying to bring forward the factory, even with all the difficulties of war, so that we can stand proudly in front of our comrades in the fields.'

Himmler inspecting Allach porcelain, Dachau, 20 January 1941

And here in Dachau there is the bonus of artistic advice to hand from Frau Eleonore Pohl, the wife of SS-Hauptamtchef Oswald Pohl. She is an artist. He is head of the SS-Wirtschafts-Verwaltungshauptamt (WVHA) that manages all the economic and financial activities of the SS. This includes concentration camps.

And Himmler has his own factory that he can bring his fellow SS officers to, walk along the benches, peer over the prisoners' shoulders and enquire and inspect. When they visit Dachau, the factory is the first place on the tour. Johannes Heesters, the most famous entertainer in Germany, is given a tour, given gifts. There is a visitor's book.

There they all are, picking up figurines, comparing things.

They turn them over, as you are supposed to do, and underneath is the mark that says Allach and the symbol is the double lightning *Sig* of the SS. Cleverly, it is also the Meissen mark of the two swords transposed.

Everyone is happy with this arrangement of Allach as a semi-autonomous company, and there are promotions and Kärner is given the honorary rank of SS-Hauptsturmführer and an honorary professorship on Hitler's birthday. And Diebitsch, who is kept hard at work designing the new regalia, the badges and kit, the flags, scabbards and caps that are so important to the particularity of the SS, becomes an Obersturmbannführer in the Waffen SS.

It is a company that is run with precision. The accounts are accurate. The numbers of the figures are filed meticulously. Himmler takes forty-five per cent of the output of the factory, sometimes paying. And in 1942, when there is a typhoid epidemic amongst the prisoners in Dachau, Himmler asks for payment for those who have died.

v

Himmler wanted his Allach to make objects that were *künstlerisch wertvolle* – artistically worthwhile – not degenerating into kitsch. The director of the State Porcelain Gallery in Dresden, Professor Dr Paul Fichter, in charge of all Augustus' porcelain collection, oversees the

designs of Allach and this gives the company more gravitas. His name, with his titles, goes on the base of some products. Professor Wagenfeld, currently attached to the glass factory at Lausitzer, is also to give advice.

Deutsch sein heisst klar sein. 'To be German, is to be clear', said Hitler.

To be clear is to be skilled and to tell stories well, not to obfuscate. Degenerate art is unskilled, merely sketched, inept. It is unclear. Hitler knows what he wants. He wants to see skill.

If you want to impress the Führer, that is all you have to do.

So Allach makes a porcelain stallion, leaping upwards, tail flowing, powerful and independent, a leader &c., &c.

Allach porcelain is 'a kind of billboard for the SS's cultural representation', wrote the head of Himmler's personal staff.

> Only highly valued, artistic porcelain was produced, so distinguished that it overcame the greatest technological difficulties. These consisted in producing a figurine horse with

Himmler's birthday gifts to Hitler of Allach figurines, Berlin, 20 April 1944

one rider supported only by the two thin legs of the
horse without the usual support of the heavy body of the horse
under the belly with an allegorical tree trunk, branch or flower.
Even the other famous German manufacturers like Meissen,
Nymphenburg, and so forth, could not manage these technical
achievements! It was the will of the Reichsführer-SS.

So there. Himmler manages what Augustus the Strong could never do,
through *will*.

And Hitler, having seen what Allach is capable of, orders the special
production of a hundred figures of *Friedrich der Grosse zu Pferd*, Frederick
the Great on Horseback. He keeps one in his office in the Chancellery.
He gives the others to those who have impressed him with their
dedication to the purity of the Reich.

vi

And there is more skill, more clarity.

Look at the modelling on the porcelain bears, the stags and does and
fawns, the fox cubs, dachshunds and alsatians. The puppies are so
expressive. *The Reclining Stag* by Professor T. Kärner is wary, every
muscle quivering to take flight. This is a German bestiary with
animals to cosset or animals to hunt.

There are stags of this splendour in the deer park on the southern
border of the Dachau camp, just beyond the barbed-wire fences and
watchtowers, carefully corralled to be shot from the lodge, after din-
ner with the commandant.

And then there are the statues of the young and perfect: maidens after
the bath, mothers with children, champions, striding female nudes, a
Hitler youth in shorts banging on a drum, eyes on the future, noisy,
and a *Bund Deutscher Mädel*, a member of the League of German Girls,
with pigtails framing her face, left foot forward. There is a run of flying
officers in full uniform with swords, and a figurine of a pilot, straight

from the cockpit, nonchalant, and an SS rider and an SS standard-bearer. 'The Standard-Bearer wears a nicely detailed SA-SS gorget', says the book for collectors. The standard-bearer is not shown in the stores and is in the personal gift of Himmler.

And then there is the SS storm trooper.

Count von Ribbentrop, the German ambassador to London, buys these to give to those in society he feels understand the complexity of the Reich. An Allach porcelain storm trooper ends up on the mantel-piece of the marquess of Londonderry's house in Ulster.

The most desired of all these figures was a muscled youth, shirtless, leaning on his epée, *Die Fechter*, The Fencer. It was given only to the elite in the party. And I find a formal portrait of Reinhard Heydrich. Heydrich chaired the Wannsee Conference in 1942 that formalised plans for the Holocaust. He was, said Hitler approvingly, 'the man with the iron heart', responsible for the *Einsatzgruppen*, the death squads that killed a million Jews.

He was a fencer. *Die Fechter* sits on a table next to him, a white trophy, 'an Omen in the Bone / Of Death's Tremendous Nearness'.

vii

Das Schwarze Korps, the SS newspaper, records the opening of the new Allach store in Berlin at Leipzigstrasse 13, on 1 April 1939. It quotes Hitler. He had proclaimed, as he saw these porcelains, that '*Kein Volk lebt länger als die Dokumente seiner Kultur*'. No people live longer than the document of their culture.

'These words of the Führer are a cultural motto for us. We know that all we may produce will be critically examined by those who come after us, and we do not want these later generations to give a poor ver-dict on our works.'

The new store is very smart indeed with a pair of huge windows flank-ing the entrance and wall sconces to light it up at night and ALLACH

above the door. *Das Schwarze Korps* for the following week takes you inside where there are vitrines to the right with spotlit figures.

The photograph shows Himmler as he walks past these glass cases, hands behind his back, reviewing his dragooners.

And in 1941 and 1942, as the army pushed east, stores for Allach were opened in the new cities of the Reich, Warsaw, Poznań and Lwów, now called Lemberg.

The *Julfest* plate for 1943 sent to leading members of the SS shows pink crocuses emerging from a snowy earth. On the back is a facsimile of Pohl's signature surrounded by a circlet of runes. On 14 January 1943, Himmler writes to Oswald Pohl that he has visited the Allach store in Poznań : 'In Allach we had a very pretty eagle in clay, matt. And now I

Allach porcelain shop, Warsaw, 1941

see this eagle in the store in Poznań glazed! It looks disgraceful. I request that this is changed immediately.' It can't be too difficult, surely, to send him the first porcelain sample which is produced and ask his opinion. And the staff are too young. They shouldn't work in such visible positions during the war. 'I really don't wish to get annoyed about one of the few things that give me pleasure.'

Details matter to Himmler. He counts on Pohl and they are in constant communication. On 6 February Pohl sends Himmler, as requested, an inventory of the materials taken from Jews in Auschwitz. 155,000 women's coats, 132,000 men's shirts, 11,000 boys' jackets, 6,600 pounds of women's hair.

There is now a very grand shop in Warsaw. Figures are peering in, a woman in a fur coat hovers on the doorstep. The porcelain is a great success, on the up, on the move, finding new audiences.

viii

Most of these figures were white.

This was at Himmler's request. They were either white glazed or unglazed bisque ware. Production numbers of white porcelain far outweighed coloured porcelain.

'White porcelain is the embodiment of the German soul', says the first catalogue for Allach.

The whiteness of the skin of this porcelain is the whiteness of marble surfaces, the perfection of the Greek statues in the museums in Berlin and Munich. The Pergamon Museum, holding the greatest sculpture of the classical world, is the whitest building in the Reich. Allach's porcelain figures obey the strictures of Germany's great critic Johann Winckelmann: 'Since white is the colour that reflects the most rays of light, and thus is most easily perceived, a beautiful body will be all the more beautiful the whiter it is.'

Here is the cult of the body, the fetishised smoothness and correct

proportions, the cleanliness, the asexuality. This is porcelain to pick up and hold, to collect. You can buy the nudes. Or you can get the set of SS types and show the accuracy of the details of the insignia to your fellow officers as you relax after fulfilling your duties.

I remember Susan Sontag writing about the films of Leni Riefenstahl and 'the contrast between the clean and the impure, the incorruptible and the defiled, the physical and the mental, the joyful and the critical'. White searches out degeneracy.

I remember Ezra Pound in Rapallo, writing letters obsessively, denouncing the Jews, Jew influence, the Hebrew disease, denouncing everyone. And in his Canto LXXIV, 'what whiteness will you add to this whiteness, what candor?'

White pretends to candour, covers so much, covers too much.

This is the story without people.

Chapter sixty-one

Allach

i

I go to Dachau to find out what happened.

It is early autumn and there is low mist. Pumpkins and squashes are stacked up outside the houses by the side of the road. Each pile has an honesty box.

It is so grey and humid that everything seems caught. I mean that I'm caught in being here and I notice the height of the perimeter fence, the watchtowers, the ground where the punishments took place, the walls for the executions, the beds of gravel that mark the run of demolished barracks for the prisoners. The poplars on the boundary are unmoving in the still air.

The archivist meets me. There is a long table, a library of research books and files. A woman is sitting quietly, whitely, looking at photographs. She makes very small pencil marks in her notebook.

The archivist has been here for fifteen years, knows the intricacies of the SS subcamps, how prisoners were detailed to work in particular

factories, the terrible realities of the granite quarries, the manifests, the trains, the death marches.

And he is kind. He brings out the documents I need to see. There is one testimony that is central, he says, and he tells me about Hans Landauer, who worked in the factory and wrote testimony, spent his life after the war speaking about what happened. His home was Vienna but he came here often.

I ask him if by any chance Herr Landauer can still be visited?

And he gestures to his office where there is a photograph of a large, open-faced, smiling man above his desk. He died last week, he says. He was a great man.

ii

Hans Landauer was an Austrian socialist who had joined the International Brigade at sixteen and was arrested fighting against Franco in the Spanish Civil War. He was deported to the French camp at Gurs and arrived in Dachau on 6 June 1941.

The archivist gives me the context for his story.

It is May 1941 and a note is circulated to Buchenwald, Auschwitz, Flossenbürg, Mauthausen, Neuengamme, Gross-Rosen and Sachsenhausen:

> due to various civil workers having to go to war, the running of the porcelain factory in Allach cannot be kept up . . . the order has been made that the possibility to use useful prisoners for this command has to be considered. This concerns modellers, kiln-firers, formers and ceramicists. There has to be an immediate check-up on forces in the concentration camps to find who has already been working in the area of ceramics and who is capable of working here.

Ten days later there is a list of names. They have located one Jew, four *ASR* — antisocial prisoners — one *Bib-F* — a Jehovah's Witness — and twelve political prisoners.

Six days after this, Buchenwald says they can't find any workers for the kilns, or modelling, but they have fourteen people for forming porcelain, one person to work a mill, one person to paint and one person to throw porcelain. These include one Jew and one labelled only as 'ill'.

On 5 July 1941, thirteen prisoners arrive in Allach to make porcelain. This group contained no kiln specialists, so an Austrian and a Spanish fighter, Franz Pinker and Karl Soldan, two *Rotspanier*, Communists, were selected to work on the firings in the factory.

And these men in turn select Hans Landauer, their comrade newly arrived from a French camp. Initially, he is to work on the railway, pulling coal from the station at Dachau to the porcelain factory, 'in the way that boats were pulled on the Volga'.

This, writes Landauer, in his memoirs, is *ein Glücksfall*, the piece of luck.

Hans Landauer, Vienna, 2006

Dachau is not an extermination camp. Death here is both deliberate and it is random.

The work is deliberate and it kills. Reveille is at 4 a.m., there is an hour or more of standing to attention at roll call and then the march to your work detail to clear rubble, work on the underground bunkers, in the factories, in the granite quarries where you carry blocks until you drop, or the plantation, where you dig ditches. Then there is the march back, the roll call of one or more hours of standing to attention, then cleaning your barracks. Lights out at 9 p.m.

The conditions are deliberate. You are given very little food. Six months later there is even less. You are debilitated. The numbers increase. There are six times as many prisoners in 1944 as 1942 in the same barracks. You are given little medical care. Every illness is endemic. Then there is no medical care.

Being here in Dachau is random.

You are here because you are asocial, political, Sinti, Christian, homosexual, Jewish, Polish, Czech, Communist.

Death comes to you randomly. You are killed trying to escape. You are killed as an example. You are killed in the quarries and on the plantation. You are killed because you are too slow marching home. You are killed through typhoid. You are killed by a kapo. You are killed because you despair.

And you try everything to make a difference, to find the way of eating a little more, keeping your strength up, not stumbling, not attracting the attention of a kapo, not dropping a block of granite though your hands run with blood.

I'm sitting in the archive and Landauer's memoirs make this contingent moment, this *Glücksfall*, seem incredibly close. This is the moment when whilst he was unloading coal in the courtyard at the factory, he was asked if he could draw.

He said yes and drew a small sketch.

This sketch takes him from the cruelty of dragging the coal wagons outside over the threshold and into Allach. It was the first step for him in the 'direction of surviving hell'. He starts work on the candle-holders and then he works on the figurines and then becomes 'irreplaceable' when he works on the horse riders that Hitler and Himmler so value.

> I only had to look out of the basement window from my desk, when the emaciated figures of the Kommando Kiesgrube, the gravel quarry, stumbled while pushing carts full of dead prisoners, or those not capable of walking anymore, back into the camp . . . It must be understood from a human point of view that I was trying to produce good work, particularly because with this production it wasn't important for the war . . . When the factory was extended – from 1942 we also produced plates, cups and cups for cream in field hospitals – we also had increased the amount of prisoners who had no formal training who were able to learn how to make these things very quickly.

And he records how strange it was that this group of workers in the Allach Porcelain Factory, from so many different nations, were the people who had to produce the cult symbol of the party, the *Julleuchter* lantern, for the solstice celebrations, and that making this product could give him and his fellow prisoners a higher chance of surviving the camp.

In Allach, the working hours were extended which meant that the prisoners didn't have to return for roll call at midday, reducing the

danger of being punished for 'bad singing or bad marching' by the SS guards. From 1943, Allach allowed the prisoners in the factory to wear proper leather shoes because it was impossible to carry the porcelain products on long boards whilst wearing wooden clogs.

Landauer is an extraordinary witness. He recalls seeing the closed carriages arriving from France, full of the dead and dying.

He recalls his fellow workers, Franz Okroy, Herbert Hartmann, Franz Schmierer. There were two more Polish prisoners, whose names he can't remember, who worked on the small figurines. One was a professor from Krakow who committed suicide in 1942 or 1943, by running into the electric fence. There was Erwin Zapf, and the porcelain painter Gustav Krippner. There was Karl Schwendemann, who after an argument with an SS modeller, was taken out of the factory and back to Dachau main camp.

Reading these names is salutary. I read them again.

Landauer is a careful man. He says when he cannot remember something. And he is careful too to say that there are moments of kindness in Allach, 'sometimes only a shy, well-meaning look', or when one of the SS guards gives Kärner's radio to the men in the kiln room to listen to at night.

I try to take care with this testimony. It isn't mine.

v

In the manner of archives, the next sheet of paper is a letter of thanks to Himmler. It comes from SS-Brigadeführer Friedrich Uebelhoer and profusely thanks the Reichsführer Himmler for his gift of a porcelain standard-bearer and the card, and the recognition of his support for all the work he's doing in building a New Germany in the East. He is the governor of Lódz, and is building the ghetto.

The second letter is from Frau Himmler to Frau E.R., which says she is very sorry to cause trouble, but has 'little Ekhart' received his *kinder-relief* candle as a gift from his godfather, the Reichsführer, yet. 'Also

whether Sigrid and Irmtraut have received their candles as well.' Frau Himmler sends condolences for the bombing.

The third letter, dated 15 January 1945, is from Dr Hopfner to an unknown recipient stating that the *Julleuchter* should no longer be produced, but the production of the plates with SS phrases on the bottom should be increased. The texts can be uplifting in 'the coming difficult months' to those who use them.

There is to be no more coal for the crematorium in Dachau, but supplies will continue to be delivered to fire the Allach kilns.

I need air and go outside for ten minutes. And when I return, the archivist explains that a local collector of Nazi memorabilia has died and his daughter has gifted a box to the archives. He brings in a grey plastic washing basket filled with Nazi objects in bags and wrapped in newspaper. There is Allach porcelain, he says, but on top there is a belt, some buttons, a chart of the thirty-eight divisions of the SS and magazines. He puts them on the table.

Then he unwraps the first object. It is Bambi.

And then following that, there is a sleeping dachshund, another standing up looking mournful, and then a deer lying down, legs tucked under it.

I'd expected a storm trooper, something white.

And I'm faced with Bambi, liquid-eyed, spindly legs, head tilted, carefully glazed. I pick it up and look underneath as you should always do and there is the cartouche with *Allach* and *TH Kärner* and the SS runes.

This is my fifth white object in the world.

vi

I thank the archivist and wrap up the porcelain again and put it back in the laundry basket. I walk down across the ground, down the long avenue between the barracks, all the way to the perimeter fence.

And on the way back to the airport, I make a detour to the first Allach factory, on the outskirts of Munich.

It is a safe jigsaw of small streets, kids on bicycles, a dog walker, trimmed hedges. A road sign says dead end, and unexpectedly there is an industrial site, prewar factories, something big alongside the road.

The taxi stops at No. 8. The street has been renamed. It is now Reinhard von Frank Strasse. No. 8 is a high gabled house, six steps up to a front door, a workshop running to the right behind a tangled hedge. It is derelict. The windows are broken and the gate is pad-locked. It looks exactly like the workshop I was apprenticed in.

This is where it began, a suburban street nowhere special.

Keep Out warns the notice.

Chapter sixty-two

false sail

i

I keep thinking of the story of Theseus' return from killing the Minotaur, and why he forgets to hoist the correct sail as he approaches home. He had promised his father King Aegeus that there would be a black sail if he had met his death, a white sail if he had been victorious. His father sits and scans the horizon. And he sees a black sail.

And that is that. Aegeus throws himself from the cliff. The coming home in triumph is a return to loss, to grief. Theseus forgets.

You make promises. You intend to keep them, and something happens, intrudes, your attention is elsewhere. And the promise is unfulfilled, left open. There is an empty space.

There are so many promises. To make things right for your children. To make a new home in a new place. To create gold, to create porcelain, a family. To return with a white punchbowl and sit and celebrate how one material turns into another.

I've left my Jesuit monk and my mathematician with his lenses and my Quaker apothecary and a child in a factory working in the dust

stranded in my story. And now I've left Hans Landauer too, in a porce-
lain factory in a concentration camp.

And if you tell stories you have to keep your promises.

You can't leave them open. I've just discovered on my laptop the novel
I was writing with Anna three years ago. We started a story one sum-
mer holiday in Scotland, about a couple of children on an adventure,
and would add bits when we could. And in Jingdezhen, in the middle
of the night, I'd write and send a chapter home, promising to finish.
But I started this journey to Dresden, Dachau, Stoke, Carolina,
Jingdezhen, and have forgotten to finish *Scotland*.

When you get in sight of land, which sail do you choose to hoist?

ii

On the night of 13 February 1945, Dresden was bombed by British
planes. It was bombed again the following day. It was Ash Wednesday.
No one had expected air raids. There was an expectation that the
cultural significance of the city would spare it.

Dresden was always densely populated but now it was crammed with
people fleeing the Russian advance, refugees from the other cities
severely bombed over the winter, Jews waiting to be sent to the
camps, American POWs, labourers drafted into the factories,
German troops.

The air was full of fire. The river was full of fire. The firestorm of the
burning city could be seen from sixty miles away.

There were limited air-raid shelters. People died in their thousands in
their cellars. At least 25,000 people died in the conflagration, possibly
many, many more. Possibly ten times this figure. These numbers have
become a fault line in history.

Dresden was destroyed. The rubble was so high that streets disap-
peared. The skyline collapsed, ragged. The Altmarkt became an open

crematorium for the bodies pulled from ruins. The photographs of the days after the bombing show stooped figures walking amongst the dead.

'The feeling, such as there is, over Dresden', wrote Air Chief Marshal Arthur Harris of Bomber Command, responding to the outcry over his raids, 'could be easily explained by any psychiatrist. It is connected with German bands and Dresden shepherdesses. Actually Dresden was a mass of munitions work, an intact government centre, and a key transport point to the East. It is now none of those things.'

He was right. It was none of those things.

The bombs destroyed tens of thousands of lives, thousands of families. It also destroyed churches and palaces, the Zwinger, 85,000 houses, innumerable artefacts, Tschirnhaus's lenses, and on a truck, parked overnight in the castle courtyard, crates of early Meissen porcelain stolen from a Jewish family in Berlin. *Dresden shepherdesses*.

iii

On 29 April, the Dachau concentration camp was liberated by US troops. The troops arriving from the West came across boxcars full of executed prisoners. Over the previous week 10,000 prisoners had been forced to leave the camp on trucks or on foot towards the Alps. 1,000 prisoners died on this march.

There were 3,000 dead in the camp. The destruction of incriminating evidence had been going on for three weeks but the crematorium was overflowing.

And the Allach Porcelain Factory had been cleared. The moulds had disappeared. There were a few models left, but none of Nazi figures, none of the incriminating models of white storm troopers.

iv

In early 1947, the porcelain factory Oscar Schaller & Co. in Windischeschenbach started to produce a range of porcelain animals, bear cubs, horses, puppies, young fauns, Bambi. Pick them up and look at the base and they say *Eschenbach Germany–US Zone*. And above this is the name of the modeller Kärner.

SS-Hauptsturmführer Kärner became Herr Kärner. He had buried the 'tainted' porcelain in the last few days before liberation, taken the moulds and started again. There were no SS runes, but the models were the same.

In Nuremberg on 17 September 1947, the defence of Oswald Pohl, director of the WVHA, made its closing statement against his indictment on war crimes and crimes against humanity. The prosecution stated that 10 million people had been imprisoned in the camps of the WVHA, that millions had died.

He was found guilty and sentenced to death. He appealed and then appealed again. He wrote a book *Credo: My Way to God* about his conversion to the Christian faith. He was personally not guilty of any crimes: 'I had never beaten anyone to death, nor did I encourage anyone to do so.' *Credo* was published with support from the Catholic Church, who asked for amnesty on Pohl. It included illustrations by his wife Eleonore, the adviser on standards of artistic quality to Allach porcelain. One of her images showed a pensive figure in deep contemplation in a prison cell. Pohl was executed on 8 June 1951, still protesting his innocence and his faith.

The new models of characteristic German animals from the Eschenbach porcelain factory were collected in the new German Democratic Republic with avidity.

v

The German Democratic Republic is formed on 7 October 1949. In Dresden crowds celebrate in Theaterplatz, surrounded by the blank

windows of ruins. The new flag hangs from lamp posts. The city is skeletal, the roads clear and empty. There is no rebuilding, but there is renaming. The Augustus Bridge across the Elbe has become the Georgi-Dimitroff-Brücke, named after a Bulgarian communist. There are reparations. A woman recalls working 'on the pile of rubbish . . . cleaning up the bricks. And then we had to dismantle the railroad – that was material for reparations, the tracks and wood ties.' Silent men from Siberia look on to make sure the Germans don't slacken.

The aspirations of the new state are great. First Secretary Ulbricht announces that there is to be a huge boulevard cutting its way through the rubble of Berlin. The populace will clear this with optimism and self-sacrifice. Stalin-Allee is to house workers and shops, and the facades are to be tiled in Meissen porcelain, with bas-relief panels of sheaves of corn and other easily legible symbols. The whole street is a white scimitar of modernity.

To celebrate Stalin's seventieth birthday there is a party in Moscow. There is a photograph of Mao and Ulbricht flanking the Leader. The Russian State Porcelain Factory makes a white porcelain model of Stalin and Mao in an edition of three. The two senior leaders sit on a sofa with tassels, comfortable in their shared vision of Red East.

And though there weren't many films made in 1949 in the GDR in the chilly aftermath of the war – a dozen or so – *Die Blauen Schwerter*, The Blue Swords is released. It is the most expensive production that year, with a considerable investment in props and costumes.

Augustus is vast, dressed in brocades and lace, the alchemist hero Johann Friedrich Böttger is lean and goodlooking. The climacteric is in the vaults, the kiln a monster of flames and smoke, with Böttger shouting that he needs *more heat*, breaking up the chairs to feed its maw, sweat pouring off him, as Augustus prowls, possibly wearing a crown.

Böttger pulls the saggar from the kiln and plunges it into a barrel of water – 'my porcelain will not break' – and opens it to reveal a lattice-ware bowl of white. It is placed in the king's hands, he looks at

it, feels it, taps it to hear it, and then turns it over. There is the cipher, the two blue crossed swords of Meissen.

Somehow, complicatedly, the worker has triumphed.

vi

The GDR is tiny, as well as poor. But it has a strong filial relationship with China, vast and poor.

There is a joke. Mao and Walter Ulbricht, the poker-faced head of the GDR with his Lenin-Lite goatee beard, are comparing how many of their populations oppose them. 'Seventeen million!' says Mao. 'Me too!' responds Ulbricht, happily.

As the Soviet Union is sending experts in dams and steel construction, Ulbricht needs to keep his end up and he decides to send technical helpers, experts, to China.

In 1955, the GDR sends experts in its own strong field of porcelain. Workers from Meissen travel to help the workers of Jingdezhen create new porcelain.

Chapter sixty-three

correct in orientation

i

It feels like the start of another East German joke.

Do you know the one about the worker who got the chance to get away? And he went to Jingdezhen?

Jingdezhen was as grey as Potsdam. The pollution from the coal-fired kilns was so bad that in summer it felt autumn and in winter, it was perpetual dusk.

The National Institute of Ceramic Art was started in the glow of East German cooperation in 1955. It was closed in 1959 when the East Germans slipped away after Mao split with Khrushchev. They left the museum half built.

What gifts do you bring your wife back from Jingdezhen in your cardboard suitcase, if you are given a couple of days' notice, are in a hurry to return?

In 1958 and unhappy with the progress of the Five Year Plan, Mao launches the Great Leap Forward. The new party slogan is 'more, quicker, better, cheaper'. In Jingdezhen, this means the reorganisation of factories into ten state-run and four large city-run ones and a change of emphasis to utilitarian wares and porcelain conductors for electricity. Only the Sculpture Factory and Art Porcelain Factory could produce other kinds of porcelain.

Terrifying output projections were plucked from the air. The expectation was to double production within two years and overtake Britain in steel production within ten. Control of quality went. 'There is no such thing as a reject product, one man's reject is another man's grain', Mao was quoted as saying.

So once again you trace the waves of the campaigns through what is made and what is not made, chart each moment of the shifts in policy.

This porcelain plaque from the Great Leap Forward shows peasants on a commune, happily working away from their fields at a smelter making useless steel by melting down useful tools.

This child banging a metal pan means 1958 and the Four Pests Campaign, the attempt to destroy all rats, flies, mosquitoes and sparrows. Sparrows were to be scared from landing until they dropped from the skies.

This figure is of Lei Feng, a People's Liberation Army guard killed in an accident in 1962. He left behind diaries revealing his devotion to Mao and was instantly canonised in the Learn from Comrade Lei Feng campaign.

You pick up a plate of a perfect snowy scene of early morning, workers on their way to a factory as shiny as a new Jerusalem, and turn it over: *Made in Jingdezhen, World-shaking New Atmosphere, Yu Wnxiang made this at Zhushan in autumn of 1964.* So this is made during the Socialist Education Campaign, when model factories were praised and held up as

exemplars. Zhushan, I suddenly remember, is Pearl Hill, the site of the imperial porcelain factory.

Images pass, as brief as barked slogans.

Mao is clear about the purpose of art: 'Writers and artists should study society, that is to say, they should study the various classes in society, their mutual relations and respective conditions, their physiognomy and their psychology. Only when we grasp all this clearly can we have a literature and art that is rich in content and correct in orientation.'

Correct is an alarming word to hear. *Not correct* comes the echo back.

iii

On 1 May 1966, at the International Labour Day rally, Mao announces the Great Proletarian Cultural Revolution. With the help of youth, the 'four olds' are to be destroyed: old customs, old habits, old culture and old thinking.

Jingdezhen is a city steeped in the four olds.

Making porcelain is an *old* in itself. The senior masters were dragged on to the streets to face humiliation, one was beaten, caged and hauled through the town, several committed suicide. A plaque painted fifty years earlier is daubed with 'Revolution is not a crime / Sweeping Away the Four Olds / Revolt is Correct'. Houses are ransacked and workshops are destroyed. Factories close as workers are sent to work in the countryside.

What can you make in a city terrorised by young Red Guards? A junior lecturer attempted to save some of his senior masters by gathering them together and establishing a workshop to paint revolutionary images on to porcelain. They were given basic subsistence but were expected to paint from dusk until dawn seven days a week to exorcise old thinking.

With Jiang Qing, Madame Mao, as director of propaganda, images are controlled with ferocity.

Imagine an over-fired image of the Leader, the Red Star running down the vase. Imagine dropping a statue.

Jingdezhen survived through Mao. His sayings were transcribed on to cups so that you could warm your hands on his words. In the summer of 1966, the first Mao badges were created in Shanghai. By the start of autumn they were ubiquitous, presented by work units, bought from propaganda shops, exchanged in their tens of millions. By the end of the year you could be challenged if you didn't wear a badge. At the start of 1968 the Jingdezhen factories began serious production; ceramic badges could be made both in vast quantities and more cheaply than in metal. But stories began to circulate. Chipped images of the Leader, a porcelain badge dropped in a jostling street, its owner forced to his knees in atonement.

On 12 June 1969, the Central Committee published *Certain questions to pay attention to concerning the propagation of Chairman Mao's image* in which it was declared that creating porcelain badges was prohibited. But the need for statues of Mao kept increasing. There was the 'official ware' bust – the only sculptured image to be distributed to all official buildings throughout China – and there are a lot of official buildings in China.

They were made of high-fired porcelain with a colourless glaze, only a few inches high, and showed an implacable Mao, jowly, his mouth set firmly against almost everything.

This whiteness is pragmatic, cutting away the fear of mistakes in the creation of these icons. This whiteness made them glow as transcendently as any goddess of mercy, any Guanyin. The emperor Yongle, builder of the porcelain pagoda, merciless, would have understood.

Chapter sixty-four

another witness

i

I have two final witnesses. They are both makers of Mao.

Mr Yang. In his sixties. He drinks tea. Lives in Jingdezhen just inside
the gate of the Sculpture Factory with his wife. His workshop is four
rooms filled from floor to ceiling with Maos. An athletic Mao
having swum the Yellow River supported by joyful peasants, a Mao
brandishing the Little Red Book, Mao presenting mangos that he
had been given by a Pakistani delegation to a group of workers. More
bulky, coated Maos than you can believe; I think how simple it is to
use a greatcoat is if you are uncertain on proportions.

I ask him how long he has lived here and he says that he was at high
school, only fifteen, when the Cultural Revolution started and they
behaved 'badly' to their teachers but 'not too badly'. And he adds that
he was a Red Guard which means that he knew how to sculpt uni-
forms properly; he is good on uniforms. He shows me his statue of
the teacher, in her spectacles, with her dunce's cap – the sign of a
rightist, class traitor. She is sitting on a stool, humiliated. He is *good* on
these details, too.

As we talk he settles himself a little, lights up.

He talks me through the decades. The poisonous politics of each diktat, of the control of the commissioners, of the three officials in the factory that became nine, the way that in the 1980s – if you were a party member – you could get your cousins on to the payroll. In the 1990s, the banks stopped lending to the collectives. The state porcelain factory went under in 1995. Half the city lost work.

I ask him about the market. Pandas, popular in the late Mao period, disappeared for a decade and roar back at the end of the 1980s. Mao has been surprisingly steady, he says, though the centenary of Mao's birth in 1993 was a high-water mark, the best year ever. Small statues of President Deng Xiaoping, plates with his face hovering like an old planet

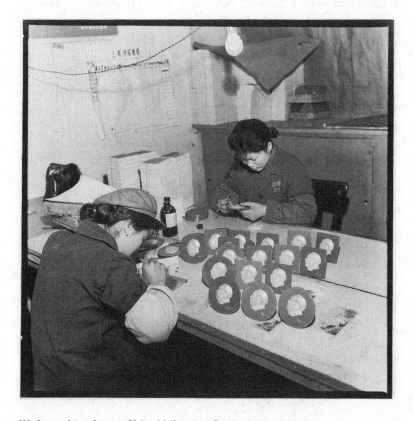

Workers making plaques of Mao, Heilongjiang Province, 1968

over the skyscrapers of Hong Kong, had their moment too, but he didn't get into making them, though he can tell me who did, if I'm interested.

I watch the carrier pick up the newly glazed Maos to take to the packing factory. And on to Shanghai to the shops where you can buy a Long March poster, something retro from the Cultural Revolution for your new apartment, high up in the grey air.

ii

Master Lieu. In his seventies. I interviewed him for two hours. We drank tea.

He has very, very long fingers that fly around as he talks and his eyes are hazel and wry. He lives in a courtyard around fruit trees in the Sculpture Factory, where he has been since 1963, as student, apprentice, sculptor, manager, director and survivor. He knows it all.

This was a hill, he says to me, with a few artisans, when it was deemed the Sculpture Factory in 1955. When you left school or college, people were told which factory to join and 'because I could use a brush I was told to come here'. He didn't want to come. Conditions were terrible but he found it was a good place to learn how to make sculpture as there was always someone making an ox or Buddha.

And then there was the Cultural Revolution. He holds his right arm steady with his left. His daughter sits next to him and waits.

> We were told to break our own moulds and we then broke them, thousands of them, all the classical figures of Guanyin and Confucius and the poets. The moulds were old – back to the Qing. Red Guards watched us doing it, checked the factory to make sure none were left. The factory was a wasteland. And we were turned into a latex-glove factory. They needed gloves. But they needed Mao more! So four or five of us were told to do models. We had to be very careful. They were very worried: no one wanted to get it wrong.

Someone has produced a large photograph of Master Lieu next to his sculpture and slips it on to the desk between us.

And this is my Mao, he says.

It is the famous model of Mao, glazed in a soft white glaze, rare, collected. The Leader is young and tall. He is wearing sandals, one foot slightly raised on a rock, and his left hand holds an unfolding map. He looks *engaged*, and I realise that the reason this sculpture works, while thousands of others are choked by their symbolism, is that it is a sort of self-portrait. This is Lieu as Mao, a young man off to gain the respect of the world.

'I also made this,' he continues, producing a model of an old farmer with an avuncular arm around a young woman learning to sow seed on a swirling green patch of ground. They are both barefooted in the good Chinese earth. I'm so distracted by the rather fetching check shirt the woman is wearing – she looks like a 1950s grad student, liberal arts – that I miss my chance to ask him about Chinese earth. I ask him who worked with him and he mentions the man who sits near the box-making factory washing chopsticks all day. He was a professor who painted here, but was sent to a village for re-education.

I've seen this man. He writes slogans in chalk on the walls and washes them away, starts again. The restaurant gives him rice. He is a survivor, of sorts. And another witness.

Chapter sixty-five

The Boehm Porcelain Co. of Trenton, New Jersey

So I hear this joke.

What do you bring to China? What do you give an emperor?

It is 1972. You cannot bring maps, or chiming clocks, or telescopes, or perspective. A piece of moon rock brought by Secretary of State Henry Kissinger to Mao on an earlier visit was met with disdain.

So President Nixon brings a pair of Alaskan musk oxen and a Californian redwood tree.

And porcelain.

He brings a sculpture of a pair of mute swans with their cygnets, three feet long and three feet high, made by the Boehm Porcelain Co. of Trenton, New Jersey. Boehm specialised in accurate representations of birds in porcelain, 'a medium in which one can portray the everlasting beauty of form and colour of wildlife and nature'. They have a brass plaque attached to their oak base explaining that they are a gift to His Excellency Chairman Mao Tse-tung and the people of the People's Republic of China &c.

It is tribute, of course. No different from those centuries of sending white stallions or coffers of gold, strange vases of a white material, translucent.

President Nixon flies back to America with a pair of pandas, Hsing-Hsing and Ling-Ling, leaving behind a fudged declaration on the status of Taiwan and his own imperial porcelain, *Nixonware.*

Coda

London – New York – London

Chapter sixty-six

<div align="right">breathturn</div>

i

I'm writing this at my table in the studio. It is all so clean. It is still early so that there is no one else here yet. I've walked the dog and now I'm quiet, with a glass of water and a blank sheet of paper. The light refracts across the white walls.

There are the places I haven't got to. And things I haven't read.

I know I should really get to grips with Goethe.

Wittgenstein wrote a response to Goethe's response to Newton on colour. I should get to his house in Vienna. He designed it slowly. So slowly that everyone he worked with gave up and moved on. It was an impossible house to live in, the house of a philosopher who started each sentence with a query.

Why should blinds come down? Why should rooms be this height?

The only thing he doesn't seem to have questioned was the colour of the building, its internal walls, the steps and window frames. They are white. Perhaps white was a query for Wittgenstein?

There are books in my room upstairs at the studio still in their pack-
ages, bought at night, necessary for all my journeys. I have the score of
John Cage's 4'33" on top of the pile. I run my hands over this ridicu-
lous heap of possibilities, of weeks of detours and re-routings. I was
to be the Emperor of White. There was to be a journey through white
pages. I was going to move from Tristram Shandy to Samuel Beckett.

What have I missed?

I've given up on my lists. My three white porcelain cups have become
five objects of porcelain. My three white hills have become four. I've
been taken elsewhere.

ii .

I go to Cambridge and I put out the white pots from Jingdezhen from
800 years ago on the new porcelain tiles from three years ago. They
look very beautiful.

I put out my shards and the Jingdezhen copies of Wedgwood's vases,
and some very early Meissen porcelain. And I hide a very small
installation of my own pots in the museum too. I write about all these
favourite pots and we print a modest catalogue with line drawings on
a sort of bible paper. This feels like a kind of paying of dues. I call the
exhibition *On White*.

iii

A few days after Ai Weiwei's sunflower seeds installation in the
Turbine Hall at Tate Modern in London is opened to the public, it is
closed, so that you cannot walk on the porcelain due to the dust.

I read the paper, *Cohort mortality study in three ceramic factories in Jingdezhen in
China*, Xiaokang Zhang et al., 2003. I read up on Potter's Rot, silicosis,
on what happens when clay becomes dust. The potter 'exists in it and
by it; it fills his lungs and blanches his cheek; it keeps him alive and it

kills him. His fingers close round it, as round the hand of a friend,' writes Arnold Bennett looking over the Potteries.

I open the report of the doctor in Staffordshire, so warmly welcomed into the workshops of potters, and hear Samuel Broster, aged thirty-three, 'I am the father of two children, and would not let my children work at it, not if ever so well paid.'

And I think of the man at the big-pot factory in Jingdezhen and his silence and the not wanting his kids to follow him into the dust. And I remember passing the door of the decal factory nearby where they prepare the images that are placed on to the porcelain like transfers. And seeing three boys working a huge machine that is spewing out dust into the chemical air.

This white porcelain has cost.

Obsession costs. Porcelain is a success. Porcelain consumes hills, the wood on the hills, it silts the rivers and clogs the harbours, enters the deltas of your lungs.

I remember my years in the workshop, sweeping. And if it costs me, that is one thing. But it is the cost to others, to all those children in the factories in Staffordshire and Jingdezhen, to the men standing by the burning lenses in the cellars with Tschirnhaus, to the boy collecting moss on the moors to dry the clay, the professor broken in the Cultural Revolution, and the modeller of the figures killed on the electric fence in Dachau.

This, I think, is what I've been trying to trace, the glimpse of white rising and then sinking below the waves again, the wind catching and eddying white dust, settling and resettling.

iv

I've been reading the poet Paul Celan. His poetry has been a constant for me over thirty years, but I only found his Darmstadt lecture a

couple of years ago. It was 1960 and Celan had won a prize. He rarely wrote prose, rarely gave lectures. There are only two interviews. A response to a request is five lines long.

This lecture is hard and hesitant. It keeps trying to start. His first sentence begins with a word and a pause. 'Art, you will remember, is a . . .'

There are snags, he writes, after nine lines. He is right. There are snags. He is trying to find out how a poem happens, how it comes into being. So he looks with concentration at the routes towards a poem and he tries to find when exactly the critical moment happens, the 'terrifying falling silent' that presages poetry.

This is what he calls the breathturn, the strange moment of pause between breathing in and breathing out, when your sense of self is suspended and you are open to everything.

Celan cannot find words to fit together easily. German is his language, but he is Jewish and German is also the language that killed his family. So Celan brings words together into newness, *Lichtzwang*, lightduress. *Atemwende*, breathturn. He compacts words and he breaks them open, spills them from one line to another.

His poems get shorter. They become fragments, cries, exhalations, attempts to start, attempts to make sound. The spaces around the poems get larger. There is more white page than words in his last books of poetry.

And in this lecture, as he writes of the routes into poems, he explores how these can also be re-routings and detours from who you are. He says that you send yourself ahead, in search of yourself. The imagery is of paths, of setting out, of digressions and a 'kind of homecoming'.

There is no straight road to finding yourself, to making something.

And then he thanks us for listening: 'Ladies and gentlemen, I find something which consoles me a bit for having walked this impossible road in your presence, this road of the impossible.' And Celan walks off down the impossible road.

Celan makes me think of how grateful you are for some company on the road, that it is this consolation, someone walking part of the way by your side, that means almost everything. Everything.

I think that Père d'Entrecolles had his friend the Mandarin, and that Tschirnhaus had Leibniz, and that William had Swedenborg and always had Sally, lost, but promised for the white eternity ahead. I have found their company on this journey too.

And I have Sue and our children. This is my white road.

v

I sit at my wheel. It is low and I am tall. I hunch. There is a ziggurat of balls of porcelain clay to my left, a waiting pile of ware boards to my right, a small bucket of water, a sponge, a knife and a bamboo rib shaped like a hand axe in front of me. I have a cloth on my lap to wipe my hands. There is music, somewhere.

My dog is nearby. And coffee.

I make small vessels in porcelain, three or four inches high. I make them quickly, leaving the top edge ragged or elliptical. After a couple of hours I can pick them up to trim them with a knife, rapid cuts, and then run a thumb along the base to smooth it clean. And then I press in my seal.

After thirty years it is now worn smooth of a name or place. It is just an empty oblong.

I use my porcelain from Limoges, near to where Père d'Entrecolles was born. I use my china clay, mined twenty miles from Tregonning Hill, the place where William found white earth.

I make 2,455 pots and they are glazed in whites.

I use all the accomplished, attempted, consolatory, melancholy, mina-tory, lambent whites from my journey. All the whites from Jingdezhen, 'white as congealed mutton fat', and Kakiemon and Nanjing and

Tibet and Venice and Saint-Cloud and Dresden, 'milk white, like a narcissus', and Meissen and Coxside on the Plymouth docks, 'white like smoke', and Bristol and Etruria and Carolina and St Petersburg and the Bauhaus. And Allach. And now here, in my new studio in West Norwood next to the bus garage.

And I place them on shelves in vitrines seven feet high and eight feet across. I call this quartet of installations *breathturn*. There are rhythms, repeated sequences of pots, and there are attempted rhythms, pauses and caesuras. There are congestions and releases. There is more white space than words.

The vitrines are photographed and then my pots are numbered and wrapped and crated and sent across the world and unwrapped and I put them back on their shelves.

This is my exhibition in New York. I call it *Atemwende*.

Sue is there, of course, and the children are let off school for a long weekend. It is their first time in New York, so we eat pizza in Chelsea

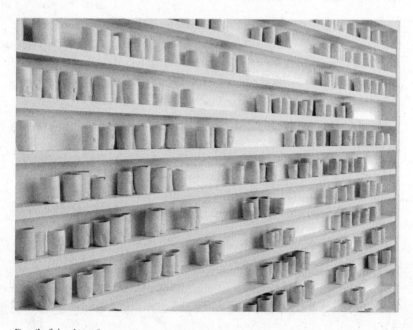

Detail of *breathturn, I,* 2013

and walk in Central Park and they are lovely about the work and proud, and I take them round, our Big Family.

And I'm asked at the opening, *How is it possible to make white things?* This question is the same question I was asked as a child. It is still a good question to ask. And I'm asked if I get bored sitting at my wheel, do my assistants make the pots? And I'm asked if I'm writing again?

To which I answer that white is a way of starting again. It is not about good taste, that making white pots was never about good taste, that making porcelain is a way of starting again, finding your way, a route and a detour to yourself. And that I don't get bored. That I make them myself.

And that no, I'm not writing. I have written. And I am making again.

Further reading

There is a vast literature on porcelain, its manufacture and consumption. For a guide to those I have found most useful, with signposts towards books and articles that may prove illuminating, please see www.thewhiteroad.com.

List of illustrations

Information concerning illustrations is displayed as follows: page number; caption; copyright owner; source (where known)

Ching-te-chen: views of a porcelain city, Robert Tichane, The New York State Institute for Glaze Research, Painted Post, 1983

61 Grinding cobalt, Jingdezhen, 1938; *Early Ming wares of Chingtechen*, A.D. Brankston, Henri Vetch, Peking, 1938

73 Page from the *Collected Statutes of the Great Ming Dynasty*, 1587; Gest Oriental Library and East Asian Collections, Princeton University; *Ten Thousand Things: module and mass production in Chinese art*, Lothar Ledderose, Princeton University Press, Princeton and Chichester, 2000

83 Engraving of the Porcelain Pagoda, Nanjing, 1665; The British Library; *Het Gezantschap der Neêrlandtsche Oost-Indische Compagnie (etc)*, Johan Nieuhof, Amsterdam, 1693

85 Monk's cap ewer, Yongle Dynasty, 1403–25; © The Trustees of the British Museum

103 Silk scroll painting of Lang Tingji by Lu Xue, 1697; Qingdao Municipal Museum; 'Lang Tingji (1663–1715) and the porcelain of the late Kangxi period', Peter

Y.K. Lam, *Transactions of the Oriental Ceramics Society*, 2003–2004

111 Mark of Meissen

124 Etching of the Trianon de Porcelaine, Versailles, c.1680 ; Bibliothèque Nationale de France

131 Tschirnhaus, 1708; SLUB Dresden / Deutsche Fotothek / Regine Richter

143 Engraving of Dresden, 1721; SLUB Dresden / Deutsche Fotothek / André Rous

144 Tschirnhaus's burning lens, made in 1686, photograph from 1926; *Der Goldmacher, Joh. Fr. Böttger*, Eugen Kalkschmidt, Died & Co, Stuttgart, 1926

160 Engraving of an alchemist, from *Twelve Keys of Basilius Valentinus*, 1678; Wellcome Library London

178 Albrechtsburg Castle, Meissen, 1891; SLUB Dresden / Deutsche Fotothek / Antonio Ermenegildo Donadini

188 Page from Böttger's note-book showing his first por-celain tests, 15 January 1708; © Meissen Couture, Meissen Archive

192 Meissen porcelain cup,

Acknowledgements

This is a book that has been many years in the writing and I am grateful to the great generosity of considerable numbers of people for their encouragement, advice, hospitality and open sharing of hard-won knowledge.

For research assistance and for translations, I'm very grateful to Dr. Kristina Meier, Dr. Wolf Burchard, Richard Lowkes and Ivy Chan.

For help in Jingdezhen and Shanghai, I would like to thank Tao-Tao Chang, Dr. James Lin, Caroline Cheng and Eric Kao. For advice on Chinese porcelain, conversations with Stacey Pierson, Jan Stuart, Mike Hearn, Peter Y.K. Lam and the late Sir Michael Butler were illuminating. In Dresden, Hartwig Fischer was hugely supportive and Dr. Ulrich Pietsch, Dr. Michael Korey, Dr. Christian Kurtzke, Falk Diessner, Peter, Sylvia Braun, Anke Scharrahs and Claudia Gulden helped in many ways. Maureen Cassidy-Geiger, Dr. Sebastian Kuhn and Henry Arnholdt were generous with insights into Meissen. At the Dachau archives, Albert Knoll was invaluable with his knowledge on Allach, and his friendship with the late Hans Landauer. In Dublin, Dr. Audrey Whitty gave me a day with the Fonthill Vase, in Amsterdam Menno Fitski gave me time with Kakiemon at the Rijksmuseum.

In North Carolina I had energetic help from Annie Carlano and Brian Gallagher at the Mint Museum, Charles Locke Moffett Jr., Martha Daniels and Katy Bruce at the Mulberry Plantation, and two wonderful days in the company of Jerry Anselmo. Christopher Benty made the journey before me and wrote of it beautifully in his memoir.

My friends at the Victoria and Albert Museum, Dr. Martin Roth, Dr. Hilary Young, Alun Graves and Dr. Reino Liefkes helped with English porcelain, Mark Damazer with Wedgwood, Richard Hamblyn with Plough Court, Mary Laven with Matteo Ricci, John Scantlebury with Cornwall. Thank you to the late Jeremy Theophilus for initiating the exhibition with the Fitzwilliam Museum and Tim Knox and Victoria Avery for making it happen. I'm grateful to Clare Tavernor, Alan Yentob and Jonty Claypole for their support on the Imagine documentary for the BBC.

Thank you to the archivists and librarians of the Jingdezhen Ceramic Institute, Fitzwilliam Museum, Cambridge University Library, British Library, London Library, National Art Library, British Museum, Swedenborg Society, Cornwall Record Office, Plymouth and West Devon Record Office, Bristol Record Office, the Wedgwood Museum archive, Bonham's in London, Stroke-on-Trent City Archive, Sotheby's in London and New York, Metropolitan Museum of Art Library, the North Carolina Museum of History, the Dresden State Art Collections, the Staatliche Kunstsammlungen in Dresden, Meissen archive, Saxon State archive, Dresden city archive, Albrechtsburg Castle, Berlin State Library and Dachau Concentration Camp archive.

Thank you to my tremendous studio team of Sam Bakewell, Stephanie Forrest, Jemima Johnson, Sun Kim and Barry Stedman, and to my friends Charlie Moffett, the late Michael Harrison, Mark Francis, Sheena Wagstaff, Tim Eicke and Daniel Morgan who kept talking to me when others would have given up.

For all their help in making this book happen, I'd like to thank the amazing Jonathan Galassi and Louise Dennys, Ileene Smith, Simon Bradley, Zöe Pagnamenta, Felicitas Feuilhauer, Herbert Ohrlinger,

Andrew Nurnberg, Eleonoora Kirk, Kate Bland, Ruth Warburton, Mari Yamazaki, Helen Flood, Fran Jessop and Jeff Seroy. John Morgan and Stephen Parker and Ian Skelton for their beautiful book design. Susannah Otter has been indefatigable as my assistant editor.

Nerissa Taysom is a marvellous researcher, assistant and reader. Felicity Bryan is a wonderful agent and a wonderful friend and in Clara Farmer, I have an editor and publisher whose clarity, imagination and patience are extraordinary. I am truly grateful for her ambition for this book.

This is a family journey. Thank you Ben, thank you Matthew and thank you Anna.

This is for Sue, who has been alongside me every step of the way.

READ MORE BY *NEW YORK TIMES* BESTSELLING AUTHOR EDMUND DE WAAL

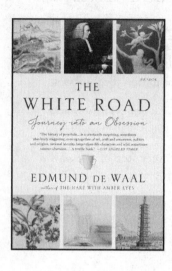

The White Road
ISBN 978-1-250-09732-3
E-ISBN 978-0-374-70909-9

"The history of porcelain, as told in *The White Road*, is a constantly surprising, sometimes absolutely staggering, coming together of art, craft and commerce, politics and religion, national identity, larger-than-life characters and wild, sometimes ruinous obsession. . . . If you read it, you'll never look at porcelain the same way again."

—*Los Angeles Times*

The Hare with Amber Eyes
ISBN 978-0-312-56937-2
E-ISBN 978-1-4299-7959-7

"Enthralling . . . [de Waal's] essayistic exploration of his family's past pointedly avoids any sentimentality. . . *The Hare with Amber Eyes* belongs on the same shelf with Vladimir Nabokov's *Speak, Memory*."
—*The Washington Post Book World*

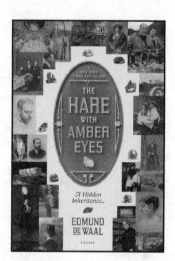